D1285294

Treasures of the NATIONAL PARKS

Yesterday & Today

By Paul Horsted

Design by Camille Riner

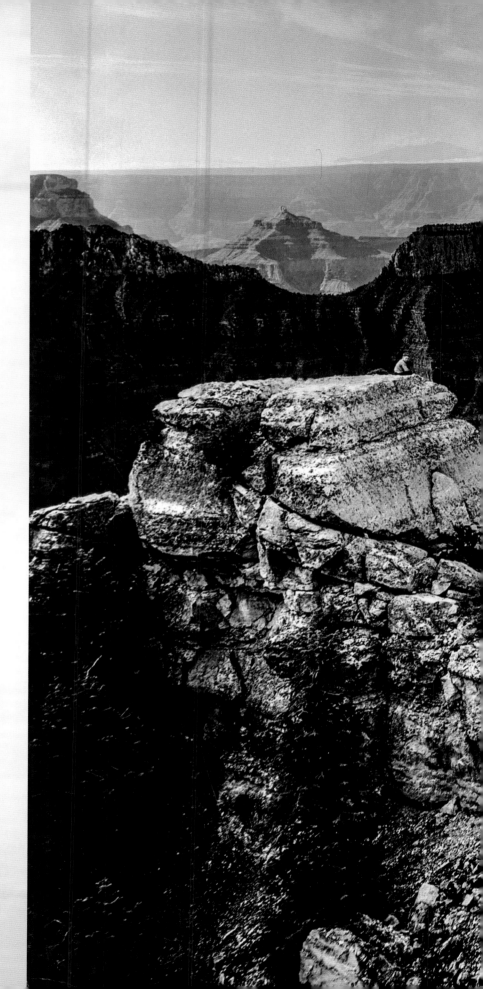

Author's Note

I enjoy speaking to groups about the beauty and history of the Black Hills and our national parks. Contact me for more information. Email or social media is the best way to reach me, or write to the address below. Please include a self-addressed stamped envelope if you'd like a reply.

Most of the images in this book are available as art prints suitable for framing. Visit paulhorsted.com for details.

Paul Horsted
paul@paulhorsted.com

Dakota Photographic LLC
24905 Mica Ridge Road
Custer, SD 57730

The beauty of today, the history of yesterday! Fine books by Paul Horsted and his co-authors, available at your favorite bookstore or online bookseller. Samples at paulhorsted.com.

Published by Golden Valley Press, an imprint of Dakota Photographic LLC, Custer, SD.

©2017 by Dakota Photographic LLC, All Rights Reserved. No part of this publication may be reproduced or transmitted in any form or by any means now known or hereafter invented, electronic or mechanical, including photocopy, recording, or any information storage, online or retrieval system, without permission in writing from the publisher. Modern photographs (if not otherwise credited) and related text are ©Paul Horsted.

The information contained in this book is accurate to the best of the author's knowledge. The author and publisher assume no liability whatsoever for errors or omissions of any kind, nor for any injury that may result from use of the information in this book. This book may depict areas that are difficult or hazardous to visit; it is the reader's sole responsibility to assess potential dangers and to prepare accordingly before entering these areas or any national park. Check with National Park Service ranger stations or visitor centers for the latest information on conditions, closures and safety issues.

First Edition: December 2017.

ISBN-13: 978-0-9718053-7-8
Library of Congress Control Number: 2017912042

Author: Paul Horsted

Designer: Camille Riner
Editor: Ernest Grafe

Produced and published in the United States of America. Printed in the Republic of Korea.

Bright Angel Point, North Rim of Grand Canyon National Park, in 1922. See the next spread for modern view. (Library of Congress/Unknown Photographer)

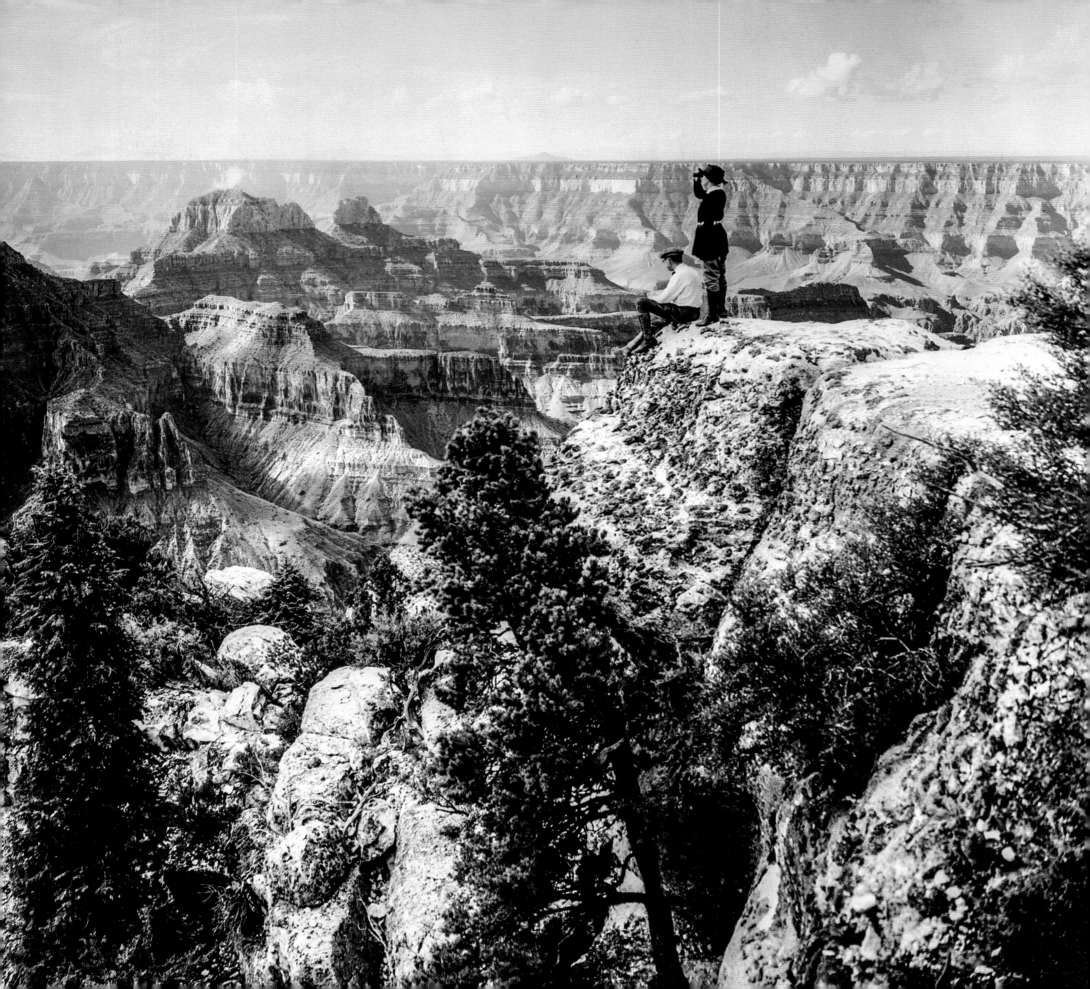

Table of Contents

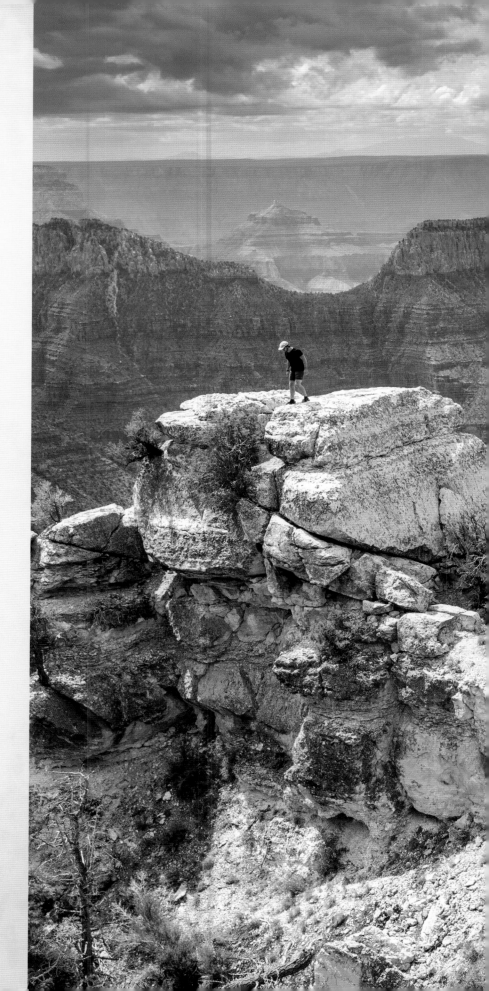

Compared to the historic photo (previous spread) Bright Angel Point looks much the same, with some of the trees now larger and a fenced overlook added for visitor safety. 8/2/15 • 36°11'37" N 112°2'55" W

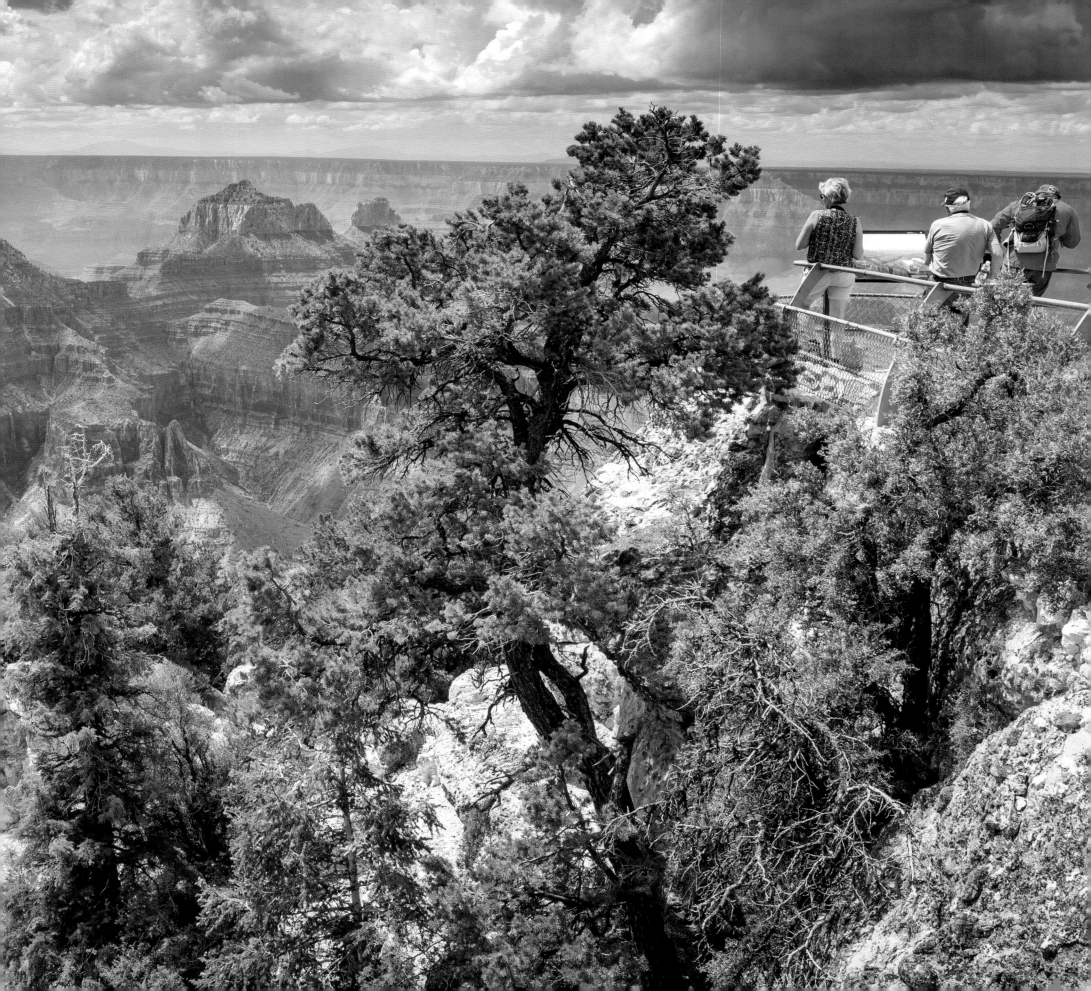

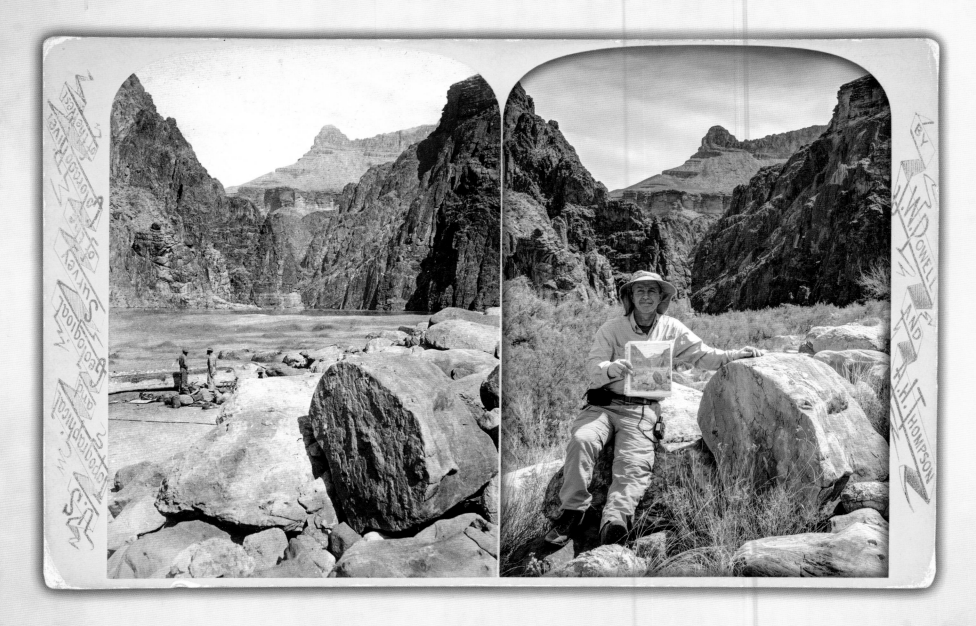

My goals for this book can be simply stated. I wanted to find the exact places where photographers of the 1800s and early 1900s had worked, across two dozen of our country's grandest national parks. I wanted to place my camera at those sites, record what is there today, discover how the landscape had changed (or not), look at how the ways we use the parks have changed (or not) and perhaps find out more about how the early photographers had worked at these sites.

I didn't know how long it would take, but after four years of field work I've achieved most of my goals. Through the 170 photo pairs presented in these pages I hope you will share my excitement about "standing in history" at these historic, scenic places across the country.

The inspiration for this book goes back to the year 2000, when I began searching my native Black Hills of South Dakota for the historic sites of about 50 photos taken during an 1874 expedition led by

"Standing in History" at an 1871 Powell Expedition site in the Grand Canyon. (S.V. Jones Collection/J.K. Hillers)

General George Armstrong Custer. After three years of work we published a book (co-authored with Ernest Grafe) entitled *Exploring with Custer: The 1874 Black Hills Expedition*. This was my first attempt at the process known as "rephotography": locating the historic photo site, then positioning a camera to create a precisely matching modern view from the same position.

The overwhelming response from readers of that first book encouraged me to try the technique at 150 other sites around the historic Black Hills and Dakotas. Three more years of field work resulted in the book *The Black Hills Yesterday & Today*. This was followed four years later by *Yellowstone Yesterday & Today* (co-authored with Bob Berry). With these last two books I also tested the notion of doing a *Treasures of the National Parks* book, using new techniques I had developed with the assistance of technology not yet invented during my first attempts.

In the captions below the photo pairs that follow, I share my experiences at each park along with some notes on history and ecology. In places I add conclusions about what I learned from comparing past and present. More about the project itself can be found in the Afterword (page 224), which includes a description of my methods as well as stories from the search. There are also a few "behind the scenes" photos of what I found along the way or around historic photo sites.

Beneath or near each modern image is not only the date it was taken but also GPS coordinates for the site, in case the reader would like to find it in Google Earth or use GPS to find it in the park. But

Right: Photo site at Lassen Volcanic National Park. Below: The same tree beneath our feet, 145 years apart, at the Tuweep area on Grand Canyon's north rim. (Library of Congress/William Bell)

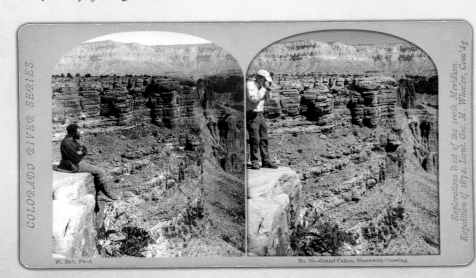

please note any special warnings that might also be included. Some of the sites I visited, well away from established trails, are not places to take small children, or to visit at any age for someone who is not absolutely sure of his or her abilities. Some early photographers went to great lengths—dangerous lengths—to get their photos. Sometimes it's astonishing to see how they posed their guides or other tourists close to a cliff edge, or to find where they themselves stood to make the photo. The last thing I would want is for this book to guide someone to a place off-trail where they could get into trouble.

I often think of looking for historic photo sites as a kind of treasure hunt; I never know what will be waiting when I reach a site and, with the old photo in hand, draw back the veil of time. My eagerness to "find what's there now" has driven me to quite obscure and remote sites, regardless of obstacles or distances, and also to sites that are more easily reached along today's roads or at overlooks. I have spoken with scientists and experts who find these photo pairs of interest in their disciplines of geology, forestry, history and more, and I touch on these subjects in the captions. But I hope the general reader will just enjoy the experience of looking into the past from the present.

When I reach these sites and suddenly recognize a boulder or a tree from a 145-year-old photo, there in front of me, visions of another time sweep through my mind. I sometimes feel as if I'm moving in a world apart from that of cars, modern noises and other nearby visitors. I am making discoveries and seeing things in the past that would be unknown without the historic photos. *Here is where Major*

John Wesley Powell's men repaired their boats at the bottom of the Grand Canyon. Look at that scrubby little tree growing from the cliff at Tuweep; it's been there since before 1872.

Sometimes my fellow visitors would see me poring over a reference print and realize I didn't quite look like the average tourist. When they asked what I was doing, I would of course share what I had found in the view before us. Their excitement usually matched my own over the discovery made at that site. I hope you the reader will also feel a sense of that discovery as you peruse the pages that follow.

Because I have often been asked if the National Park Service hired me to do this project, I'd like to reply here that, no, this book project was entirely self-funded. Or rather, it was funded by my readers, to whom I am most grateful. If you purchased this book or any others we've produced (page 2), my wife (and book designer) Camille Riner and I give you our most sincere thanks for making our work possible. We couldn't do it without you.

Paul Horsted • Custer, SD

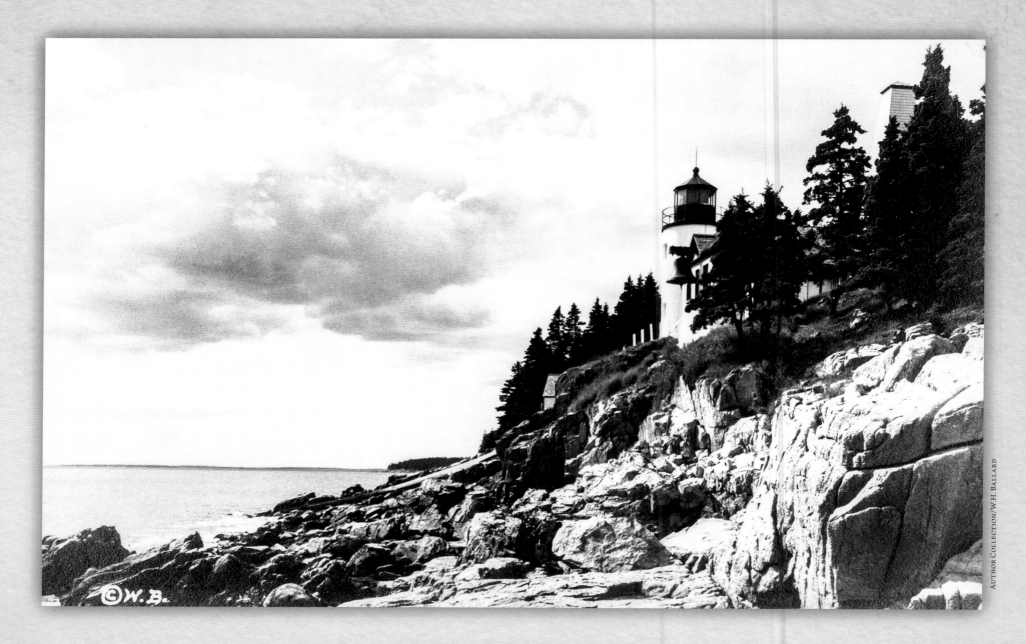

AUTHOR COLLECTION/W.H. BALLARD

Circa 1940 ~ Bass Harbor Lighthouse

Established in 1858, the Bass Harbor Lighthouse in Acadia National Park had already been in service for some 80 years when photographer W.H. Ballard made this postcard view at the southernmost tip of Mt. Desert Island.

Kerosene fueled the original beacon. The lighthouse was electrified in 1949 and its beam can be seen up to 13 nautical miles away, according to an interpretive sign at the site. The site is operated today by the U.S. Coast Guard but open to Acadia visitors.

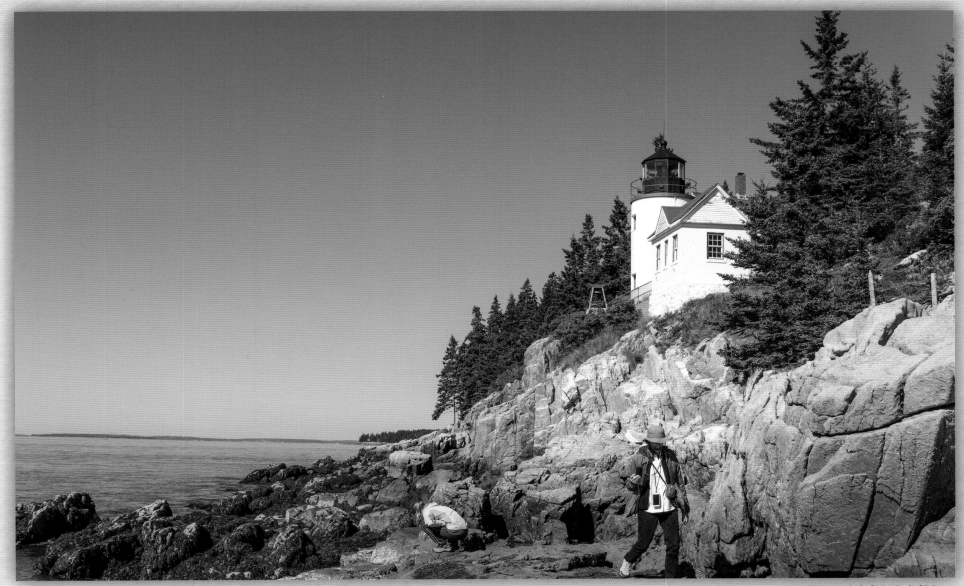

9/17/14 • 44°13′18″ N 68°20′12″ W

Although I hadn't planned for it, the tide was going out when my family and I arrived at the Bass Harbor Lighthouse. By chance the low tide pretty well matched what is seen in the historic image, and also allowed access to a car-size boulder (surrounded by the sea at higher tides) that turned out to be the photo site. Stepping past tidal pools, I scrambled to the top of the boulder and found the view seen in the historic photo. It was quite obvious where Ballard had stood due to the limited space on top of the boulder. Unlike some that follow, this historic photo was an easy one to match once I got there.

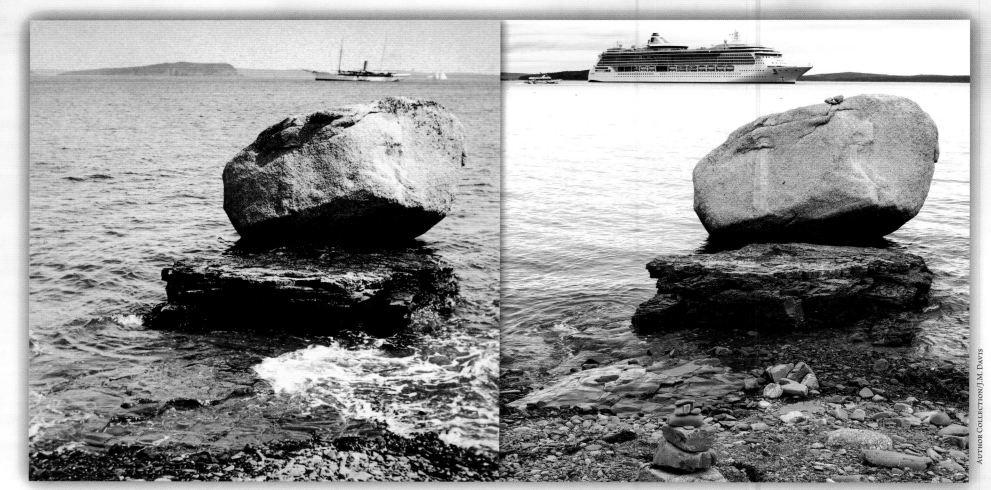

Author Collection/J.M. Davis

9/16/14 • 44°23'20" N 68°12'1" W

Circa 1900 ~ Balance Rock, Bar Harbor

Although Bar Harbor itself is not technically part of adjacent Acadia National Park (nor is Grant Park, the specific location of these photos), several nearby islands are in the park, including Long Porcupine Island in view at upper left. And when I found this site along the shoreline, with its balanced boulder deposited by the last glacier perhaps 15,000 years ago, I had to include it here. The boulder hadn't moved—at least not in the past 100 years.

I was also struck by the contrast between the two ships moored in roughly the same location: what a change in ocean-going technology! A recent issue facing Acadia and the town of Bar Harbor is how to cope with thousands of people arriving at one time on cruise ships such as this. As this book went to press, public forums were scheduled in the town to talk about possible limits on ship size and the number of visitors coming in at one time.[1]

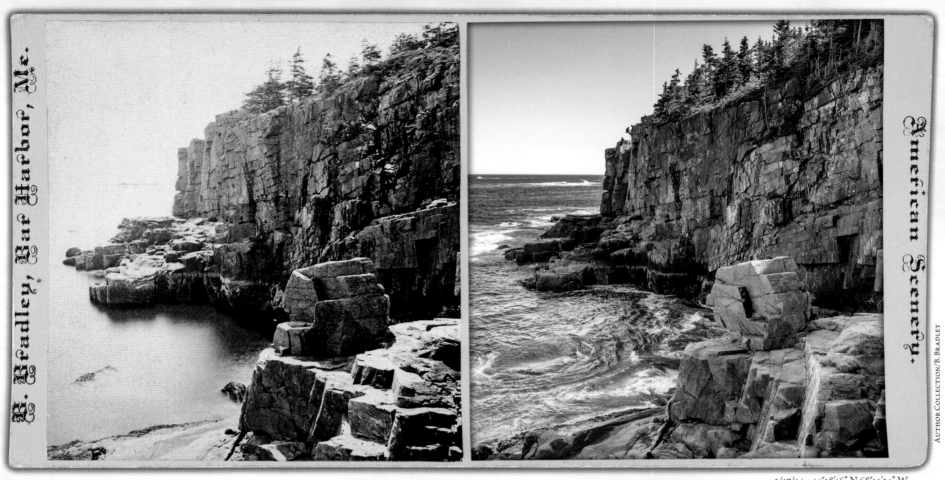

B. Bradley, Bar Harbor, Me.

American Scenery.

Author Collection/B. Bradley

9/17/14 • 44°18′46″ N 68°11′24″ W

Circa 1885 ~ Otter Cliffs

I scouted this location near the beginning of my only Acadia visit to make sure of access, returning when conditions and time permitted later in the week. The tide is a little higher in my photo, but I had decided early in this project not to worry too much about temporary conditions such as water levels or clouds. I do wait for the light to get a beauty shot, when possible, but there was too much ground to cover in too little time for me to do that at every site, or to worry about other transitory changes.

At a glance, the rock formations look much the same now, but the foreground block has been eroded, probably by 130 years of crashing seas. On the other hand, tree cover seems to have increased.

The Otter Cliffs are a popular rock-climbing area; there's a man just coming up over the edge at a point of the cliff. I saw no otters, which is apparently typical, but online video shows that they inhabit other areas along the coast in Acadia.[2]

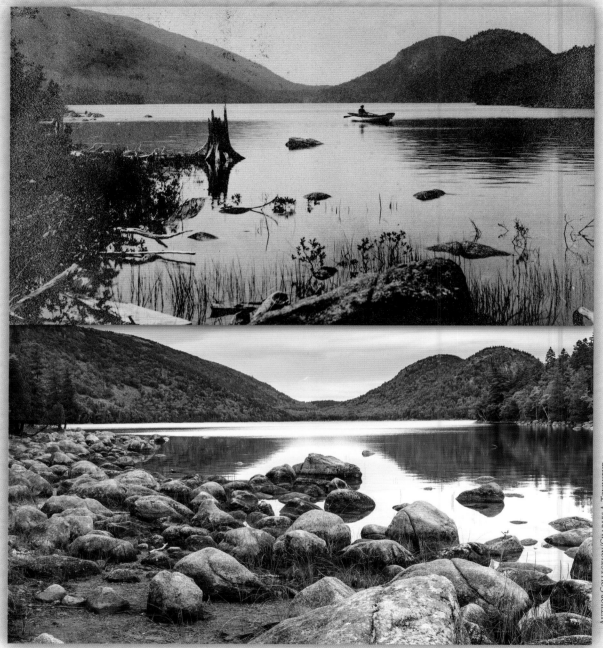

Author Collection/Charles A. Townsend

9/16/14 • 44°19'25" N 68°15'1" W

1905 ~ Jordan Pond

Strolling along a path near the southeast corner of Jordan Pond, I watched as the point at right gradually came into alignment with the rounded mountains in the background, classic Acadia landmarks known as the Bubbles. Suddenly I realized I was standing in view of the foreground boulder with the vertical crack. The other boulders had been almost completely submerged in 1905, but an online survey of photos shows that water levels fluctuate at Jordan Pond, so either scene may have been typical at different times.

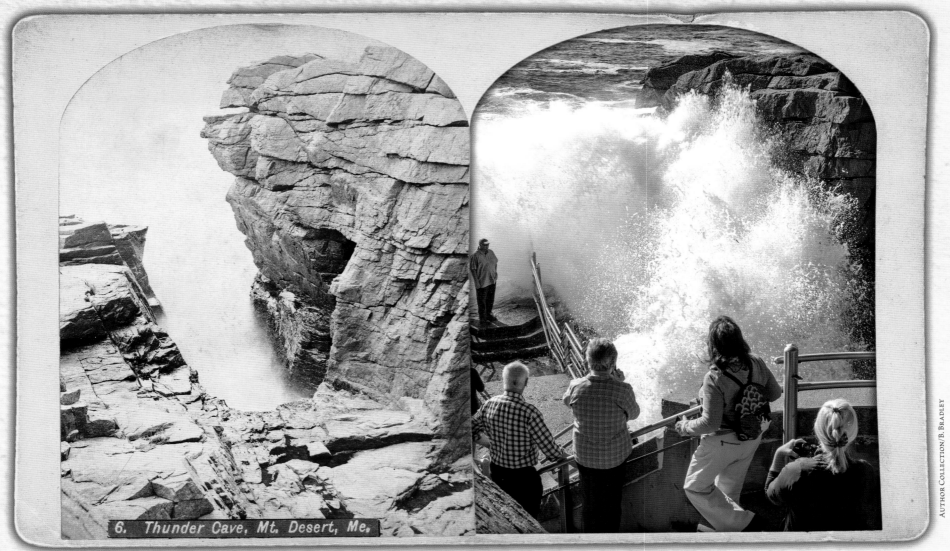

6. Thunder Cave, Mt. Desert, Me.

AUTHOR COLLECTION/B. BRADLEY

9/19/14 • 44°19'15" N 68°11'19" W

Circa 1885 ~ Thunder Hole

The title on the historic view is either an early version of a place-name or, more likely, a typo. There is no "cave" here, but other early images use the word "cove" for this small inlet where waves collide with cliffs, creating a huge spray of water and emitting a thunderous "boom" when conditions are right. Today this area is called the "Thunder Hole."

During my visit, the period between breaking waves was long enough that arriving visitors had time to reach the lower platform without being aware of what was to come. I gently tried to warn them about what I'd been observing for an hour, but the gentleman at far left got a soaking anyway. People have been swept away and even drowned by breaking waves here, so use caution when the seas are rough.

If there are no waves crashing when you visit, return when the tide is coming in (early in the morning, if possible, to avoid crowds). The right combination of tide and wind, or even a storm far out to sea, will cause the Thunder Hole to fully live up to its name.

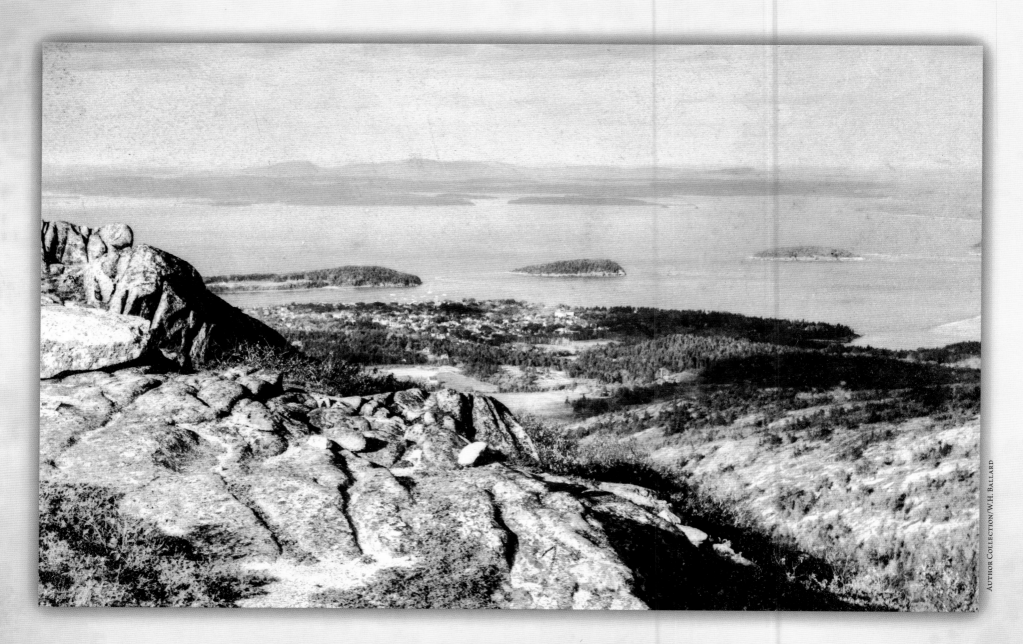

AUTHOR COLLECTION/W.H. BALLARD

Circa 1940 ~ Bar Harbor & the Porcupines from Cadillac Mountain

This Acadia image, on a postcard published by Jordan Pond House decades ago, is not credited to any photographer. But I found a scan of the same photo in the Southwest Harbor Public Library that indicated it was taken by W.H. Ballard, and that he had called the foreground feature "Pulpit Rock," a name which does not seem to be in use today on park or topographic maps.

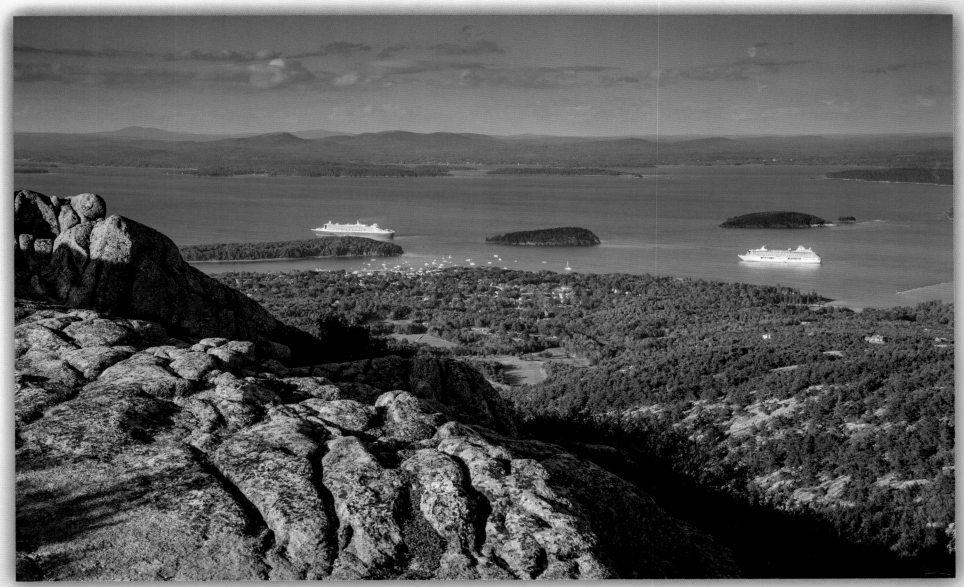

9/18/14 • 44°21'12" N 68°13'18" W

Whenever the conditions are clear, the view from Cadillac Mountain over Bar Harbor to the Porcupine Islands beyond is simply stunning. I scouted the location of this site just off the Gorge Path, finding it at the summit, about 300 yards from the parking area. Since it was so easy to get here, I returned two days later for the afternoon light. It was then that I realized—from an article I'd seen in the local paper—that the "cruise ship" on the left was actually the ocean liner *Queen Mary 2*, visiting Bar Harbor for only a day. (The other ship was named the *Crystal Serenity*.) I'd like to say that this was due to my precise advance planning, but it was really just sheer luck.

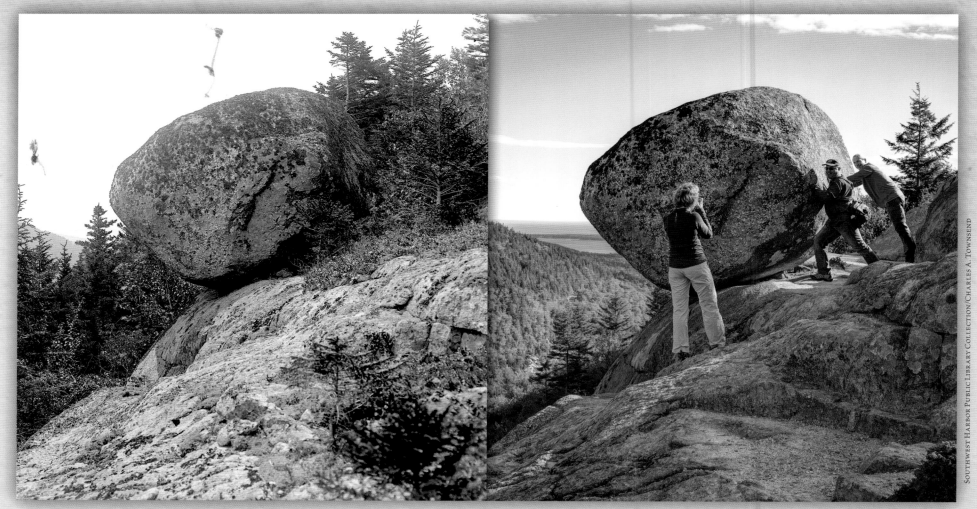

SOUTHWEST HARBOR PUBLIC LIBRARY COLLECTION/CHARLES A. TOWNSEND

9/18/14 • 44°20′23″ N 68°15′11″ W

Circa 1930 ~ Bubble Rock

Bubble Rock was named for its location on a shoulder of the South Bubble, a small rounded mountain overlooking Acadia and the ocean beyond. This large boulder, a glacial erratic, was deposited in an unlikely location when the glacier melted away thousands of years ago. Even now it looks ready to topple into the basin below at any moment.

I hiked the Bubbles Divide Trail and easily found the boulder. After aligning my camera to match the historic photo, I awaited developments. In almost every group of hikers that passed, someone would push on the boulder. This group was having fun and taking photos too, and I obtained permission to photograph their attempt to move the boulder. But it looks as though it will be there a while yet.

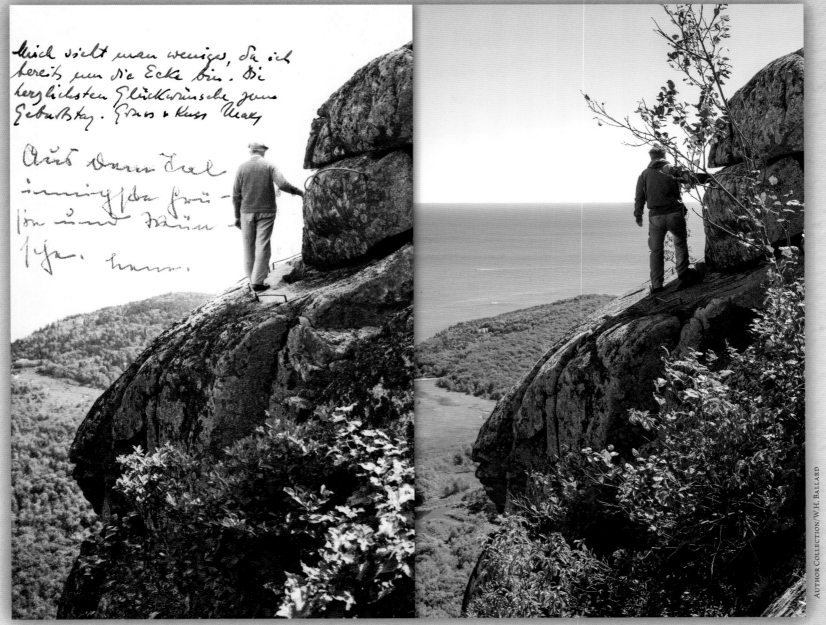

Author Collection/W.H. Ballard

9/19/14 • 44°20'60" N 68°11'30" W • Caution: Exposure to Falls.

1938 ~ Precipice Trail, Champlain Mountain

Metal rungs and ladders aid climbers past and present on this aptly named cliff-side trail. Some sections are even more scary than this photo indicates.

Notes found with another print of the historic photo indicate that the man was T.A. McIntire, 69 years old, and that the photographer was W.H. Ballard, whose work I revisited at two other sites in these pages.[3]

Not all the German words on the postcard are legible, but it seems that the writer had hiked to this location, and was sending birthday wishes to a friend.

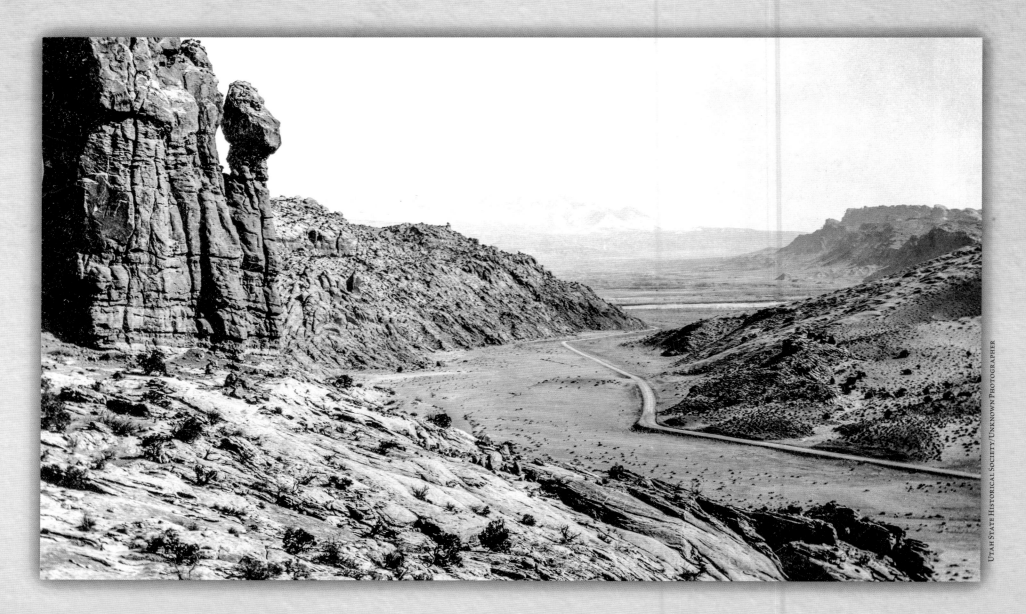

Utah State Historical Society/Unknown Photographer

Circa 1935 ~ Moab Valley, South Entrance to Arches Nat'l Monument

This view was among a set of Utah Writers' Project photos taken in Arches National Park (then a Monument). At that time the entrance was several miles to the northwest, behind the camera.[4]

In the 1930s the town of Moab had probably not extended far enough into the valley to be visible in this view, but at that distance the area was obscured by haze.

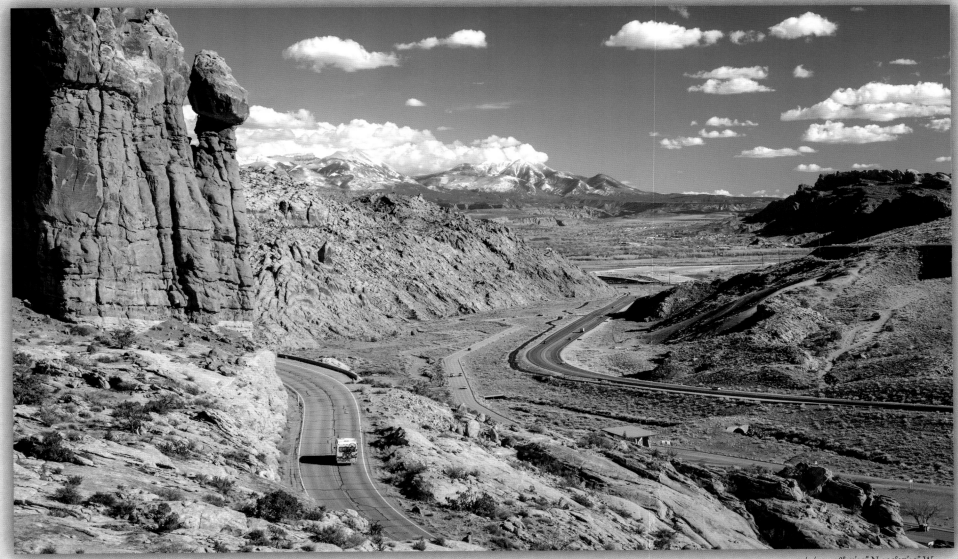

3/2/14 • 38°37′10″ N 109°37′12″ W

I found this site by climbing up from the present-day entrance road until my back was almost against the canyon wall. The historic photographer had apparently moved up as far as possible to take in the scenery.

It is a remarkable view, but I had to look closely (and later drive down the valley) to see all that is truly revealed here. On the left side of Highway 191 are sections of the entrance road, built in 1958 to accommodate visitation that has grown to 1.5 million people per year. But on the bluff at right, just outside the rel-atively-protected national park, I saw newly-formed gullies and other erosion caused by off-road vehicles. Beyond the bluff lies the site of the Moab Mill, where uranium was processed from 1956 to 1984. The mill tailings were later found to be contaminating ground water and the adjacent Colorado River. In 1998 the mining company went bankrupt as is often typical when there's a mess, so a massive "reclamation and long-term management" has been in progress for the past 20 years—funded by taxpayers.[5]

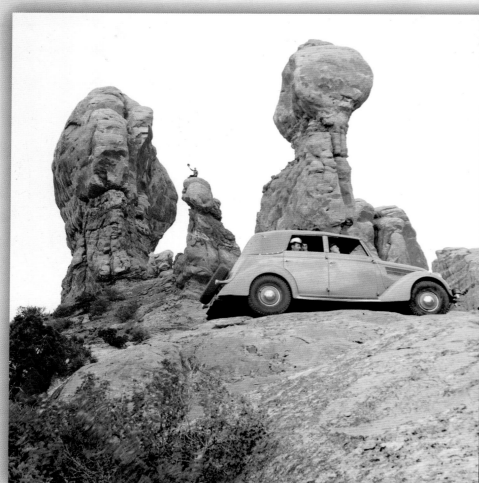
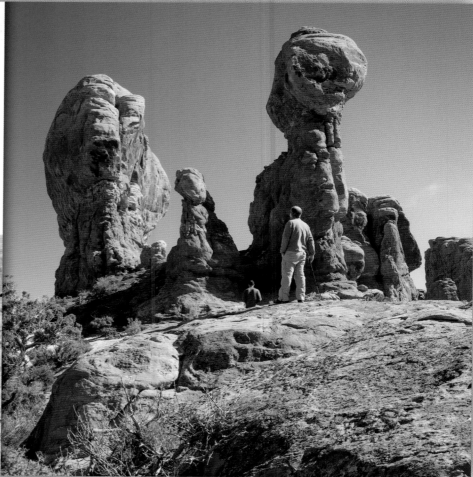

Author Collection/Harry Reed

3/3/14 • 38°41'52" N 109°32'59" W

1936 ~ Adam & Eve, Garden of Eden

I was puzzled by how the car got to where it is in the historic photo, and finally concluded that it had been backed in for the photo op. The man in the front seat is identified in a visitor center display of similar images as Dr. J.W. "Doc" Williams, while the car is referred to in other photos as "the first car in Arches National Monument," on June 15, 1936. The other passenger and the climbing cowboy on the background rock formation are not identified.

Viewing the stone formations with some imagination, I could see Adam eating an apple at left while Eve looks on; thus the name for this area of the park.

Harry Reed, the photographer for this and the Arches photos that follow, was appointed custodian of what was then a national monument in 1935. Arches was designated a national park in 1971.

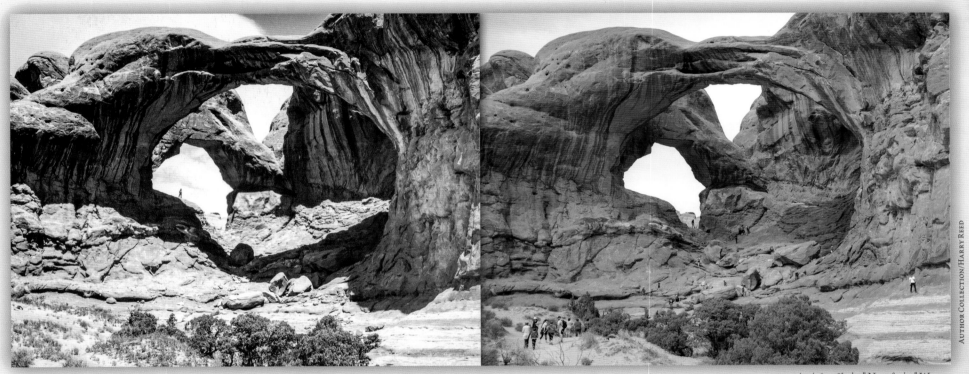

Author Collection/Harry Reed

3/21/16 • 38°41′27″ N 109°32′22″ W

Circa 1936 ~ The Double Arch

This photo site was located along the trail from the parking lot to these magnificent arches, adjacent to a viewing area partly encircled by rocks that offer seating. I came to a small mound where photographer Harry Reed must have tried to gain a little elevation. A distant figure provides scale in his photo, while more numerous modern hikers do the same in mine.

This is one of the most popular areas in the park, and the parking area is often full by late morning during the peak season. I came here in March, a "shoulder season"—the time between peak and off-peak visitation—and still saw plenty of people hiking the trail to Double Arch.

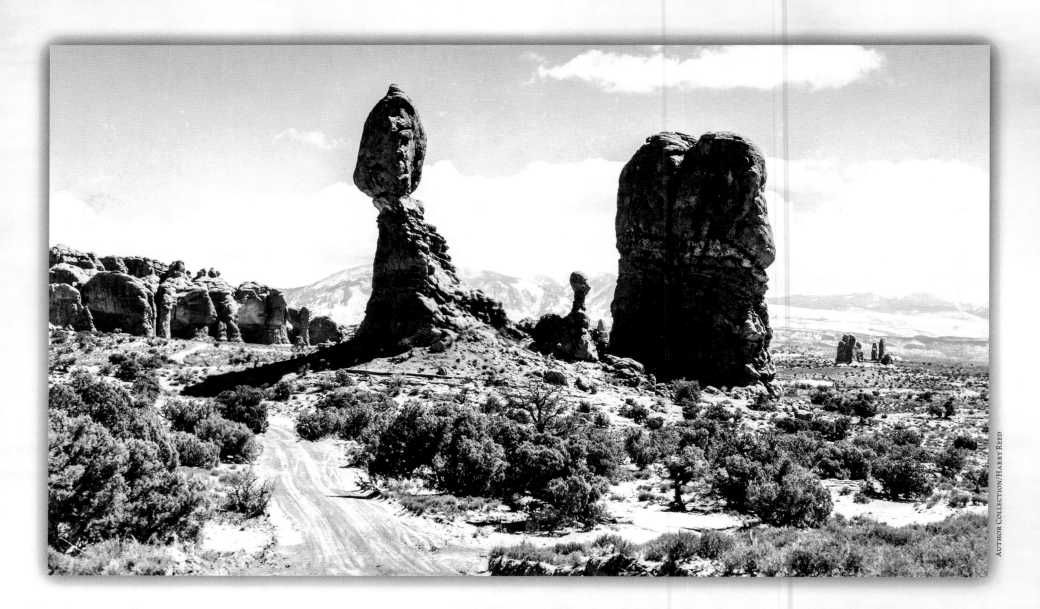

AUTHOR COLLECTION/HARRY REED

Circa 1940 ~ The Balanced Rock

This image was taken along the original entrance road into Arches National Park. The old road, which still exists, enters the park from Highway 191 about eight miles behind the camera, crossing Courthouse Wash and reaching today's park boundary in four miles, before continuing another four miles to this point at Balanced Rock. Here it meets the paved surface of today's main park road.

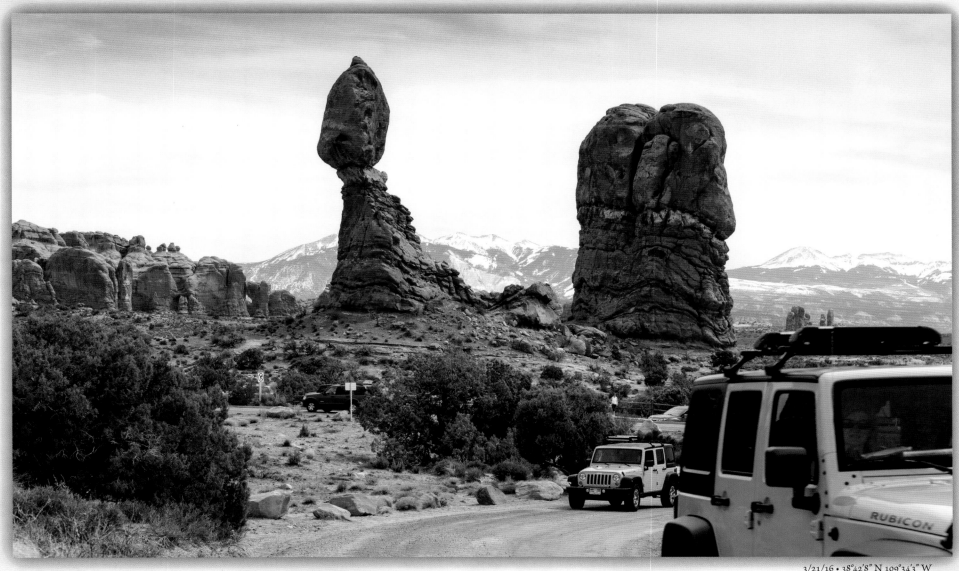

3/21/16 • 38°42'8" N 109°34'3" W

I set up my camera on the edge of the old entrance road, now somewhat improved with gravel and partially re-routed at this location. Even in March there was a fairly constant stream of traffic along the main park road (in the middle of this photo), with ubiquitous yellow Jeeps and other four-wheel-drive vehicles traveling the historic park road as well.

This park and others in Utah especially were heavily marketed by the Park Service and the tourism in-

dustry during the run-up to the National Park Service Centennial in 2016. The effort was so successful that Arches had to close its entrance on May 23, 2015, when visitor traffic backed up all the way into the main highway, creating a safety hazard.[6]

Beyond improved roads and an increase in traffic, there is another change visible in this photo: A small balanced rock at the center, known as "Chip Off the Old Block," fell over during the winter of 1975-76.

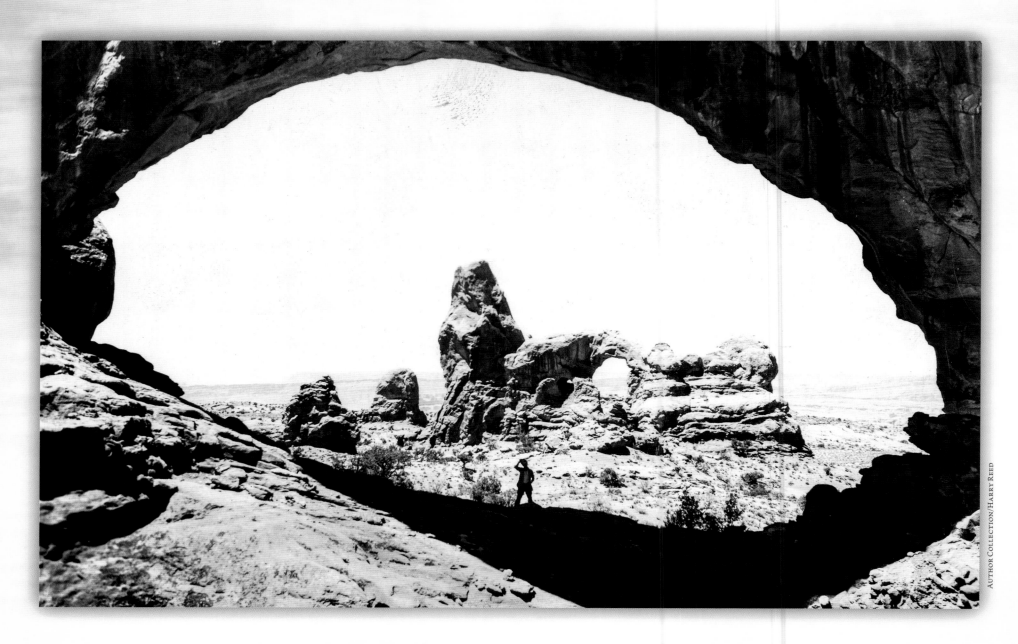

AUTHOR COLLECTION/HARRY REED

Circa 1940 - Turret Arch as Seen Through ᴛʜᴇ North Window

Judging by the shadows, this image was made near mid-day, when the shade of North Window Arch must have felt welcome to the hiker standing beneath it in this image. Photographer Harry Reed (Arches custodian at the time) seems to have been expanding his portfolio of postcards with additional images of what was then a recent addition to the National Park System.

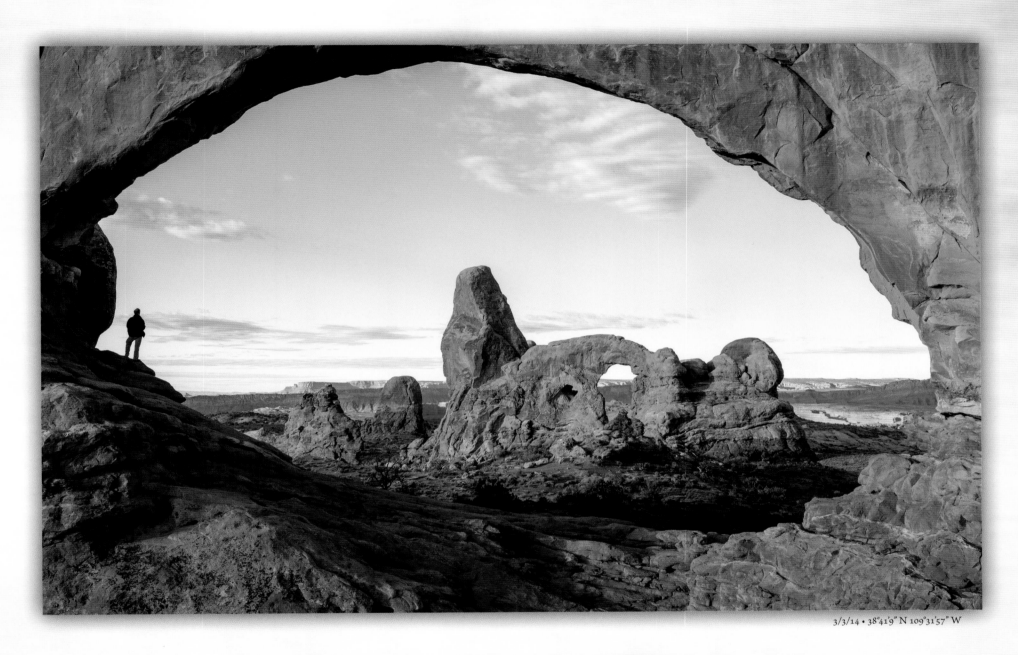

3/3/14 • 38°41'9" N 109°31'57" W

After hiking through the North Window Arch, I found the place where Harry Reed stood by looking back from a rocky knoll to see the arch perfectly framing nearby Turret Arch.

Internet searches show that the view created by Reed nearly 80 years ago has been unknowingly replicated hundreds if not thousands of times since.

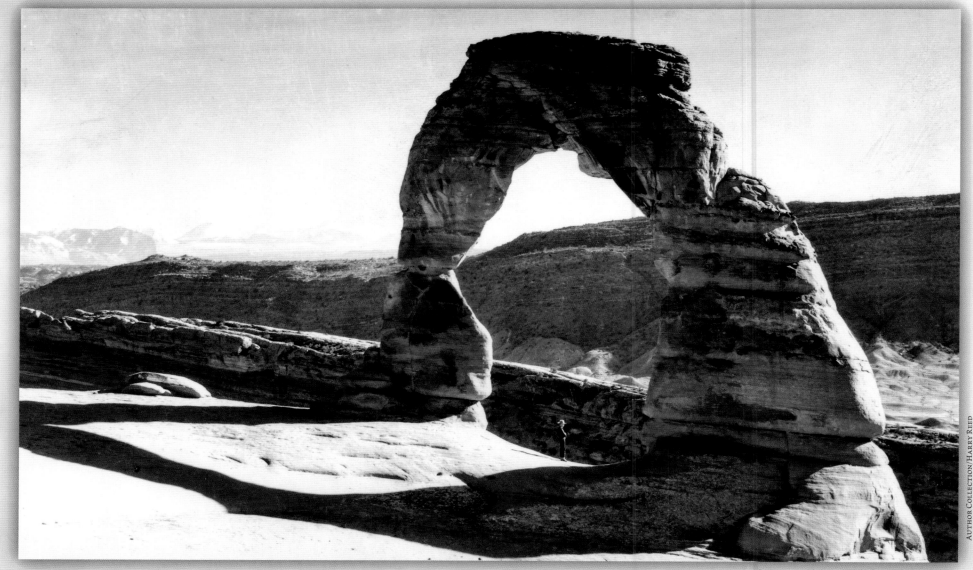

AUTHOR COLLECTION/HARRY REED

OPPOSITE: 3/2/14 • 38°44′39″ N 109°29′59″ W

1940 ~ Delicate Arch

Delicate Arch is arguably the most famous in the world, and on a March evening hundreds of people were seated to my left and right, watching as I did while the sun went down. They had came to see the arch despite its location three miles from the nearest parking lot.

People took turns walking down to pose for group photos and selfies under the landmark. Most were polite, but as often happens in crowds, not everyone was on their best behavior. I stopped one young man from carving his initials in the sandstone nearby. He seemed surprised that anyone would dare object to his activity, but he stopped. I wanted to avoid further confrontation, but I also wanted to ask: "What do you think this place would look like if the 1.5 million visitors in 2015, and the millions in the years before them, had all carved their names into the rocks around us?"

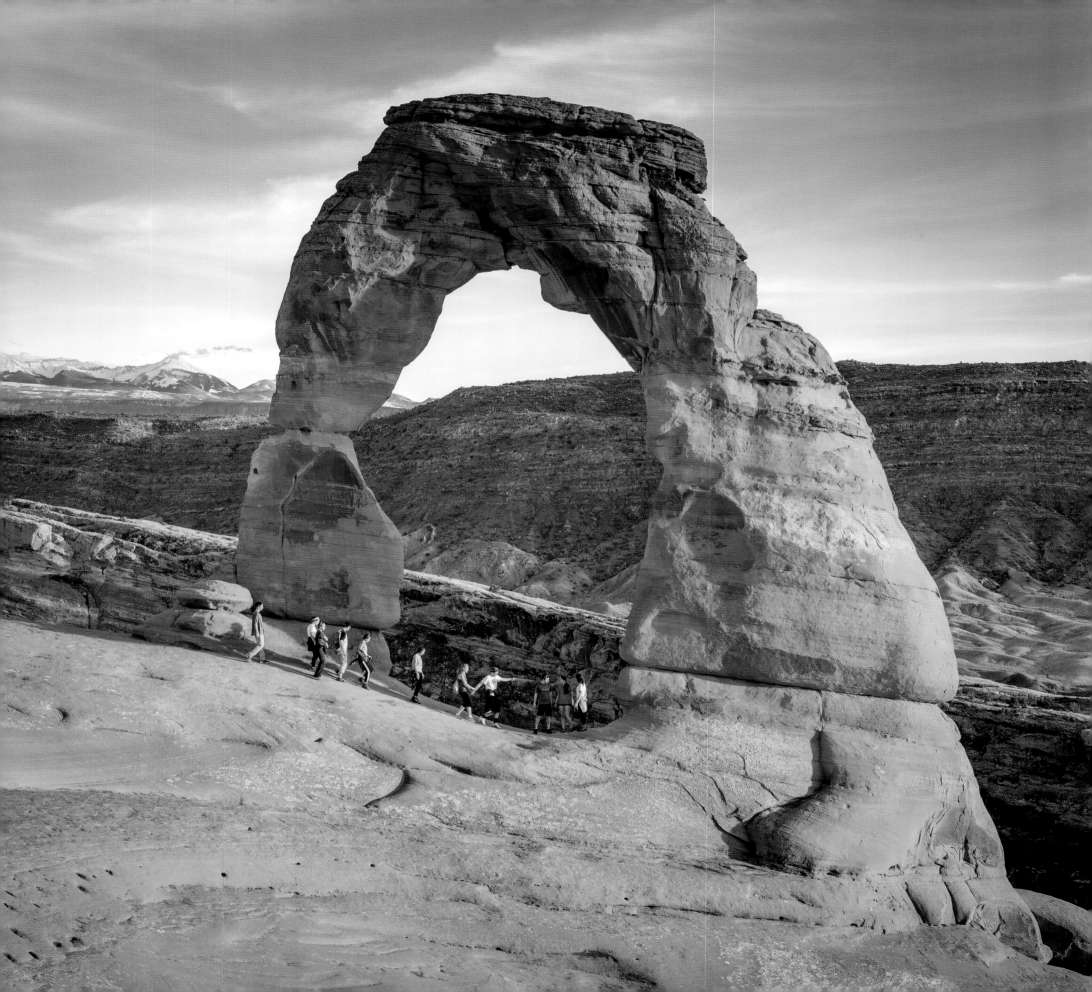

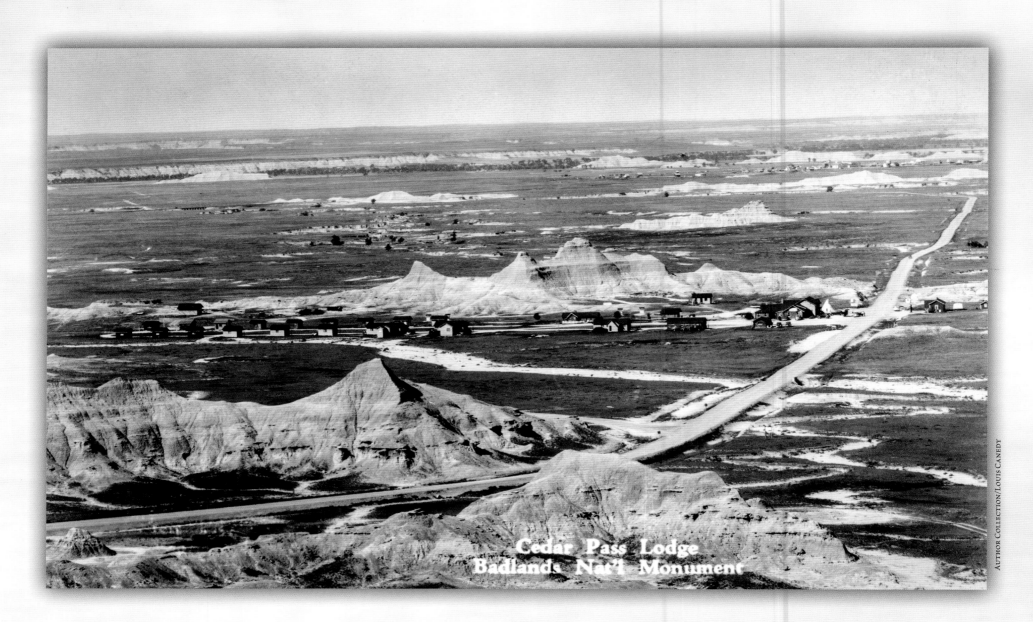

Cedar Pass Lodge
Badlands Nat'l Monument

Author Collection/Louis Canedy

Circa 1936 ~ Cedar Pass Lodge

This site is located below an old overlook now closed to cars but open to hiking at Cedar Pass in Badlands National Park. Continued natural slumping in the Cedar Pass area has made it difficult for the Park Service to maintain the road or pullouts for visitors in this vicinity. But photographer Louis Canedy's location, farther down the Badlands wall, seemed intact. I found that he walked out nearly as far as he could go before the land drops off into a gully. My estimated date for this photo is based on careful examination of the automobiles parked near Cedar Pass Lodge at center right.

Several more of Canedy's excellent Badlands postcard views from the 1930s appear on the following pages.

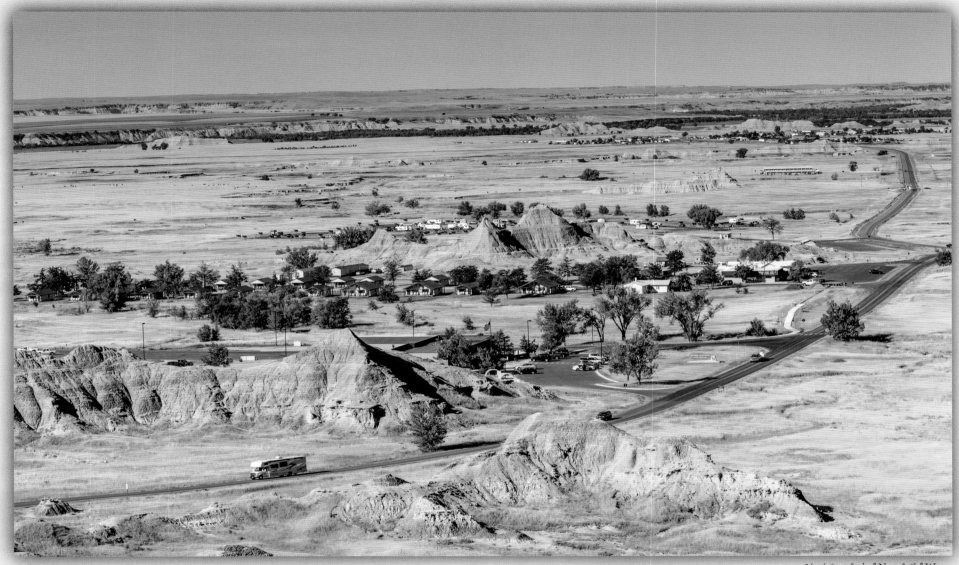

8/15/16 • 43°45'12" N 101°56'9" W

The former gravel road from the town of Interior (outside the park at upper right) has long since been paved for use by the nearly 1 million visitors who come to these badlands each year. The roadway has also been realigned, moving it away from the lodge, where the old route is now followed by a walking path (bordered by orange construction fencing in this photo). A gas station to the right of the old road has been removed.

The Ben Reifel Visitor Center now lies in the foreground, and additional cabins and employee housing have also been added to the scene. A campground appears in the middle distance. The landscape is peppered with cottonwood trees today, at least some of which were likely planted during development of this area of the park.

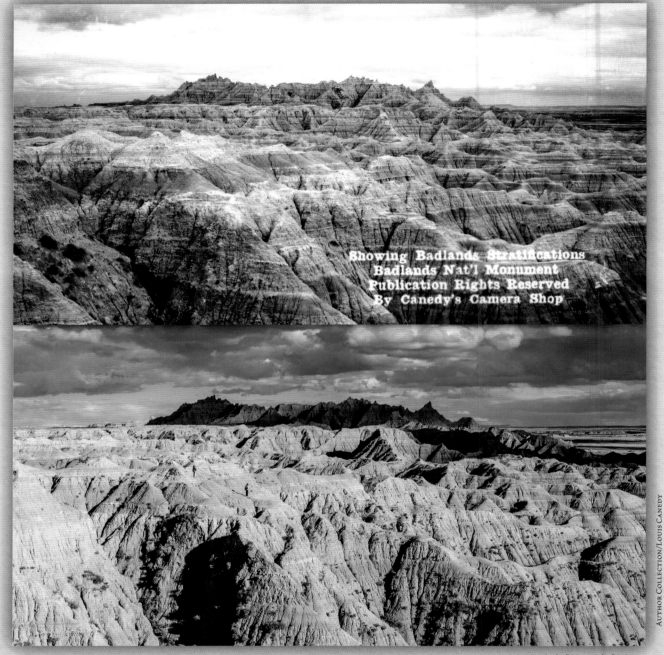

Showing Badlands Stratifications
Badlands Nat'l Monument
Publication Rights Reserved
By Canedy's Camera Shop

AUTHOR COLLECTION/LOUIS CANEDY

9/9/16 • 43°47'41" N 102°3'41" W

Circa 1935 ~ Showing Badlands Stratifications

I walked out onto a badlands fin to match the historic view, trying to capture the stratifications of these unique formations. The layers are more visible when they're wet, so perhaps the photographer was here after a rain.

Distant peaks seem unchanged at a glance, but careful comparison reveals subtle differences where small spires have changed shape or even disappeared as the badlands continue to slowly erode.

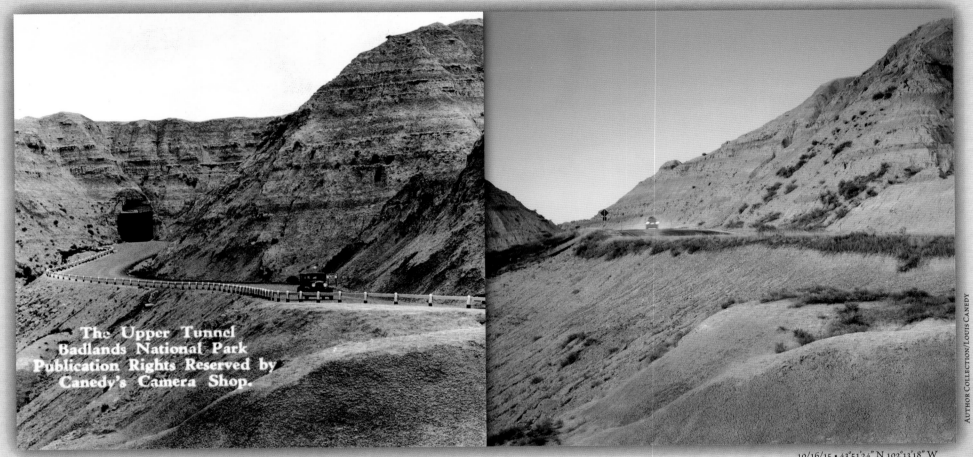

The Upper Tunnel
Badlands National Park
Publication Rights Reserved by
Canedy's Camera Shop.

Author Collection/Louis Canedy

10/16/15 • 43°51′24″ N 102°13′18″ W

Circa 1936 ~ The Upper Tunnel

Once upon a time there were two tunnels along what today is called the Badlands Loop Scenic Byway (Highway 240). One tunnel was located half a mile west of the Ben Reifel Visitor Center, while the Upper Tunnel, seen in the photo above, was about half a mile east of the Pinnacles pass. In a park where erosion is a main feature of the landscape, the tunnels were troublesome to maintain. Rotting timbers and instability forced the park to begin removing the 175-foot Upper Tunnel in December of 1938, just a couple of years after it had been built. The other tunnel was apparently removed about the same time.[7]

I parked at a pullout off-camera to the right and descended on foot from the highway. On a flat space near the center of the modern photo I saw remnants of wooden posts, which I realized were the guardrails of the 1936 highway. The old road is almost completely buried under fill from the tunnel's removal. I kept going down the deep gully to the left, then climbed to a plateau where Canedy had stood with his camera. The foreground hill, and the old road remnant above it, helped me comprehend the complicated and extensive changes in the background.

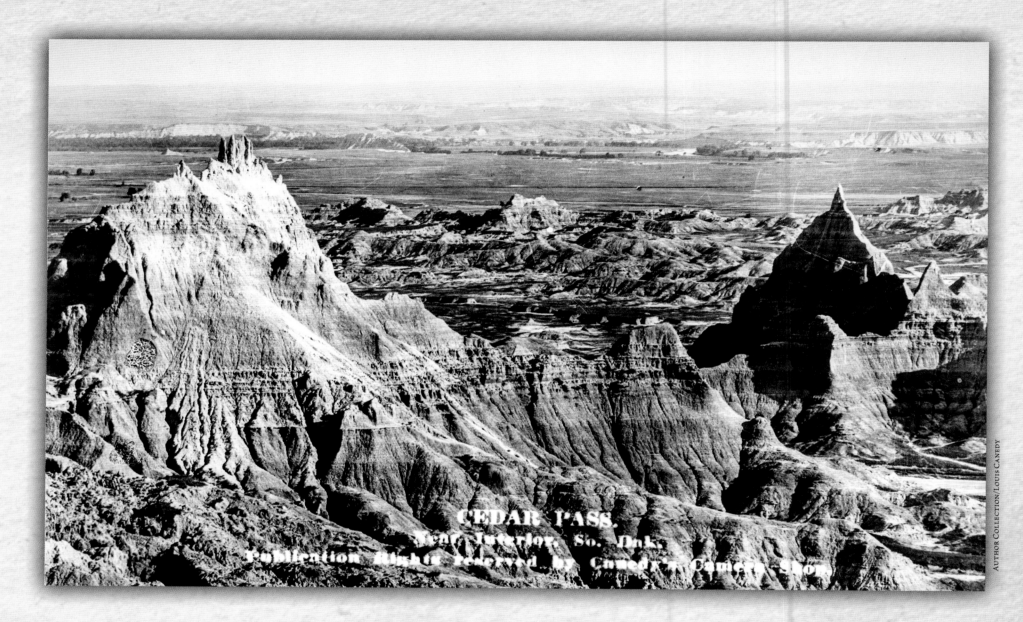

CEDAR PASS.
Near Interior, So. Dak.
Publication Rights reserved by Canedy's Camera Shop.

Author Collection/Louis Canedy

Circa 1940 - Cedar Pass

Photographer Louis Canedy must have returned to the Badlands several times, based on the large number of his real photo postcards available on auction sites today. His work is of high quality, and here he seems to have used a telephoto lens, which was somewhat unusual among photographers of the era. I wish I knew what kind of camera he had, but I suspect it used 35mm film. This image, when matched with my own, indicates that the focal length of his lens was 105mm.

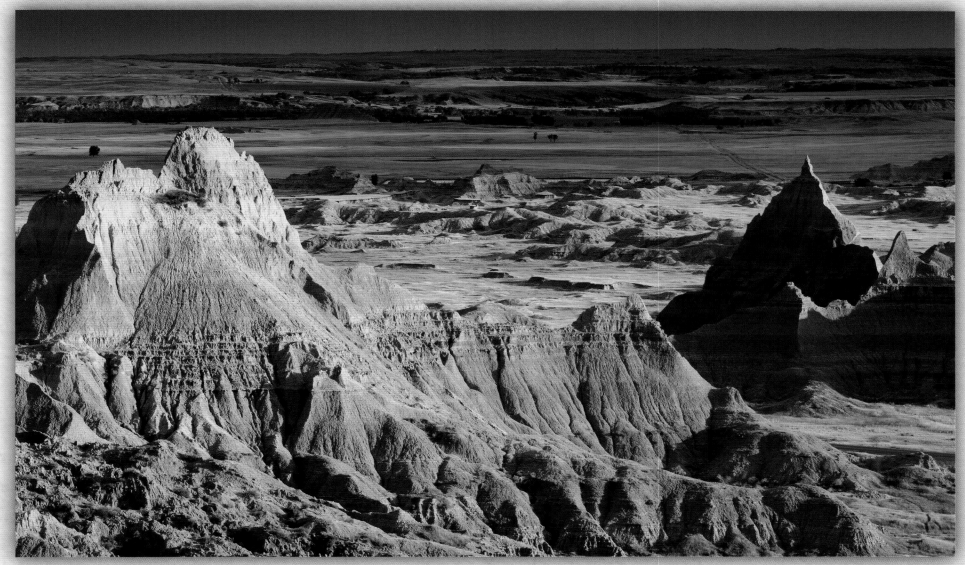

8/14/16 • 43°45'20" N 101°56'16" W

To find this site, I parked near the top of Cedar Pass and hiked west up into the peaks that form the summit of the Badlands wall in this area. The hiking is not difficult, but navigating the rocky slopes is sometimes akin to walking on marbles. There are steep drop-offs as well, so use caution if you travel here.

I came out to a plateau where, just above the final drop-off from the wall, Canedy found his angle on the formations below and the plains beyond. The banks of the White River also break through the grasslands in the distance.

Visit the Badlands at sunrise or sunset if you can. I was there about the same time of day as Canedy was, but variations in the shadows suggest that I was visiting at a different time of year, when the sun was at another angle.

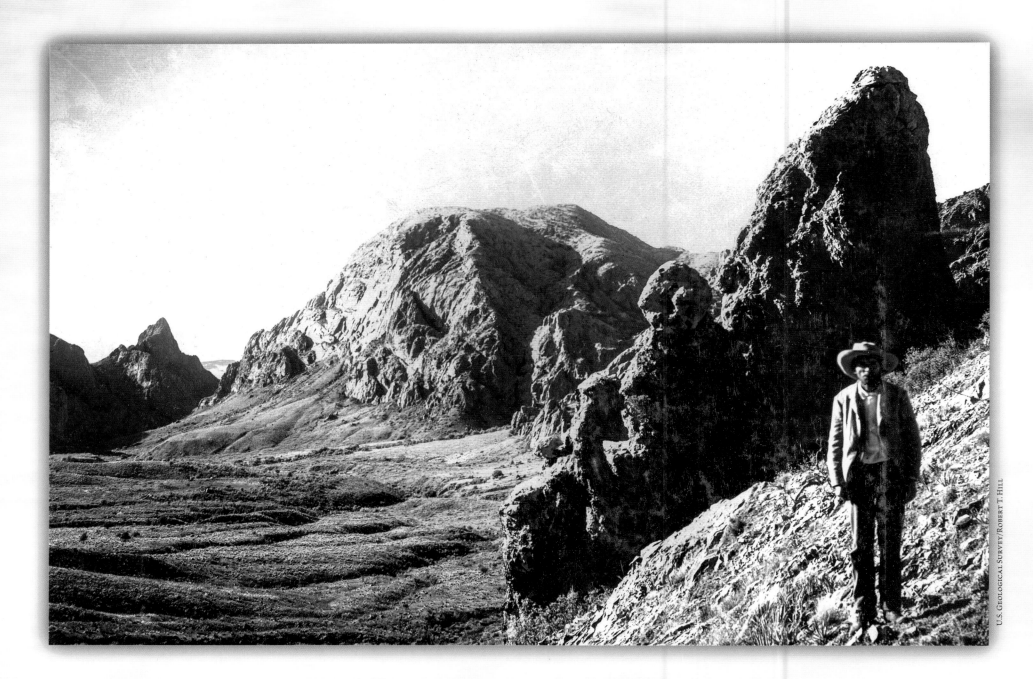

U.S. GEOLOGICAL SURVEY/ROBERT T. HILL

1899 - Rhyolitic Summits in Chisos Mountains

In 1899 Robert T. Hill of the U.S. Geological Survey led a six-man exploration of the region that would later include Big Bend National Park. Some of the photographs taken then are featured on the following pages.

The man in this photo is not identified, but he's standing above what is now called the Chisos Basin. Behind him in the mountains at left is a notch known today as the Window.

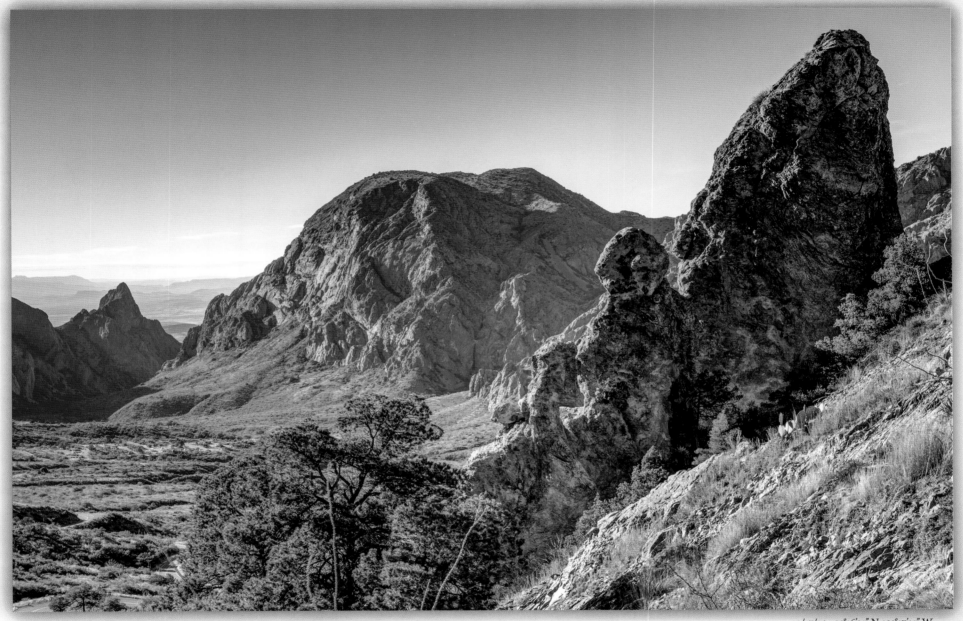

11/17/14 • 29°16'31" N 103°17'11" W

I saw faint signs of foot traffic in this area (unless they were deer trails), so someone does climb to nearby locations, but the hill is steep and, as mentioned in the historic photo's geologically oriented title, covered with crumbling rhyolite, a type of volcanic rock.

When I aligned the background with the foreground formation, I found that Hill's camera site was on a slope, although it's possible that the ground was more level at the time of his visit.

Chisos Basin is one of the major destinations in Big Bend, containing a visitor center and lodging (off-camera to left) at the end of the Chisos Basin Road (just visible at left). A campground is also seen in the basin below.

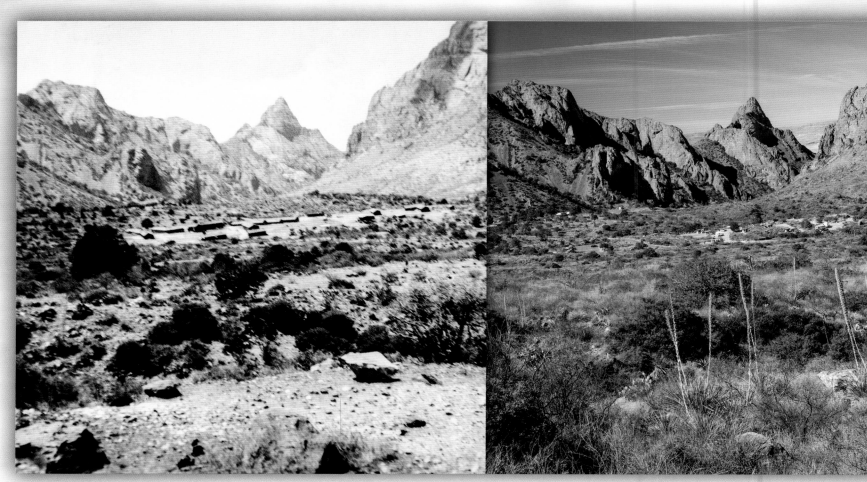

MARFA, TX PUBLIC LIBRARY/UNKNOWN PHOTOGRAPHER

2/16/16 • 29°16'31" N 103°17'37" W

1933 ~ CCC Camp and the Window, Chisos Basin

As in other national parks across the United States during the 1930s and '40s, the Civilian Conservation Corps built trails, roads, bridges, campgrounds and buildings at Big Bend. The historic photo shows the CCC camp in Chisos Basin, with the Window in the background. The year "1933" is written on the back in what appears to be handwriting of the time, but other photos of the camp indicate that buildings were not constructed here until a year or two later. The young men of the CCC were originally housed in tents.

I found this site next to a small pullout as I drove down the Chisos Basin Road. Despite the increase in vegetation, I could see prominent foreground boulders in the old photo that remain in place today. The one at far left is now hidden by bushes.

I stayed for several nights in the campground that now occupies the site of the former CCC camp. Temperatures dropped very fast after sundown, but the days were beautiful in February at this southern national park.

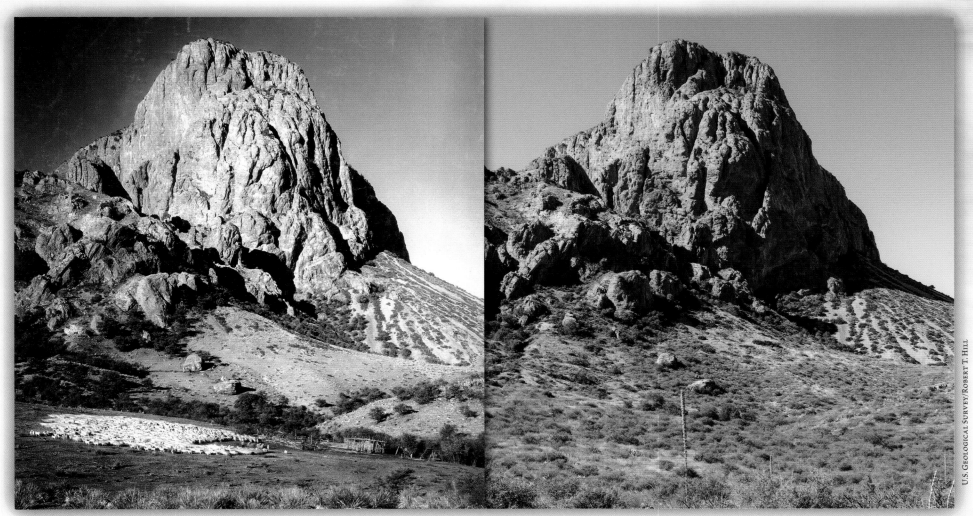

U.S. Geological Survey/Robert T. Hill

11/17/14 • 29°18'5" N 103°16'14" W

1899 ~ North Peak, Chisos Mountains

North Peak features prominently in this photo pair, but I was also interested in the flock of sheep near a small corral in the foreground. Grazing sheep seem to have cleared much of the vegetation in the historic photo, apparently a common situation in this area at the time. Park interpretive signs indicate that the landscape is still recovering from overgrazing that took place before Big Bend became a national park.

I tried to avoid the cactus as I waded through sharp, pointy bushes, causing considerable wear and tear to my clothing, until I found this photo site about one-quarter mile from the Chisos Basin Road.

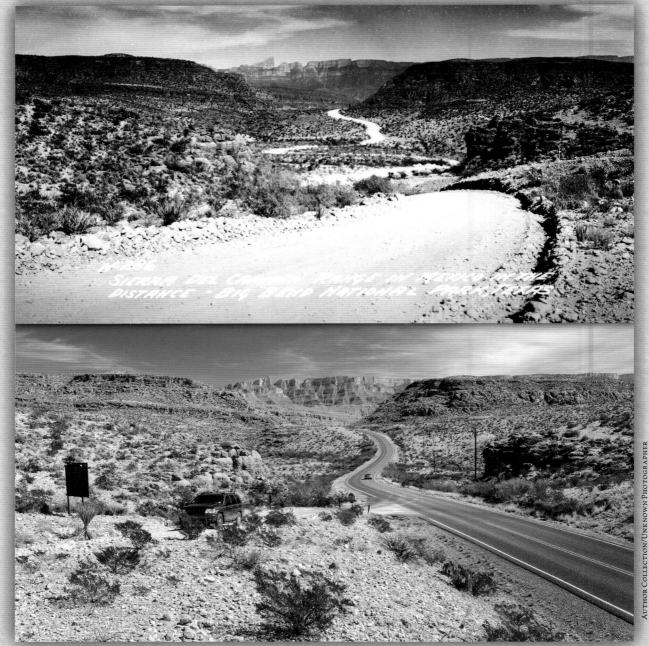

SIERRA DEL CARMEN RANGE IN MEXICO IN THE
DISTANCE • BIG BEND NATIONAL PARK TEXAS

Author Collection/Unknown Photographer

2/7/16 • 29°12'8" N 102°59'19" W

Circa 1940 ~ Sierra Del Carmen Range In Mexico

The original photo site is now in open air, about 20 feet to the right of where I stood on the bank of today's road cut, created when the modern highway was built. Once my camera was set up, I admired the view for an hour while waiting for a car to exit the highway and continue up Old Ore Road, which continues for miles behind the camera point. As stated in the photo's title, the distant mountain range is in Mexico.

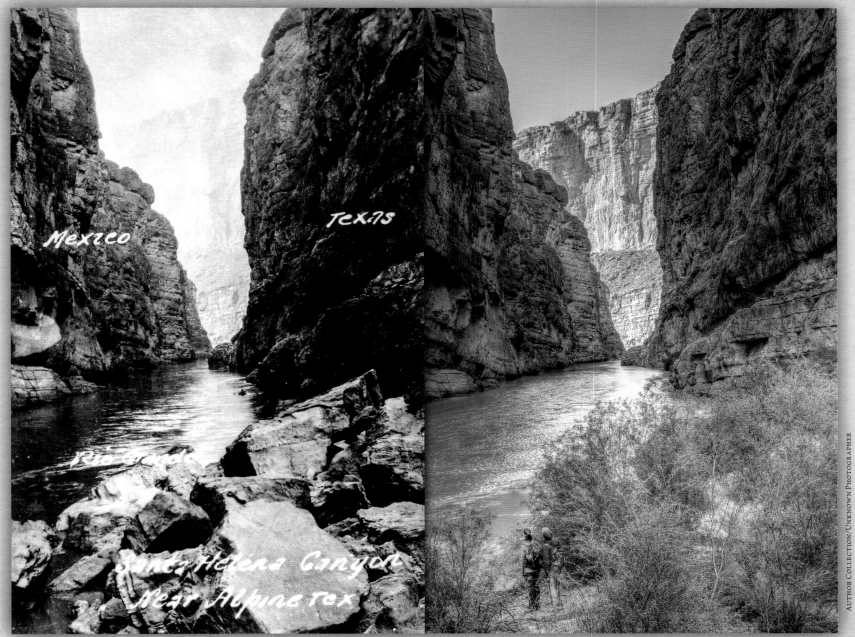

Mexico

Texas

Rio Grande

Santa Helena Canyon
Near Alpine Tex

AUTHOR COLLECTION/UNKNOWN PHOTOGRAPHER

11/19/14 • 29°9'48" N 103°37'4" W

Circa 1935 ~ Santa Helena Canyon

Contrary to the caption on the historic image, official sources call this "Santa Elena" today. The boulders in the historic photo are much larger than they appear, perhaps the size of a large truck, and they are now almost completely buried in sand deposited after the Rio Grande was dammed upstream. A lack of natural flooding lets the sand build up, allowing invasive species such as tamarisk to flourish.[8] (This is similar to what has happened in the Grand Canyon; see page 93.) I found the earlier photographer's elevated view on top of an even larger boulder, which remains uncovered today.

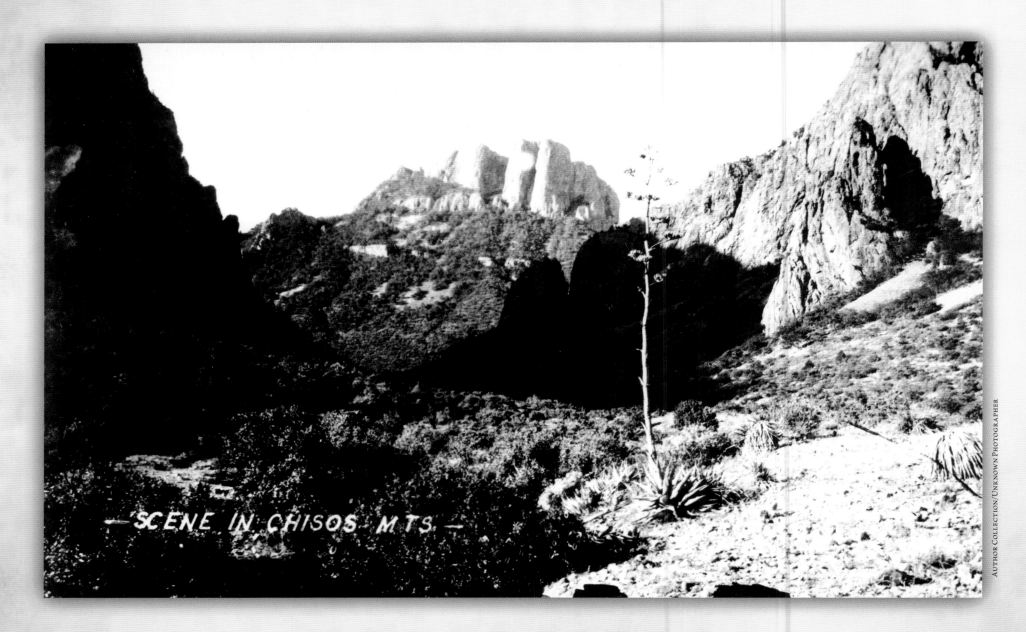

SCENE IN CHISOS MTS.

AUTHOR COLLECTION/UNKNOWN PHOTOGRAPHER

Circa 1930 ~ Scene IN Chisos Mountains

It took a while for Big Bend to become a national park after Congress approved the acquisition of land in 1935. Property transfers and other issues delayed the park's official designation until 1944.

This postcard view predates the park's approval, and shows a mountain called Casa Grande as seen from the north.

11/20/14 • 29°16′57″ N 103°16′55″ W

I located the photo site on a hill about 100 yards west of the Chisos Basin Road. While I waited for the light, I found a prehistoric stone tool on the ground nearby, and then two ancient spark plugs as well as some other metal debris. It led me to wonder if this had been a travel route or campsite used by early populations—and again thousands of years later by tourists. I left everything where I found it, of course.

The road into Chisos Basin passes along the slope in the middle distance at left, and would be in plain view except for the vegetation that hides it. The area in the foreground appears to have recovered from earlier overgrazing here, about two miles south of the site on page 37. But it's unknown whether the same variety of plants that once grew here will return.

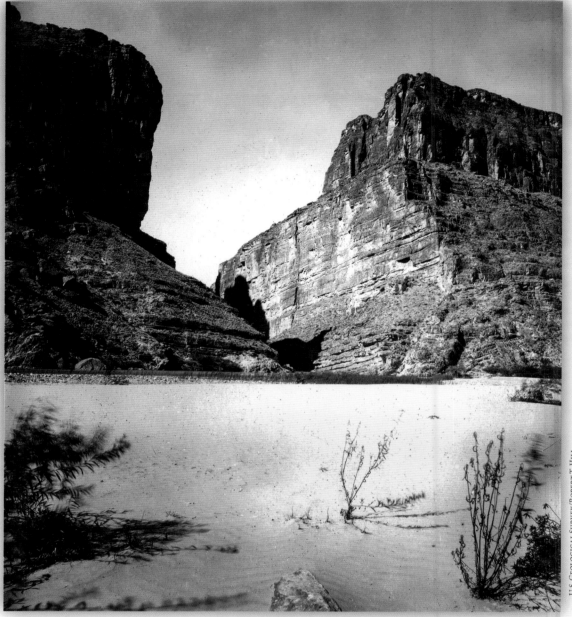

U.S. GEOLOGICAL SURVEY/ROBERT T. HILL

OPPOSITE: 2/6/16 • 29°9'57" N 103°36'35" W

1899 ~ Boca Grand Cañon de Santa Helena

In 1899 the Rio Grande flowed along the base of the slope to the left of the "boca" ("mouth" in Spanish) of Santa Elena (as it is known today) Canyon. Obviously the foreground was much drier than it is in today's view, and it appears that the main channel has shifted.

The matching photo site would be in the river now. I considered wading in, as I strive to reach the ac-

tual historic camera point whenever possible. But I thought the U.S. Border Patrol (whose vehicles I'd come across earlier) might see me and get the idea I had crossed from the far shore, which is in Mexico. It was also very muddy, not to mention cold at sunrise in February, even on the Texas-Mexico border. Thus I compromised at this photo site.

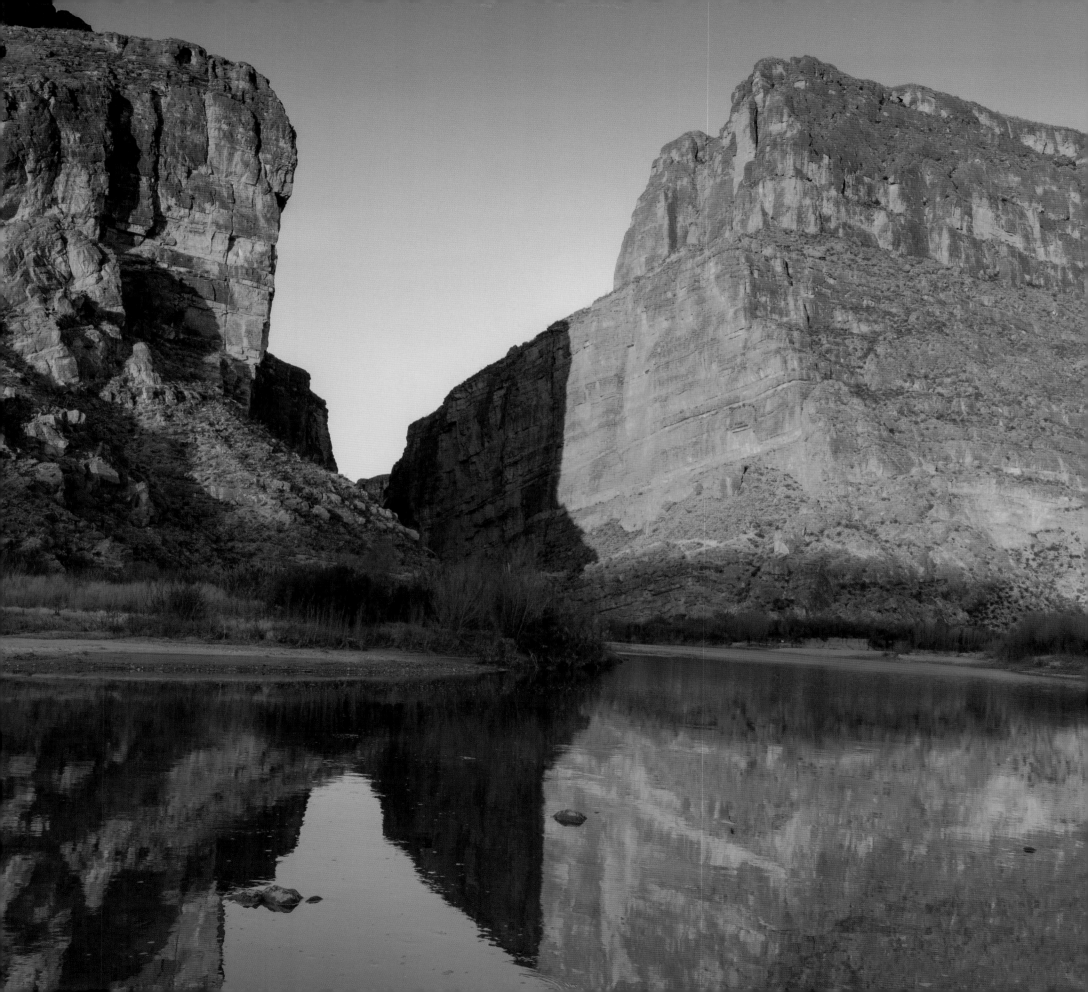

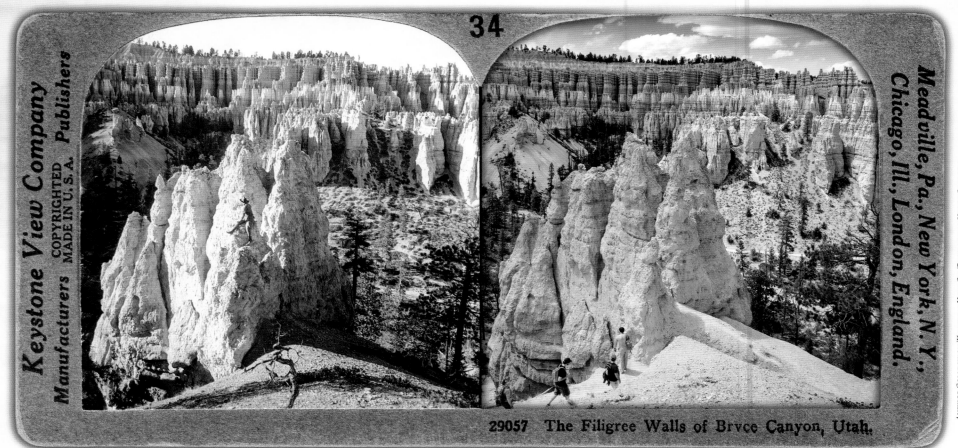

Keystone View Company
COPYRIGHTED
Manufacturers MADE IN U.S.A. Publishers

34

Meadville, Pa., New York, N.Y.,
Chicago, Ill., London, England.

AUTHOR COLLECTION / KEYSTONE VIEW CO. / PROBABLY BY HENRY PEABODY

29057 The Filigree Walls of Bryce Canyon, Utah.

5/21/14 • 37°36'58" N 112°9'43" W

1925 ~ The Filigree Walls of Bryce Canyon

The photographer's note on a different print of this image in the Keystone-Mast Collection says, "This guide had as much nerve as the nerviest—impossible to stand up straight." The cowboy-guide appears in other photos taken in Bryce Canyon National Park, also dated 1925, probably by the same photographer, Henry Peabody.

The site was located along the Peakaboo Loop Trail, about 1.5 miles down in the canyon. Hikers passing by in the modern photo are walking a portion of the loop. I found that the photographer had walked up to a small rise above the trail, perhaps to bring the background formations more fully into view.

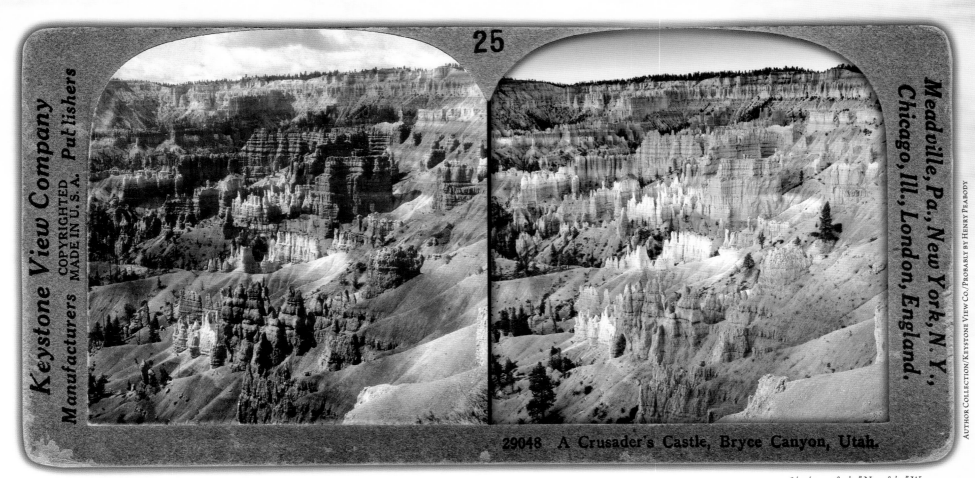

Author Collection/Keystone View Co./Probably by Henry Peabody

Keystone View Company
Manufacturers COPYRIGHTED Publishers
MADE IN U.S.A.

Meadville, Pa., New York, N.Y.,
Chicago, Ill., London, England.

25

29048 A Crusader's Castle, Bryce Canyon, Utah.

8/10/15 • 37°37'41" N 112°9'49" W

1925 ~ A Crusader's Castle, Bryce Canyon

I located this classic view of Bryce Canyon National Park a few yards southwest of Sunrise Point. But I'm afraid that makes it sound easier to do than it was. Comparing the intricate detail of Bryce's formations in a 90-year-old grayscale photo to the modern view in full blazing color, and identifying the foreground shape at lower left so I could place my camera precisely, took a few hours of searching on an earlier scouting trip. I marked the site on my GPS and returned at sunrise for the full scenic effect.

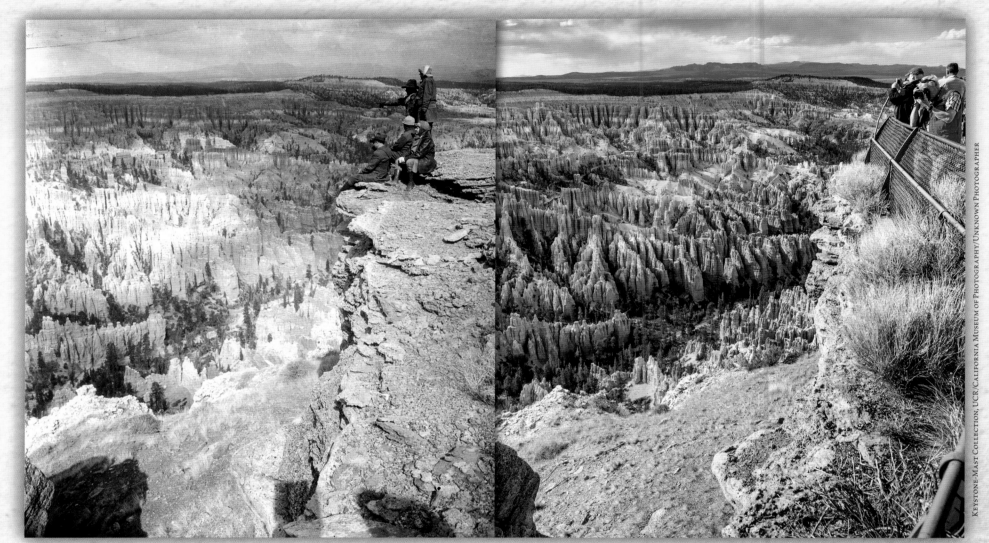

Keystone-Mast Collection, UCR/California Museum of Photography/Unknown Photographer

5/21/14 • 37°36′21″ N 112°9′27″ W

1925 ~ From Bryce Point Looking North

I think Bryce Point offers the best view of the canyon anywhere in the park, the reds of the formations contrasting nicely with the green canyons as well as the hills and mountains beyond.

I scouted this location when the weather was cold and cloudy (and when there was no one else at the overlook), then returned a year later to shoot this view just before sunset.

As at most national parks where people gather in large numbers, a protective railing has been installed around this flat point to prevent errant visitors from going over the edge. I had one leg of my tripod across the railing to get a nearly perfect copy of the angle used in 1925.

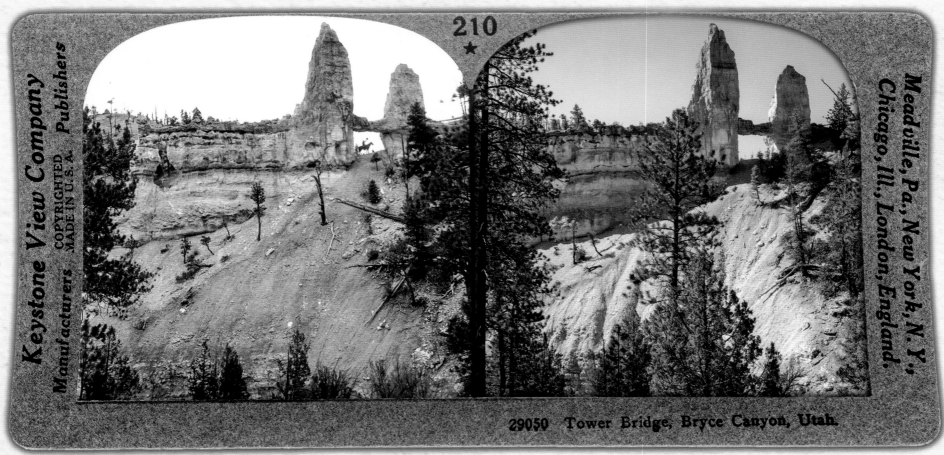

210
★

Keystone View Company
COPYRIGHTED Publishers
Manufacturers MADE IN U.S.A.

Meadville, Pa., New York, N.Y.,
Chicago, Ill., London, England.

AUTHOR COLLECTION/KEYSTONE VIEW CO./PROBABLY HENRY PEABODY

29050 Tower Bridge, Bryce Canyon, Utah.

5/22/14 • 37°37′57″ N 112°8′41″ W

1925 ~ Tower Bridge

The Tower Bridge is an impressive (and of course natural) feature about 1.5 miles down the Fairyland Loop Trail. The fearless cowboy-guide from page 44 makes another appearance here, beneath the bridge.

I hiked down on a pleasant May morning and found the proper alignment from a slope across the valley, not on the trail below. Perhaps the original photographer was trying to get clear of the trees and bushes that have continued to grow, partially blocking the view today. A few trees on the far slope have survived while others have disappeared.

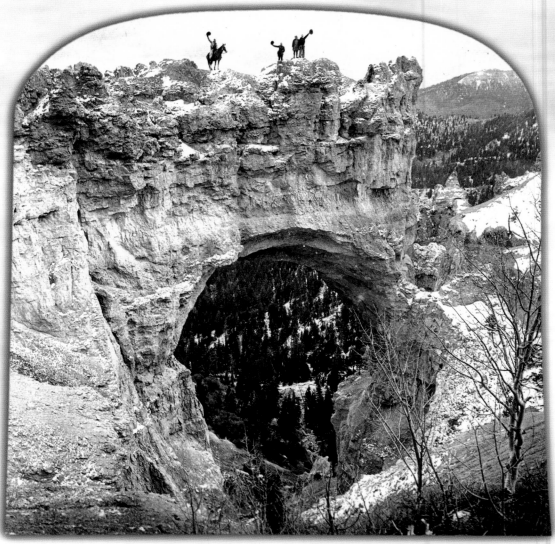

AUTHOR COLLECTION/KEYSTONE VIEW CO./PROBABLY BY HENRY PEABODY

OPPOSITE: 3/4/14 • 37°31′55″ N 112°15′37″ W

1925 ~ Natural Bridge

When I arrived for my first visit to Bryce Canyon late on a March afternoon following a long drive, I hoped I could find the Natural Bridge and have one shot done before checking into my hotel that night.

Reaching a nearby parking area, I was surprised to see snow on the bridge that nearly matched the historic photo. I also saw that I was too elevated on today's overlook, which was built perhaps 12 feet above the original ground level. My solution was to lower the camera over the railing, upside down on my tripod, blindly pointing it in the general direction from the

approximate height of a man standing on the ground below. I fired a series of shots by remote control.

Returning to my car, where my laptop was already receiving images from the camera via a wireless connection, I compared my blind shoot to the historic image. I had to repeat this process several times as the sun sank below the horizon behind me, but finally I had a shot that was a very close match to the original, complete with snow and nice light.

By the way, the area over the arch is now closed to all visitors, two- and four-legged.

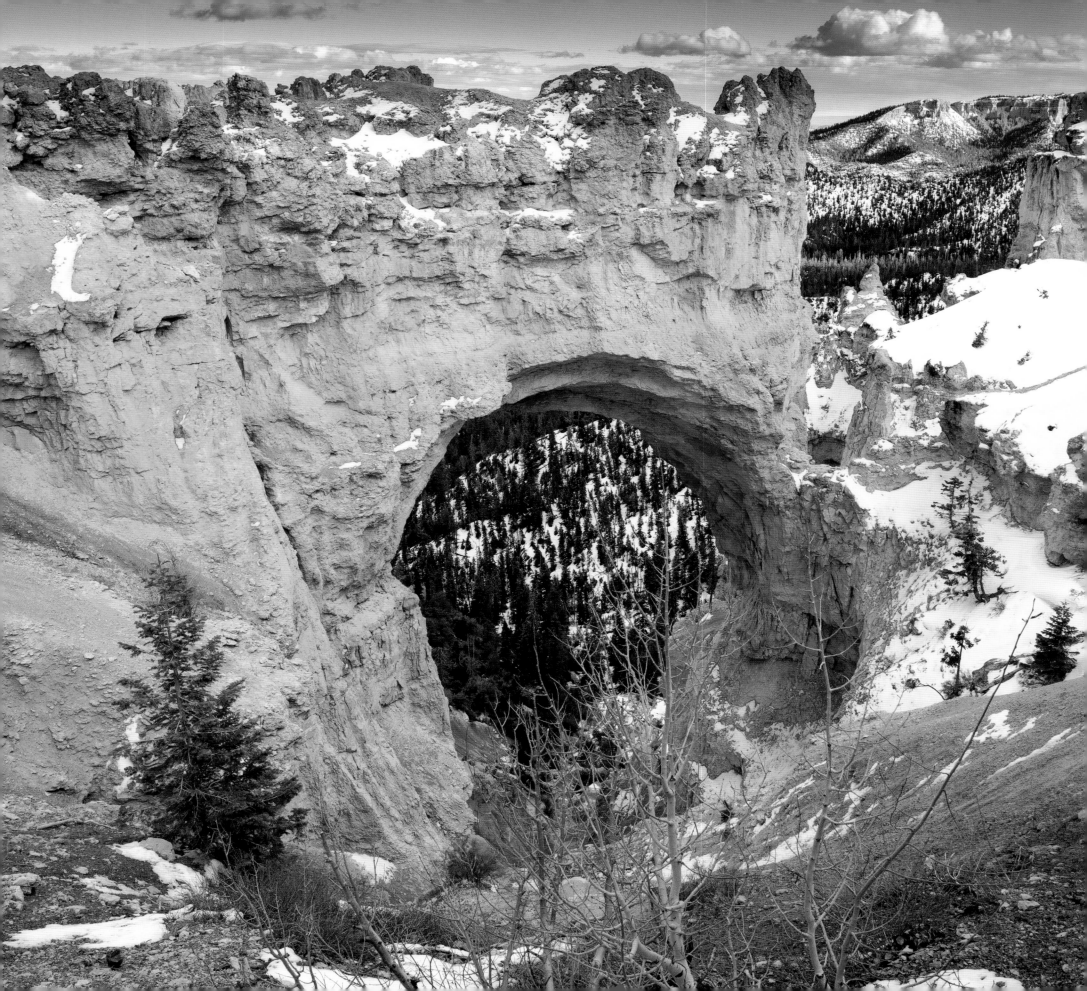

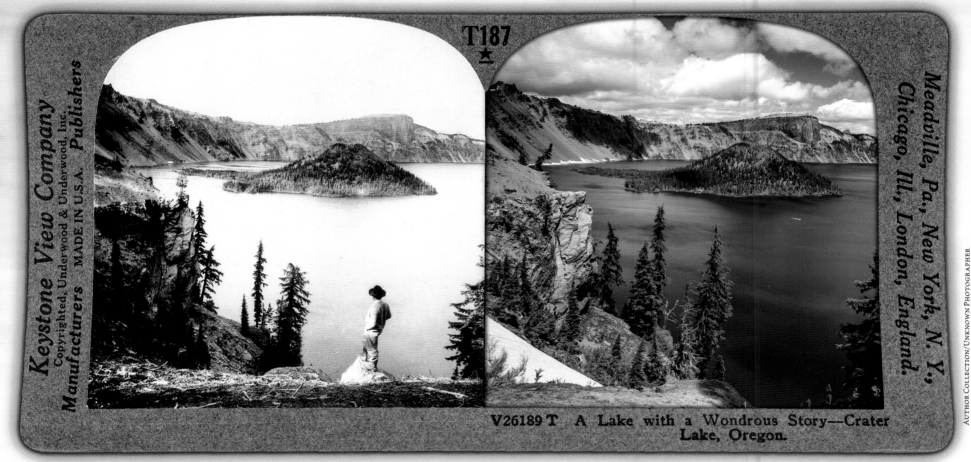

Keystone View Company
Copyrighted, Underwood & Underwood, Inc.
Manufacturers MADE IN U.S.A. Publishers

Meadville, Pa., New York, N. Y., Chicago, Ill., London, England.

AUTHOR COLLECTION/UNKNOWN PHOTOGRAPHER

T187
★

V26189 T A Lake with a Wondrous Story—Crater Lake, Oregon.

7/12/16 • 42°54'45" N 122°8'56" W

Circa 1925 ~ A Lake with a Wondrous Story – Crater Lake

Just two hundred yards from Crater Lake Lodge, I located this site overlooking the lake toward Wizard Island. A trail passes right through the camera point, so I had plenty of company as I worked, chatting with several visitors about what I was doing with that sheaf of papers (historic photos) and what I was photographing so intently.

If you want to look official, even if you aren't, carry a clipboard or a pile of papers and stare intently at them once in a while. Scribble on the papers at intervals.

The wake visible just below the island in the modern photo was left by one of the Crater Lake tour boats. No private boats are allowed on the water today.

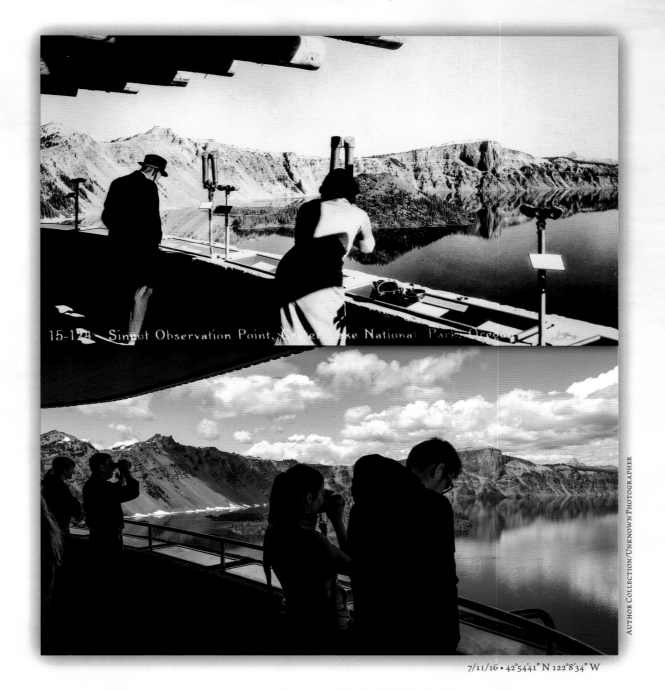

15-124 Sinnot Observation Point, Crater Lake National Park, Oregon

AUTHOR COLLECTION/UNKNOWN PHOTOGRAPHER

7/11/16 • 42°54'41" N 122°8'34" W

Circa 1940 ~ Sinnott Observation Point

The Sinnott Memorial Overlook was named for a U.S. Representative from Oregon who helped obtain national park status for Crater Lake. In addition to the area shown in the photos, there is an interpretive museum inside a historic building behind the camera.

The overlook is busy on a summer day, with tour groups and park interpreter programs as well as the comings and goings of other photography nuts. I gave up on the idea of using a tripod, which would have blocked traffic, and shot this view with a hand-held camera. That can work out all right, but sometimes it is not quite as precise.

51

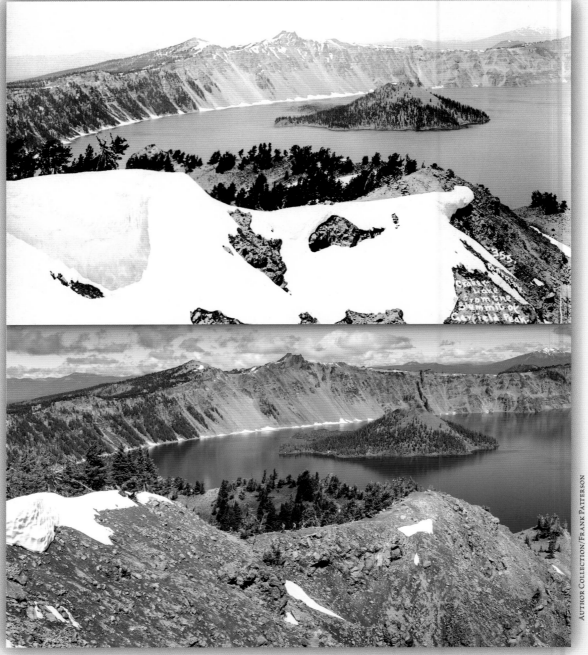

AUTHOR COLLECTION/FRANK PATTERSON

7/11/16 • 42°54′15″ N 122°7′23″ W

Circa 1922 ~ Crater Lake from the Summit of Garfield Peak

One hurdle in the production of this book was the deep snow that can remain in many national parks for up to eight months of the year. To reach this site on July 11, for example, I had to cross snow banks that covered parts of the trail.

Fortunately there was also snow in the historic photo, and I was able to work around Crater Lake for two fantastic days following a period of rain that had cleared the air. The 1.5-mile hike to Garfield Peak was strenuous but exhilarating.

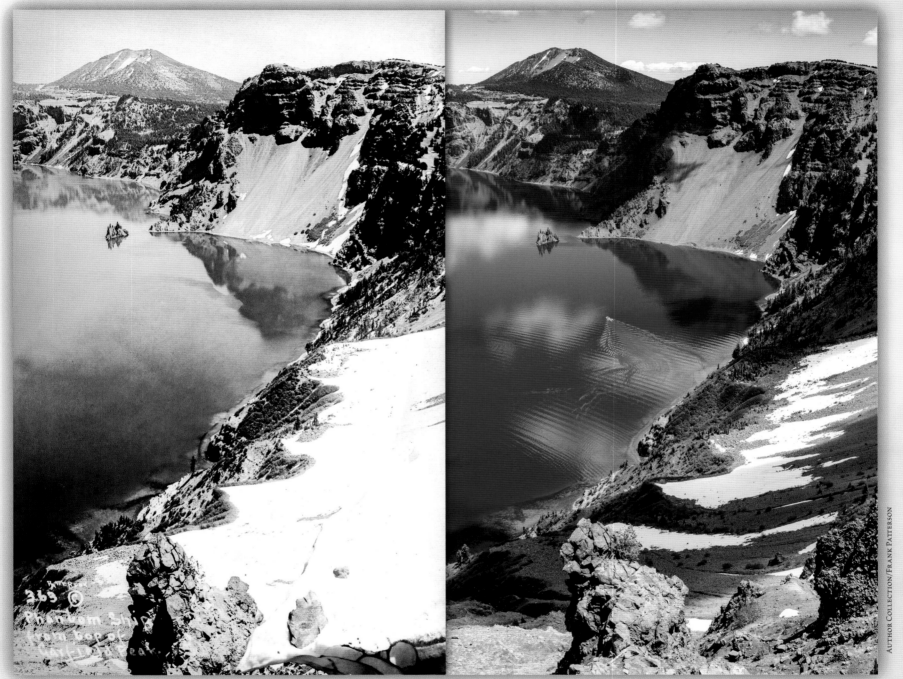

AUTHOR COLLECTION/FRANK PATTERSON

7/11/16 • 42°54'19" N 122°7'26" W

Circa 1922 ~ Phantom Ship from Top of Garfield Peak

The historic photo was probably taken on the same day as the one on the opposite page, based on the photographer's series number at lower left as well as the lighting and snow levels. In the modern image, a Cra-ter Lake tour boat passes below, giving visitors a close-up view of the Phantom Ship, an island that looks much like a mysterious old sailing ship on the water.

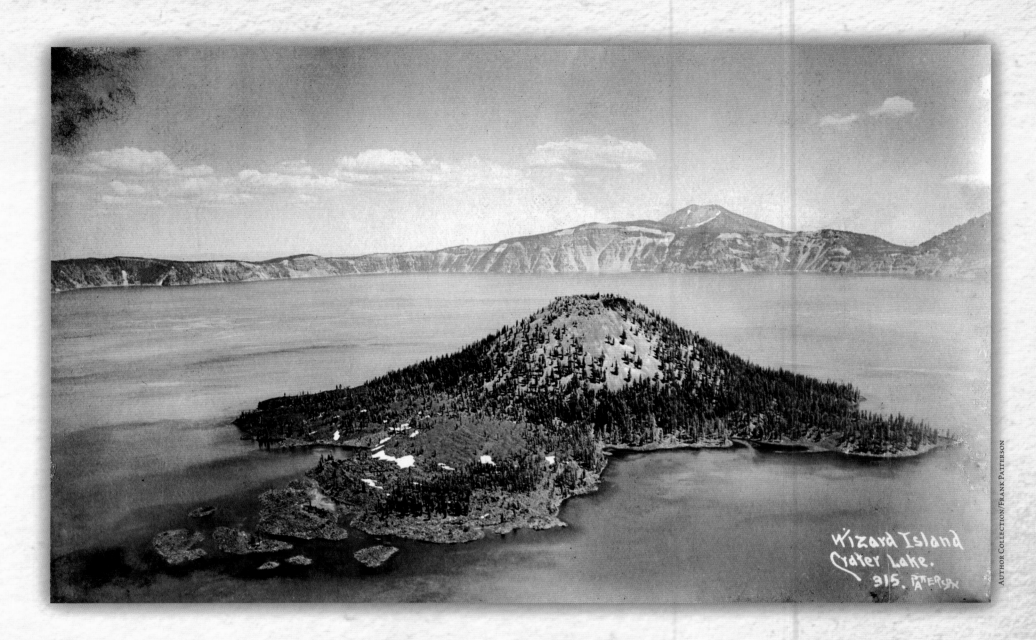

AUTHOR COLLECTION/FRANK PATTERSON

Wizard Island Crater Lake. 315. Patterson

Circa 1922 – Wizard Island, Crater Lake

This beautiful early view of Crater Lake, with Wizard Island in the foreground, was captured by photographer Frank Patterson, whose work is also seen on the previous two pages.

I had hoped to work on historic photos taken from a higher overlook nearby, on Watchman Peak, but it was still closed at the time of my July visit because of deep snow along the access trail. So I was quite excited to find this similar view on a lower part of the rim, just to the south of Watchman.

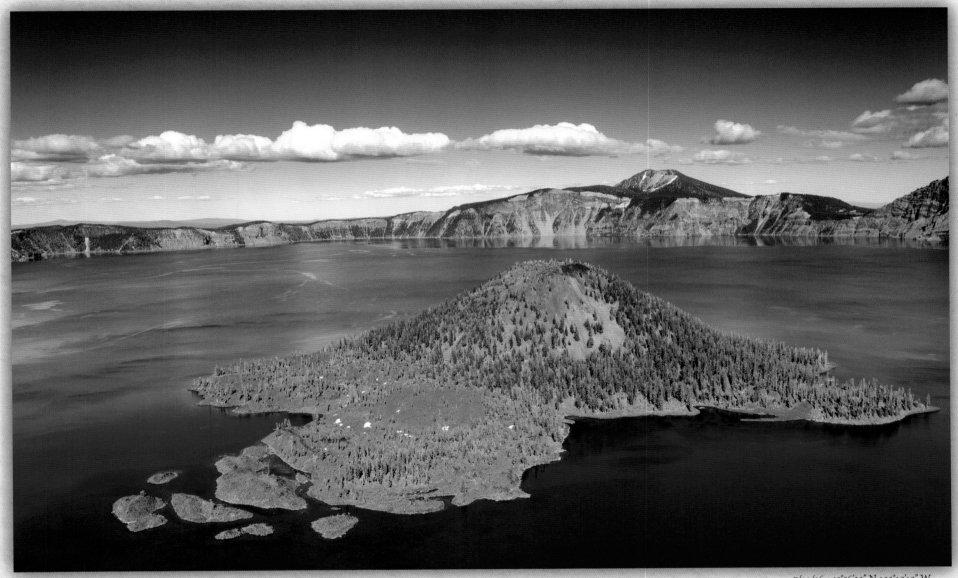

7/11/16 • 42°56'22" N 122°10'10" W

I haven't said it yet, but here is a good place to do so: This is the natural color of Crater Lake, without photographic enhancement. The deep blue constantly drew my eye as I hiked along the rim or drove by on Rim Drive.

I found this site adjacent to what was obviously an old roadway and former visitor overlook, abandoned for years and now mostly restored to its natural state. I speculate that Patterson drove to this area whereas I had to walk in. But Rim Drive is only a few hundred yards away, and I was able to park at a pullout about one-quarter mile to the south.

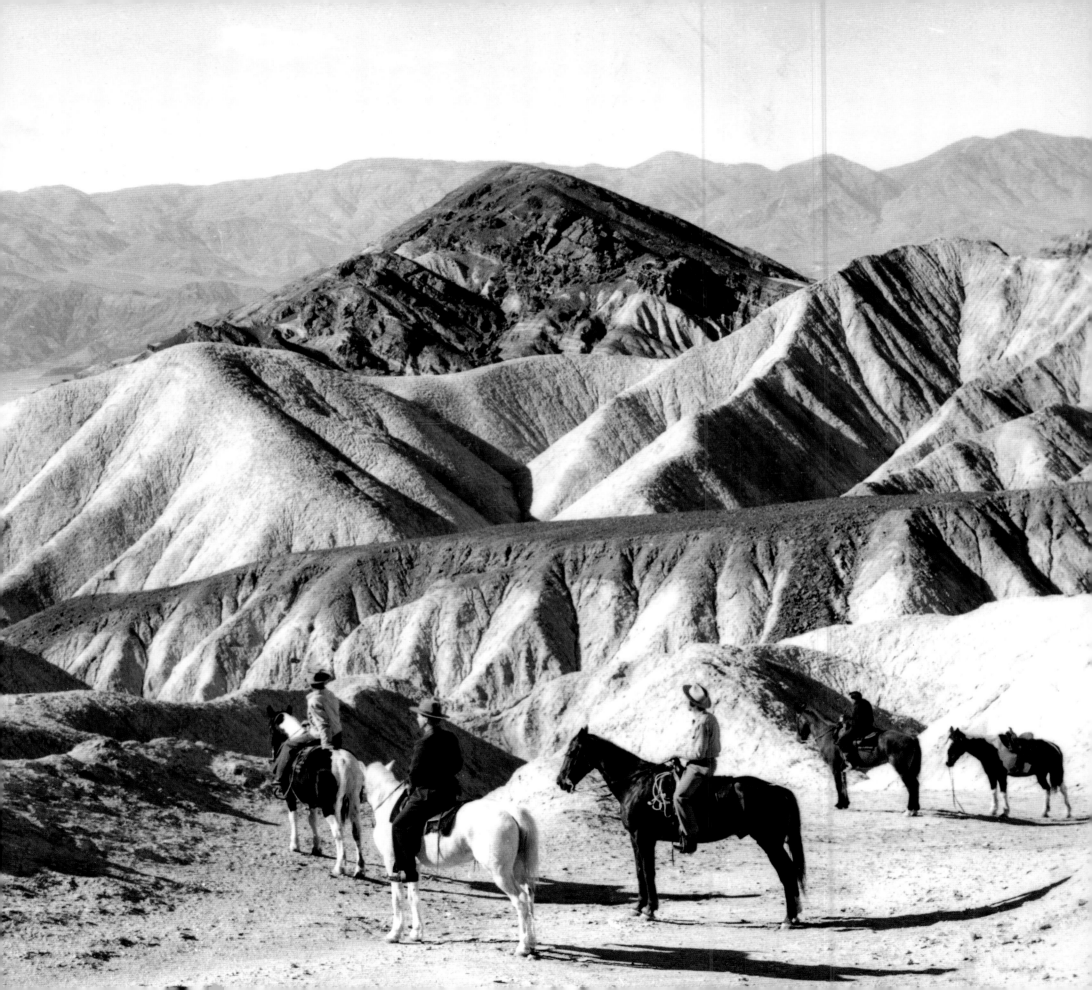

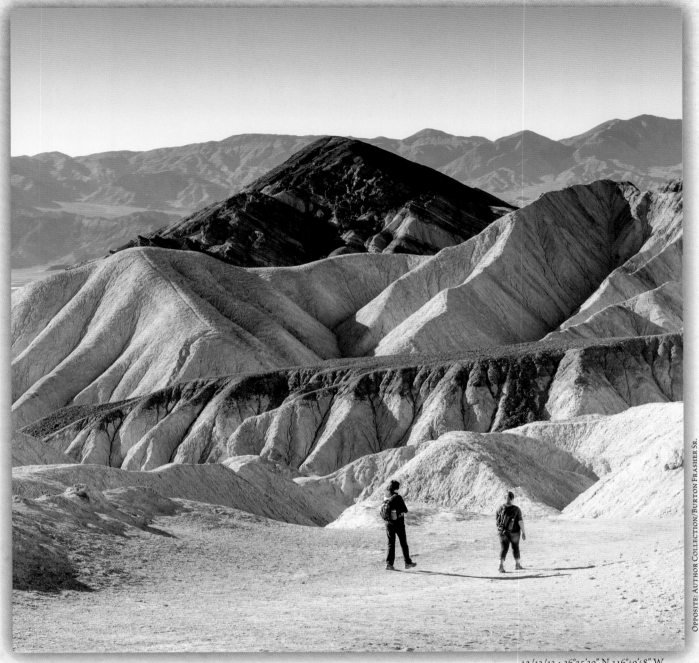

Opposite: Author Collection/Burton Frasher Sr.

12/13/13 • 36°25′30″ N 116°49′48″ W

1946 ~ On Golden Canyon Trail Near the Foot of Manly Beacon

I found this site in Death Valley National Park by hiking up the Golden Canyon Trail from the valley floor a mile below. The peak called Manly Beacon is actually behind the camera here, but visible in the photos on page 61.

While horses may be ridden elsewhere in the park, traffic on this trail is now limited to hikers such as those who came by as I worked on a clear December day.

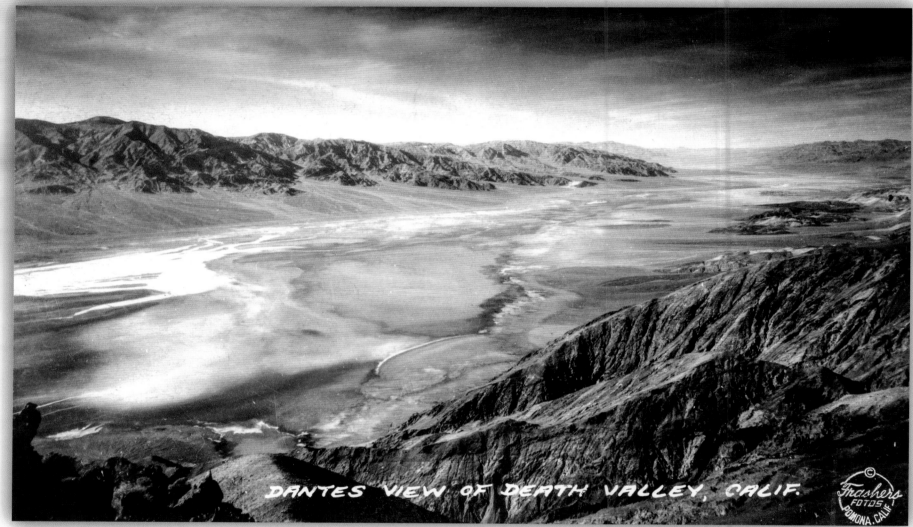

Author Collection/Burton Frasher Sr.

1930 ~ Dante's View of Death Valley

Photographer Burton Frasher Sr. wrote an unusually long caption on the back of the 1930 view: "From this point in the Black Mountains, an unlimited view of Death Valley may be obtained. Below are the Salt Beds and Badwater, the lowest point in North America, 279.6 ft. below sea level. To the west is the Panamint Range and the sand dunes are seen to the north."

Frasher took several views from this location at different times, apparently over a period of years. I suspect Dante's View was a favorite place of his to visit, and I can understand why.

While the "elevation" in the photo caption is accurate for Badwater—the pool seen on page 60—the true lowest point in North America is several miles to the west, 282 feet below sea level, and its position can vary depending on rainfall and evaporation patterns.[9]

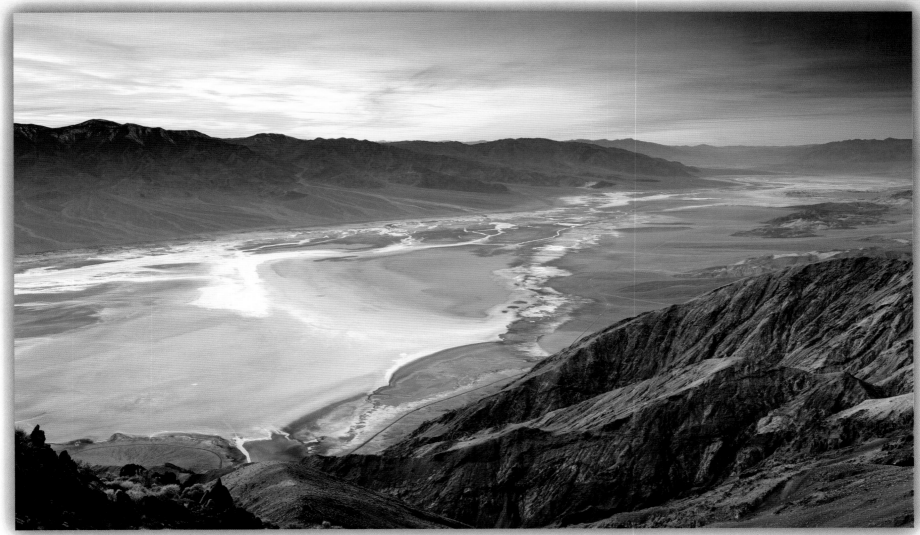

12/15/13 • 36°13′6″ N 116°43′44″ W

It was so windy during my first visit here, gusting to perhaps 60 m.p.h., that I could barely walk along the ridge and keep my hat on, let alone set up a tripod. I quickly scouted the photo site and retreated to my car. I returned a few days later and waited for the sun to set behind the Panamint Range, leaving its diffused light trailing behind. I wasn't always able to wait for the light while working on this book, but doing so paid off here.

The photo site is a few yards below the main trail that follows the ridge, about 1,000 feet southwest of the parking area at Dante's View.

The area at lower left on the valley floor, today's Badwater Basin, is shown on the next page from a closer point of view.

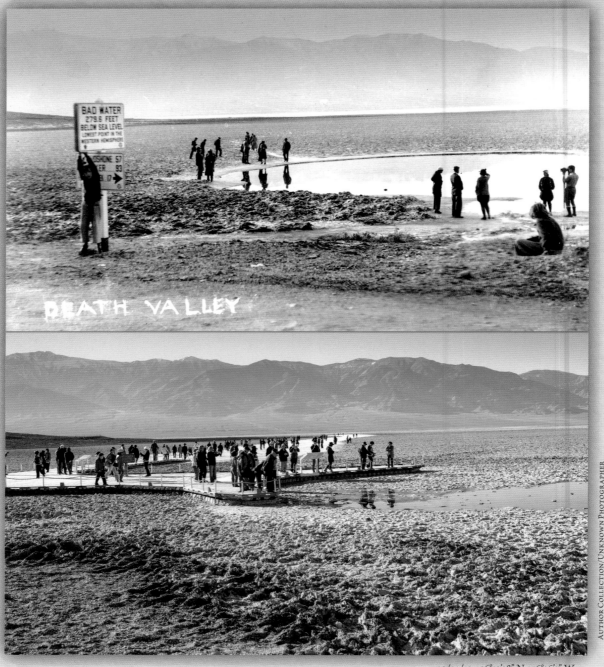

Author Collection/Unknown Photographer

12/11/13 • 36°13'48" N 116°46'2" W

Circa 1935 – Death Valley, at Badwater

At the time of the historic photo, visitors trampled on the salt crust surrounding this spring-fed pool, damaging a resource that harbors one of Death Valley's rarest animals: the Badwater Snail that makes its home in the briny, undrinkable water.[10] Visitors are now encouraged to stay on the boardwalks to help protect this delicate environment.

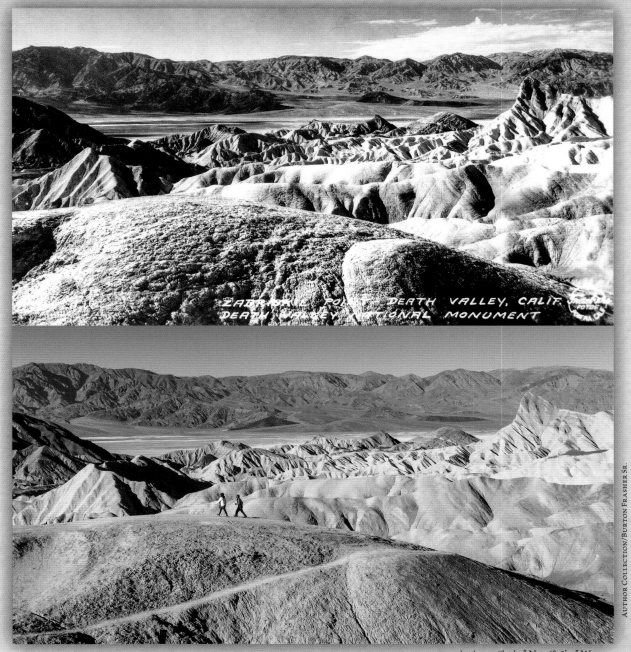

12/11/13 • 36°25'13" N 116°48'44" W

AUTHOR COLLECTION/BURTON FRASHER SR.

1933 ~ Zabriskie Point

This is the classic Death Valley view from Zabriskie Point, where I found the photo site just northwest of today's main overlook.

The high point on the right carries the seemingly odd name of Manly Beacon, but it honors William L. Manly, one of two men who rescued members of an ill-fated gold-rush party here in 1849, after one man had already died.[11] As they left, a member of the group looked back and said "Goodbye, Death Valley"—giving us the name we still use today.[12]

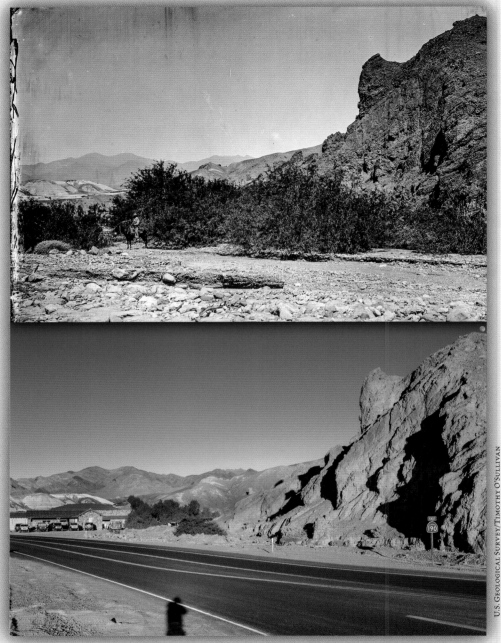

U.S. Geological Survey/Timothy O'Sullivan

12/13/13 • 36°26'56" N 116°51'8" W

1871 ~ View Up Furnace Creek

The U.S. Geological Survey dates the historic image to the 1871 Wheeler Survey, tasked by the government with mapping the country west of the 100th meridian.[13]

I had doubts about locating this photo site, but on my third day in Death Valley I saw the unusual "horn" shape on a hill above the highway. I returned at sunset, when I also captured the moon rising over the hilltop, and my own shadow in the foreground.

Near where a four-legged mule stands in the historic photo is now an old gas station that rents four-wheel-drive vehicles.

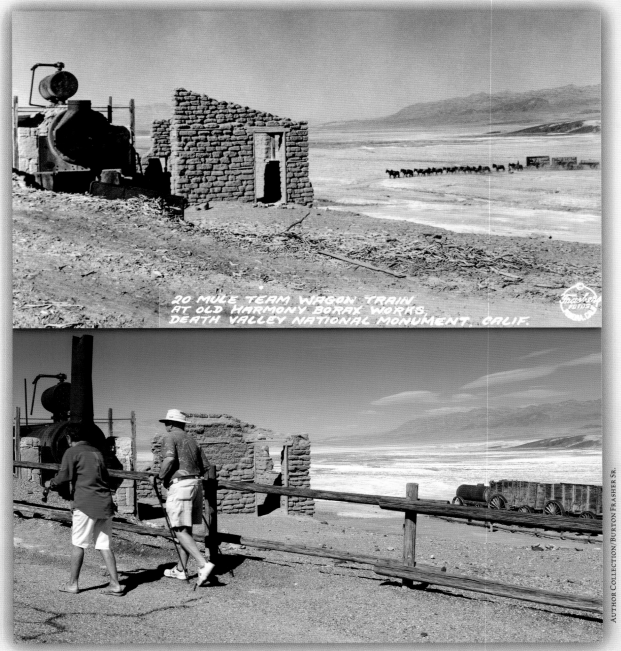

20 MULE TEAM WAGON TRAIN AT OLD HARMONY BORAX WORKS, DEATH VALLEY NATIONAL MONUMENT, CALIF.

AUTHOR COLLECTION/BURTON FRASHER SR.

2/26/15 • 36°28'46" N 116°52'30" W

1936 ~ 20 Mule Team Wagon Train at Old Harmony Borax Works

The Harmony Borax Works had been closed for nearly 50 years when a mule team and wagons reappeared in 1936 as part of a re-enactment and publicity stunt for the Pacific Coast Borax Company. Signs on the wagons read in part, "The Original 20 Mule Team

Wagon Used for Hauling Borax Out of Death Valley."

The ruins are in surprisingly good condition more than 125 years after they were abandoned. I couldn't tell if the wagons in my photo were the same as those used in 1936, but they are quite similar.

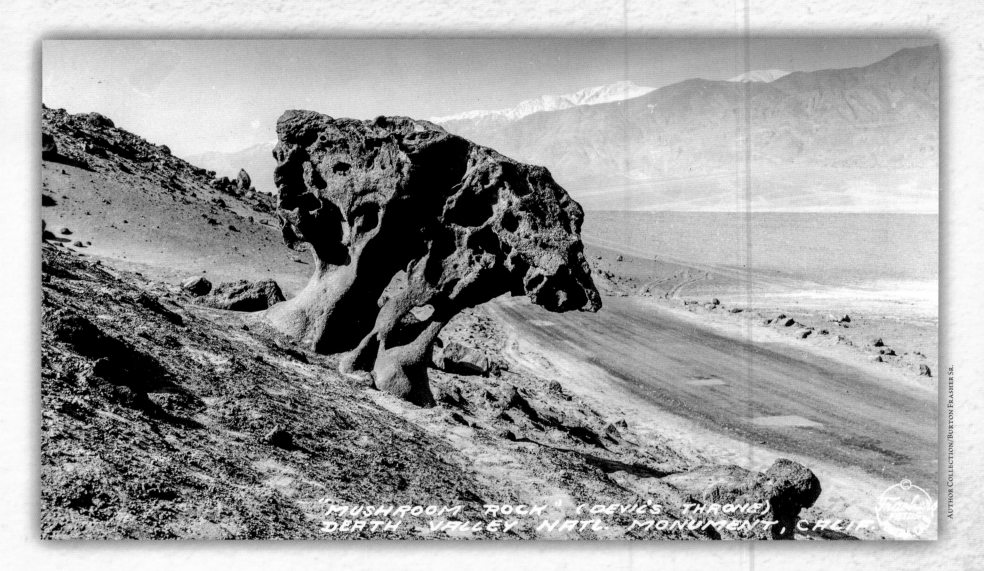

"MUSHROOM ROCK" (DEVIL'S THRONE)
DEATH VALLEY NATL. MONUMENT, CALIF.

AUTHOR COLLECTION/BURTON FRASHER SR.

1938 ~ Mushroom Rock (Devil's Throne)

"Mushroom Rock" and "Devil's Throne" were both names for a Death Valley landmark that was featured on local maps as recently as the 1980s.

The formation stood about eight feet high and perhaps six feet wide in its natural state. There was a parking area nearby, which was used by thousands of visitors over the years.

2/25/15 • 36°23'13" N 116°51'5" W

Mushroom Rock looks much different today, a prime example of a national park feature being "loved to death" by unwitting visitors. It's still about eight feet tall, but as more and more people stopped to admire it—often standing on top for photos or taking pieces as souvenirs—about half of the rock eventually broke off and now lies below.

Some accounts say the bulk of this damage occurred when a group of Boy Scouts gathered on top of the rock for a photo in the 1950s. In a quick internet search I also saw recent photos of other visitors posing on top of what now remains—including one man with his bike. Some people don't realize that their actions, multiplied by thousands of others doing the same thing, can eventually destroy features such as this one.

The area remains open today but there are no markers and it no longer appears on park maps. The road has also been moved away from where the pullout used to be located.

65

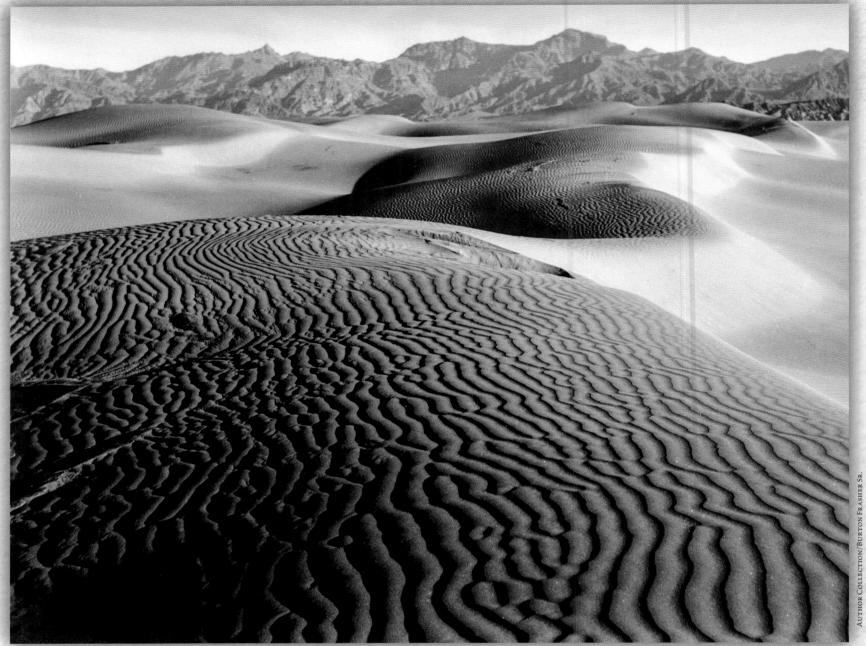

Author Collection/Burton Frasher Sr.

Opposite: 12/13/13 • 36°37′36″ N 117°5′12″ W

1946 ~ Mesquite Flat Sand Dunes

I hiked into the dunes at sunrise and found a matching location, where I recorded the GPS data listed above. The character of the dunes has remained much the same over time, but clearly the dunes themselves continue to shift and change shape.

This is a fabulous area for hiking, and December is a great time to visit Death Valley, but the sandy dunes and surrounding salt flats quickly took the finish off my formerly-shiny leather hiking boots.

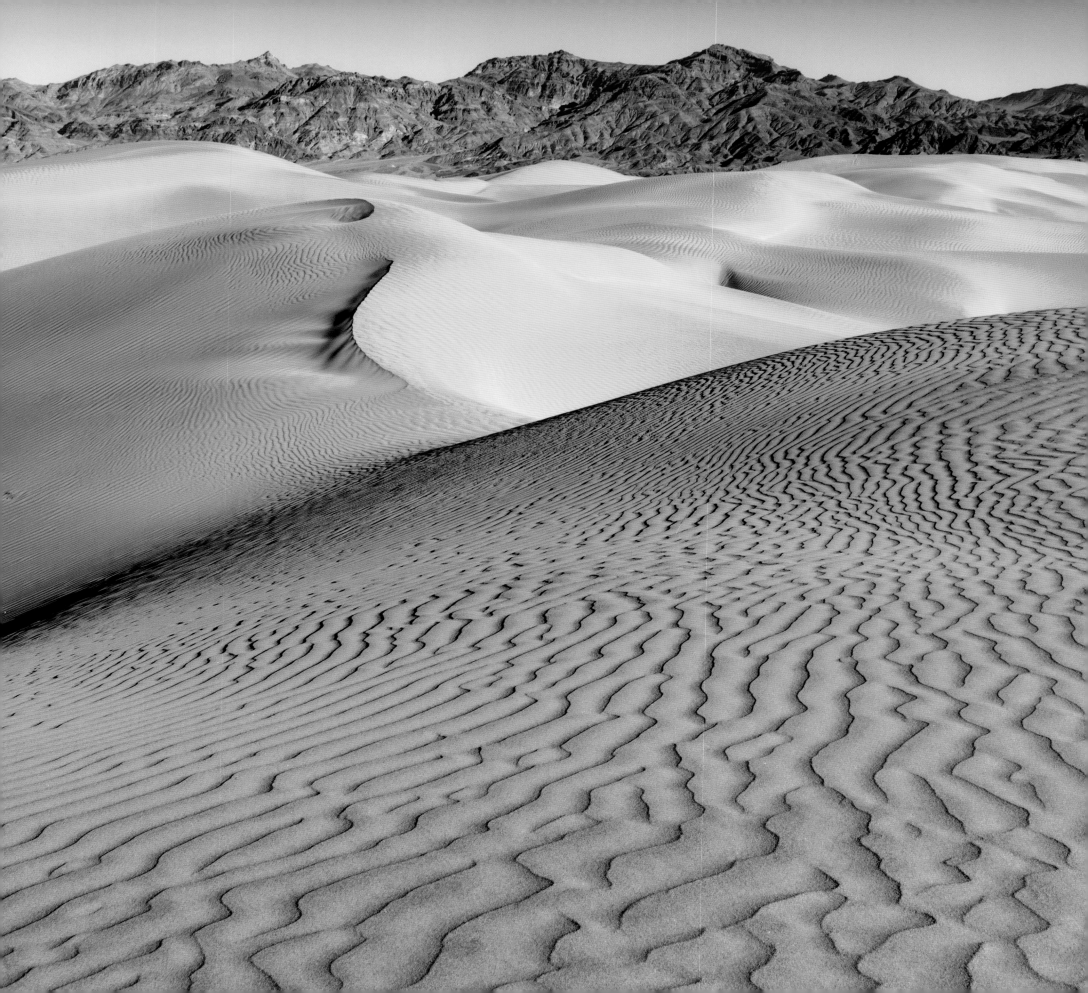

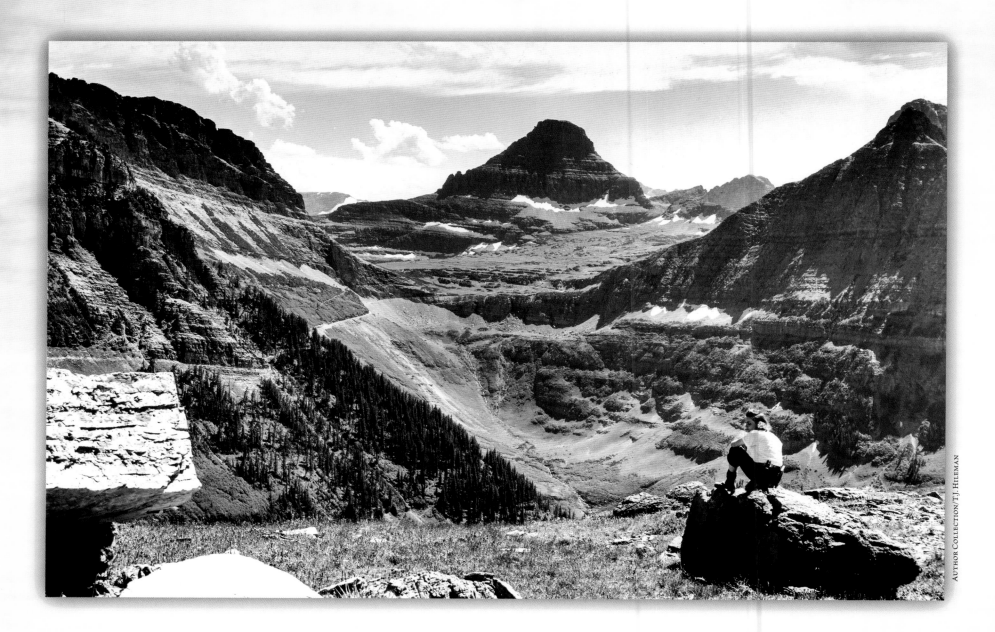

AUTHOR COLLECTION/T.J. HILEMAN

Circa 1930s ~ Logan Pass AND Trapper Creek Valley

Tomar J. Hileman, the official photographer for the Great Northern Railway starting in 1924, produced many beautiful images of Glacier National Park. This 8x10 print, purchased from an auction site, is stamped on the back: "Great Northern Railway Photo, credit line will be appreciated," and "This print is from Glacier National Park and must be so credited where ever used." A much smaller stamp says, "Appreciating the words 'Photo by Hileman' in small text if possible." The print was dated "1959," but Hileman had died in 1945. This image likely dates to the late 1930s, but Hileman's work obviously continued to promote the park for many years after he'd passed on to an even more beautiful land.

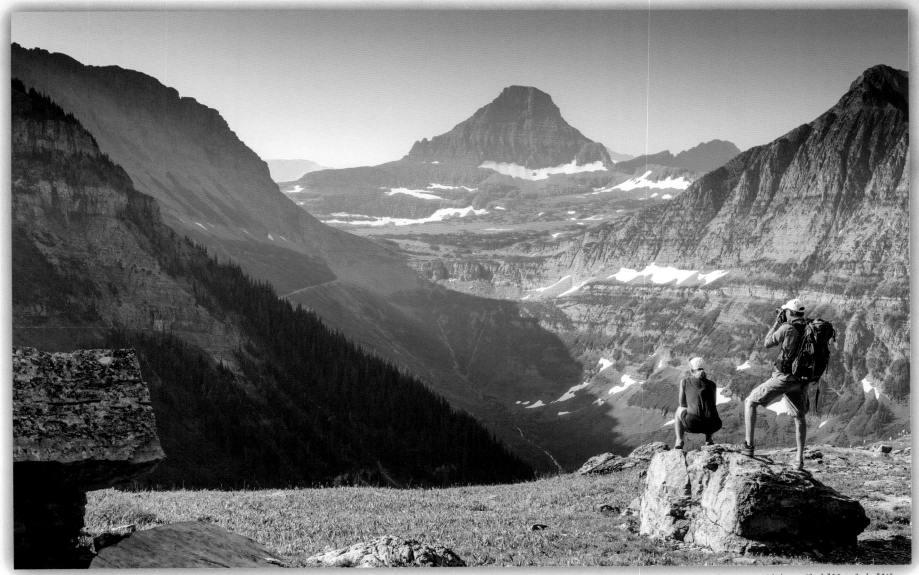

8/5/14 • 48°44'9" N 113°43'31" W

I prefer not to pose people in my photos if I can catch them naturally doing their thing at a photo site. But after I got talking with this couple, who passed by on the trail a few feet behind me, I asked them to stand on the boulder for the sake of scale and visual interest. They kindly obliged, and I don't think they minded taking in the view for a while.

The Highline Trail, visible in the distance along the left side of the photo, is the route I used to reach this site. I'd left my vehicle a few hours earlier in the parking area at Logan Pass, to the left of Clements Mountain, the prominent peak at center.

After making this image I still had a few miles to go to reach Granite Park Chalet (see the next page).

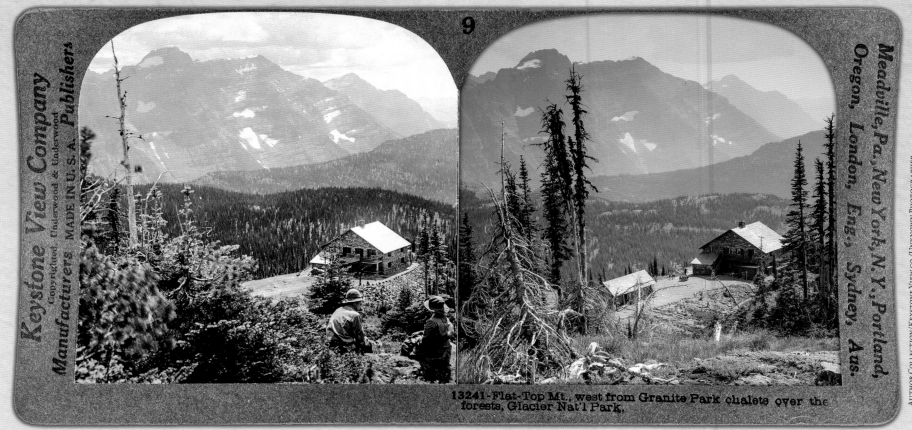

Author Collection/Keystone View co./Unknown Photographer

13241-Flat-Top Mt., west from Granite Park chalets over the forests, Glacier Nat'l Park,

8/5/14 • 48°46′21″ N 113°46′18″ W

Circa 1915 ~ Flat-Top Mountain West from Granite Park Chalet

I hiked the Highline Trail from Logan Pass to reach Granite Park. It's not the shortest route, at 7.6 miles, but it included the Trapper Creek Valley photo site on the previous pages.

The women in the historic image were seated on a short ledge still seen in the new photo. Construction of the chalet below started in 1914, 101 years before my visit. Given the shiny-new appearance of the structure, without the additional lodging building now visible at left, I concluded that the historic image was taken shortly after construction had been completed.

Some trees have grown in the last century (at left and right) while others have declined (at left).

Once I had my shot in the can, as photographers still say, I bought snacks and souvenirs at the shop inside the chalet. All the goods for sale are brought in by pack mules twice a week, so prices are necessarily a little higher.

Lacking a reservation or a permit for backcountry camping, I hiked out via the Loop Trail, another five miles, and caught a shuttle bus back to the car I'd parked at Logan Pass that morning. It was a 13.6-mile hike when I was done, and I was done-in at the end of it.

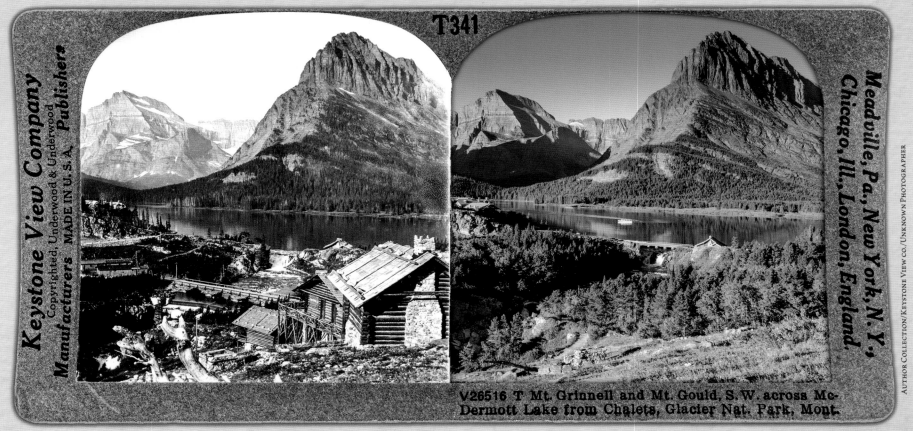

Keystone View Company
Copyrighted, Underwood & Underwood
Manufacturers MADE IN U.S.A. Publishers

T341

V26516 T Mt. Grinnell and Mt. Gould, S. W. across Mc-
Dermott Lake from Chalets, Glacier Nat. Park, Mont.

Meadville, Pa., New York, N.Y.,
Chicago, Ill., London, England.

AUTHOR COLLECTION/KEYSTONE VIEW CO./UNKNOWN PHOTOGRAPHER

9/1/13 • 48°48'5" N 113°39'13" W

Circa 1915 ~ Mt. Grinnell & Mt. Gould, S.W. from Chalets

The area known as Many Glacier is far more accessible than Granite Park (previous page), with a good road leading to the cabins or chalets that were built here about 1913. The Many Glacier Hotel (at far left) had been constructed by 1915.

Starting around 1900, the lake was called "McDermott" for a local lumberman, but it had previously been known as Swiftcurrent, an Indian name it regained in 1928. The chalets in the foreground of the historic image burned down on Aug. 31, 1936, after

lightning sparked a fire in the nearby mountains 13 days earlier. The hotel was barely saved by staff members who sprayed water on it all night.[14]

I found broken dishes and nails around the foundation of the chalet closest to the camera. A pile of rock marked the location of its chimney, and a stone structure I could not identify (a barbecue?) stands partly intact to the left of where the chalet once stood. It helped me positively identify the photo site.

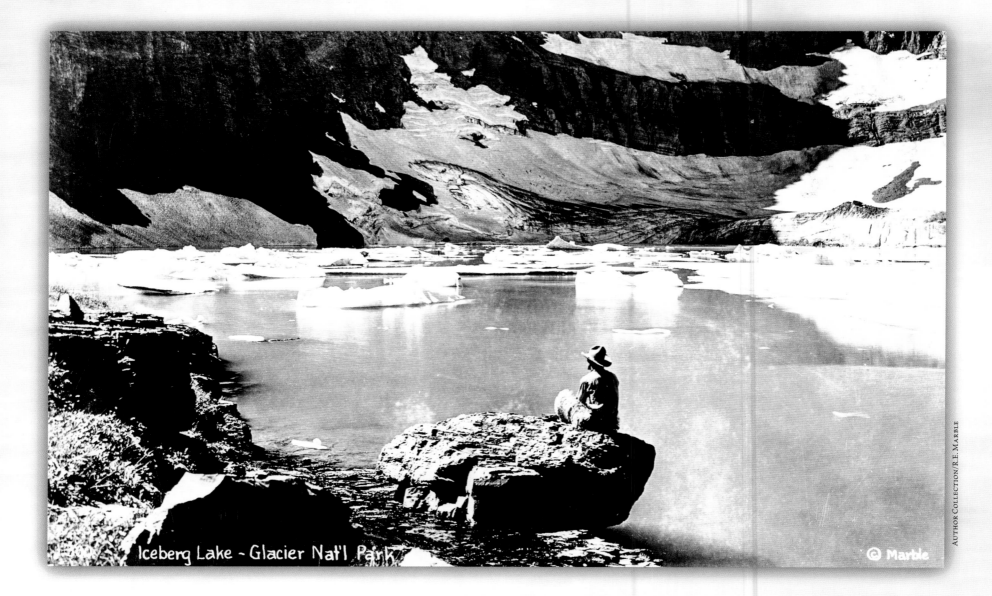

Iceberg Lake - Glacier Nat'l Park

© Marble

AUTHOR COLLECTION/R.E. MARBLE

Circa 1930 ~ Iceberg Lake

Judging by his hat and the woolly chaps on his legs, I speculate that this was a cowboy guide posing for the photographer at the edge of Iceberg Lake. Other historic photos from the era show us that horses were often used to access backcountry areas such as this one in the massive park.

I had several intriguing historic images of Iceberg Lake at my disposal for this project, but I found that most of those sites were now blocked by the trees that have grown around the lake in several areas. Fortunately, as it turned out, this unobstructed photo site was also the best of them all.

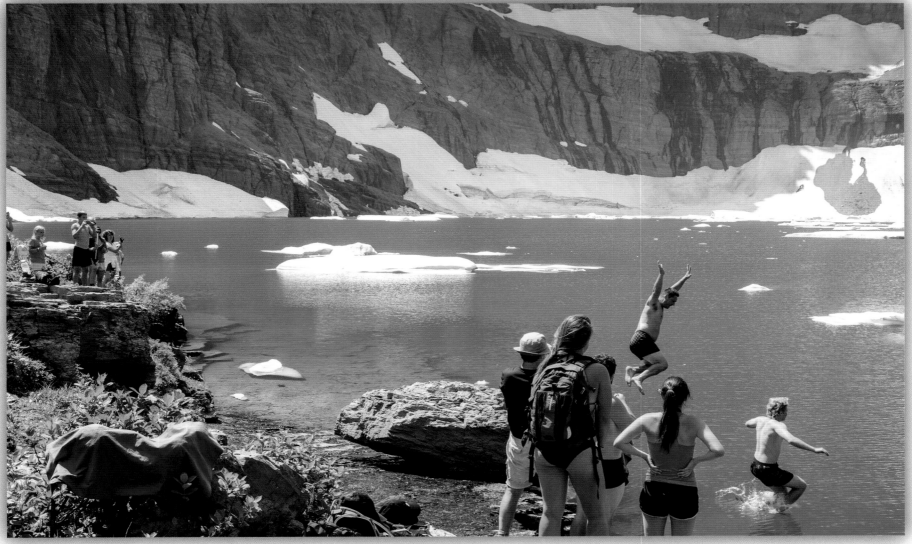

8/7/14 • 48°48'52" N 113°44'27" W

Completing the nearly five-mile hike to Iceberg Lake, I saw from a distance what I hoped was the same distinctive boulder in the foreground. I had been here once before, but didn't have the historic photo at the time. Once I was able to purchase the old postcard image, I decided to go back for another look.

This is exactly the kind of thing I'm trying to illustrate with images of national parks past and present: in the past, relative solitude and low visitation. Today, ten times the number of visitors (or more) as people continue to "find their park," to quote a recent National Park Service ad campaign. I agree that everyone should be able to visit these places, but the character of areas like Iceberg Lake is surely changed with the afternoon crowds arriving all summer.

These college students amazed me by repeatedly jumping into water that was just above freezing, kept cold by the floating icebergs. They were not doing it just because I was taking photos; they had barely noticed my approach.

The foreground rocks, now draped with towels and clothing, are also nearly covered by vegetation that wasn't there back in the 1930s.

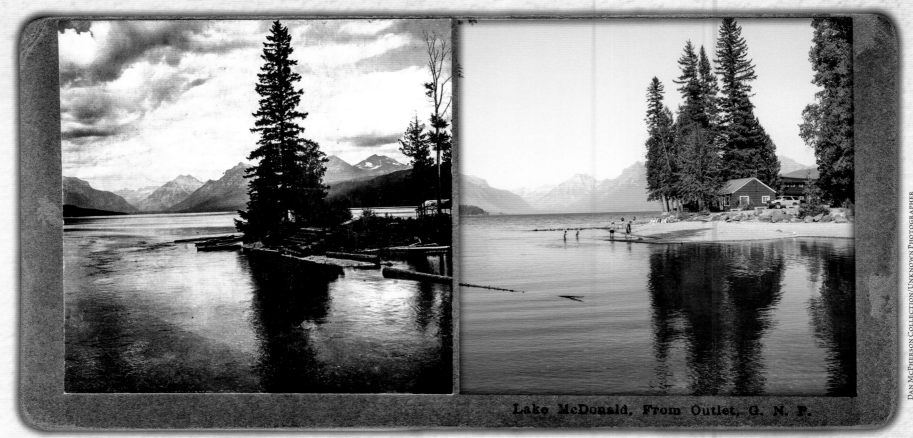

Lake McDonald, From Outlet, G. N. P.

Dan McPherson Collection/Unknown Photographer

8/23/13 • 48°31'44" N 113°59'47" W

Circa 1910 ~ Lake McDonald, From Outlet

The title of this 103-year-old stereoview proved accurate. During pre-trip planning I had located Lake McDonald's outlet on Google Earth and set a waypoint, which I later followed to the west side of McDonald Creek. From there I had little difficulty identifying the approximate photo site.

Apgar Village, one of the main developed areas in Glacier, with roots in the 1890s, lies a few hundred feet off-camera to the right. In the historic photo, two canoes, a pile of logs and a picnic shelter hint at what was to come. Development in the area now extends to this spit of land, where lakeside cabins have been built for the enjoyment of visitors. A vacationing family was wading in the shallow water of McDonald Creek as I photographed from the opposite shore.

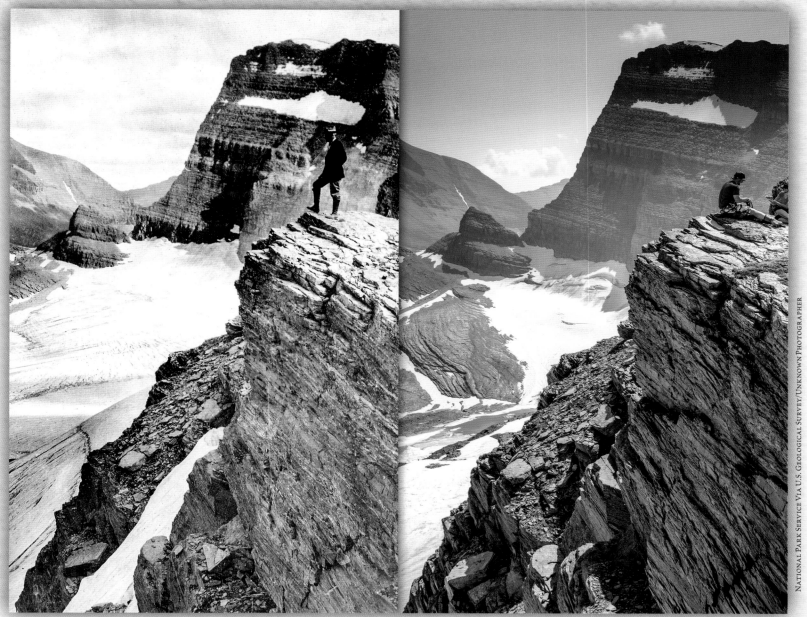

National Park Service Via U.S. Geological Survey/Unknown Photographer

8/5/14 • 48°45′44″ N 113°44′36″ W • Caution: At Cliff Edge.

1920 ~ Stephen Mather at Grinnell Glacier Overlook

The U.S. Geological Survey includes the historic image with many others they have rephotographed to study changes in this park. Their conclusion: All glaciers here are shrinking, and at this rate none will remain in Glacier National Park by the year 2030. I am glad I was able to see what remains of Grinnell Glacier, from above (this summit is part of the Continental Divide) and from below (at upper right on the next spread). To get to this site, I hiked up the Garden Wall Trail from the Highline Trail.

Stephen T. Mather, the man in the historic image, was the first director of the National Park Service. The hikers having lunch at right just happened to be seated in the same area as I rephotographed the scene.

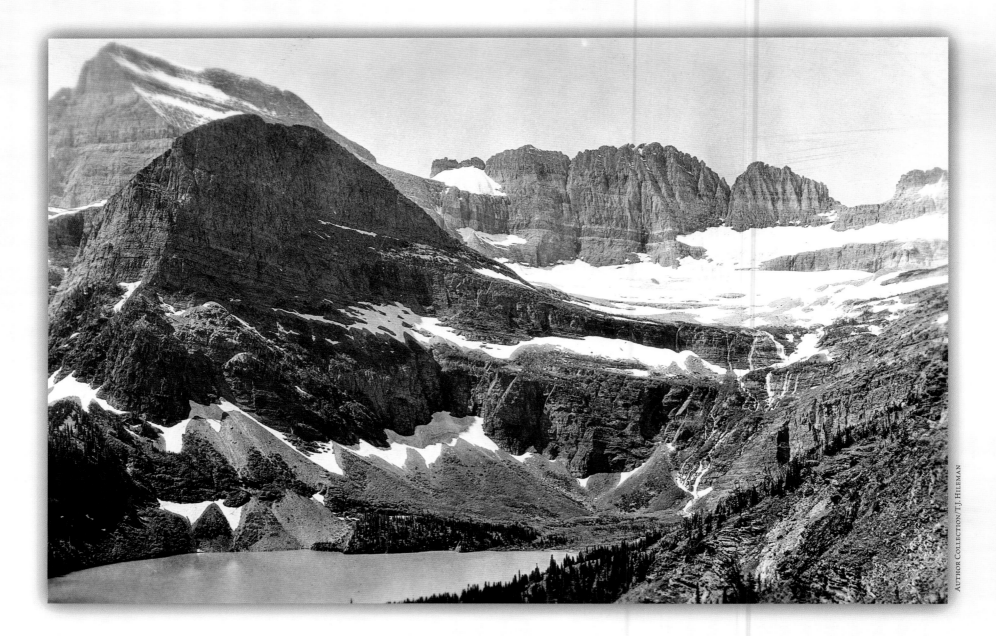

AUTHOR COLLECTION/T.J. HILEMAN

1933 ~ Grinnell Lake & Glacier

There are actually two glaciers in view here: Salamander at upper right and, just below it, Grinnell. George Bird Grinnell is credited with discovering these glaciers in 1885.[15]

The date "1933" is stamped on the back of this postcard by well-known Glacier photographer T.J. Hileman, but it may have been taken earlier than that.

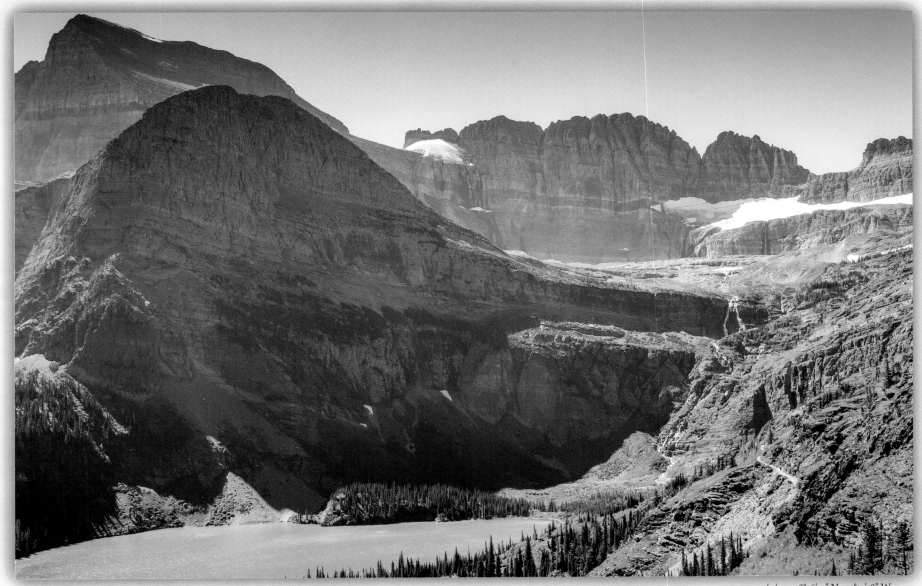

9/1/13 • 48°46'33" N 113°41'48" W

This site puzzled me for most of the day I spent searching for it. Hiking the Grinnell Glacier Trail (at lower right in my photo), I realized I was far too low for a view that matched the historic image. Yet my GPS and trail maps showed no trail above me. I began a steep ascent above the marked trail, pulling my way up through dense vegetation and making noises that I hoped would help avoid surprising any grizzly bears in the area. (I always carried bear spray in this park and elsewhere when appropriate.) I eventually reached what seemed to be the remnant of an old trail, in the vicinity of where the historic image had been recorded.

The reduction in size of both Salamander and Grinnell glaciers is readily apparent when comparing these two images.

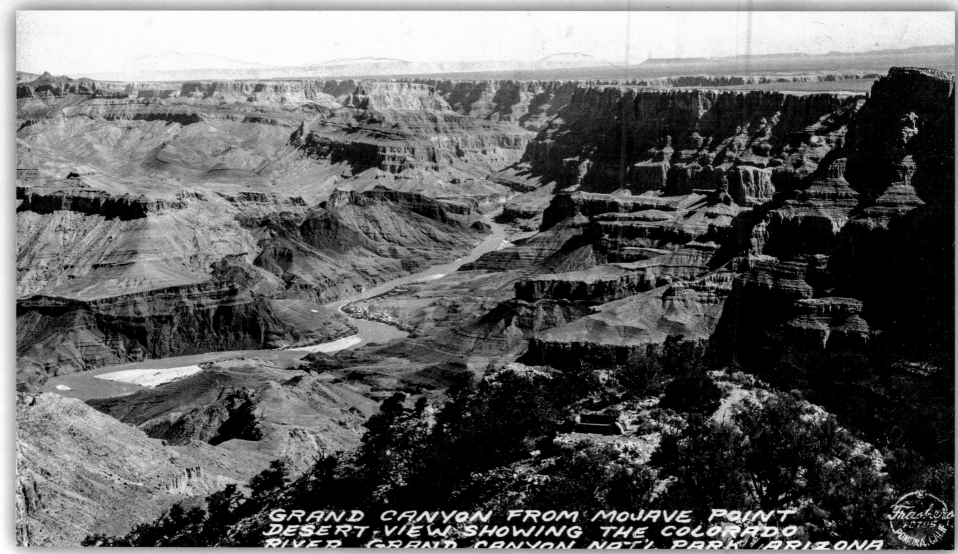

GRAND CANYON FROM MOJAVE POINT
DESERT VIEW SHOWING THE COLORADO
RIVER GRAND CANYON NAT'L PARK ARIZONA

AUTHOR COLLECTION/BURTON FRASHER SR.

1936 ~ Desert View Showing THE Colorado River

The caption on this Burton Frasher Sr. photo appears to be a rare factual error from this outstanding postcard photographer. Mojave (or Mohave) Point is miles away, while this view is from Navajo Point near the Desert View Watchtower—a 70-foot-high stone building completed in 1932 and designed to resemble an Anasazi watchtower from a distance. We are of course looking at Grand Canyon National Park.

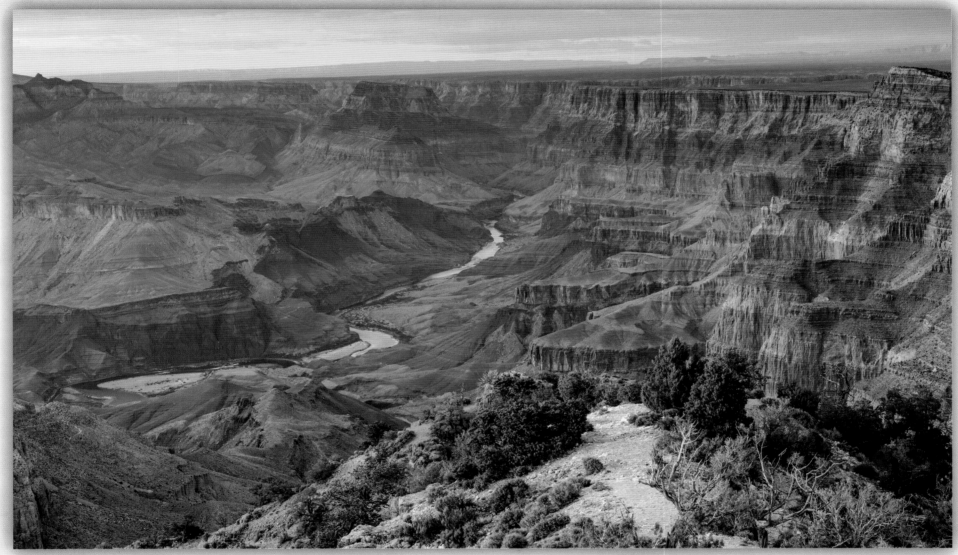

4/17/15 • 36° 2'39" N 111°49'33" W

Thanks to the words "Desert View" on Frasher's post-card, I realized that this angle was probably near the northeast portion of Desert View Drive along the south rim of the Grand Canyon. It turned out that he had been at the extreme end of the overlook below the Desert View Watchtower.

Especially at sunset, there is a friendly jockeying for position among "serious photographers" at popular viewpoints such as this one, along with much trading of camera technique and travel plans as the sun gradually goes down. I enjoyed speaking with several people on the evening I took this photo.

What seems to be a stone bench in the historic image is now gone. Other changes are more subtle but hint at what I encountered elsewhere in the canyon: somewhat larger juniper trees and, because the Glen Canyon Dam 100 miles upstream reduces natural flooding, more vegetation on sandbars along the distant Colorado River.

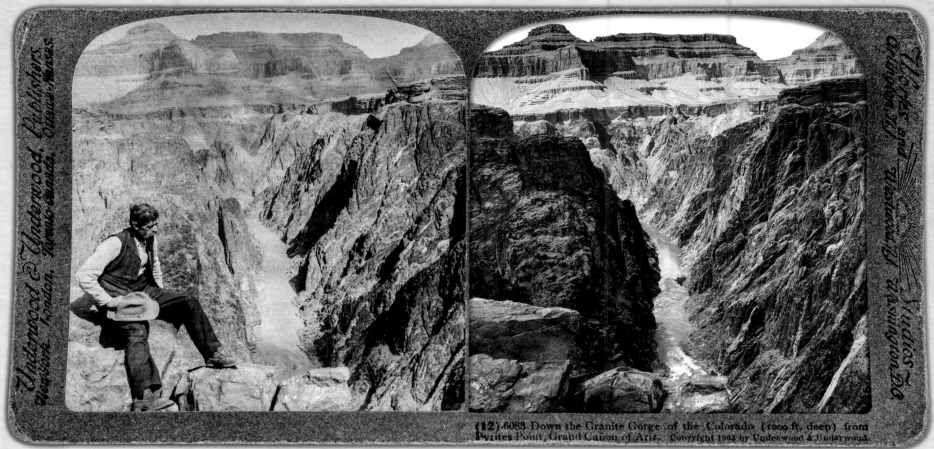

(12) 6083 Down the Granite Gorge of the Colorado (1200 ft. deep) from Pyrites Point, Grand Cañon of Ariz. Copyright 1903 by Underwood & Underwood.

4/19/14 • 36°5′39″ N 112°7′40″ W • Caution: At Cliff Edge, Hazardous Hike.

Author Collection/Underwood & Underwood

1903-04 ~ Down the Granite Gorge of the Colorado from Pyrites Point

The photographer's name of "Pyrites Point" was apparently never used by anyone else, at least not by map-makers or the National Park Service. Initially I thought the view would be from Plateau Point; an existing trail there made it a logical possibility. But on my third day of hiking from the south rim, about seven miles away, I finally located this photo site about half a mile to the west of Plateau Point (as the condor flies, or about a mile and a half on foot), above a hair-raising drop-off at the edge of the Granite Gorge. I'm not afraid of heights per se, but I approach edges like this one with a great deal of caution. The hike down a side canyon to reach this point was also quite extreme.

There are at least three versions of this historic view, with the unidentified subject in various poses but always looking dusty, hot and tired. I could relate after making three 14-mile trips down here.

At upper left is the Tower of Set, one of several Grand Canyon features with Egyptian-inspired names. Horn Creek Rapids lie far down in the gorge.

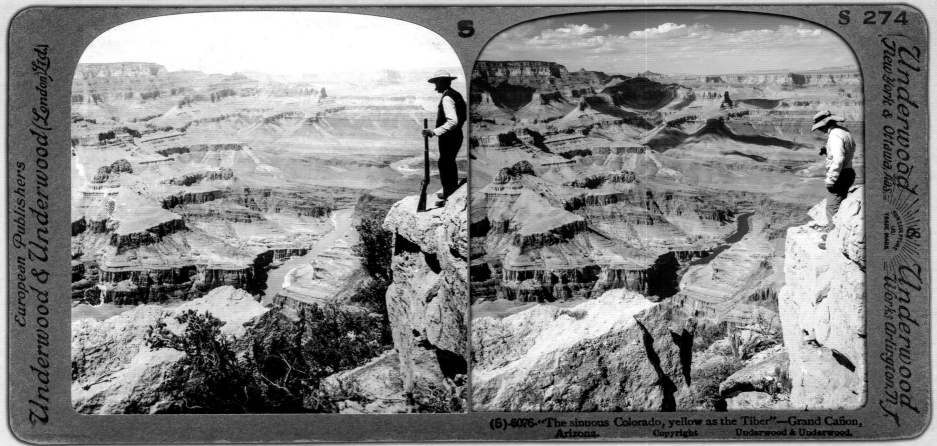

S 274

European Publishers
Underwood & Underwood (London) Ltd.

Underwood
(New York & Ottawa, Kas.)

Underwood
Works Arlington, N.J.

Author Collection/Underwood & Underwood

(6)-6076-"The sinuous Colorado, yellow as the Tiber".—Grand Cañon, Arizona. Copyright Underwood & Underwood.

4/18/15 • 36°0'56" N 111°54'44" W

1903-04 ~ Zuni Point Overlooking Colorado River

The unidentified cowboy in the historic image seems to be the same man who appears on the opposite page. He looks fresher here, and this site was definitely easier for both of us to reach. Today's Desert View Drive passes Zuni Point half a mile away, although there are no sign posts pointing the way.

Fortunately the name still appears on some modern maps, and finding Zuni Point—assuming the title was correct—was a matter of identifying it in Google Earth and setting a waypoint. I then navigated to this site among the dozens of other Grand Canyon loca-

tions I checked while working on this project over a four-year period.

I parked along the main road and hiked to the point, at times following what looked like an old trail or road. About two hours of exploring and searching brought me to the spot where I could align my camera. I noticed that the rock Mr. Cowboy was standing on had toppled over the edge. I kept this in mind as I stood at right for a self-portrait, and remembered it again at many other places where I was near an edge.

KEYSTONE-MAST COLLECTION, UCR/CALIFORNIA MUSEUM OF PHOTOGRAPHY/PHILIP BRIGANDI

OPPOSITE: 4/4/16 • 36°5'2" N 112°11'20" W

1925 ~ On the Tonto Trail Along Monument Creek to the Monument

Fortunately for me, this site was conveniently located a short distance from the Monument Creek back-country campground where I had a two-night reservation. This gave me the option of returning to the site in near-matching light around 9:00 a.m. on an April morning, although the angle of the sun suggests that the original photo was taken in another month.

My real goal on this trip was to reach Granite Rapids farther down the trail (page 93), but I couldn't pass up this view of the Monument along the way.

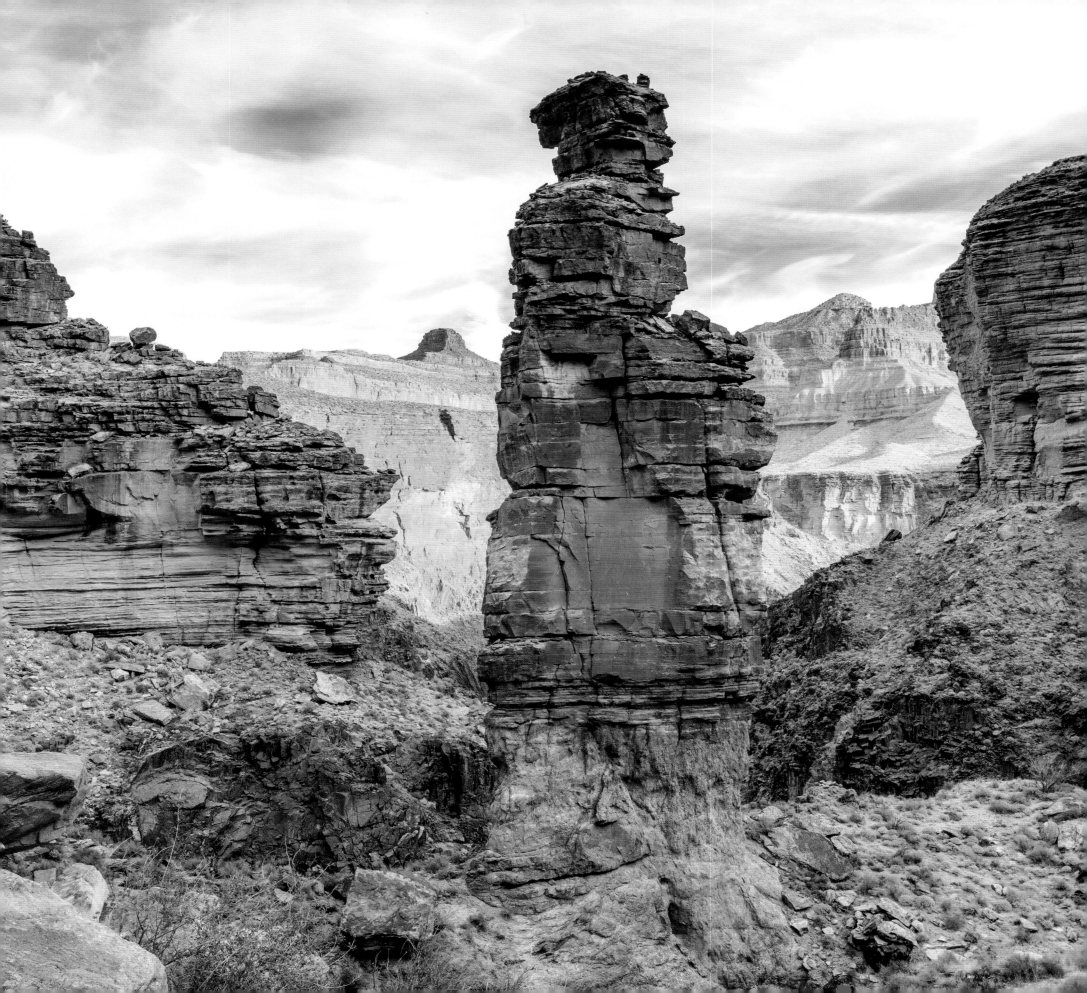

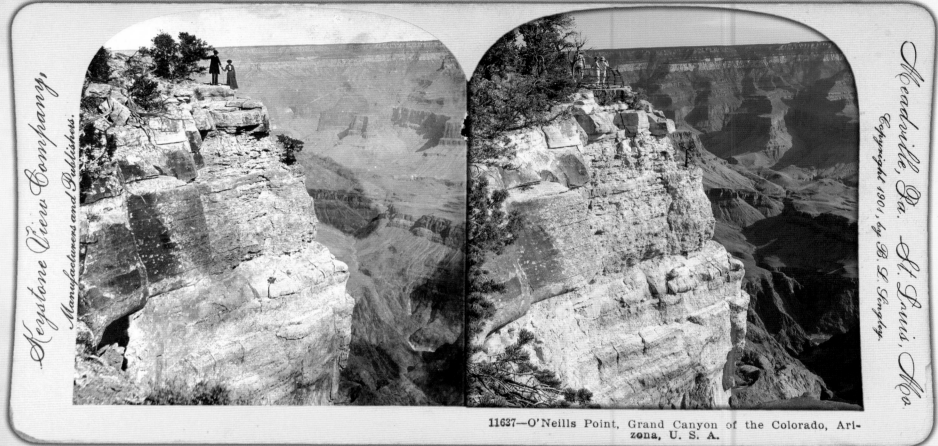

Keystone View Company, Manufacturers and Publishers.

Meadville, Pa. St. Louis, Mo. Copyright 1901, by B. L. Singley.

AUTHOR COLLECTION/KEYSTONE VIEW CO./B.L. SINGLEY

11637—O'Neills Point, Grand Canyon of the Colorado, Arizona, U. S. A.

6/28/13 • APPROX. 36°3′56″ N 112°7′0″ W • CAUTION: AT CLIFF EDGE.

Circa 1900 ~ O'Neill's Point (Yavapai Point)

"O'Neill's Point," labelled Yavapai Point on today's maps, is one of the major overlooks along the South Rim of the Grand Canyon.

As is often the case in late-1800s stereoview images, people are dramatically posed on what was then an unfenced view area over the canyon. I get a good laugh during my live presentations by pointing out that the man grasping the tree has positioned his wife in an even more dangerous position than he was in.

People do fall into the canyon, so it's not always a joking matter. Where the photographer stood for this image remains unfenced, with a straight drop below. I never work at these areas unless no one else is near me and the wind isn't blowing. My actions are also carefully considered; I do nothing in a hurry.

That didn't stop my wife Camille and daughter Anna Marie, who posed behind the railing now installed at Yavapai Point, from looking over and telling me to be careful. Actually, I think Camille said, "Don't go out there!" But she was pretty far away, I couldn't hear her clearly, and as I said, I was very careful.

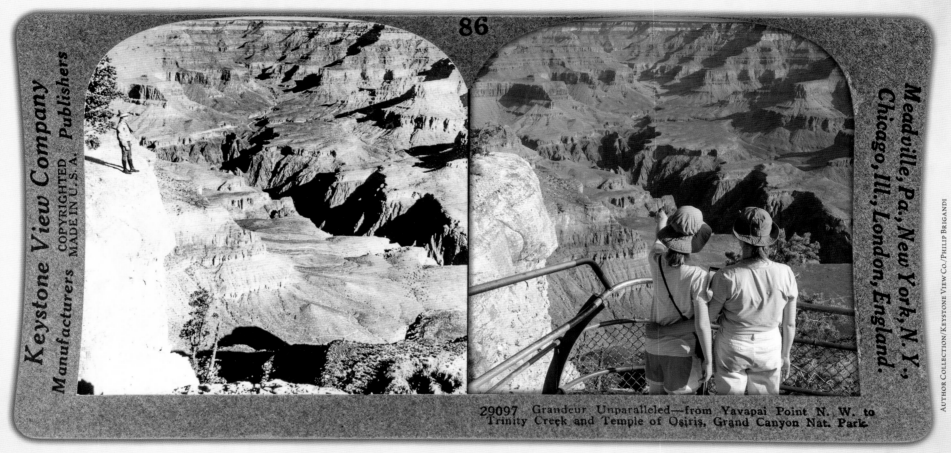

86

Keystone View Company
Manufacturers COPYRIGHTED *Publishers*
MADE IN U.S.A.

29097 Grandeur Unparalleled—from Yavapai Point N. W. to
Trinity Creek and Temple of Osiris, Grand Canyon Nat. Park.

Meadville, Pa., New York, N.Y.,
Chicago, Ill., London, England.

AUTHOR COLLECTION/KEYSTONE VIEW CO./PHILIP BRIGANDI

6/28/13 • 36°3′57″ N 112°7′1″ W

1925 ~ Grandeur Unparalleled – From Yavapai Point

This view, from behind the overlook pictured on the opposite page, is angled more to the west. Once again a daring man stands unprotected near the edge, but he apparently survived. He appears in other early views of the canyon.

By chance, my daughter's pointing finger is just to the left of the area I later hiked to with some difficulty, looking for a photo site the photographer called "Pyrites Point" (see page 80).

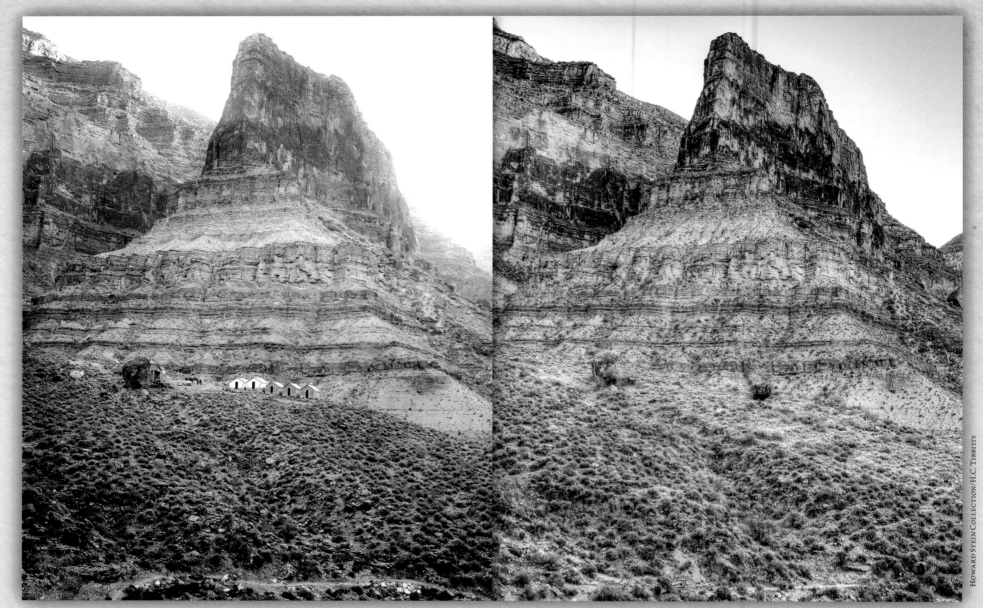

Howard Stein Collection/H.C. Tibbitts

4/2/16 • 36°5'1" N 112°12'38" W

Circa 1912 - Hermit Camp

Hermit Camp, seen here early in its life, operated until the 1930s, when it was abandoned in favor of a more attractive site at Phantom Ranch.

I was concerned about making a long solo hike via the Hermit Trail, said to be more strenuous than the Bright Angel (opposite page), but I prepared carefully. With permits in order and a favorable weather forecast, I made the eight-mile trek to a campsite here.

The area is littered with fascinating junk from the time of the Hermit Camp. I explored old foundations as well as the crude stone structures that remain standing. My green backpacking tent looks like a bush to the left of the tree (I like to blend in). I stayed here one night before refilling my water bottles from nearby Hermit Creek (filtered of course) and continuing on to other photo sites at Monument Creek and Granite Rapids.

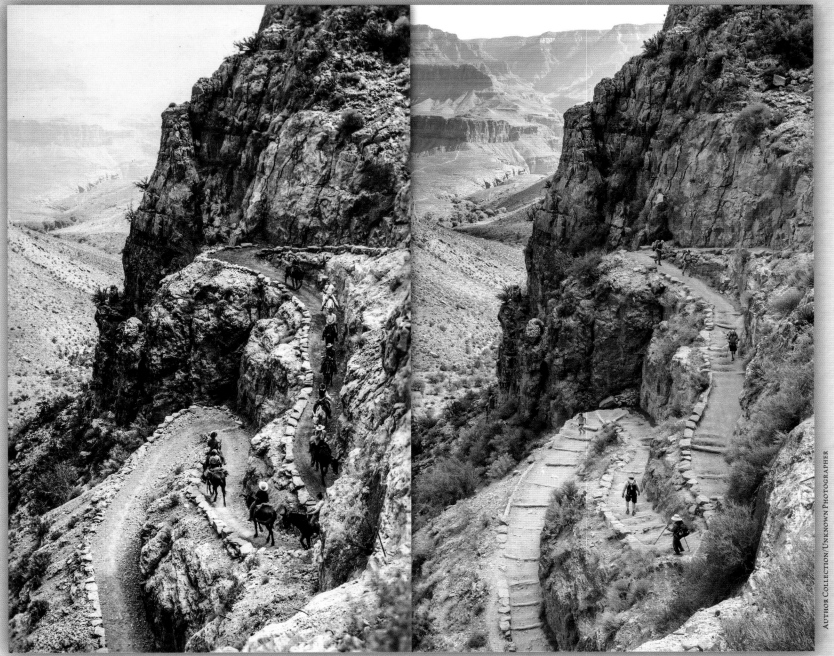

AUTHOR COLLECTION/UNKNOWN PHOTOGRAPHER

4/19/15 • 36°3′54″ N 112°8′13″ W

Circa 1935 ~ Going Down the Bright Angel Trail

This section of the Bright Angel Trail, called Jacob's Ladder, is located just below the Three-Mile Resthouse. The area of green trees in the distance at upper left is Indian Garden, which tantalizes downward-bound hikers with its promise of shade and water.

Tourist-laden mule trains still make their way down this section of trail twice a day during the main season. I preferred to hike, since the mule rides only stop at a few designated locations, without allowing enough time for my work here.

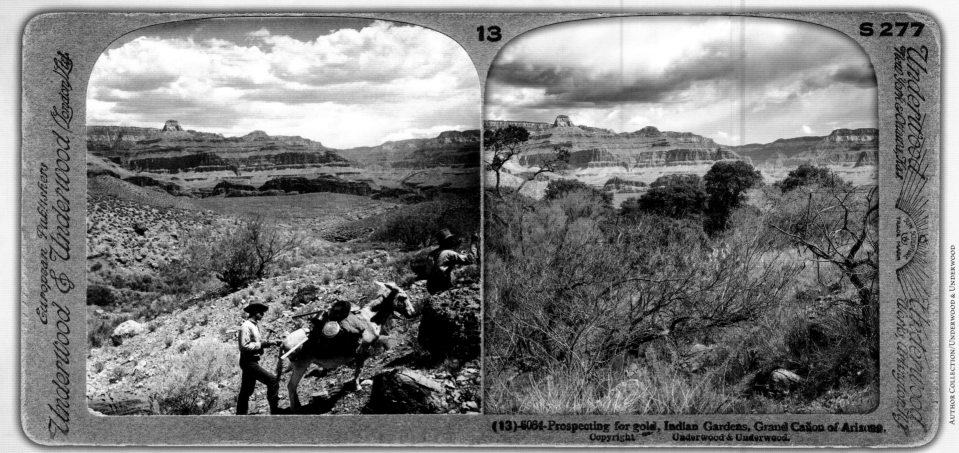

AUTHOR COLLECTION/UNDERWOOD & UNDERWOOD

(13)-6064-Prospecting for gold, Indian Gardens, Grand Cañon of Arizona.
Copyright Underwood & Underwood.

4/19/15 • 36°4′38″ N 112°7′43″ W

1903-04 ~ Prospecting for Gold, Indian Garden

There are a couple historic photo sites in this book I was determined to find from the moment I first saw them. This is one. I love the way the miners and their burro are so carefully posed, and I was drawn by the desire to find the exact spot on which they had stood.

Hoping that the Indian Garden reference in the stereoview's caption was accurate, I began by reviewing hundreds of geotagged photographs taken by other visitors and uploaded to Google Earth. Eventually I found an image that showed the background (the tall formation at left is known as "Buddha Temple") as well as some of the middle ground. I could now work toward the foreground.

With a camping permit again in hand, I hiked five miles down to Indian Garden, and began searching. After one afternoon and part of another morning, I found the cracked boulder visible at lower right in the old photo, now almost hidden in brush and cactus only a few yards off the Bright Angel Trail. A campground and rest area for hikers would be in plain view in the modern photo were it not for the remarkable growth of cottonwood trees and other vegetation.

Apparently a little placer gold was indeed found in the Canyon in the early days, although not in quantities to make it worth pursuing on a large scale.

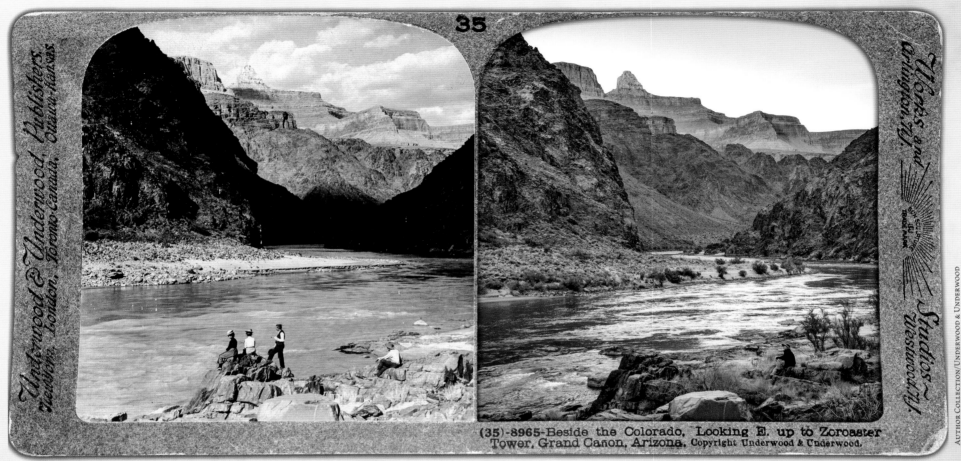

(35)-8965-Beside the Colorado, Looking E. up to Zoroaster Tower, Grand Cañon, Arizona. Copyright Underwood & Underwood.

AUTHOR COLLECTION/UNDERWOOD & UNDERWOOD

4/3/14 • 36°5'57" N 112°6'43" W

1903-04 ~ Beside the Colorado, Looking East Up to Zoroaster Tower

In retrospect this turned out to be a logical place for a 1903 photo, at the point where the Bright Angel Trail almost touches the Colorado River for the first time as visitors come from the South Rim eight miles away.

I found this site on my very first hike to Bright Angel Campground near Phantom Ranch, where I stayed for two nights. On the way down from the South Rim I kept my eye on the Zoroaster Temple (as it is known today), knowing it was in the background of the old photo. The middle ground formations also came into view when I reached the river, and I saw the rise where the people were posed. But where was that foreground boulder? Backing up to a higher point above the river, I saw the distinctive striped boulder and set up the tripod to finally achieve a perfect match. I decided to wait an hour for the softer light of sunset. Seated as one of the earlier visitors had been, I used a remote to take the photo above.

I then hiked the remaining 1.5 miles to the campground. The only "hikers" I encountered after dark were a few mule deer, their eyes reflecting my head lamp as they watched me pass. I crossed over the Colorado River on the Silver Bridge in the darkness, found my campsite, set up my tent, and was quickly asleep.

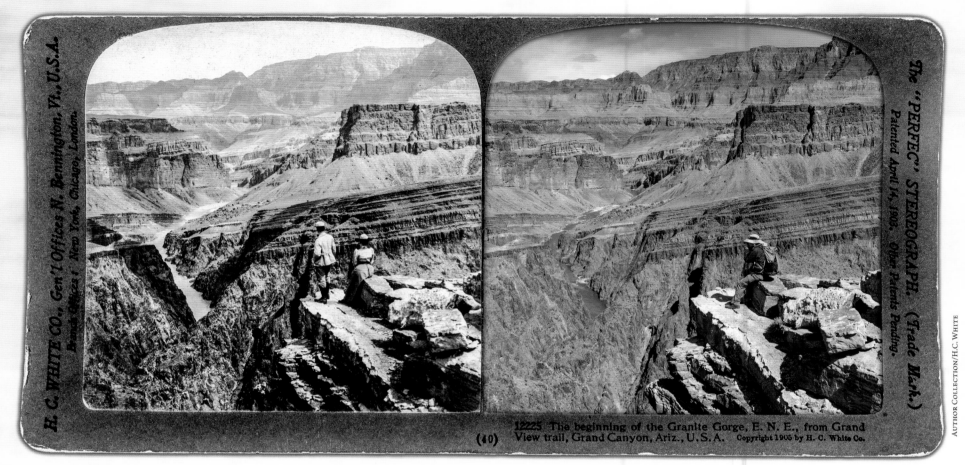

12225 The beginning of the Granite Gorge, E. N. E., from Grand View trail, Grand Canyon, Ariz., U.S.A. Copyright 1905 by H. C. White Co.

(40)

4/16/15 • 36°2'32" N 111°57'39" W

1905 ~ The Beginning of the Granite Gorge...Grand View Trail

Truly obscure locations like this one—well away from parking lots, crowded overlooks and official trails—appeal to me. Perhaps it's the idea that I might be only the second photographer to have visited them. That's probably an illusion, but this area was remote enough that it's possible. I hoped I was at least the first to visit with the historic image in my hands.

I knew where the Grand View Trail (mentioned in the stereoview caption) began, and I could see the far background of this image in Google Earth. So I acquired a permit to camp along the trail at Horseshoe Mesa, three miles down and near the site of an old copper mine. I found dozens of late-1800s food cans around my camp, and even a bashed-in miner's coffee pot of ancient design. All very interesting, but the photo site was miles farther down the trail. During

the night it rained (at my camp) and snowed (on the canyon rim far above), but the dawn broke clear and I was able to get an early start after my standard backpacking breakfast of freeze-dried eggs, ham and potatoes, and a cup of freeze-dried coffee. (What would those miners have thought?) Connecting to the Tonto Trail, then traveling about a mile east, I could see I was getting close as the middle-ground features came into view. Going off-trail toward the final drop-off to the river below, I came over a rise and finally saw the rocky foreground of the historic photo. By chance I got a fair match for the time of day as well.

I hadn't seen anyone for at least six hours, so with no models available I again climbed into a historic photo site and triggered my camera remotely.

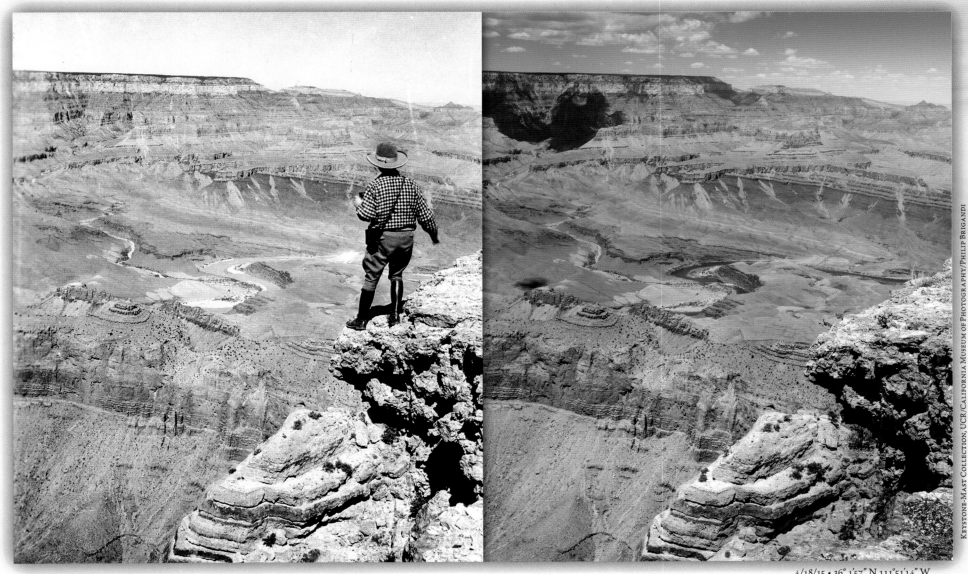

Keystone-Mast Collection, UCR/California Museum of Photography/Philip Brigandi

4/18/15 • 36° 1′57″ N 111°51′14″ W

1925 ~ North from Lipan Point to Colorado River

This was one of the first sites I went to at the Grand Canyon. I had already visited this park as a casual tourist earlier in my life, so I had some ideas about the best locations with which to begin. Maps showed that Lipan Point was easily approachable, and I wouldn't have to go out on a ledge as the guide in the checked shirt is doing here. (He's pictured wearing the same outfit in other historic images and was probably assisting the photographer.)

I discovered that the camera location was indeed safe, but the railing at today's overlook kept me a little too far back. So I stuck my head through the barrier (still perfectly safe) and hand-held the camera for a matching view. Leaning on the railing provided some of the stability normally provided by a tripod for greater accuracy and sharper images.

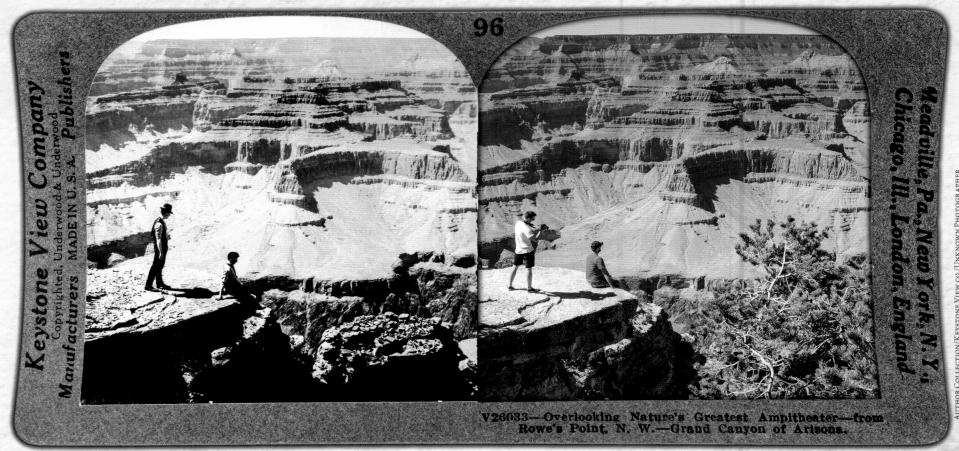

Keystone View Company
Copyrighted, Underwood & Underwood
Manufacturers MADE IN U.S.A. Publishers

96

V26033—Overlooking Nature's Greatest Ampitheater—from
Rowe's Point, N. W.—Grand Canyon of Arizona.

Meadville, Pa., New York, N.Y.,
Chicago, Ill., London, England

Author Collection/Keystone View co./Unknown Photographer

4/8/14 • 36°4'26" N 112°9'15" W

1903-04 ~ Overlooking Nature's Greatest Amphitheater

The camera point for these views was about 75 yards west of Hopi Point, across a chasm and partially hidden behind some trees. I can't be certain that the historic image was posed, but alternate versions of it show the two men in various positions on the ledge, as if they were being directed by the photographer.

In my case, once I had set up my camera in the semi-hidden vantage point, I watched as a procession of visitors came and went. A good number of them either sat down like the man in the red shirt, or peered over the edge. One visitor had a camera mounted on his head, while others took selfies or did yoga poses. But I liked the unposed view above best because it was most like the historic image—minus a camera in the hands of the old-time tourist standing at left.

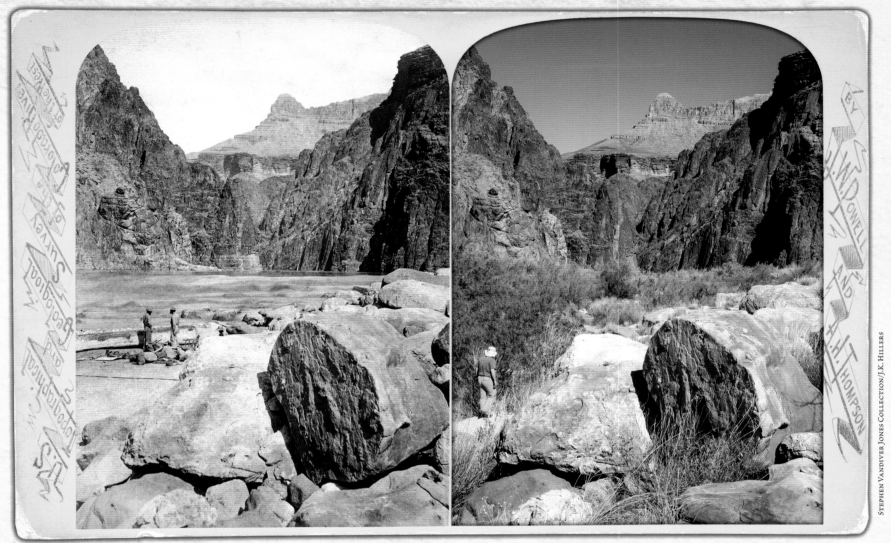

Stephen Vandiver Jones Collection/J.K. Hillers

4/4/16 • 36°5′53″ N 112°11′4″ W

1871 ~ At Granite Rapids

The stereoview is from the second Powell Expedition (1871-72); some of the crew members are making repairs on their overturned boats.

My research indicated that I might find this site near Granite Rapids. I reached the area after first hiking 8.3 miles to Hermit Camp (where I stayed for a night, page 86), then 3.5 miles to Monument Creek campground (two nights), and finally 1.6 miles down to the Colorado River. After climbing another 13 miles back up to the rim in a single day, I collapsed in a nearby hotel.

I was quite happy to find the foreground boulders still in place. I explored the area where Powell's men had been working, but of course found nothing. Still, I was "standing in history," as I call the experience of visiting the scene of an historic photograph.[16]

I had hoped to photograph rafts going through Granite Rapids in the background, but the view of the river is now blocked. Construction of the Glen Canyon Dam has reduced natural flooding, allowing invasive plants such as tamarisk to spread over formerly open beaches along the Colorado River.

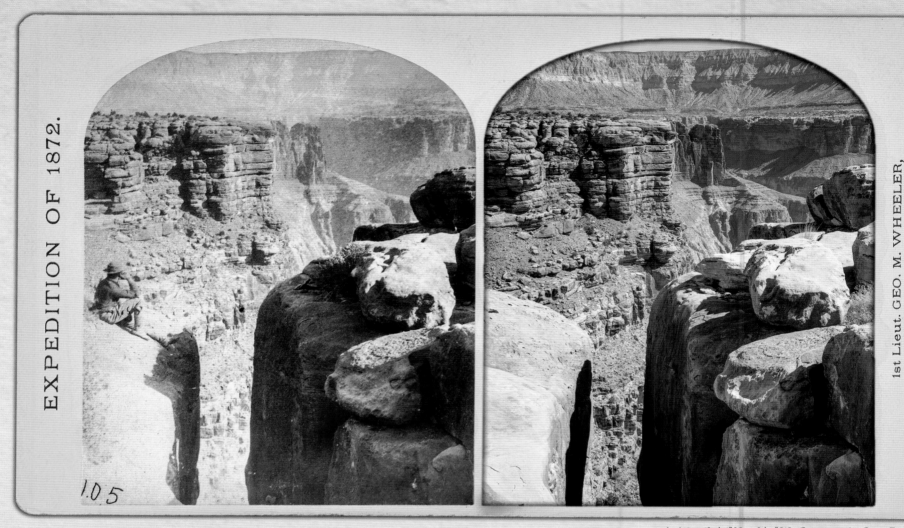

EXPEDITION OF 1872.

1st Lieut. GEO. M. WHEELER, Corps of Engineers Commanding.

New York Public Library/William Bell

1.0.5

3/17/16 • 36°13′46″ N 113°2′40″ W • Caution: At Cliff Edge.

1872 ~ Northern Wall of the Grand Canyon of the Colorado, Near Foot of Toroweap Valley

William Bell and John K. Hillers are credited with a number of images taken in 1872 at Tuweep, at or near Toroweap Overlook, on the North Rim of the Grand Canyon. The following four views are a sample of many they made for what was known as the Wheeler Survey. Tuweep is reached via a 60-mile gravel, dirt and rock road (25% of vehicles get at least one flat tire, warns the National Park Service) that leads nearly to the canyon's edge. There, a 3,000-foot drop to the Colorado River awaits. A primitive campground is located nearby.

The site shown above is another two miles to the northeast, reached on foot partly via the Tuckup Trail and then by going off-trail toward the rim. I awoke early at camp to start my search, finding the location within a few hours. This site and a few others in the vicinity were rephotographed for a 2012 art book[17], likely the first time that had been done here. But the authors didn't record their locations, so I had the joy of discovering them again on my own. Ignore the GPS coordinates I've provided if you'd like to do the same.

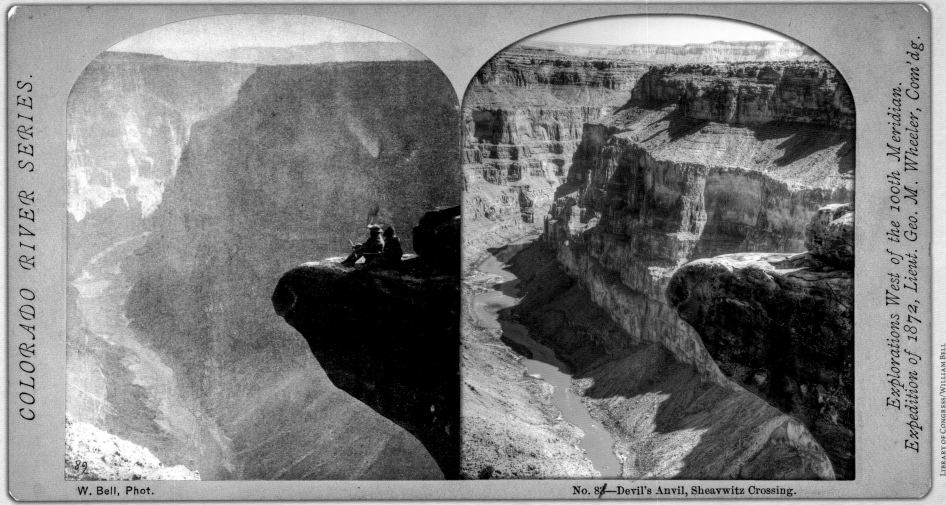

COLORADO RIVER SERIES.

82

W. Bell, Phot.

No. 83—Devil's Anvil, Sheavwitz Crossing.

Explorations West of the 100th Meridian.
Expedition of 1872, Lieut. Geo. M. Wheeler, Com'dg.

LIBRARY OF CONGRESS/WILLIAM BELL

3/17/16 • 36°13′46″ N 113°2′40″ W • DON'T EVEN THINK ABOUT IT.

1872 ~ Devil's Anvil at Sheavwitz Crossing

A few feet away and a camera turn to the right from the previous view, I contemplated this site looking up the canyon past a ledge the photographer called "Devil's Anvil." What can't quite be seen in the photos above is a large crack running vertically down through the Anvil. It gave me shivers to think of any extra weight out on the end, and although I examined this feature from various vantage points, I did not venture out to where the explorers had been seated. There's enough risk just getting to a place like this without additional extreme behavior.

I could make out yellow specks on the river below, which proved to be rafts passing by. At times I could hear the voices of people aboard, though not what they were saying. I don't think they could see me on the rim 3,000 feet above, at least not without binoculars. But I waved anyway.

The name "Sheavwitz Crossing" is no longer in use.

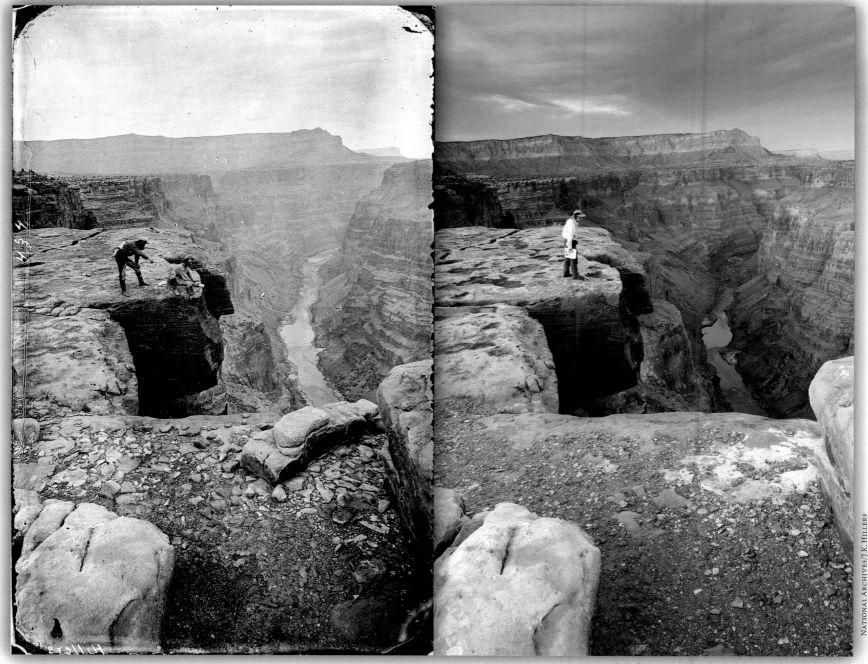

8/4/15 • 36°12′51″ N 113°3′24″ W • That's As Close As I'd Go.

National Archives/J.K. Hillers

1872 ~ Near Foot of Toroweap, Looking East at Grand Canyon

This view, awesome as it is, also gave me clues to the previous Tuweep photo sites: Some of the same background features were visible, which led me up the canyon in that direction as I explored the area.

I believe the missing rocks in the modern image were probably helped over the edge by other visitors over the years. Wherever you are, it's a really bad idea to throw rocks off cliffs; you never know who may be below, even in remote areas. Remember the rafters in the previous photo?

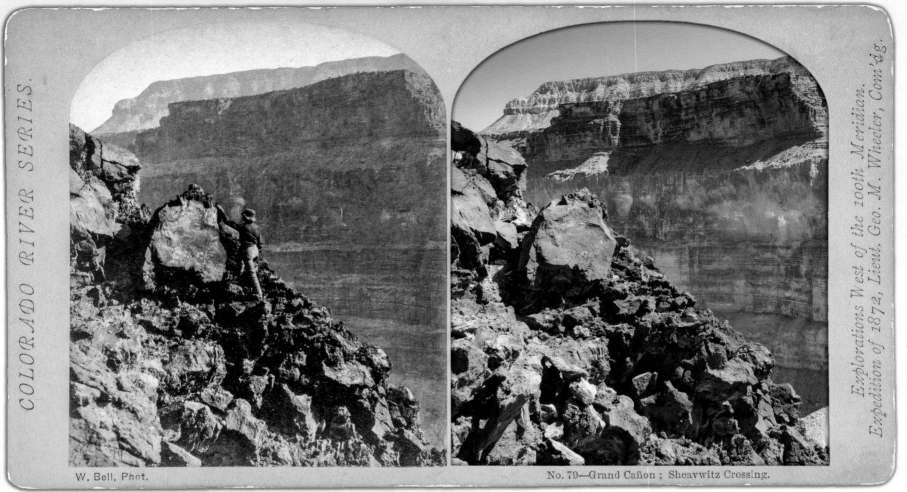

COLORADO RIVER SERIES.

W. Bell, Phot.

No. 79—Grand Cañon ; Sheavwitz Crossing.

Explorations West of the 100th Meridian.
Expedition of 1872, Lieut. Geo. M. Wheeler, Com'dg.

LIBRARY OF CONGRESS/WILLIAM BELL

3/18/16 • 36°12′30″ N 113° 4′57″ W • HAZARDOUS TRAIL, PEOPLE HAVE DIED HERE FROM HEAT EXHAUSTION.

1872 ~ Grand Canyon Above Lava Falls

The Lava Falls trail is reached via a spur road off the previously described 60-mile gravel/dirt/rock road to Tuweep. A sign at the trail head that looked new in 2016 talked of three recent deaths here, with some victims expiring just minutes before they could reach the top. But these were deaths from heat exposure, and I was carrying six quarts of water while hiking in March, when high temperatures were around 70. I had carefully reviewed maps and other hikers' trip reports back home, so I went down—cautiously.

Perhaps 100,000 years ago, a volcano spewed its contents down into the canyon at this point, so the "trail" is made of sharp lava rocks and cinders that can slice through clothing and flesh (I wore gloves). I hoped to reach the river to photograph Lava Falls, as the historic photographer had done, but was stymied by a drop-off just below this photo site. I could not find a route past it without a descent even steeper than the one pictured above. I was alone and it was already mid-afternoon, my turnaround time, so I decided it would be unwise to proceed. But I was pretty happy that I had reached the area, one of the more obscure I have located for this project. The reader can review additional sites I *did* find that day on my website, along with others that we didn't have room for in the book.

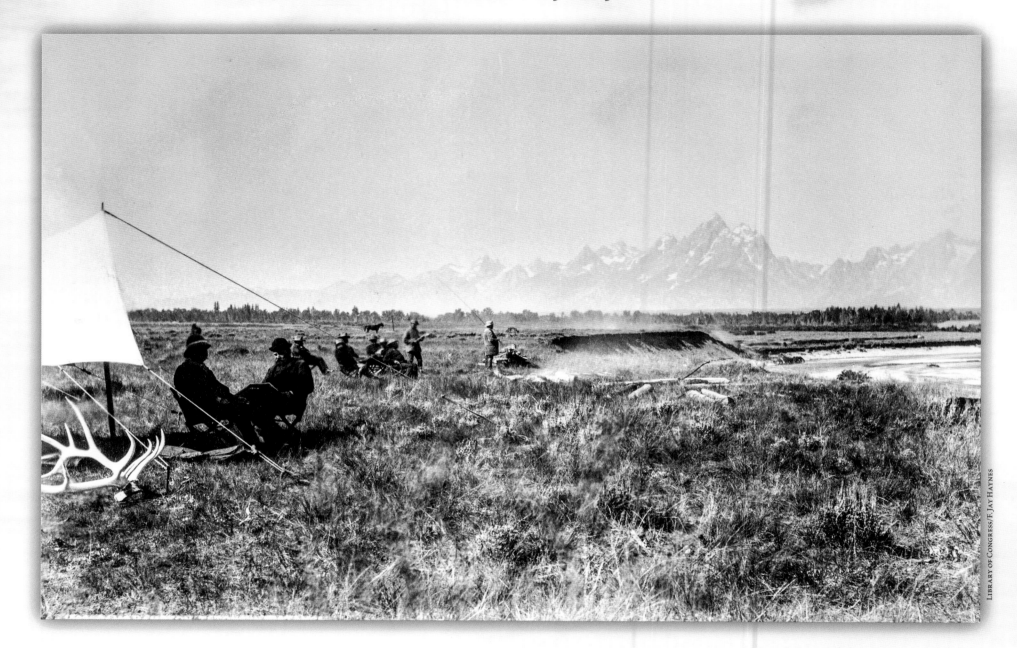

LIBRARY OF CONGRESS/F. JAY HAYNES

Aug. 20, 1883 ~ Camp Hampton, Tetons in the Distance

President Chester Arthur is identified by his features (more visible in other photos of this trip) as the man in the left chair in the foreground. He and a group of other dignitaries under military escort toured what is now Grand Teton National Park on horseback during a one-month, 400-mile trip that eventually took them north for the first presidential visit to Yellowstone (already a national park since 1872). The President reportedly spent much of his time fishing for trout; this "Camp Hampton" was conveniently located on the bank of the Snake River, and one man at center is holding a fishing pole.[18]

98

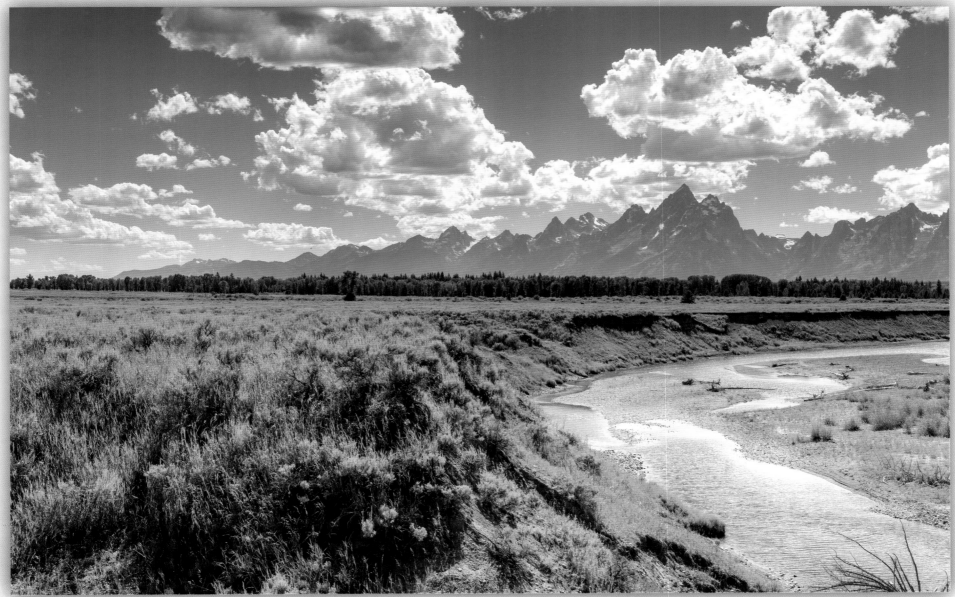

7/16/16 • 43°48'46" N 110°31'51" W

I am indebted to National Park Service Interpretive Ranger Doug Crispin for pointing me directly to this photo site on a map. It was the only time during the entire project where I had that kind of direct aid from anyone. I met Doug by chance when I stopped at a nearby visitor center, and I showed him what I was trying to do. He had already discovered this and several other photo sites from the 1883 journey by President Arthur, a fascinating addition to the annals of presidential history.

We both thought this was an especially interesting site, as it shows how the Snake River has cut a new channel well into what was the 1883 campsite. Satellite images reveal multiple former channels in the area, confirming the river's changes in course over time.

I came here twice over two days in 2014 to work on a matching photo. Although I was in sunshine, Grand Teton and the rest of the range were obscured by clouds the entire time. I finally gave up, but returned two years later to photograph this sunnier view.

The nearest access for this location is from the Elk Ranch Flats turnout, about 400 yards away.

99

C-20 Nature's Rockery - Jenny Lake and Tetons

Author Collection/Unknown Photographer

7/16/16 • 43°46'41" N 110°43'49" W

Circa 1935 ~ Nature's Rockery — Jenny Lake and Tetons

A few yards below the Jenny Lake Trail on the north shore of this crystalline lake, I found the foreground rocks of this postcard view with the Tetons high above.

The uncredited historic photographer was apparently crouched on a rock just above the water level, perhaps peering down into the top-mounted viewfinder of a typical 1930s postcard camera held low. I bent down into a bizarre pose to position my camera low enough, and peered through it while balanced on the same rock. I'm sure the people in the passing boat wondered what I was doing, but on the other hand there's a lot of odd behavior in national parks. In this case I was joining the crowd.

The slope in the middle distance (and a large area off-camera around me) burned in the 1999 Alder Fire, and is now growing back.

Menors Ferry - Grand Teton in the background - at the Snake River in Jackson Hole

AUTHOR COLLECTION/ HAROLD SANBORN

8/10/14 • 43°39'30" N 110°42'41" W

Circa 1940 ~ Menor's Ferry with Grand Teton IN the Background

Menor's Ferry provided a reliable crossing of the Snake River from 1894 until about 1927, when a bridge was built nearby. At the time of the historic photo the ferry was being operated as a re-creation of the past, as it still is today. Bill Menor's cabin and country store are also open for visitors on the opposite shore.[19]

The tiny spruce at left (historic photo) has today become a giant overlooking the scene.

U.S. GEOLOGICAL SURVEY/WILLIAM HENRY JACKSON

1872 – Teton Range AND Jackson Lake

Photographer William Henry Jackson's view captures a landscape cleared by a naturally caused fire, likely sparked by lightning.

This photo resides in the U.S. Geological Survey archive, which estimates its date as 1872. The com-manding view of the Teton Range is from a shoulder of Signal Mountain, where visitors can look across Jackson Lake (named for an 1820s trapper, not the photographer) to see Grand Teton at left and Mt. Moran at right.

7/16/16 • 43°50'44" N 110°34'35" W

I drove up the winding Signal Mountain Road to the first parking area and, like other tourists, walked a few yards down the trail to the Jackson Lake Overlook, about half a mile from the summit. I'd hiked around this area during earlier visits, and also visited the summit itself, where I found views of the western mountains almost completely blocked by trees.

I suspect Jackson's photo site is now hidden in deep forest to the right of this modern view, not far from the overlook, but it's hard to know without more clues in the foreground. This area will also gradually be obscured over time, although the National Park Service may prune trees to avoid that. It's also possible that, as in Jackson's time, fire may one day open the view again, and perhaps I'll take another look here.

THOMPSON PHOTO CO./JAMES E. THOMPSON

4/17/16 • 35°36'40" N 83°25'34" W

Sept. 2, 1940 ~ Dedication of Great Smoky Mountains National Park

James E. Thompson was a leading Knoxville photographer whose images were among those reviewed by Congress as it considered creating the Great Smoky Mountains National Park.

Here at Newfound Gap he documented the dedication of the park, which included a visit by President Franklin D. Roosevelt, speaking at the podium in this photo. I climbed a high hill through brush and brambles to reach a "window" in the trees where Thompson had set up his camera. It's a vantage point not many people visit today, but I could see why Thompson selected it for his truly historic view of the dedication ceremony.

4/21/16 • 35°40′5″ N 83°41′25″ W

McClung Historical Collection/Thompson Brothers

Circa 1930 ~ Indian Head Rock on Little River Road

There's no sign or marker at Indian Head Rock, but it's a well-known feature along Little River Road. The rock was in danger of falling onto the road due to erosion, so in 2008 engineers drilled holes in the formation, injecting resin glue in some and inserting rock anchors in others. Do I dare call that a facelift?

4/24/16 • 35°40′39″ N 83°35′36″ W

OPPOSITE: THOMPSON PHOTO CO./JAMES E. THOMPSON

Circa 1935 ~ Laurel Falls

A pleasant 1.25-mile hike from Little River Road brought me and my family to beautiful Laurel Falls. Despite an interpretive sign indicating that this area had been logged before it became a national park, I spied the same tree still growing at left.

THOMPSON PHOTO CO./JAMES E. THOMPSON

Circa 1935 ~ Approaching the Chimney Tops on the Indian Gap Trail

There were the foundations of an old bridge on the stream bank here, and I believe photographer James Thompson stood on that bridge for his view of Chimney Tops, one of the few instances of a bare-rock summit in the Smoky Mountains. I had to perch on a high boulder, tripod fully extended, to get the same elevation. Note matching boulders at left, center and right in both views.

4/23/16 • 35°38'15" N 83°29'35" W

Little did I know at the time of my visit in April of 2016 that Chimney Tops (the point more visible in the historic photo) would be the origin of a November arson fire that eventually spread across the mountains into the nearby town of Gatlinburg.[20]

I considered making a return trip to this area to see how it had changed, but learned that the picnic area just behind the tall trees had not burned in the fire and that the Chimney Tops Trail would be closed for restoration in 2017, the year of this book's publication. It's unlikely that the view here has changed much, but I look forward to finding out one day.

Thompson Photo Co./James E. Thompson

4/19/16 • 35°38'14" N 83°22'36" W

Circa 1930 ~ Charlie's Bunion

Getting to the Bunion may raise a few of your own. It's about eight miles round-trip from the nearest trail head at Newfound Gap parking area. I had two destinations in this area, and found both of them (this page and next).

A 1925 fire (which killed trees) and then a severe rainstorm (which washed the dead trees away, along with the blackened soil they had once stabilized) apparently cleared this area of much of its vegetation. The few plants in the 1930 view are the beginning of regeneration.[21]

This feature is named for a hiker named Charlie Connor, who suffered from the affliction for which he has now gone down in history.

The area continues to regain vegetative cover, but I noted that the boulder at upper right is quite a different shape now. From my time in the parks, where I've witnessed people picking up rocks and tossing them over an edge, I speculate that a similar form of vandalism has happened here. If true, those responsible have expedited the mountain's erosion; may they get a large bunion on their next hike.

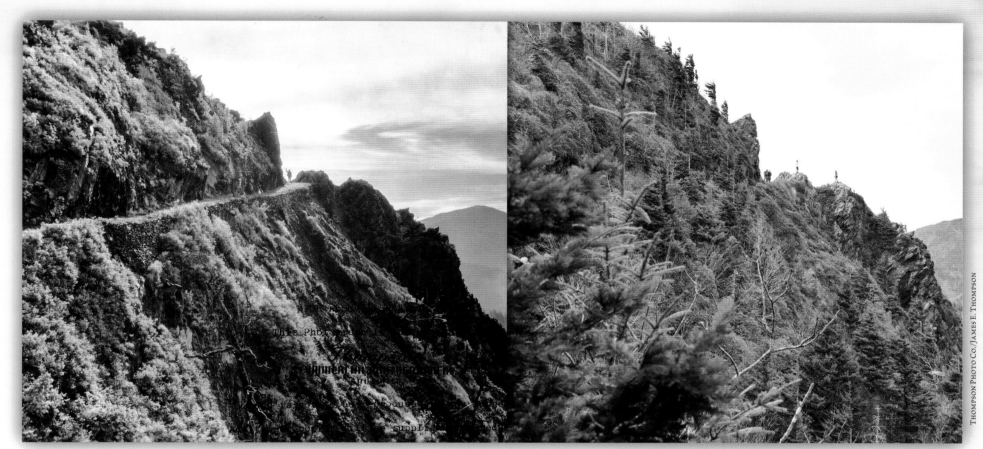

4/19/16 • 35°38'15" N 83°22'32" W

THOMPSON PHOTO CO./JAMES E. THOMPSON

Circa 1935 ~ Charlie's Bunion

Around the corner and a few hundred yards from the previous view, I found this one, though not without some trouble. I had come down the trail at left, part of a detour loop to Charlie's Bunion that connects to the nearby Appalachian Trail.

From the trail, however, I puzzled over how to proceed up a small rise that seemed to be the historic photo site. This hillside had fully regenerated from the previously mentioned 1925 fire (if indeed this specific area actually burned). It was densely packed with vegetation, with not even a deer trail in sight. In the end I literally crawled up the slope on hands and knees at the base of trees and bushes, and finally stumbled out to a semi-open view of the Bunion, where I could see other hikers posing for selfies. I took my shot also.

Back on the Appalachian Trail, I brushed off leaves and pinecones collected during my crawl and headed back to Newfound Gap.

The historic photo has some text on it that includes the photographer's credit and other information about Thompson Photo Company of Nashville, which is still in business today. This photo, and the historic images on several preceding pages, were kindly loaned to me by a descendant of the well-known Nashville photographer who took them, James E. Thompson.

4/21/16 • 35°33'25" N 83°29'46" W

AUTHOR COLLECTION/W.M. KLINE

1937 ~ Parking Place at Clingman's Dome, the "Skyway"

I enjoyed tracking down this site on a beautiful April day in Great Smoky Mountains National Park. The photographer had scrambled up on some rocks, the kind 10-year-old boys like to climb (but not when their mothers are around).

Park Service interpretive signs explain that this area had been logged before it became a park, and there may be some evidence of that at left in the historic photo. The forest is certainly growing well there today.

4/20/16 • 35°38'20" N 83°26'43" W

THOMPSON PHOTO CO./JAMES E. THOMPSON

Circa 1930 ~ Alum Cave on the Alum Cave Bluff Trail

My family and I enjoyed a beautiful hike to Alum Cave, in an area that was mined for various salts and minerals until the Civil War. The cave appears un-changed since the time of the 1930s photo, with the exception of the spruce tree at right; it has grown up to, and then around, the tip of the cave's ceiling.

CRATER OF HALEAKALA, "MAIN ISLAND" HAWAII.

Author Collection/Unknown Photographer

Circa 1925 ~ Crater of Haleakalá

The words "Main Island" on the historic postcard refer to what is now commonly called "the Big Island," Hawai'i, nearly lost in distant haze at the top of the photo. The foreground is part of Maui, from what today is called the Kalahaku Overlook, last stop before reaching the Haleakalá Visitor Center near the summit.

I learned that this is not technically a volcanic crater, as the historic postcard caption states. Long ago the area was covered by a mountain, which simply eroded away. Later eruptions, lava flows and cinder cones have partially refilled the eroded basin.

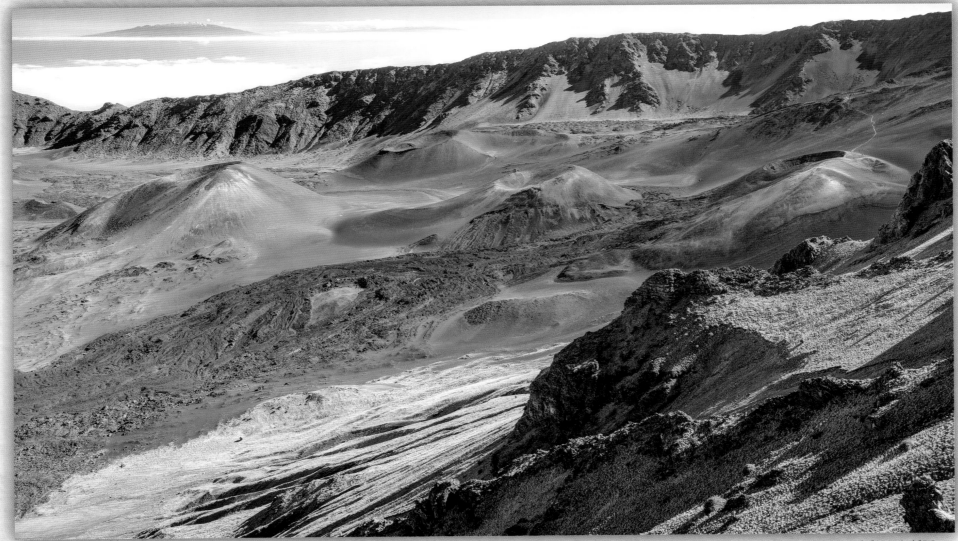

1/28/15 • 20°44'13" N 156°14'2" W

A stark but beautiful volcanic landscape is fully revealed in the modern photo. Also more clearly in view, at upper left, is the Big Island of Hawai'i about 80 miles away. My family and I flew there a few days after this photo was taken to visit Hawai'i Volcanoes National Park (pages 118-121).

An understanding of how this landscape has evolved is still, well, evolving. A sign at the Haleakalá visitor center says this volcanic island has erupted at least six times in the past 1,000 years, most recently 400-600 years ago. That estimate is on a label placed over the previous estimate, which has apparently been reconsidered in light of more recent research.

SUNRISE OVER HALEAKALA
MAUI, T. H.

Author Collection/Unknown Photographer

1/28/15 • 20°44'13" N 156°14'2" W

Circa 1930 ~ Sunrise Over Haleakalá

Helping people see the sun rise over Haleakalá has become a minor industry for local tour companies, who promote it on their websites. The parking areas near the summit were full well before dawn on this morning. The sun's different location on the horizon is evidence that I was there at another time of year than the original photographer.

If you prefer not to join the pre-dawn frenzy, try sunset. There's less traffic, and it'll be warmer. I wore every layer I had on this cold morning.

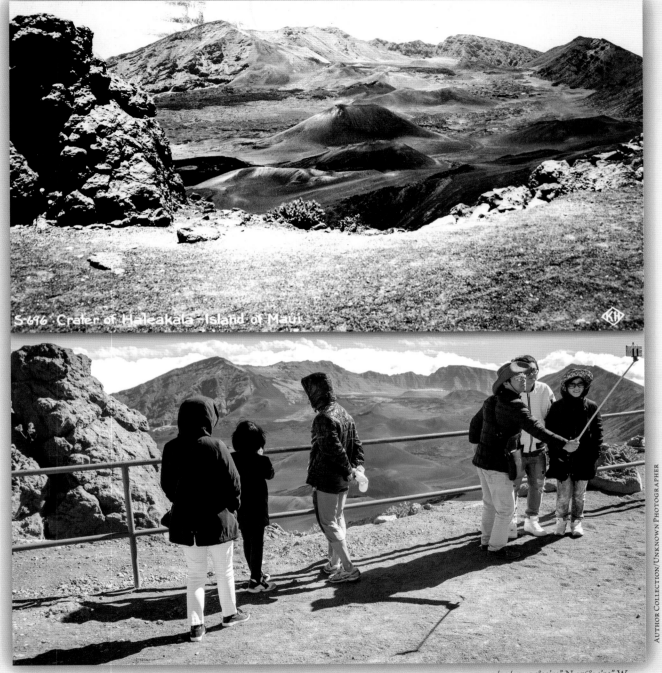

S-696 Crater of Haleakala - Island of Maui

1/30/15 • 20°42'53" N 156°14'59" W

Author Collection/Unknown Photographer

Circa 1945 ~ Crater at Haleakalá — Island of Maui

The site is a few yards south of the Haleakalá visitor center, where today a railing helps keep visitors away from the drop-off. The day I was here with my family, it was so windy that we could barely stand upright.

It's an amazing experience to stop here in the morning, wearing a winter coat, then drive 45 minutes (and about 10,000 feet lower) to lie on a warm, sunny beach.

EXPLOSION CLOUD, KILAUEA VOLCANO, HAWAII NATIONAL PARK 3:P.M. MAY 23, 1924

AUTHOR COLLECTION/TAI SING LOO

2/7/15 • 19°25'47" N 155°16'2" W

May 23, 1924 - Explosion Cloud, Kilauea Volcano AT 3 p.m.

Moving now from Maui over to the Island of Hawai'i (to Hawai'i Volcanoes National Park), the early view shows Halema'uma'u crater during one of its more than 50 eruptions over the course of one month in 1924. A U.S. Geological Survey report called it a "small" eruption, compared to those of 500 years ago or to those that may occur in the future.[22]

I found the site at nearby Steaming Bluff, where I shot time exposures after sunset to capture the glow of a pool of lava reflected off the vapor above it.

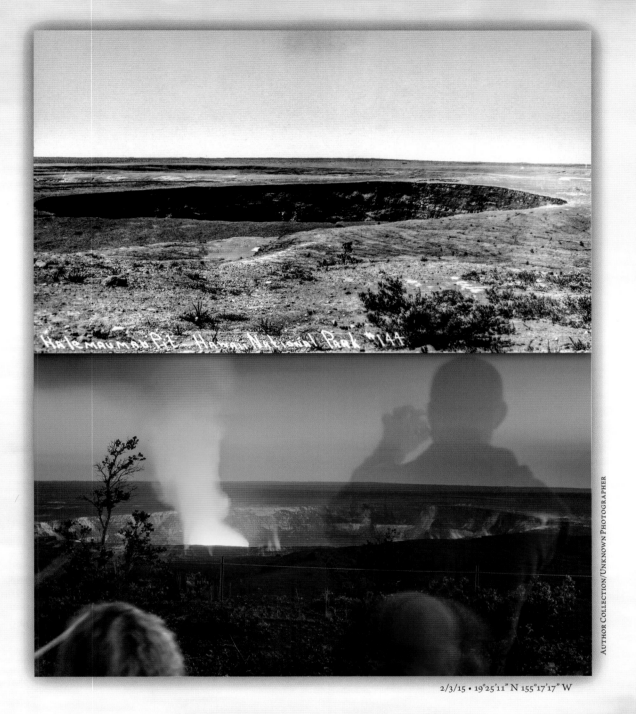

2/3/15 • 19°25'11" N 155°17'17" W

AUTHOR COLLECTION/UNKNOWN PHOTOGRAPHER

Circa 1935 ~ Halema'uma'u Pit

This view was taken from the Kilauea Visitor Center, where visitors are drawn—as I had been—by the glow of Halema'uma'u on the clouds of vapor above.

For reasons of safety, the National Park Service won't let visitors look over the crater rim, and the lava lake below is not visible from ground level. Seeing the reflection is a consolation, best viewed in the near-dark hours. I liked the way one of my fellow visitors stood up during my 30-second exposure and left a ghostly indicator of the crowds around me at this site.

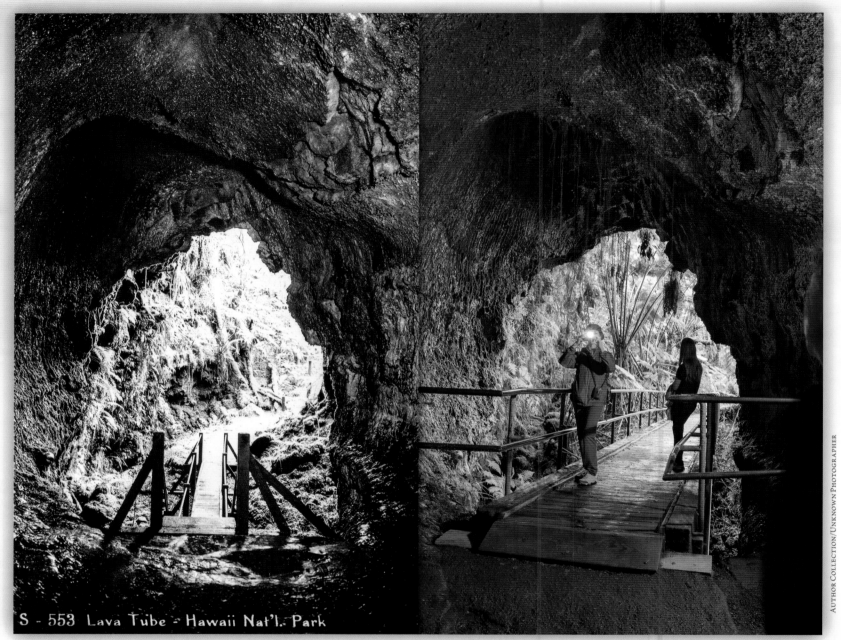

S - 553 Lava Tube - Hawaii Nat'l. Park

2/2/15 • 19°24'51" N 155°14'16" W

Author Collection/Unknown Photographer

Circa 1940 ~ Thurston Lava Tube

The Thurston Lava Tube was discovered in 1913 by a local newspaper publisher named Lorrin Thurston, and is now part of a hiking trail. The tube was formed several hundred years ago when magma passed beneath an already-hardened lava flow. I still don't fully grasp this phenomenon, but the fact remains that walking through a one-third-mile-long lava tube is pretty cool. It is lit artificially, but the lights are known to malfunction at times and a headlamp can still be handy.

The ceiling and entrance formations seem unchanged here, but the boardwalk has been upgraded.

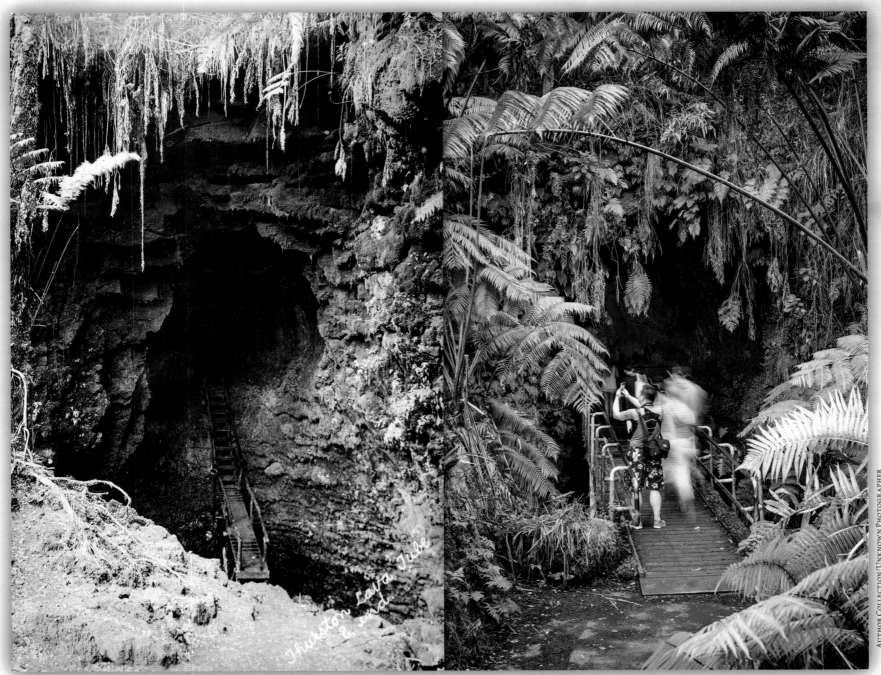

Thurston Lava Tube E. end

AUTHOR COLLECTION/UNKNOWN PHOTOGRAPHER

2/3/15 • 19°24'51" N 155°14'16" W

Circa 1920 ~ Thurston Lava Tube East End

Just yards from the previous site, but outside looking in, I found this reverse view revealing extensive changes in foliage. I carelessly referred to the growth around us as a jungle, but the super-knowledgeable and polite interpretive park ranger reminded me that we were actually in a tropical rain forest. It's definitely shrouding the entrance to Thurston Lava Tube in an interesting and beautiful way today.

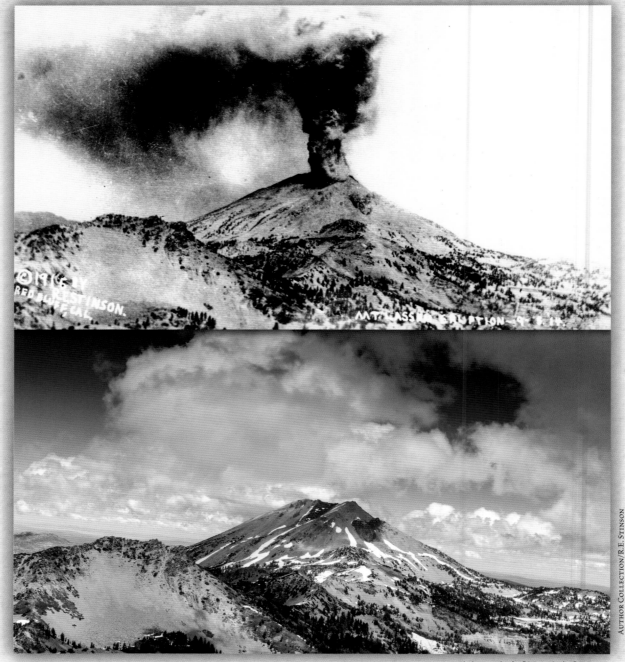

AUTHOR COLLECTION/R.E. STINSON

7/9/16 • 40°26'44" N 121°33'34" W

Sept. 5, 1914 ~ Mt. Lassen Eruption FROM Brokeoff Mountain

Lassen Volcanic National Park, located at the southern end of the Cascade Range in northern California, saw a series of eruptions from 1914 to 1917, including this early one. I had a nice 3.5-mile hike to the summit of Brokeoff Mountain to reach this site. The peak was hidden in clouds when I arrived, but high winds moved them rapidly across the sky, at times revealing my objective and letting me recapture the view.

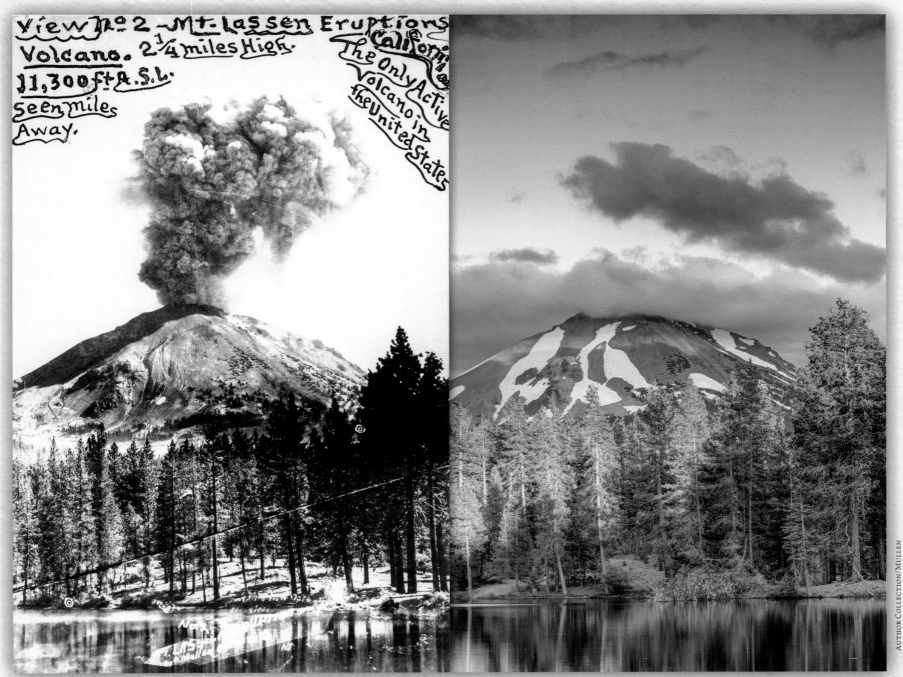

View No. 2 ~ Mt. Lassen Eruptions. California. The Only Active Volcano in the United States. Volcano. 2 1/4 miles High. 11,300 ft. A.S.L. Seen miles Away.

AUTHOR COLLECTION/MULLEN

7/8/16 • 40°32'17" N 121°34'2" W

Oct. 1915 ~ Mt. Lassen Eruptions Seen Miles Away

I love the elaborate hand-written description on this historic postcard. Additional information at the bottom is obscured but appears to say "Mullen Oct. 1915."

I got lucky at sunset in July when breaking clouds allowed a warm light to shine through on the trees and mountains at Reflection Lake.

Author Collection/Jervie H. Eastman

1939 ~ Mt. Lassen from Raker Peak
Showing Damage Done by 1915 Eruption

Mt. Lassen erupted explosively in 1915, spewing a column of volcanic ash that was visible more than 40 miles away. This photo was taken 24 years after the cataclysmic event, and the Devastated Area—as it became known—still looked quite rough.

A wall of muddy water and ash had swept down from the summit during the night of May 19 that year. A dog received credit for saving lives after barking to wake its owner, who in turn warned other residents downhill.

A second event a few days later caused additional damage on the mountain.[23]

7/8/16 • 40°31'23" N 121°28'16" W

I located this site on the south shoulder of Raker Peak after projecting its approximate location in Google Earth. This view was on the short list for my visit to Lassen because I'm interested in the way forests regenerate. That normally happens after a major fire, but in this case a large area of the hillside had been swept nearly clean by volcanic activity 101 years before my visit. It's impressive to see what nature has accomplished in that time, after what she did in only a few minutes in 1915.

The site is only about one-quarter mile from High-way 89, but requires a steep climb through an area of forest that burned in a nice mosaic pattern in 2012. I believe this site would have been blocked by trees if not for the recent fire. Standing snags of two of the many trees that once grew here are visible at left and right. Others have fallen over the steep hillside in front of the camera, out of view.

I really like Lassen Volcanic National Park. It's less crowded than other parks and just as beautiful and unique in its own way.

"Hot Rock" Brought Down in 1915 Mud Flow.
Lassen Vol. Nat. Park.
Loomis 52.

AUTHOR COLLECTION/B.F. LOOMIS

Circa 1925 ~ "Hot Rock" Brought Down in 1915 Mud Flow

This site is about 1.5 miles north of and below the one on the previous page. Many "hot rocks" were transported by mud and debris from their origins near the summit of Mt. Lassen to locations far away. The rocks were still hot to the touch several days after the 1915 eruption, thus the name carried on this postcard.

7/10/16 • 40°32'6" N 121°29'27" W

There was no way to gauge the size of the rock on the postcard, so that was a puzzle until I arrived at the highway pullout here. The boulder is surprisingly large considering it was carried to this point on a mud flow. It's now a popular climbing site for kids who have been riding for hours in a car on family vacation. I smiled to myself as I observed some visitors reading the "hot rock" sign and then carefully, tentatively, reaching out to touch the surface to check its temperature. It has definitely cooled off in 101 years.

I was also interested in the tiny pine trees behind the boulders at right in the historic image, and their grown-up look today.

To get the correct angle, I had to stand in the highway without the aid of a tripod. I marked the location with a piece of tape on the road so I could return to it quickly, watching for traffic as I shot the scene.

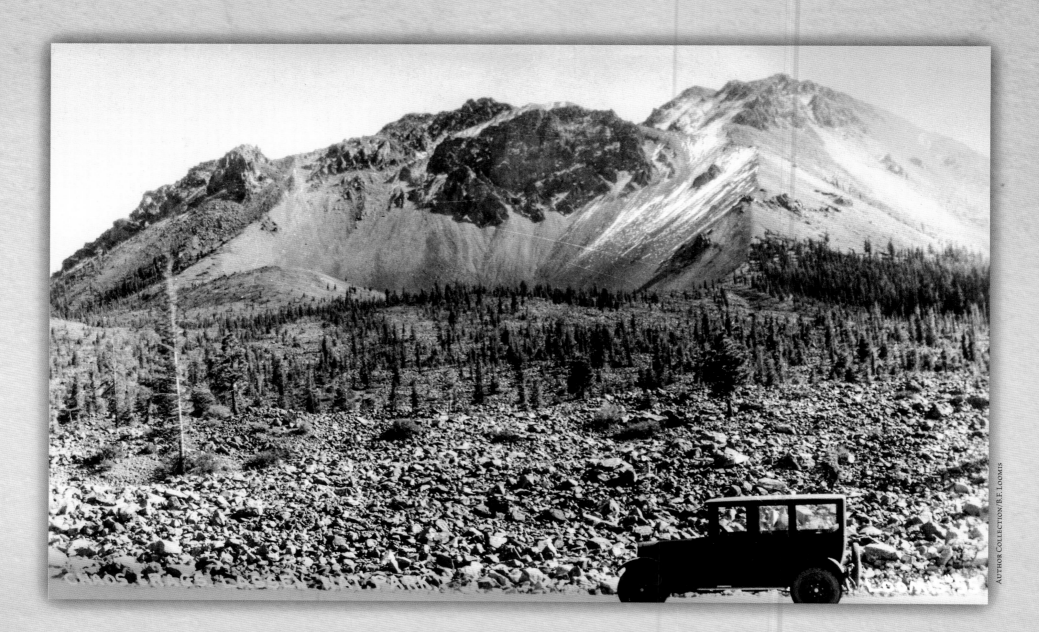

AUTHOR COLLECTION/B.F. LOOMIS

Circa 1925 ~ Chaos Crags, Lassen Volcanic National Park

Rather than looking back a mere century, as at the Devastated Area (pages 124-125), here we see the results of Lassen's previous known eruption, about 1,100 years ago. This one caused an avalanche on the northwest side of the mountain that was greater than the flow of ash and debris at the Devastated Area.[24]

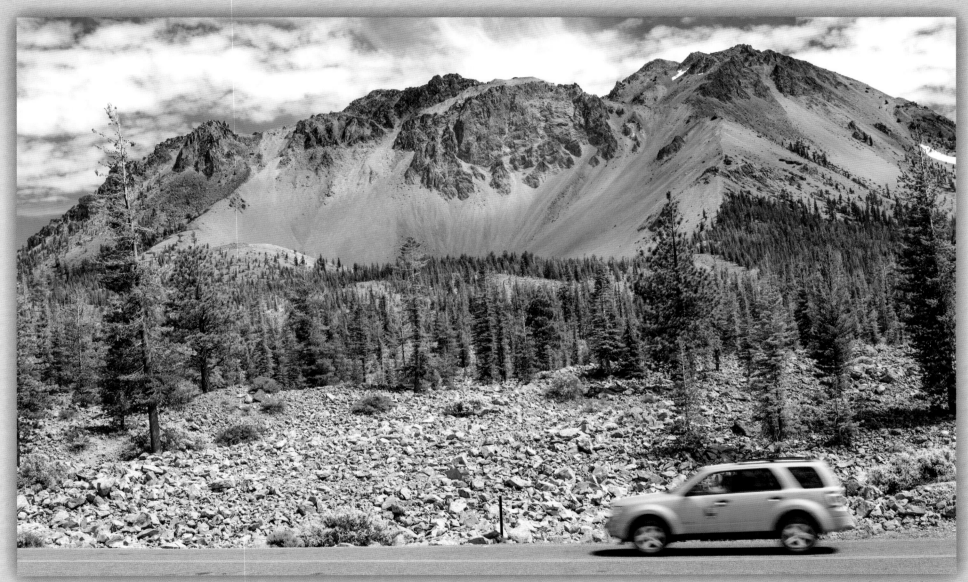

7/9/16 • 40°32'30" N 121°32'36" W

I found this site at what is now an established overlook, about a mile northeast of the Loomis Museum. Signs along a nearby paved interpretive loop trail describe how this area was formed.

Several pines and shrubs that had found a place to grow by 1925 remain in place today. This area is known as the Dwarf Forest due to its stunted appearance in the rocky landscape.

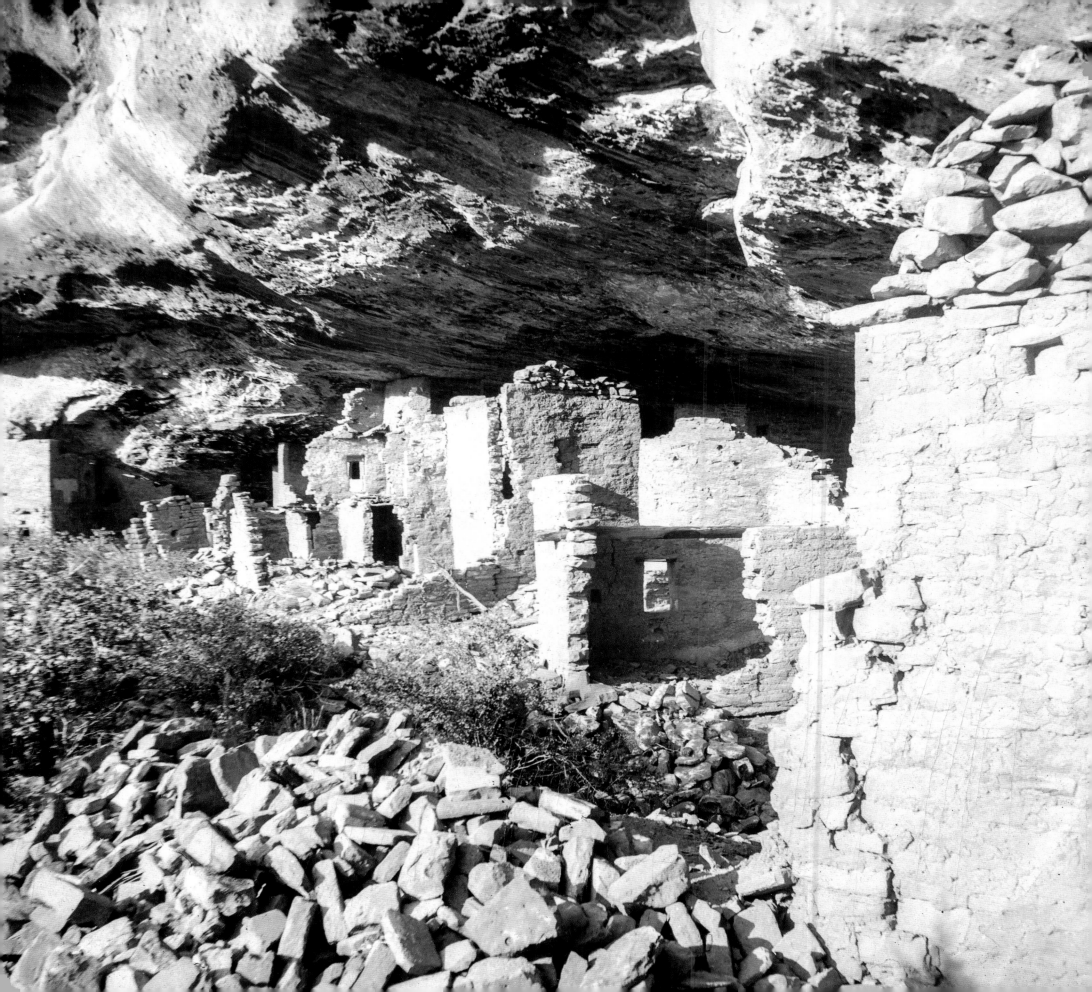

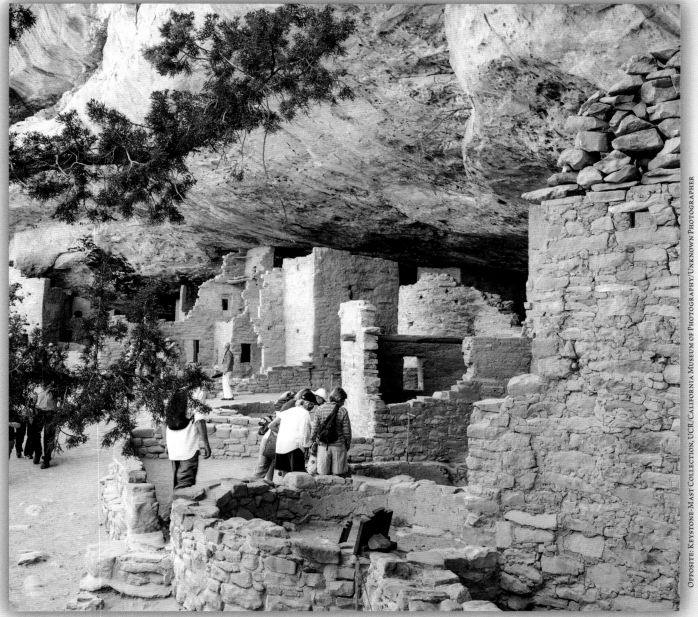

Opposite: Keystone-Mast Collection, UCR/California Museum of Photography/Unknown Photographer

6/22/13 • 37°11'1" N 108°29'15" W

Circa 1900 ~ Spruce Tree House, Cliff Dwellers of the Mesa Verde

The photo at left may predate the establishment of Mesa Verde National Park (in 1906) by a few years. It may provide an idea of the way the ruins looked when they were discovered by cowboys in 1888.

National Park Service interpretive materials and statements by rangers on the day of my visit indicate that in the 1930s Civilian Conservation Corps workers stabilized some of the structures while they were also building park roads and trails. The comparison view gives us an idea of how much rebuilding the CCC did, but also shows what was original at the time these buildings were inhabited about 700 years ago.

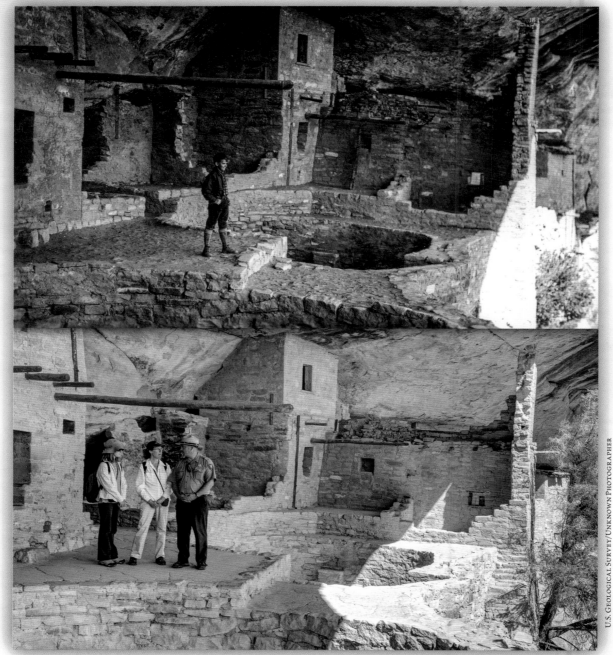

U.S. GEOLOGICAL SURVEY/UNKNOWN PHOTOGRAPHER

6/22/13 • 37° 9′46″ N 108°27′53″ W

1931 ~ Kiva in Balcony House

My family and I signed up for the Balcony House tour, climbing 20 feet up a steep ladder to reach these pre-historic structures. Mesa Verde had been a national park for 25 years by the time of the historic photo, and it's likely some restoration had been done by then.

We made a brief stop here on the tour, and while my wife and daughter chatted with the park ranger I quickly sized up the angle and did my best to obtain a matching view.

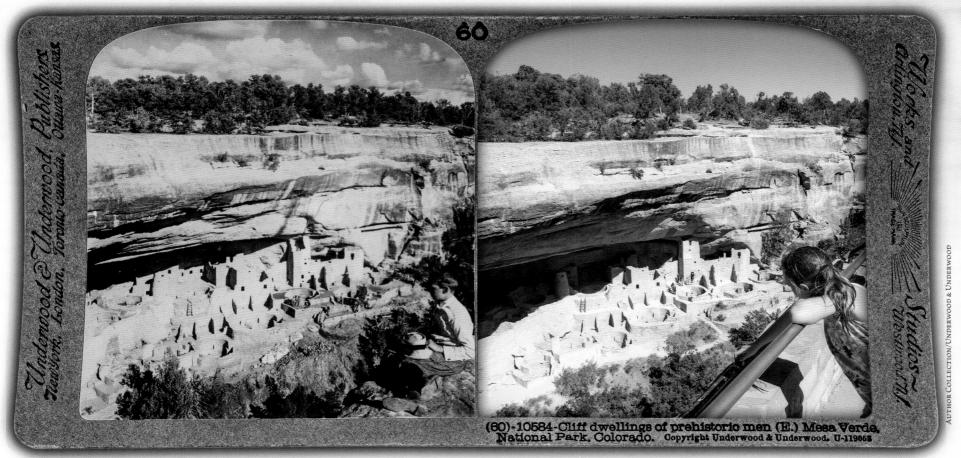

(60)-10584-Cliff dwellings of prehistoric men (E.) Mesa Verde, National Park, Colorado. Copyright Underwood & Underwood. U-119058

AUTHOR COLLECTION/UNDERWOOD & UNDERWOOD

6/22/13 • 37°10'1" N 108°28'25" W

Circa 1904 ~ Cliff Dwellings of Prehistoric Men

I found this photo site at today's Cliff Palace Overlook, where a natural rock outcropping is now covered by a paved surface surrounded by a railing.

A tour of the ruins was in progress as I worked at this location. In the old photo several cowboys and other people are in view just below where the modern tour group was standing.

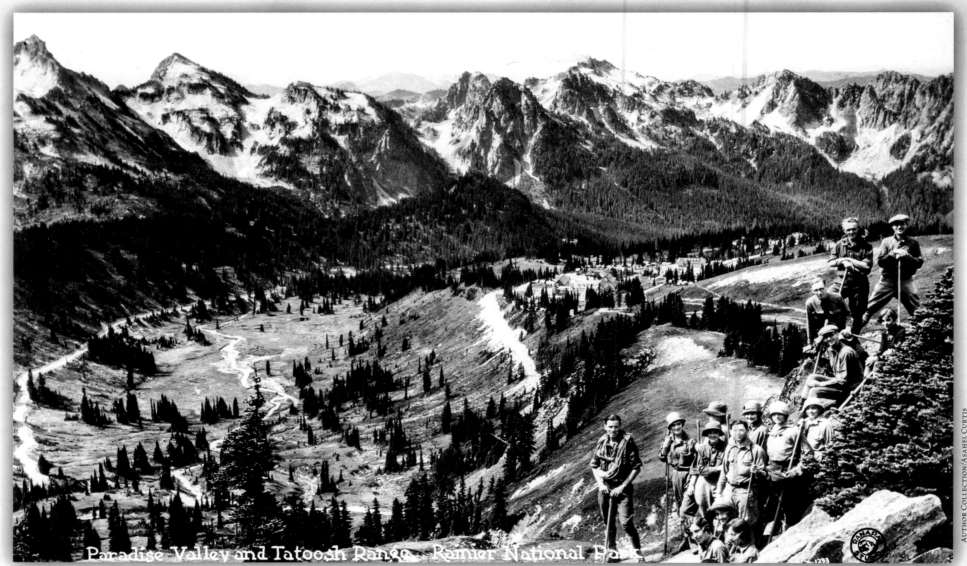

Paradise Valley and Tatoosh Range. Rainier National Park

AUTHOR COLLECTION/ASAHEL CURTIS

Circa 1940 ~ Paradise Valley and Tatoosh Range

I had my doubts about finding this site on Mt. Rainier for some reason, but my standard technique of looking for the background and then triangulating to the foreground was successful. It pointed me to the Golden Gate Trail, where I arrived near the end of the day after a hike around most of the Skyline Trail.

As with many historic images, there is unfortunately no identification for the people seen here. The man at left is the only one carrying a rope and ice axe (the others carry hiking poles), so I speculate that he's a guide leading a group of tourists on a Mt. Rainier hike.

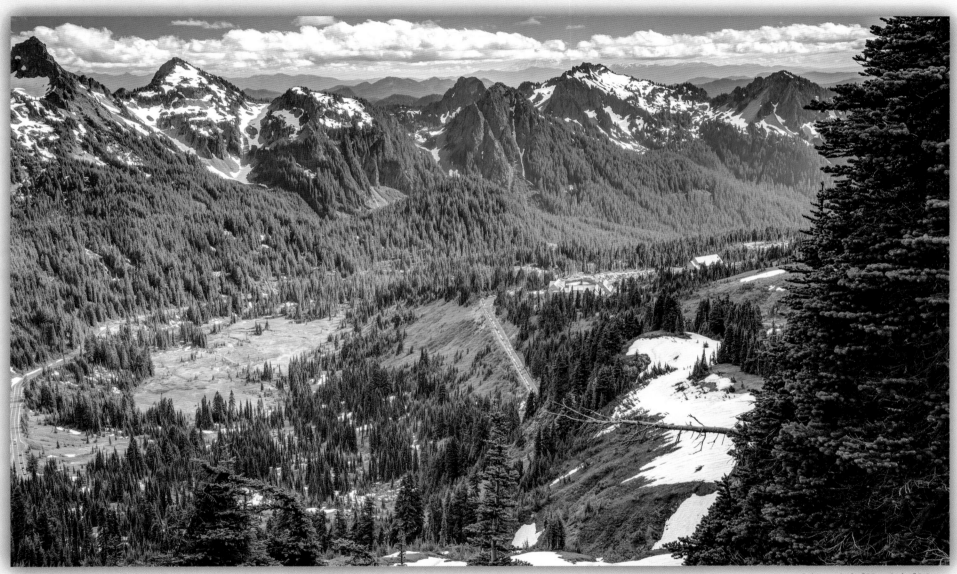

7/3/16 • 46°47′55″ N 121°43′26″ W

There was still plenty of snow on the trails on July 3, and I shot my photo from the top of a snowbank, which may have been the same technique used by the original photographer.

The tree at right has grown to cover the foreground rocks seen in the historic photo, and tree cover in the background has generally increased as well.

Curiously, the historic photo shows snow in places where mine does not, and vice versa.

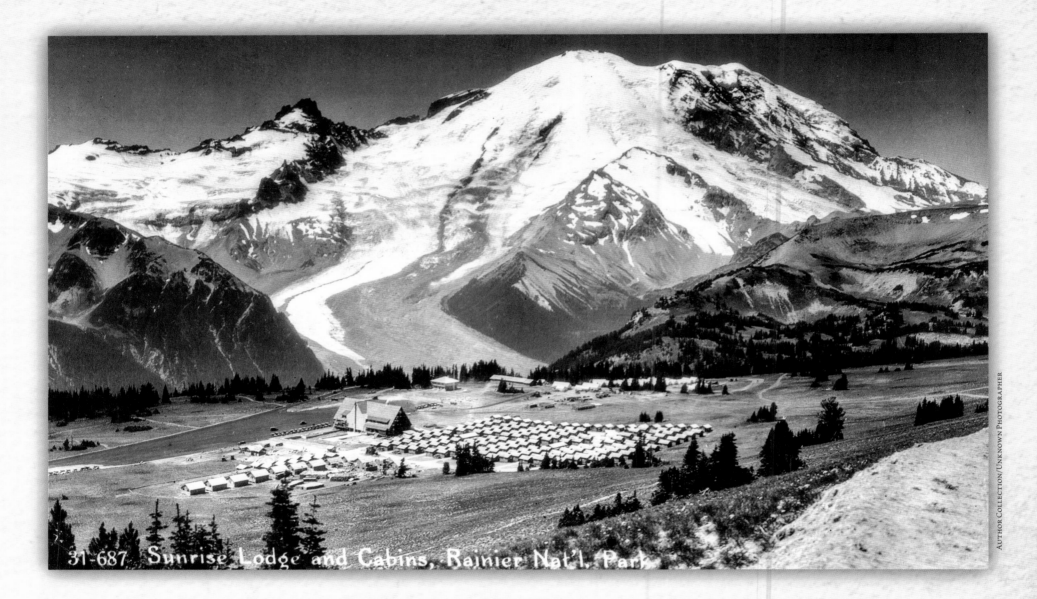

31-687 Sunrise Lodge and Cabins, Rainier Nat'l. Park

AUTHOR COLLECTION/UNKNOWN PHOTOGRAPHER

1931 ~ Sunrise Lodge and Cabins

Development started in 1929 on the meadows known as Yakima Park around the newly minted Sunrise area, where 215 housekeeping cabins and a rustic day lodge had been built by 1931. The goal was to relieve some of the visitation pressure already occurring at the popular Paradise area (see page 139), on the opposite side of Mt. Rainier but 50 miles away by car.

Several of the structures are still being completed in the image above, which helped in dating the photo to about that time.

The cabins didn't hold up well in this harsh environment, and apparently weren't very successful given the short summer tourist season. They were removed in 1944 and used for war housing elsewhere. Earlier plans for a hotel here never materialized, and today this area is reserved for day-use only.[25]

136

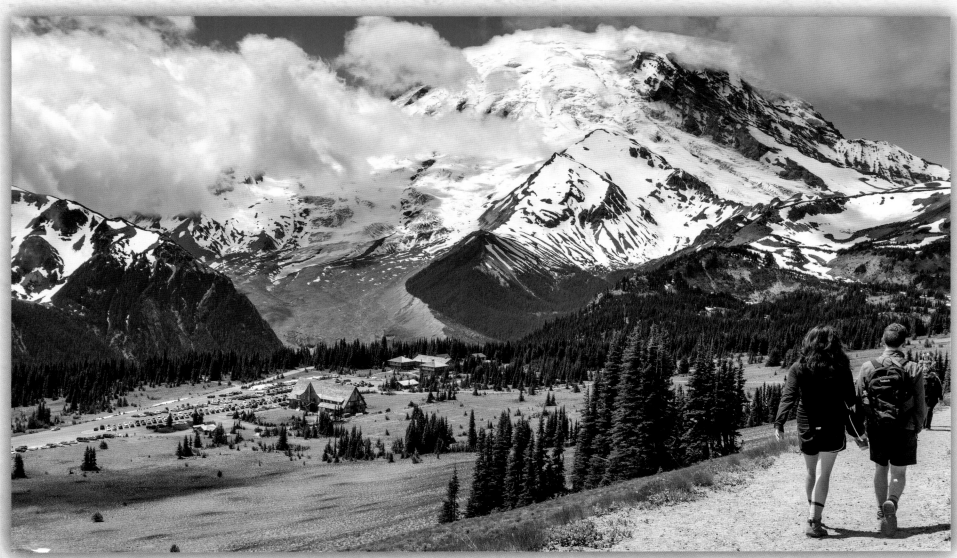

7/4/16 • 46°55'7" N 121°38'14" W

From this angle I could still see the foundations of some of the housekeeping cabins, though not well. Other 1930s buildings remain, as do trails built by the Civilian Conservation Corps. (What would we have done without the CCC in our national parks?) The hikers at right are on the Sourdough Ridge Access Trail below the junction with the main Sourdough Ridge Trail.

Vestiges of the once-massive Emmons Glacier can also be seen here; note the difference in size compared to the other photo taken 85 years earlier.

I visited this park three times. Despite promising weather forecasts, the mountain was socked in by clouds more often than not, which is not unusual for Rainier. I was fortunate to get a partial view on this beautiful day.

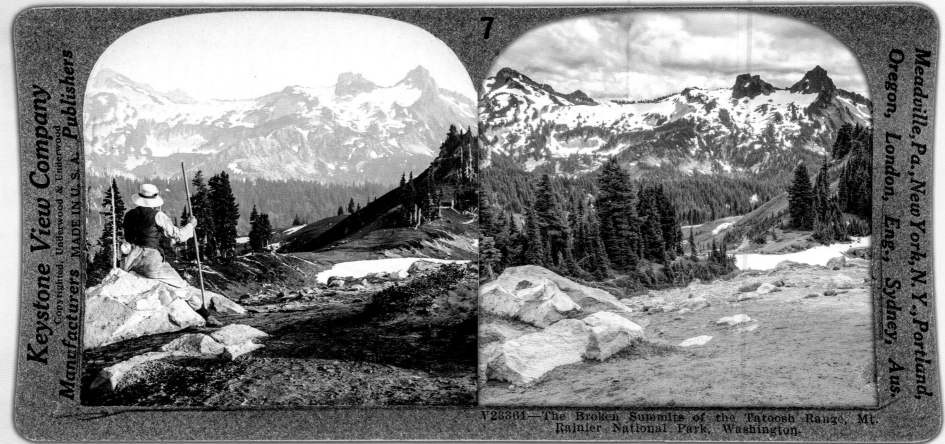

Keystone View Company
Manufacturers MADE IN U.S.A. Publishers
Copyrighted Underwood & Underwood

Meadville, Pa., New York, N.Y., Portland,
Oregon, London, Eng., Sydney, Aus.

AUTHOR COLLECTION/KEYSTONE VIEW CO./UNKNOWN PHOTOGRAPHER

V23361—The Broken Summits of the Tatoosh Range, Mt. Rainier National Park, Washington.

7/3/16 • 46°47′46″ N 121°44′12″ W

Circa 1905 ~ The Broken Summits of the Tatoosh Range

I found the site of this stereoview along a segment of the Deadhorse Creek Trail less than a mile from the Paradise area trail head.

A century of visitation is evident in the foreground, where thousands of walkers have worn away several inches of soft dirt around the first boulder. Part of the larger boulder behind it is missing, for an unknown reason.

The nearby Skyline Trail is visible in the middle distance, today overshadowed by taller trees than in the historic photo.

I should add that this site is technically off-trail in an area that may be closed during summer months.

At Rainier you can hike almost anywhere as long as snow still covers (and protects) the ground and plants beneath. On the very day I shot this image, July 3, as the previous winter's snow continued to melt, National Park Service staff were busy installing poles and rope barriers to keep people on the official trails, to protect fragile emerging plant life on the alpine meadows. I was politely shooed away from this area as the crews came by. There wasn't much growing in the foreground here, but that could change in time if it is protected. The wildflowers that carpet lower-traffic areas of the higher meadows are almost unbelievable.

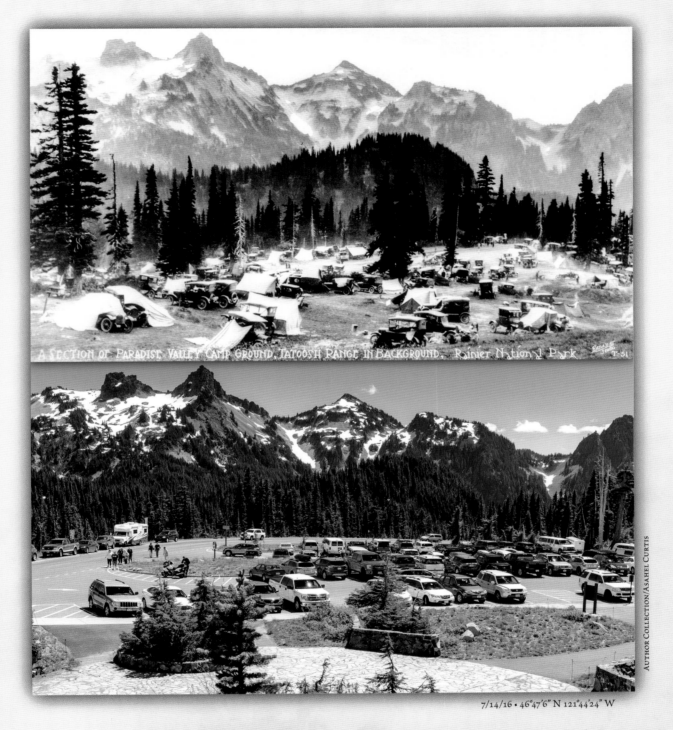

A Section of Paradise Valley Camp Ground. Tatoosh Range in Background. Rainier National Park. T-51

7/14/16 • 46°47'6" N 121°44'24" W

Author Collection/Asahel Curtis

Circa 1925 ~ A Section of Paradise Valley Campground

A National Park Service report called "Paradise Camp" detailed the development of "Rooms & Tents" in this area of the park. The tents of 1925 gave way in turn to rooms, a lodge, and then the Jackson Visitor Center in 1966.[26] That building, which stood directly in front of this view, was demolished in 2008—the year of the report—when a new visitor center opened 300 yards to the east.

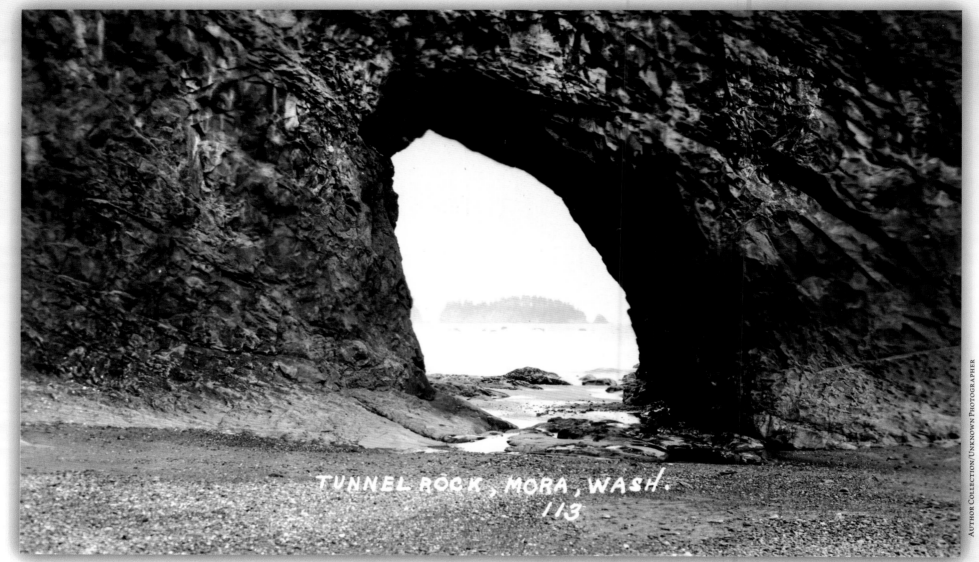

TUNNEL ROCK, MORA, WASH.
113

Author Collection/Unknown Photographer

Opposite: 3/8/15 • 47°56′31″ N 124°39′4″ W

Circa 1930 ~ Tunnel Rock

My family and I located this site 1.5 miles north of picnic grounds and a parking area at Rialto Beach in Olympic National Park. I had identified its probable location in Google Earth, and we followed my GPS to this location.

Labeled Hole-in-the-Wall on today's maps, the formation frames a view of islands and formations called sea stacks that were separated from the mainland by ocean erosion.

On this day in March we had miles of beach nearly to ourselves, even if the trade-off was weather that was a bit windy and cloudy. As in the historic view, the tide was low, so we could pass through the tunnel, which is flooded at higher tides.

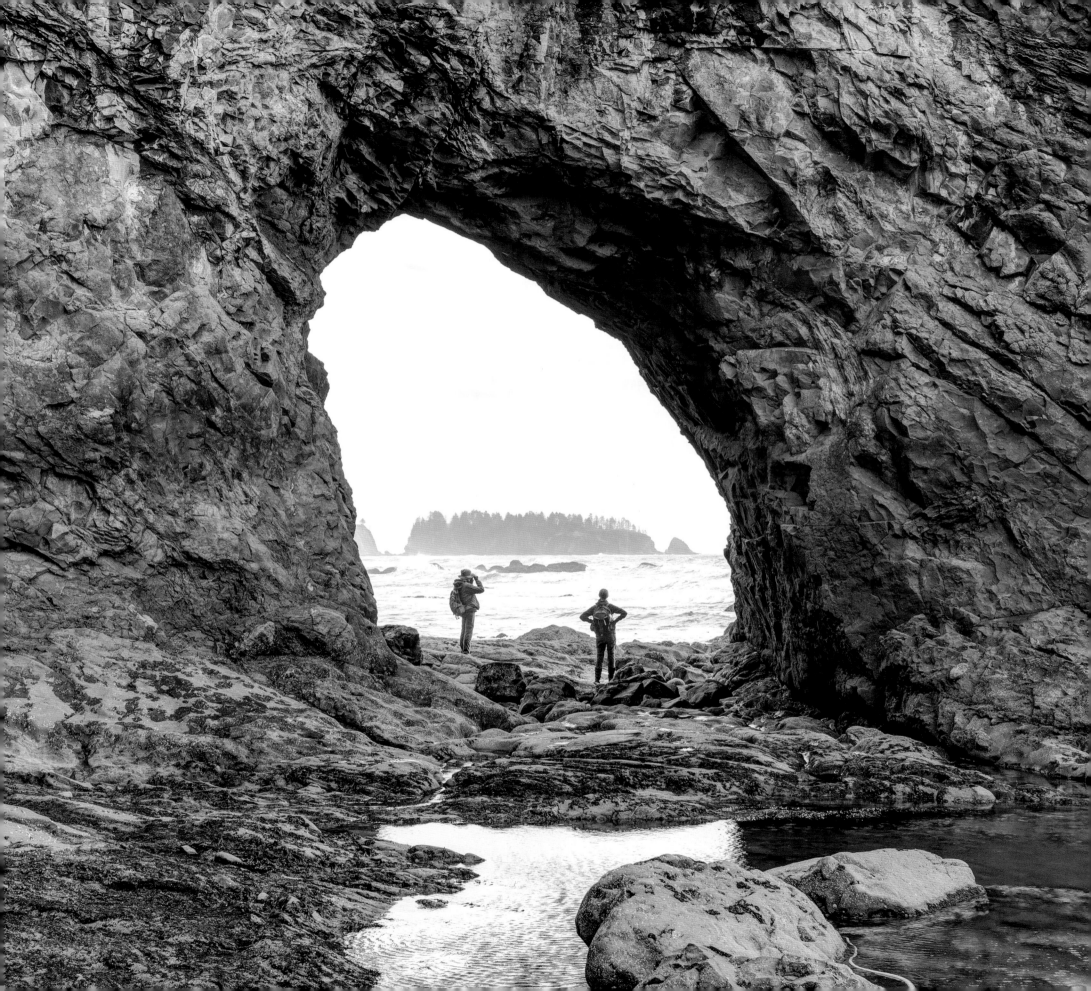

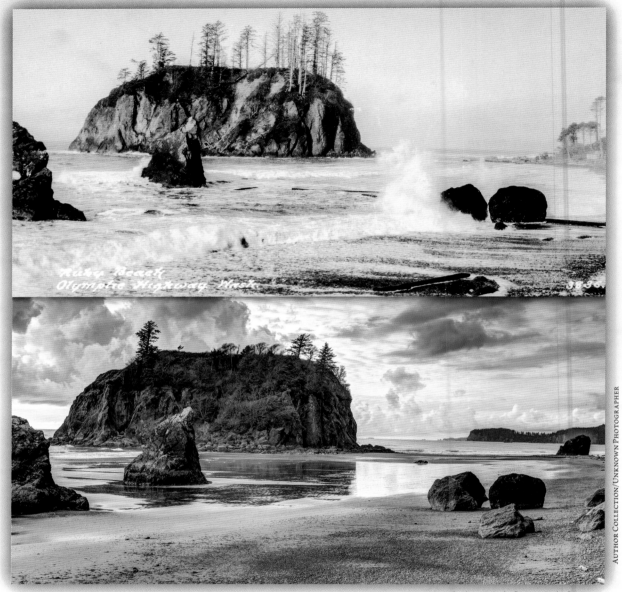

AUTHOR COLLECTION/UNKNOWN PHOTOGRAPHER

3/17/15 • 47°42'46" N 124°24'60" W

Circa 1930 ~ Ruby Beach, Olympic Highway

I found this site easily enough once I arrived at Ruby Beach, but could not confirm what had happened to the spit of land at far right in the historic image. It had disappeared, revealing the sea stack beyond. I can't explain it except as the work of waves and ocean storms on exposed land, although other features have not been affected to the same extent.

The distant shoreline seen clearly in the new photo is also present in the historic image, but barely visible in the haze.

Another unknown is what apparently killed all the trees on Abbey Island sometime before the 1930s. Other trees are now growing in their place.

I do my best to research and explain what I find at each historic photo site, but here, mysteries remain.

TWIN ARROWHEAD ROCK, MORA, WASH.

Author Collection/Unknown Photographer

3/18/15 • 47°56'25" N 124°38'56" W

Circa 1925 ~ Twin Arrowhead Rock

I encountered these impressive sea stacks while hiking to Tunnel Rock (page 140), and recognized them from the historic image I was carrying with me.

I could find no reference to "Twin Arrowhead" as a place name here today. The National Park Service map labels the formation Split Rock.

Whatever the sea stacks are called today, I was surprised by their size. For a sense of scale, note my wife and daughter at lower left.

Far in the distance at left are more islands and sea stacks along this beautiful Olympic coastline.

HURRICANE RIDGE HIGHWAY · WASH. ELLS 85

Author Collection/J. Boyd Ellis

7/6/16 • 47°58'10" N 123°30'48" W

Circa 1940 ~ Hurricane Ridge Highway

Due to the fire suppression policies of earlier times, there are locations in almost every park I visited where more trees appear today than in early photos. In this case they're hiding the location where the historic car is parked above several switchbacks, now part of a hiking trail that I carefully followed to confirm this site.

The former "highway" is below the Elwha River Trail, about half a mile down from Hurricane Ridge Road.

I looked for the sites of other historic photos taken on Hurricane Ridge, but large areas are now closed to foot traffic to protect natural resources, so I couldn't access those sites.

SUNRISE AT LENOIR'S ON LAKE CRESCENT. WASH.

Ellis 3480

AUTHOR COLLECTION/J. BOYD ELLIS

3/21/15 • 48° 4'6" N 123°54'57" W

Circa 1940 ~ Sunrise at Lenoir's on Lake Crescent

One place there were *fewer* trees as well as complete access was here on the western shore of Lake Crescent, near what is now called Fairholme. There were some large trees right behind me, but the shoreline was clear.

I couldn't have planned a better morning to match the foggy and cloudy view captured by the postcard photographer named Ellis. This weather is probably more typical than sunshine in the region. Few visitors were in the park, where it was calm, quiet and beautiful on this March morning.

"OLD FAITHFUL LOG" MUSEUM AND
THIRD FOREST IN THE DISTANCE
PETRIFIED FOREST NAT'L MONUMENT,
ARIZONA

AUTHOR COLLECTION/BURTON FRASHER SR.

2/27/15 • 34°48'56" N 109°52'2" W

1934 ~ Old Faithful Log & Museum, Petrified Forest

The large petrified log at right, among the largest in the park, is known as Old Faithful. It is 10 feet wide at the base and 35 feet long. After it was damaged by lightning in 1962, park staff reconstructed it, using concrete to hold pieces together.[27]

Mom is taking a photo of Dad in front of the famous log; we were driving from their South Dakota home to warmer places in Arizona, and stopped for a visit here on the way.

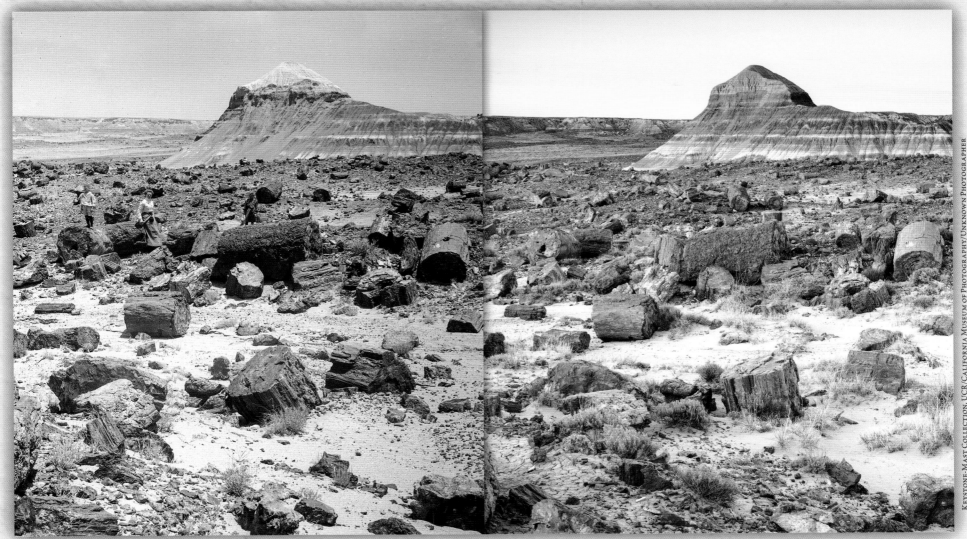

Keystone-Mast Collection, UCR/California Museum of Photography/Unknown Photographer

4/11/15 • 34°53'19" N 109°48'49" W

1903 ~ A Long-Buried Chapter in the Tale of the Ages

I parked at the Jasper Forest Overlook and followed a path down into the badlands-like area below. There I saw evidence of old roads, which I followed at times, while elsewhere I picked my way across the landscape. While wandering among the buttes I passed what seemed like thousands of petrified logs, each one a little different. At last I spied what appeared to be the same background as in the historic photo, and gradually found my way to the foreground as well.

Many of these logs have shifted or rolled from their positions in the 1903 photo, as they have probably done many times since they were exposed by erosion after being buried 225 million years ago.

The process of erosion is seen directly on the butte at the top, which has lost perhaps a foot or more of soil. Park staff have confirmed this phenomenon elsewhere with their own rephotography project in the Petrified Forest.

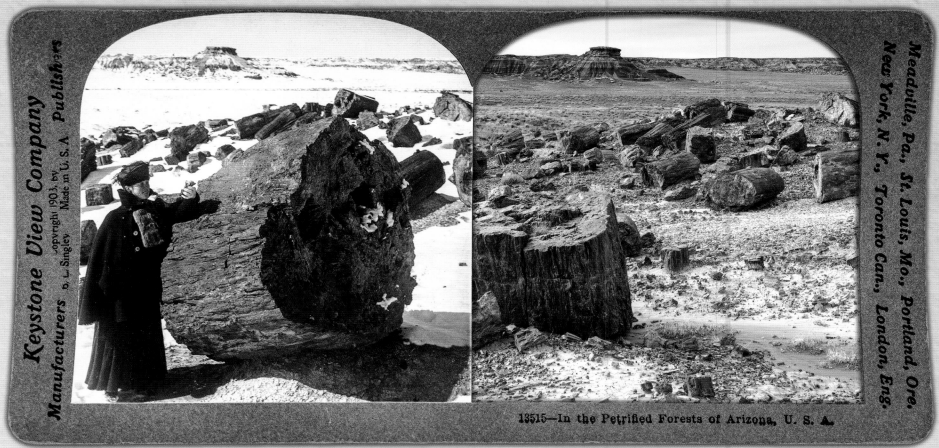

13515—In the Petrified Forests of Arizona, U. S. A.

12/15/14 • 34°53'10" N 109°48'59" W

1903 ~ In the Petrified Forest of Arizona

This happy tourist appears at another site on the next page, and in a photo I've seen from the Grand Canyon, so she must have been on quite a tour. The massive log she's leaning against has now toppled backward, accounting for the apparent difference in its size, while others behind it have shifted only slightly or haven't moved at all.

I found this site in the Jasper Forest area, perhaps a mile out from the overlook. An old road, not in use today, is seen as a background line in the historic image.

I was all alone on this plain in December, walking along and thinking of the horses and wagons that brought tourists like this one back in the olden days.

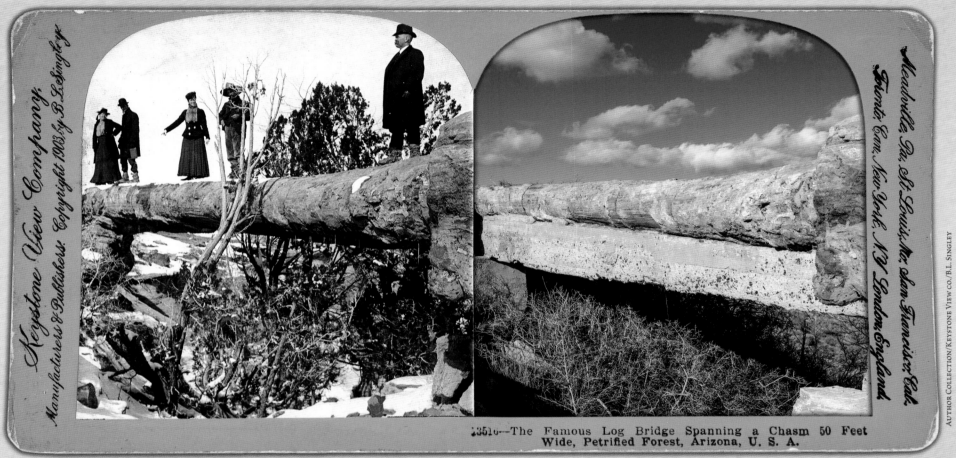

Keystone View Company,
Manufacturers & Publishers. Copyright 1903. by B. L. Singley.

Meadville, Pa., St. Louis, Mo., San Francisco, Cal.
Toronto, Can., New York, N.Y. London, England

AUTHOR COLLECTION/KEYSTONE VIEW CO./B.L. SINGLEY

13516—The Famous Log Bridge Spanning a Chasm 50 Feet Wide, Petrified Forest, Arizona, U. S. A.

12/14/14 • 34°53'33" N 109°47'38" W

1903 ~ The Famous Log Bridge Spanning a Chasm 50 Feet Wide

Historic photos of this natural bridge, created when a gully formed beneath a 110-foot petrified tree, show a sequence of changes over time: the unsupported span (as at left), then a period where it was artificially supported by two pillars of stone (I estimate around 1910), and finally the concrete support beneath, apparently installed in the 1930s and still in place. I don't think the National Park Service would have done this type of thing today, when natural processes such as erosion are usually undisturbed regardless of how big a tourist attraction the feature might be. Now the concrete support is itself historic, and will likely remain until it too erodes away some day.

The "Log Bridge" is called Agate Bridge on National Park Service maps today. It's near a parking area along the main park road, but signs on both ends state that visitors are not to walk on it anymore.

Perhaps these old-time tourists came to Petrified Forest in December, as I did, but they found snow. Note the burlap bags on the feet of the man in front; the soils here are gumbo—very sticky when wet—and the bags probably helped keep his boots clean.

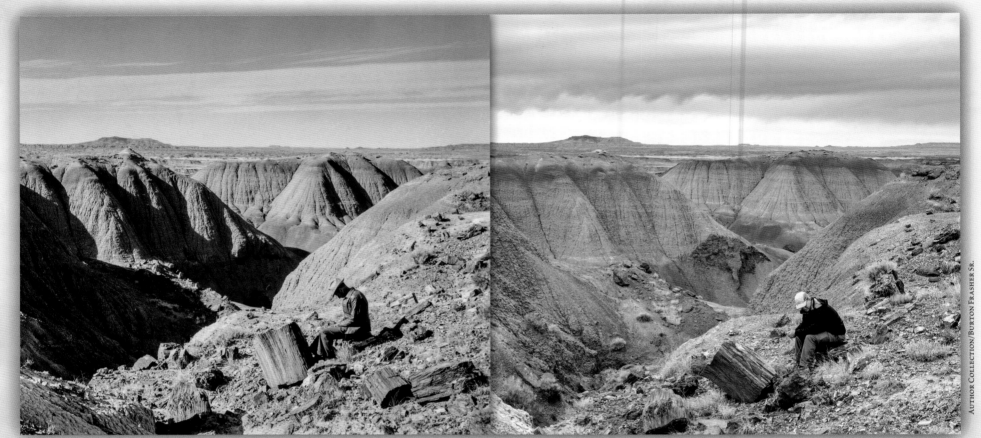

Author Collection/Burton Frasher Sr.

12/16/14 • 35°5′2″ N 109°45′57″ W

Circa 1940 ~ Present-Day Indian of the Painted Desert

I admire the photography of Burton Frasher Sr. He covered a lot of ground, and his were the only historic images I found of several locations in this book. That appears to be Frasher above, in a rare self-portrait, and I like to think he had a sense of humor (evidenced in the title) as I try to have. Since I was alone out in the Painted Desert, there I am where he was. The missing petrified wood at lower right was already gone when I got there.

On my way to this site, I walked on a long-abandoned stretch of Route 66 (now called Pinta Road). This is far from the areas where the historic highway is marked (and marketed), just a lonely stretch where the pavement used to go. I found an old tire, labeled "U.S. Royal Air Ride," half-buried in the ditch. When I researched it later, I found that it was a model used on 1950s Corvettes. There is a lot to discover in our national parks, even in old road ditches.

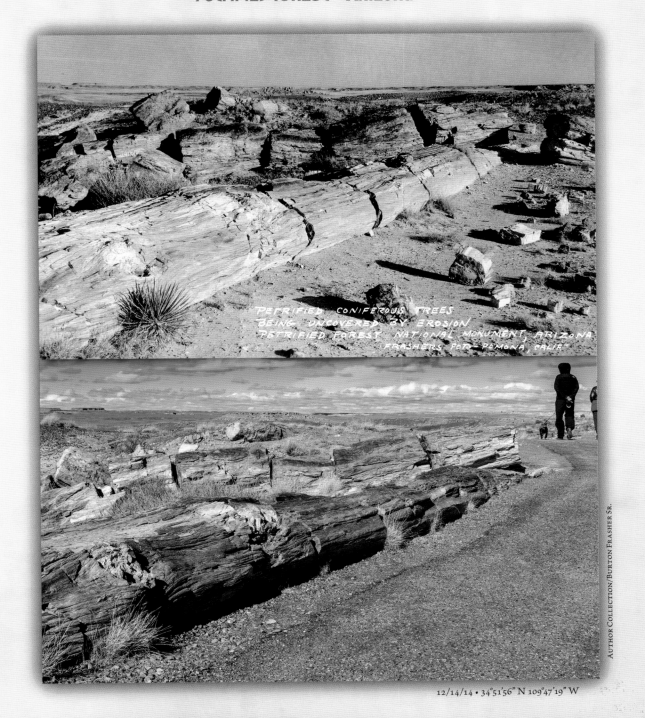

PETRIFIED CONIFEROUS TREES
BEING UNCOVERED BY EROSION
PETRIFIED FOREST NATIONAL MONUMENT, ARIZONA
FRASHERS FOTO—POMONA CALIF

AUTHOR COLLECTION/BURTON FRASHER SR.

12/14/14 • 34°51'56" N 109°47'19" W

1934 ~ Petrified Coniferous Trees Being Uncovered BY Erosion

Unlike in the previous view, Frasher stayed out of this shot, and so did I, since there was a little more action as everyone and their dog strolled past on a pretty December morning.

About halfway around the Crystal Forest Loop Trail I found this pile of petrified trees, broken up as if they were ready for a petrified fireplace.

Most national parks do not allow dogs on trails, but I found out that they are welcome at Petrified Forest. I'm bringing my rat terrier Trixie along next time.

151

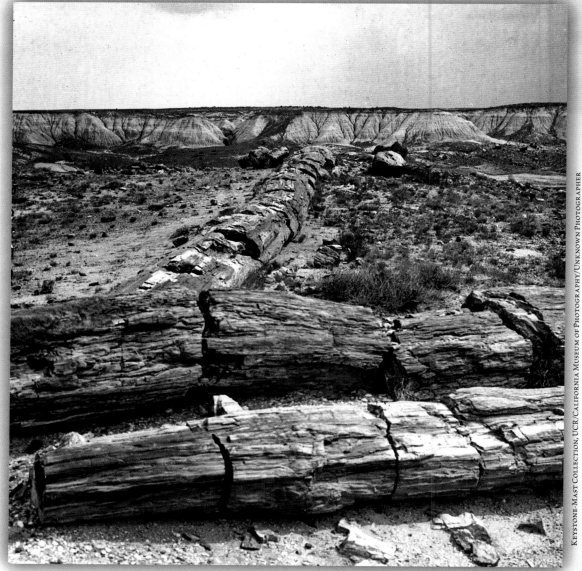

Keystone-Mast Collection, UCR/California Museum of Photography/Unknown Photographer

Opposite: 12/12/14 • 34°51′56″ N 109°47′19″ W

1903 ~ Petrified Trees and Painted Desert

The pile of logs on the previous page is seen here from the opposite angle, and a smaller piece of petrified wood has disappeared at lower left. The park has had problems with theft over the years, one reason it now has gates and closes about sundown each day.

The visitor center displays letters from various tourists who returned pieces of wood they took, after connecting their theft with bad luck that followed. It's humorous, but humbling, to read letters such as this: "I am reterning (*sic*) this rock and the bad luck that follows it. . . . bike stolen, blisters, girlfriend leaving."

So don't take petrified wood—or anything—from a national park. The woman in the photo is just touching, not taking. The raven, on the other hand, will take whatever he can get. Don't feed the wildlife either!

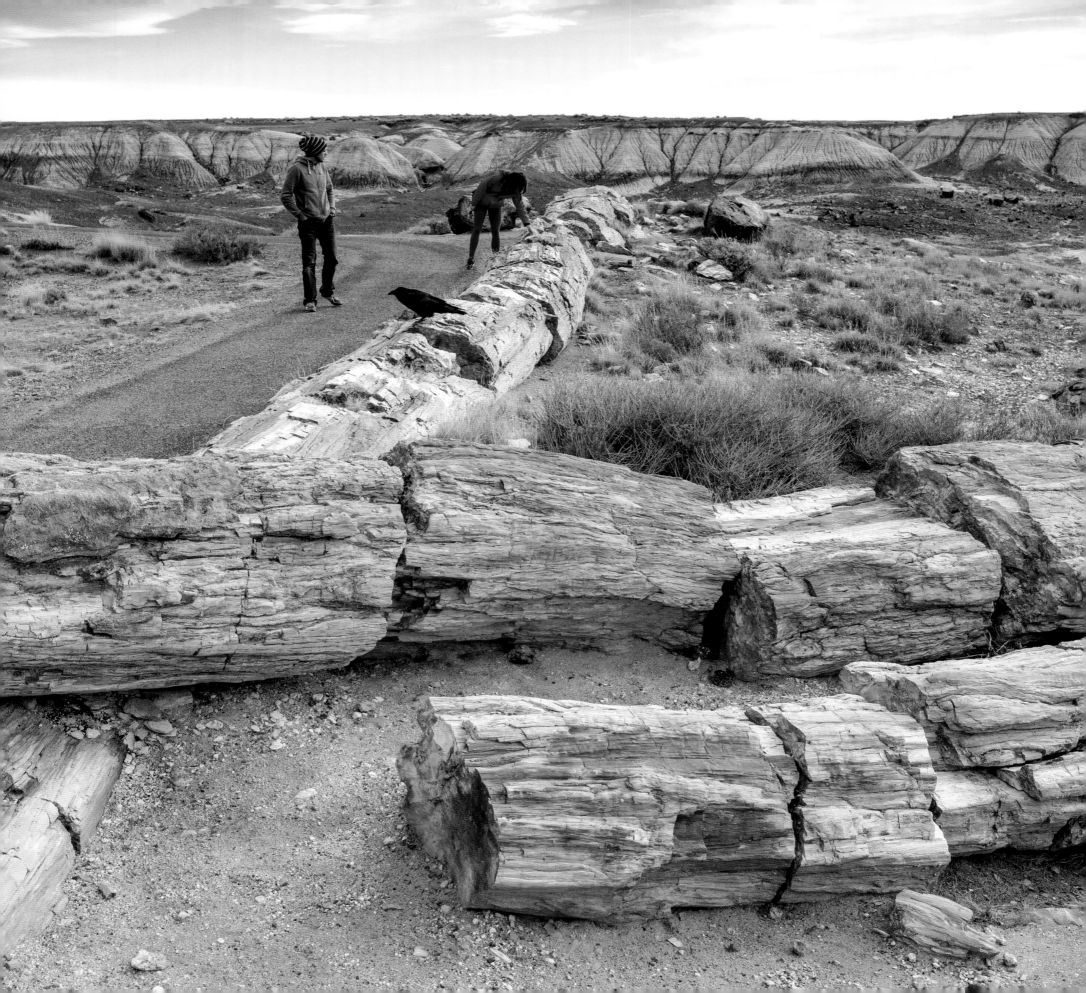

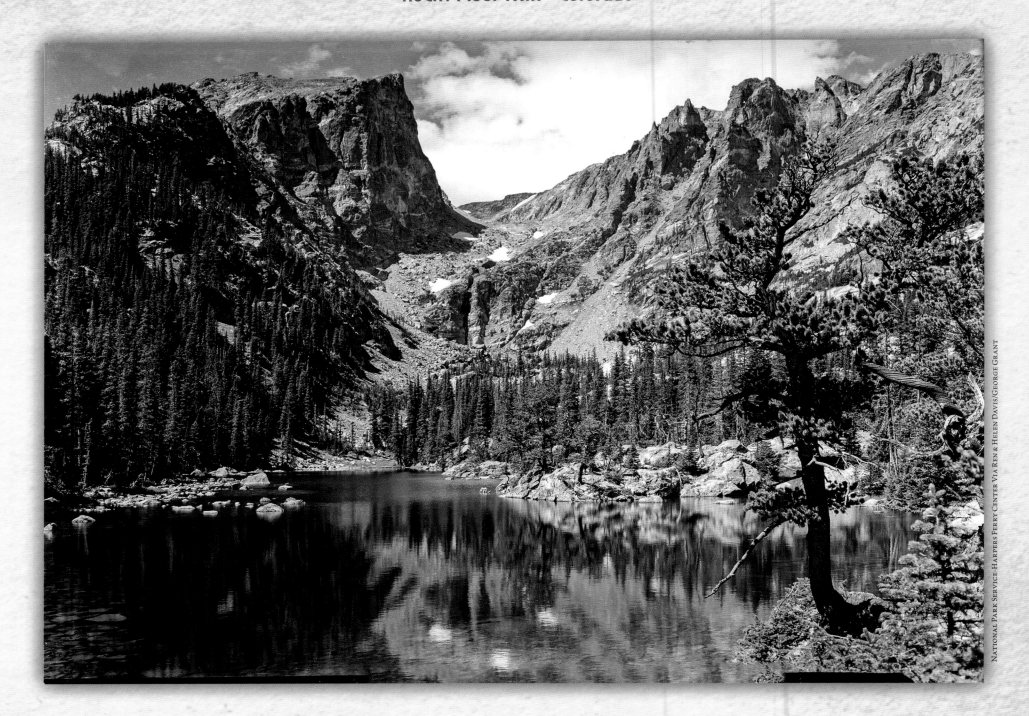

National Park Service-Harpers Ferry Center Via Ren & Helen Davis/George Grant

Aug. 25, 1938 ~ Dream Lake Beneath Hallet Peak

George Grant was an official National Park Service photographer from about 1929 until his retirement in 1954. He created thousands of documentary and landscape views such as this one at Dream Lake in Rocky Mountain National Park.[28]

9/1/16 • 40°18′35″ N 105°39′25″ W

Grant had set up his camera where the most obvious overlook at Dream Lake is located today, 1.1 miles up the trail from the Bear Lake trail head. I shared the view with dozens of day hikers. Though only three of them are in view here, others were at my elbows or walking around the lake as I worked.

As it turned out, Grant's visit and my own were only a week (but many years) apart, which allowed for the angle of light and shadow to be quite similar. I was a bit late, so the afternoon shadows have just started to lengthen in the photo above.

The prominent old tree at near right remains, joined by others today. A dead snag is also visible at far right, but has rolled toward the lake in the modern view.

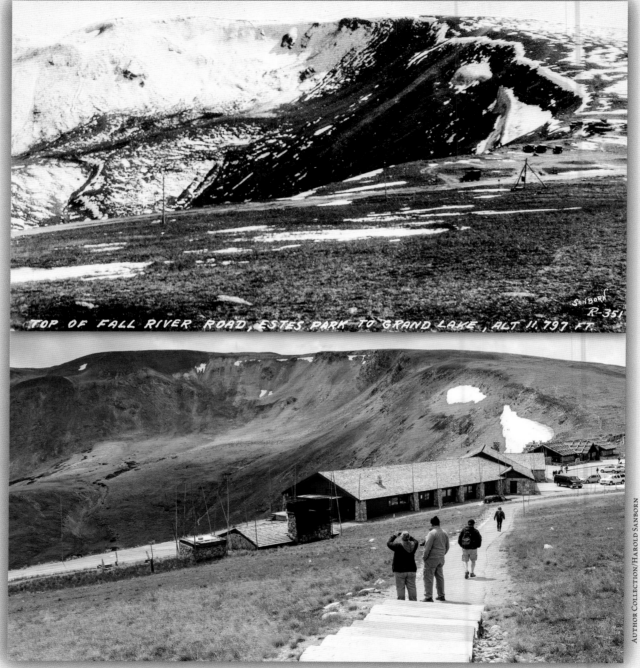

TOP OF FALL RIVER ROAD, ESTES PARK TO GRAND LAKE, ALT. 11,797 FT.

SANBORN R-351

AUTHOR COLLECTION/HAROLD SANBORN

9/2/16 • 40°26'32" N 105°45'10" W

Circa 1930 ~ Top of Fall River Road, Alt. 11,797 Feet

The true photo site was a few feet to the right of where I stood at my tripod ("on rear of 13th trail step" say my notes), but the National Park Service asks people to keep off the delicate tundra here. I obliged.

Since the time of the historic photo, a visitor center (far right in new photo) as well as a gift shop, restaurant and maintenance facilities have been added at the "Top of Fall River Road."

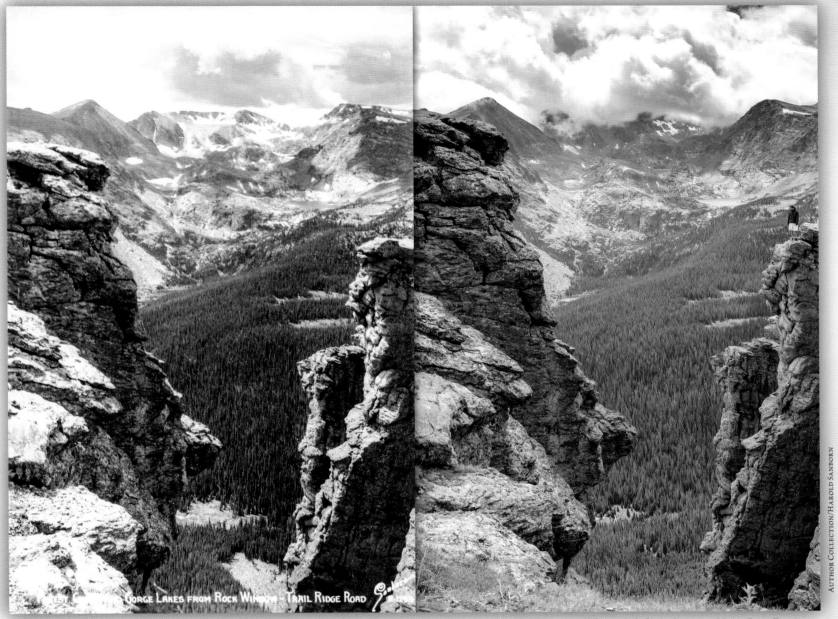

FOREST CANYON AND GORGE LAKES FROM ROCK WINDOW - TRAIL RIDGE ROAD

AUTHOR COLLECTION/HAROLD SANBORN

9/2/16 • 40°24′39″ N 105°43′54″ W • CAUTION: NEAR CLIFF EDGE.

Circa 1935 ~ Forest Canyon and Gorge Lakes FROM Rock Window

Large areas along Trail Ridge Road are off limits to the general public for the legitimate purpose of protecting fragile meadows or alpine tundra. But it was sometimes frustrating to see a photo site that looked very interesting, perhaps within 100 feet, only to find that it was behind a "closed area" sign.

It is possible to apply for a special permit, but the NPS process is cumbersome and the minimum fee is $200. So I was glad to find this open site near the summit of today's Trail Ridge Road, where by chance I photographed a young man peering over the cliff at right. I doubt he realized that a big boulder had already fallen (see historic photo) from the very place he was standing.

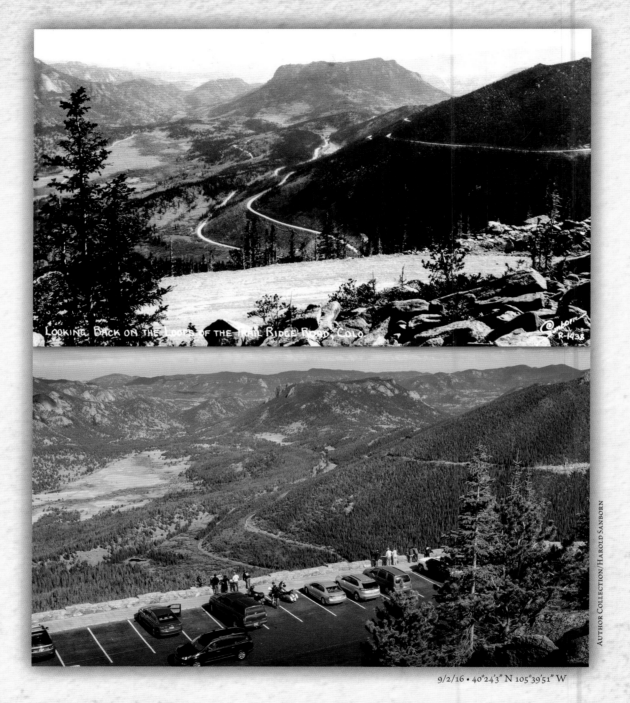

Looking Back on the Loops of the Trail Ridge Road, Colo.

Sanborn R-1438

AUTHOR COLLECTION/HAROLD SANBORN

9/2/16 • 40°24′3″ N 105°39′51″ W

Circa 1935 ~ Looking Back on the Loops of THE Trail Ridge Road

This overlook is now called Rainbow Curve. I climbed all over the rock formations above the parking area and determined that the foreground boulders of the historic photo had been removed or shifted when the original road was widened to include the overlook.

If you cross the road to climb to this site, use care. Cars and RVs come speeding downhill around a curve at left, as if the road were a highway. But with a short hike up into the rocks you can rise above the cars and people below.

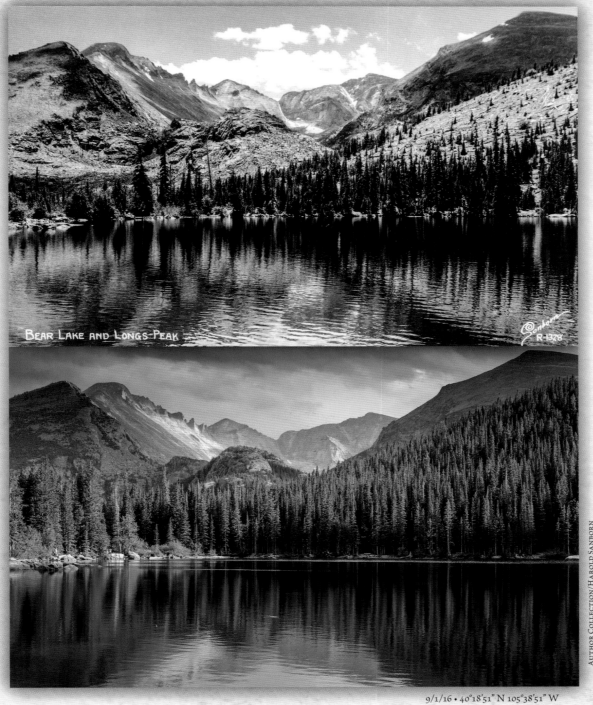

Bear Lake and Longs Peak

Sanborn
R-1328

Author Collection/Harold Sanborn

9/1/16 • 40°18′51″ N 105°38′51″ W

Circa 1935 ~ Bear Lake AND Longs Peak

Climbing up on a large boulder a foot or two offshore, I found a match for the historic photo. Rain drops fell, I waited, and my patience was rewarded when the sun broke through for a few minutes. The location is reached via the Bear Lake Trail; look for it on the north shore.

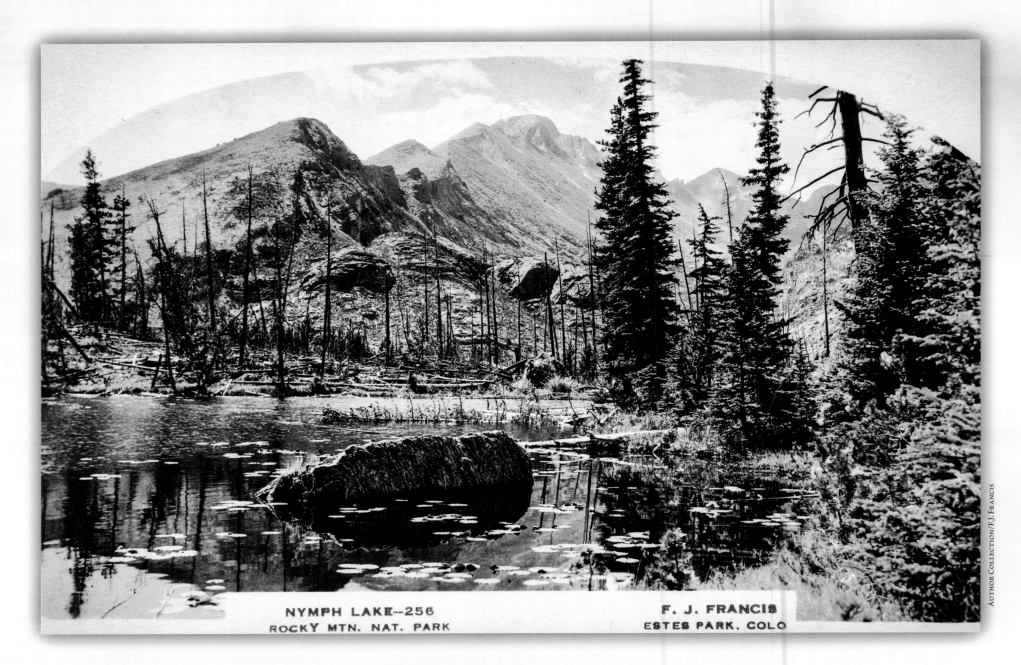

NYMPH LAKE--256
ROCKY MTN. NAT. PARK

F. J. FRANCIS
ESTES PARK, COLO

AUTHOR COLLECTION/F.J. FRANCIS

Circa 1925 ~ Nymph Lake

Nymph Lake lies about one mile from the parking area at the Bear Lake trail head, along one of the most popular hiking trails in the park.

The background of the historic postcard photo shows a fire-blackened landscape below Longs Peak. A volunteer NPS interpreter told me that a careless visitor had let a campfire escape around 1902, resulting in a fire that burned a large area of the forest.

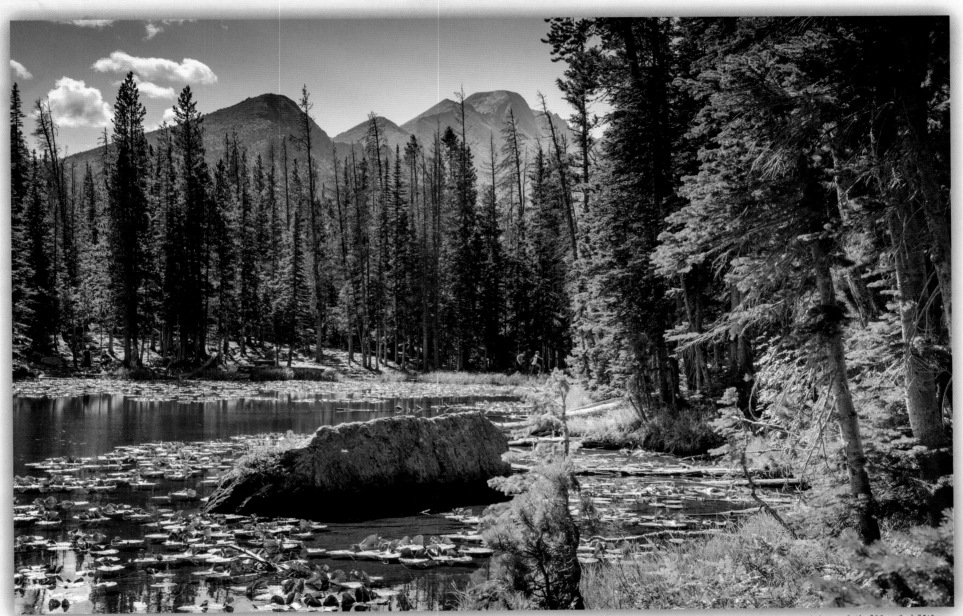

9/1/16 • 40°18'37" N 105°39'7" W

I visited Nymph Lake on my way to Dream Lake (pages 154-155). The names alone were enough to draw me up the trail, but I especially like any view with a prominent foreground boulder that helps me "lock in" a site.

The forest is regenerated today and, due to its density, increasingly vulnerable to fire—whether caused by man or by nature.

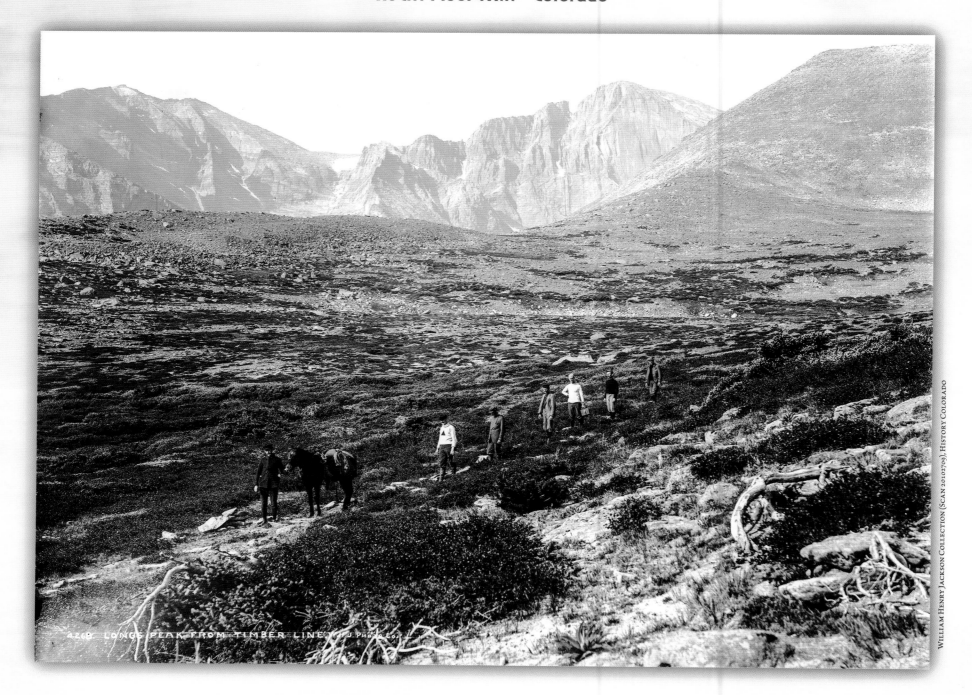

4268 LONGS PEAK FROM TIMBER LINE W.J. PHOTO CO

WILLIAM HENRY JACKSON COLLECTION (SCAN 20102709), HISTORY COLORADO

Circa 1882-1890 ~ Longs Peak from Timber Line

Well-known Colorado photographer John Fielder deserves credit for finding this site for his book of re-photography *Colorado 1870-2000*. He didn't record the location, however, so I had the pleasure of working that out for myself on a hike toward Longs Peak (top).

I found another William Henry Jackson site just over the ridge in the photo (not published in this book; see my website) before thunderstorms chased me back down the mountain. I don't like being the tallest object on an open plain beneath a storm, and a good number of people are hit by lightning every year in Rocky Mountain National Park.

9/3/16 • 40°16'17" N 105°35'4" W

To reach this area I followed the East Longs Peak Trail about 2.5 miles from the trail head, then turned up the Jim's Grove Trail. The site is on the timberline, the area at around 11,000 feet where the forest thins out, trees can barely grow, and high alpine tundra begins. I was in the midst of a small grove of chest-high trees that had apparently grown here since Jackson's time.

I found a single food can on the ground in the underbrush, close to my tripod. It was a "hole in cap" style of can that I'd seen before, lying on the ground after 140 years, during field work for books on Gen. Custer's 1874 expedition through the Dakotas. This type of can dates to at least the 1870s, and it made me wonder if Jackson and his crew had lunch here before continuing their trek.

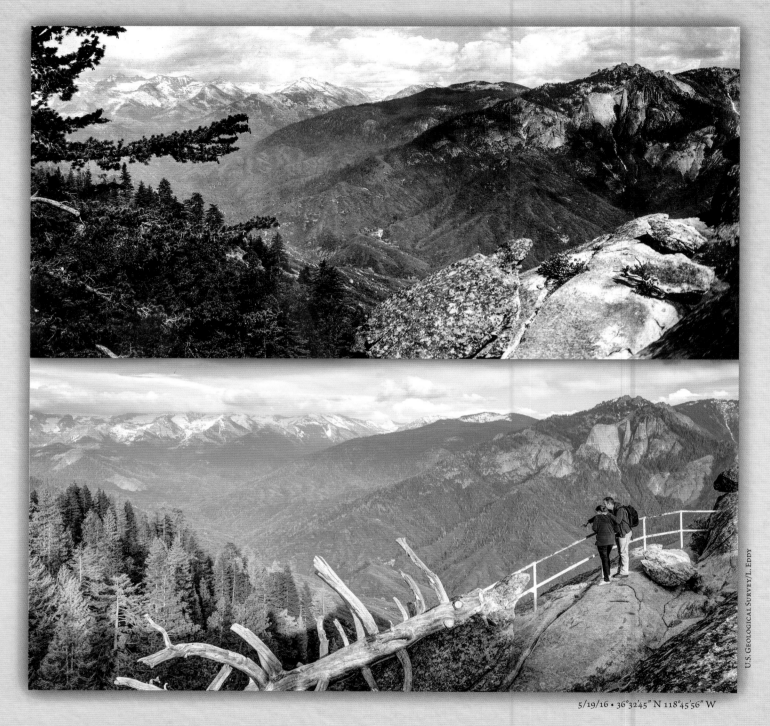

U.S. Geological Survey/L. Eddy

5/19/16 • 36°32'45" N 118°45'56" W

1925 - From Base of Moro Rock, Turtle Rock ɪɴ Foreground

I found the site as described in its title, looking southeast from the base of Moro Rock in Sequoia National Park. A Google search for "Turtle Rock Sequoia" brings up zero results, which I found interesting, considering how much the foreground formation does look like the reptile.

Trees in the background died during a prescribed burn in 2014.

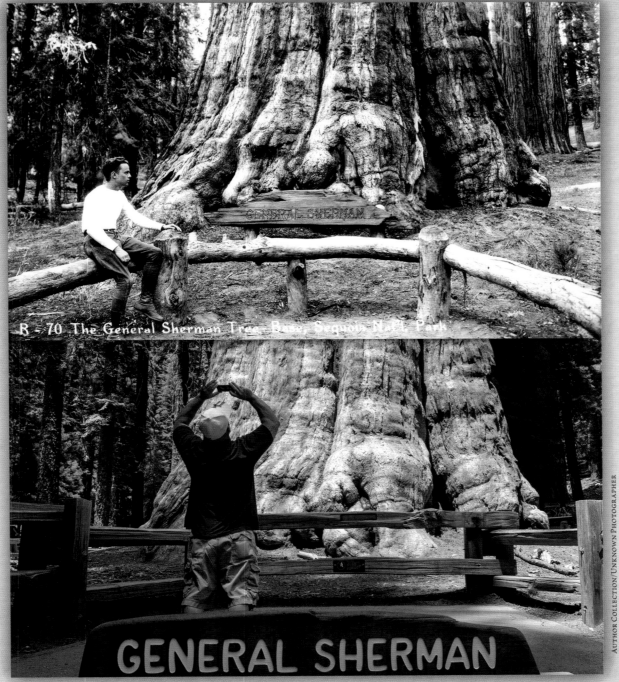

R - 70 The General Sherman Tree Base, Sequoia Nat'l Park

AUTHOR COLLECTION/UNKNOWN PHOTOGRAPHER

6/2/14 • 36°34′53″ N 118°45′5″ W

Circa 1930 - The General Sherman Tree Base

It boggles the mind when you stand before this tree, which is around 2,500 years old and—at 275 feet tall and 36.5 feet in diameter—the largest in the world, measured by volume. All you can do is just gawk at the sight. Then you take a picture.

AUTHOR COLLECTION/UNKNOWN PHOTOGRAPHER

R-2 Coffee Shop, Giant Forest - Sequoia Nat'l. Park, Calif.

Circa 1930 ~ Coffee Shop, Giant Forest

I'm fond of finding places where commercial facilities were once developed for visitors, and the facilities then disappeared for one reason or another. At Giant Forest, the National Park Service gradually came to realize that such development amid these treasured big trees was not a good idea, because it was bad for the trees. It's a situation that can be found in other parks (too many people in a small area of ecological sensitivity), although it doesn't always motivate change.

By the time of this photo, the Giant Forest had "four campgrounds, dozens of parking lots, a garbage incinerator, water and sewage systems, a gas station, corrals, and over 200 cabin, tent-top, dining, office, retail, and bath-house structures. Many of these were located directly among stands of monarch sequoias."[29]

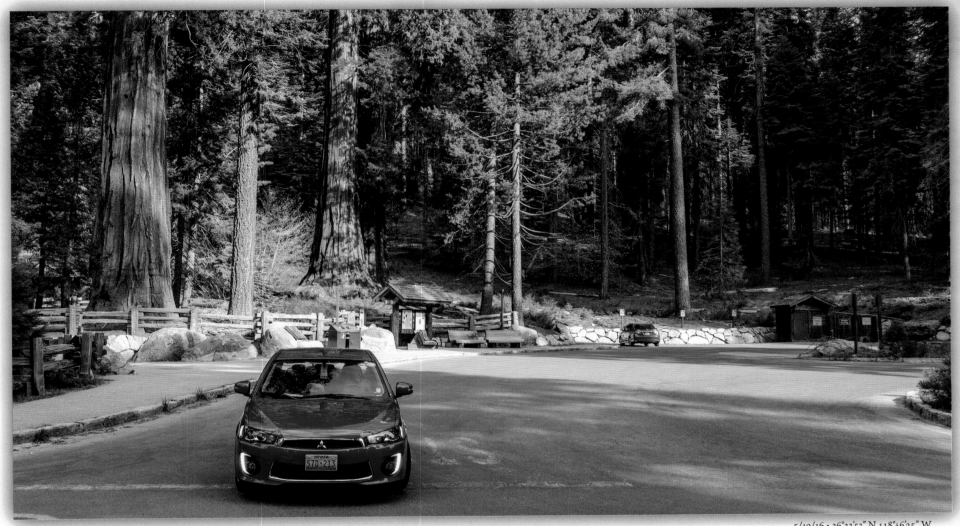

5/19/16 • 36°33'53" N 118°46'25" W

As early as the 1920s, some advocates were speaking out about the impact of overdevelopment on the environment at Giant Forest. Most of that development had been removed by 2000, though the main roads remain, as seen above. The area went from having nearly 300 buildings down to just four.[30] By aligning on the trees that remained, I could see that the historic photo was taken from the roadside just across from where the coffee shop and tent cabins once stood. Similar facilities are still available at Sequoia, just not in this sensitive area.

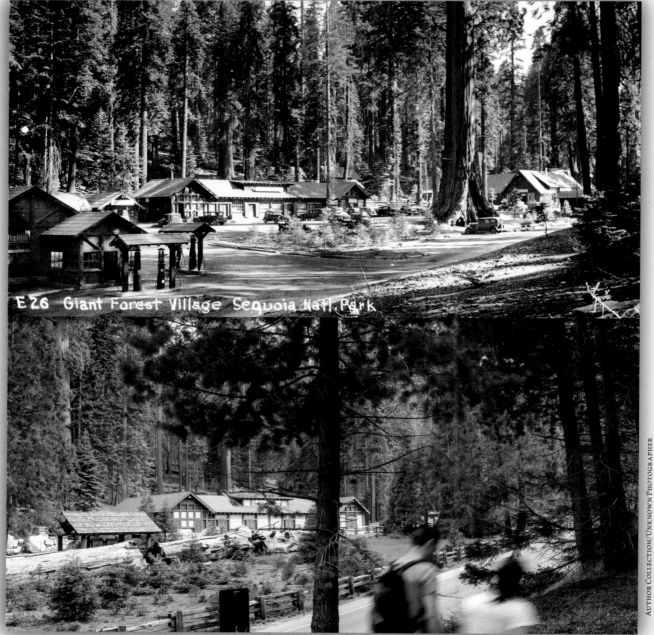

E26 Giant Forest Village Sequoia Nat'l Park

5/19/16 • 36°33'56" N 118°46'22" W

AUTHOR COLLECTION/UNKNOWN PHOTOGRAPHER

Circa 1930 ~ Giant Forest Village

This view is 150 yards down the road from the one on the previous page; the coffee shop is now seen at far right in the historic photo. A former grocery is today a museum and visitor center for the Giant Forest. A gas station at left in the 1930 view is gone, and young trees grow in the vicinity. Perhaps some of them will still be there hundreds of years from now.

The prominent tree at right in the historic photo remains, but its base is now shrouded by younger trees. This photo site is along a walking path.

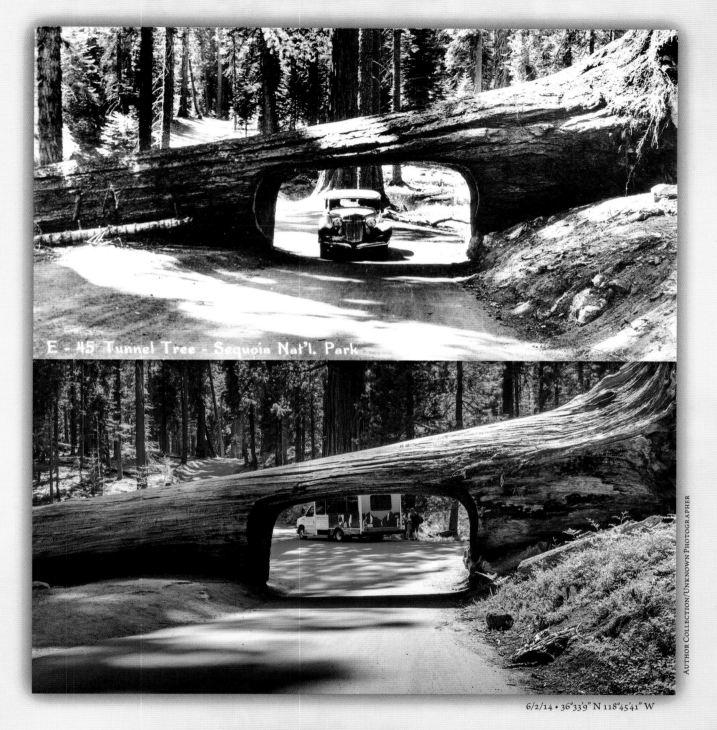

E - 45 Tunnel Tree - Sequoia Nat'l. Park

AUTHOR COLLECTION/UNKNOWN PHOTOGRAPHER

6/2/14 • 36°33'9" N 118°45'41" W

Circa 1938 - Tunnel Tree

Officially called the Tunnel Log today, this tree was cut through in 1938, a year after it fell across the Crescent Meadow Road.[31] It should not be confused with tunnel *trees* in nearby Yosemite or elsewhere in California. The National Park Service is arguably wiser today, and is done tunneling through trees, alive or dead.

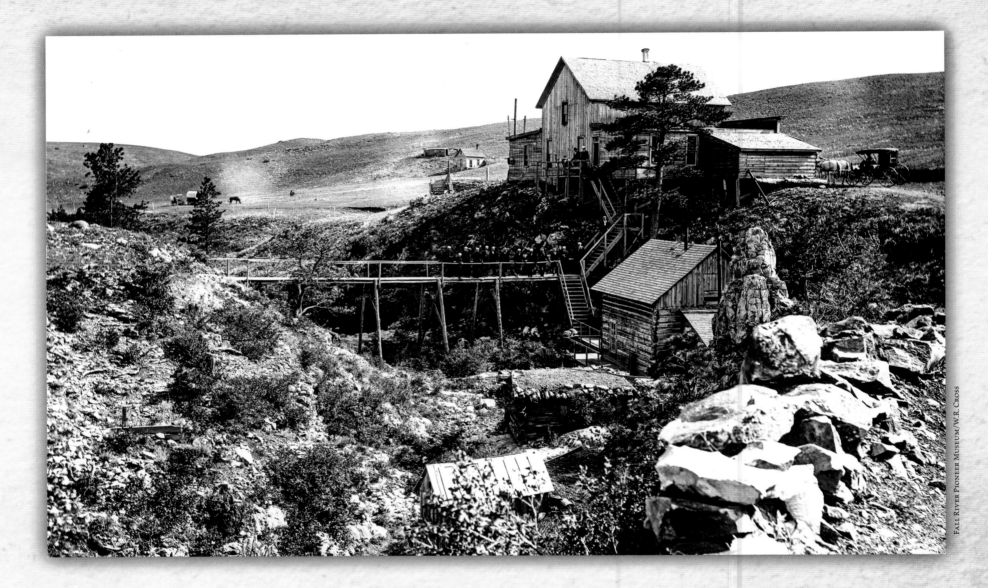

Fall River Pioneer Museum/W.R. Cross

Circa 1895 ~ Wind Cave Headquarters and Natual Entrance

Wind Cave, in the Black Hills of South Dakota, is one of our earliest national parks, established in 1903. This image dates to a few years before that time, when tourists would travel from nearby towns to explore what was then a privately operated cave by candlelight. The taller building at center right was built above the vicinity of the natural entrance to the cave. Anecdotal history says the natural entrance was discovered in 1881 when a cowboy following a wounded deer heard a whistling sound. Air rushing out of a hole in the ground knocked off his hat when he tried to look in. This natural entrance was enlarged over time to accommodate visitors, and still remains (see opposite page), but in 1938 a man-made entrance was created a few hundred yards away, complete with elevator, to further improve visitor access.[32]

8/25/16 • 43°33′31″ N 103°28′46″ W

Because I had visited this site for an earlier project in my native Black Hills, I knew where to find this view, which approximates the historic photo. I balanced on the stone wall partially visible on the right to get a better angle into this small canyon. In the absence of fire, brush and trees have grown up here, 200 yards north of today's visitor center (off-camera to the left). With the old buildings removed long ago, the natural entrance is now visible by looking into the alcove just behind the low rock wall near the sidewalk.

The building at right has served as a park residence and offices.

As exploration continues in Wind Cave, its known length gradually increases. At 143 miles as of this writing, it is the sixth-longest cave in the world.

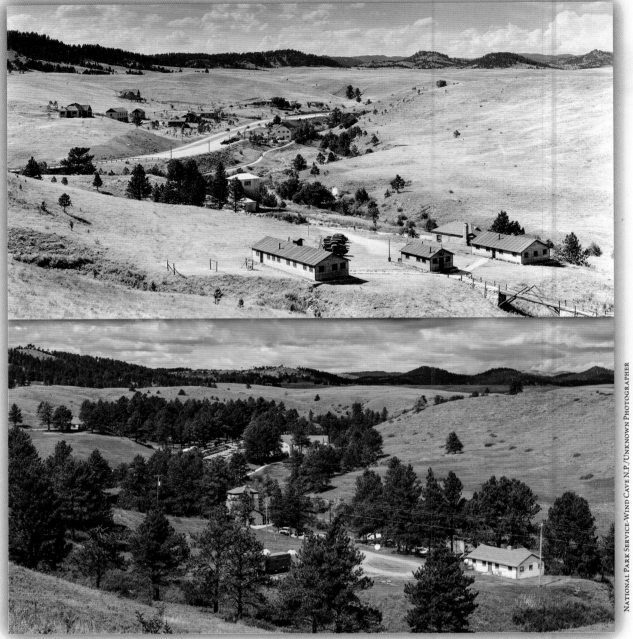

National Park Service-Wind Cave N.P./Unknown Photographer

8/25/16 • 43°33'12" N 103°28'28" W

Circa 1939 ~ CCC Camp and Administrative Area

Members of the Civilian Conservation Corps worked on numerous road and building projects after this camp was established at Wind Cave in 1934. Among the buildings seen here are the cave elevator building (center left in both photos), completed in 1938, and the visitor center (at center). The trees in the modern photo may have been among the 5,000 "trees and shrubs" planted by industrious CCC men in 1935.[33]

The photos on the next page were taken from the ridge at the top center of these photos.

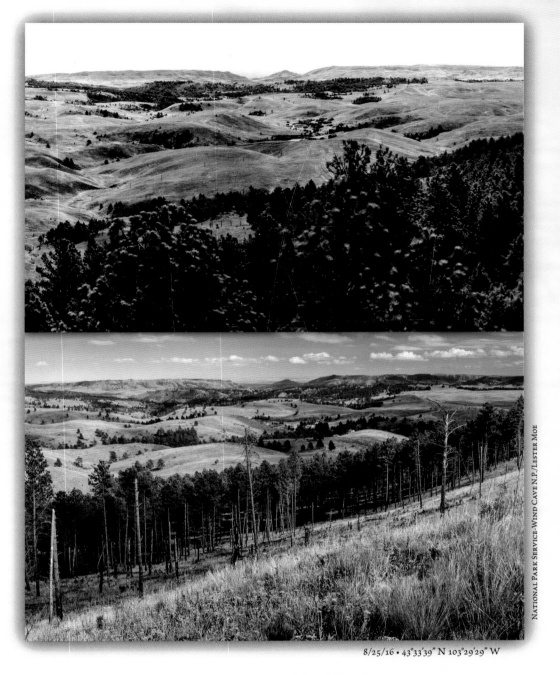

National Park Service–Wind Cave N.P./Lester Moe

8/25/16 • 43°33'39" N 103°29'29" W

July 8, 1937 – View FROM Elk Mountain

Photographer Lester Moe worked for the U.S. Forest Service and later the National Park Service in the 1930s, documenting hundreds of sites in panoramic photographs, often from the tops of fire towers. I believe he was on the Elk Mountain Fire Tower for this image (cropped from a wider panorama that had the specific date recorded on it). The tower is long gone (although its foundation holes remained visible near my location), but trees that would have blocked my view from a few feet lower had been thinned by a prescribed fire in 2009.

Note the visitor center and nearby buildings (seen from the opposite angle on the previous page) visible near the center of the images.

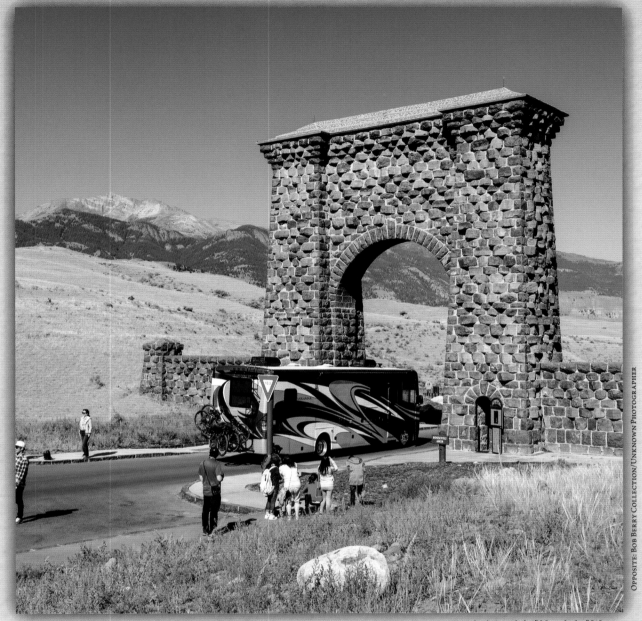

Opposite: Bob Berry Collection/Unknown Photographer

7/30/16 • 45° 1'46" N 110°42'30" W

Circa 1903 ~ Roosevelt Arch

Completed in August 1903, the Roosevelt Arch still serves as a grand entrance to Yellowstone National Park, although a bypass leads directly to the park entrance booth for those in a hurry. I had no trouble finding this location, of course, but was interested to see that a recent renovation project had removed orig-inal foreground boulders that were still there a few years ago, when I photographed this area for the book *Yellowstone Yesterday & Today*. More parking, curbs and sidewalks have been added, and the hillside has been graded over. At least the Arch itself and Electric Peak in the background remain unchanged.

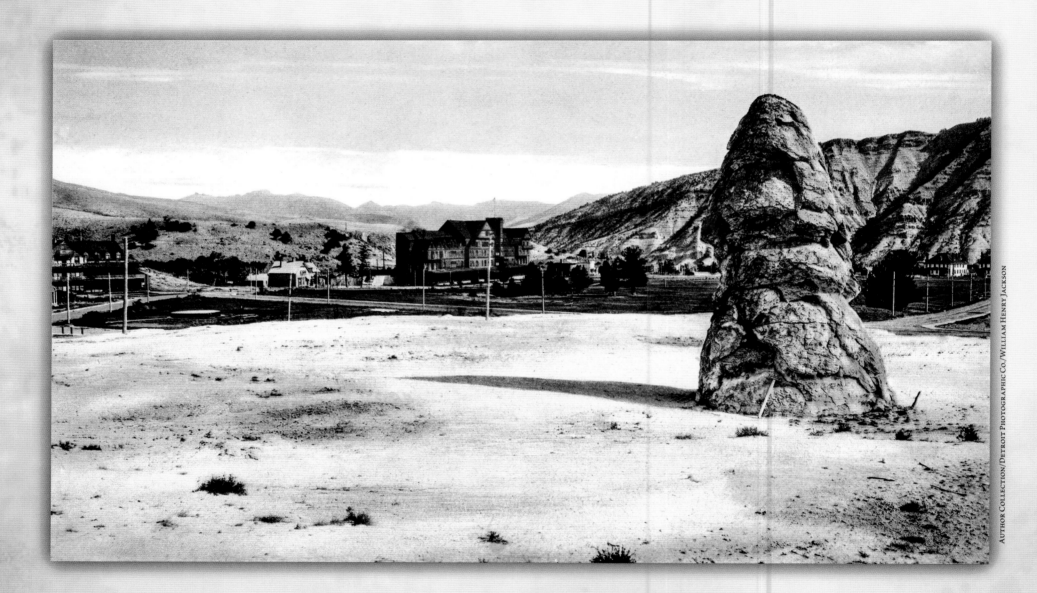

Author Collection/Detroit Photographic Co./William Henry Jackson

1902 ~ Liberty Cap, Yellowstone National Park

Liberty Cap, the source of a hot spring that no longer flows, is a well-known feature of the Mammoth Hot Springs area in Yellowstone. The hotel in the background was built in 1883 with the current structure (see modern photo) built in its place from 1936-38.

This historic view is a colorized image (technically it was called a "Photochrom") made from a black-and-white negative, using an early Swiss color-printing technology.

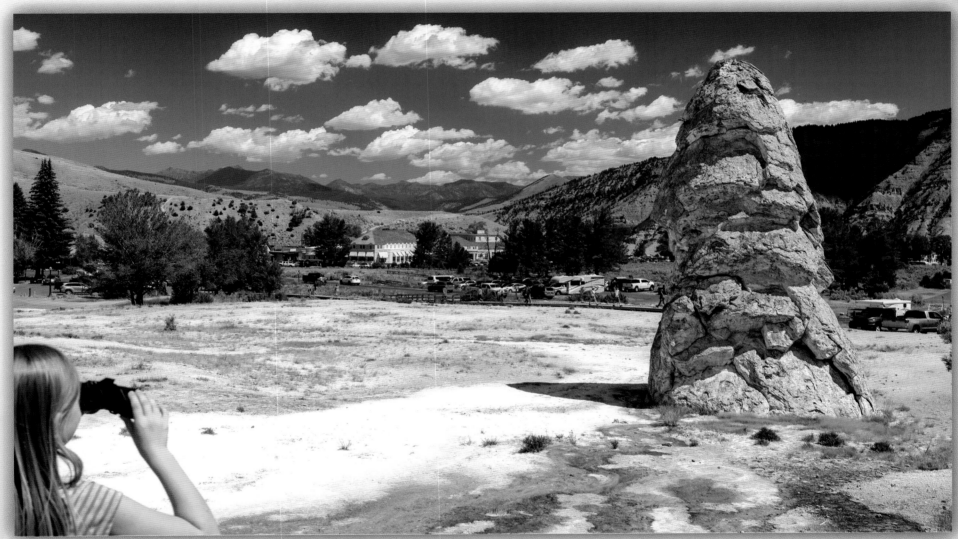

7/30/16 • 44°58'22" N 110°42'17" W

Restricted to boardwalks that now protect delicate surfaces formed by the flowing water, I found a similar view on the walkway that crosses between Liberty Cap and the terraces behind the camera. In 1902 the photographer, W.H. Jackson, would have been standing nearby on the ground below.

In the new photo, a young tourist examines Liberty Cap on a beautiful summer day, not far from parking lots full of cars. Heavy traffic and crowds of people are typical here in July. I enjoyed just standing at the rear of the boardwalk, listening to people talk about what they had seen or where they were going next.

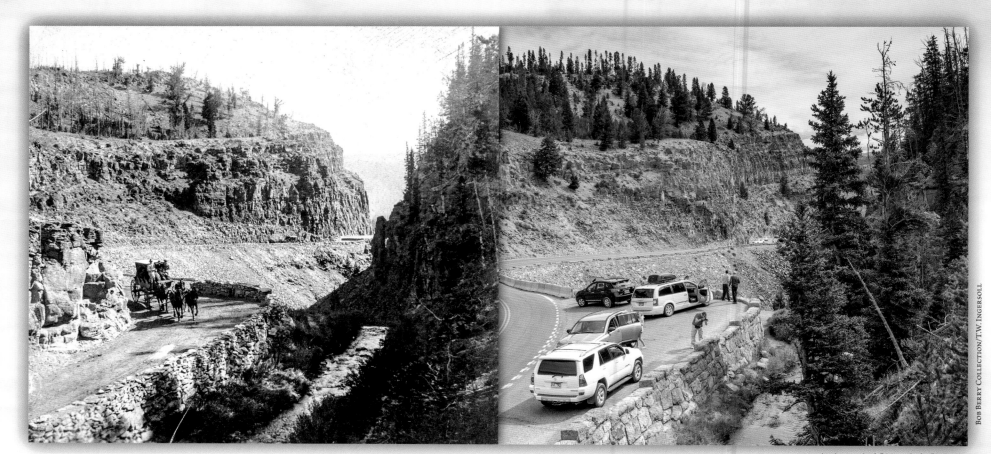

BOB BERRY COLLECTION/T.W. INGERSOLL

7/18/15 • 44°56'0" N 110°43'35" W

Circa 1905 ~ At the Head of Golden Gate Canyon Road

The road through Golden Gate opened in 1885, circumventing an earlier, much more difficult route. It's much wider today (the small cliff at left has been obliterated), and the old wagon road now appears to be part of the pullout where tourists gather to admire the view.

It wasn't as easy as it may look to reach this photo site, despite its proximity to the road. Walking back from my car in the pullout, I eventually found a place to cross Glen Creek, then scrambled up a steep hillside where few visitors seem to go. I found what I have to call a perch that had been used by the earlier photographer. It's always odd to go someplace like this and have other visitors staring at you, clearly wondering, "What's he doing up there?" But T.W. Ingersoll did it, so I did, tying my tripod to a tree to keep it from going over the edge and into the stream below.

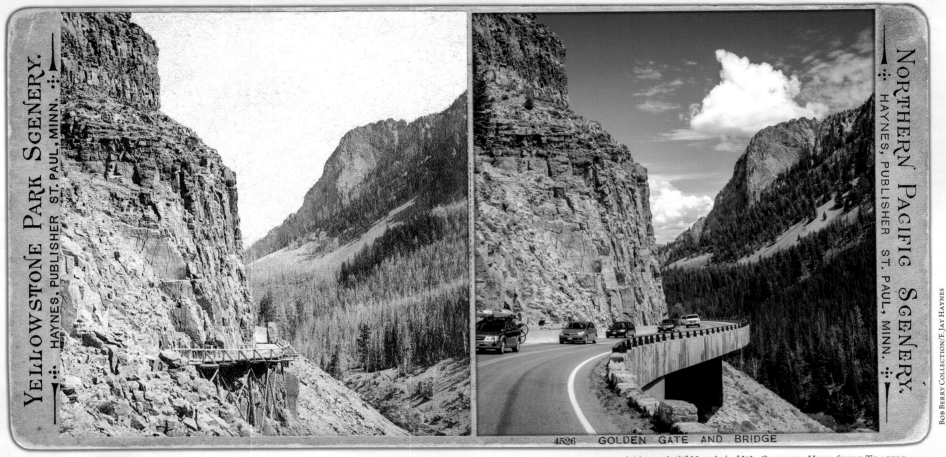

YELLOWSTONE PARK SCENERY. HAYNES, PUBLISHER ST. PAUL, MINN.

NORTHERN PACIFIC SCENERY. HAYNES, PUBLISHER ST. PAUL, MINN.

4526 GOLDEN GATE AND BRIDGE

Bob Berry Collection/F. Jay Haynes

7/18/15 • 44°56′6″ N 110°43′25″ W • Caution: High-Speed Traffic

Circa 1885 ~ Golden Gate and Bridge

Among the most difficult shots re-created for this project are those where the historic photographer stood in a little-used wagon road. These routes are usually busy highways in today's parks, which means darting in and out of traffic to study the scene. That makes it very difficult to examine the foreground, and impossible to use a tripod.

In this case I sized up the angle from the stone wall at right, waiting for a break in the stream of cars to step out and snap a few shots at a time. Then I would check them on my laptop for accuracy while sitting safely just outside the wall.

Today's bridge (technically a trestle) was completed in 1977, the third structure to occupy this space since the original wooden bridge seen in the historic photo. The stone pillar at the far end of the original bridge, known as the Pillar of Hercules, has been a landmark here since the beginning, but was relocated around the corner, probably for safety reasons.[34]

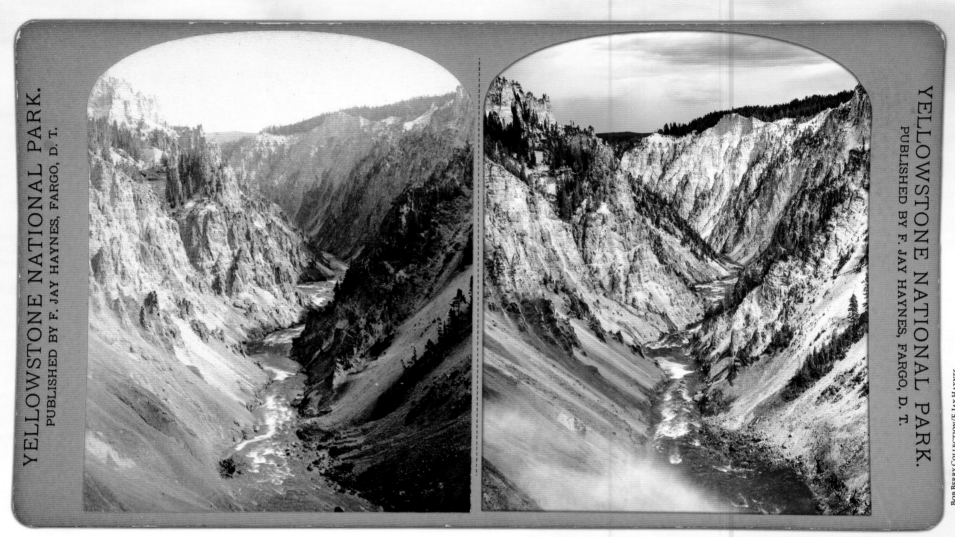

YELLOWSTONE NATIONAL PARK.
PUBLISHED BY F. JAY HAYNES, FARGO, D. T.

YELLOWSTONE NATIONAL PARK.
PUBLISHED BY F. JAY HAYNES, FARGO, D. T.

BOB BERRY COLLECTION/F. JAY HAYNES

8/10/13 • 44°43′5″ N 110°29′46″ W

Circa 1883 ~ Grand Canyon of the Yellowstone from the Brink

Long before there was a railing here (the one I stood behind for the new photo), F. Jay Haynes stood at the top of the Lower Falls of the Yellowstone River and made his view with a stereo camera.

I followed the steep but mostly-paved trail that leads from the parking area high above down to this site. By waiting for spray from the waterfall to be carried into the air by wind, I managed to capture a rainbow with the sun behind me at 2:45 p.m.

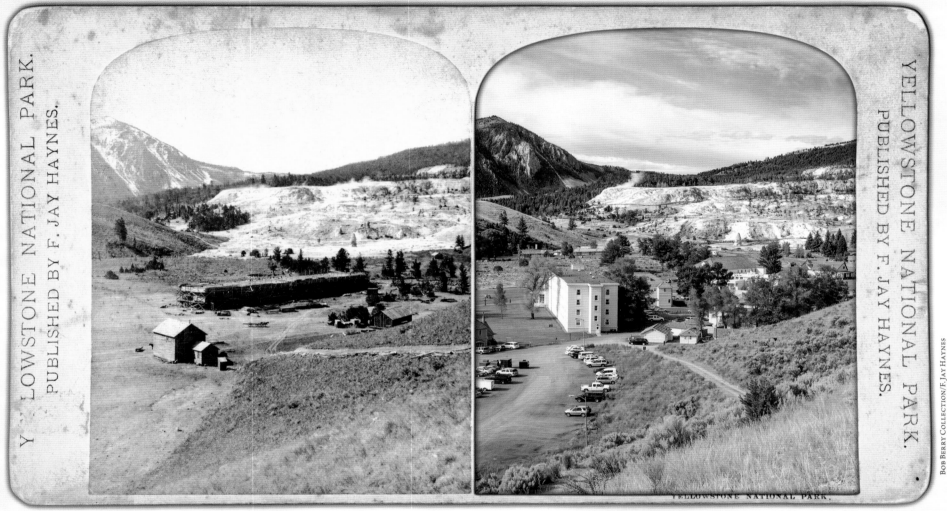

YELLOWSTONE NATIONAL PARK.
PUBLISHED BY F. JAY HAYNES.

Y LLOWSTONE NATIONAL PARK.
PUBLISHED BY F. JAY HAYNES.

YELLOWSTONE NATIONAL PARK.

BOB BERRY COLLECTION/F. JAY HAYNES

7/18/15 • 44°58'45" N 110°42'2" W

Circa 1884 ~ Mammoth Hot Springs

While working on my earlier book project about Yellowstone, I was initially confused by the placement of roads in the foreground of the historic and modern views of this area. I finally realized that the original road is now a barely visible hiking trail where several people are walking above the newer road, which leads eventually to Gardiner, Montana. Though this gravel road is still open much of the summer, it too has been bypassed by a highway that roughly parallels it going north out of the park.

The earlier hotel has been replaced and added to in stages, among the many structures that have appeared as the park developed over the past 130 years. The terraces of Mammoth Hot Springs have also changed, though more subtly, as flowing mineral-laden water gradually adds layers to the formations.

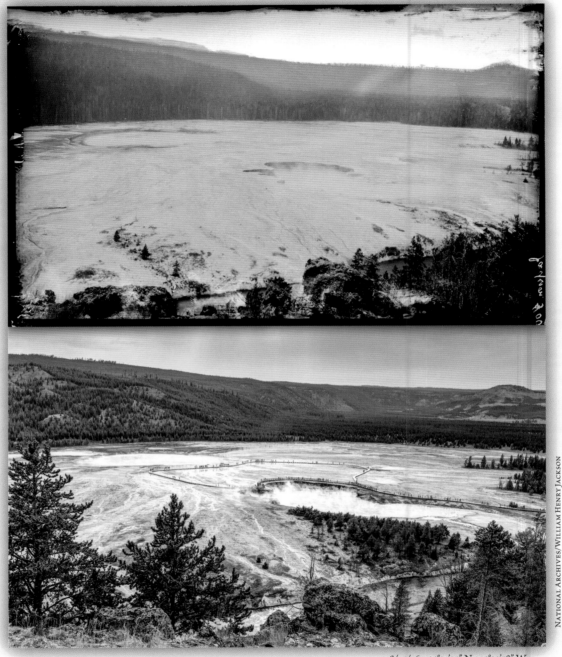

NATIONAL ARCHIVES/WILLIAM HENRY JACKSON

8/15/16 • 44°31'35" N 110°49'58" W

Circa 1878 ~ Excelsior Geyser

Foreground boulders in W.H. Jackson's image helped me identify the precise site at the top of a cliff across the highway from Excelsior Geyser (and Grand Prismatic Spring, at left). A social trail—created by a steady stream of visitors climbing the hill to this point—had been blocked by the National Park Service after it began to erode, but there are other, less-direct routes that have been left open. This location offers a beautiful view across Midway Geyser Basin, away from the crowds on boardwalks below.

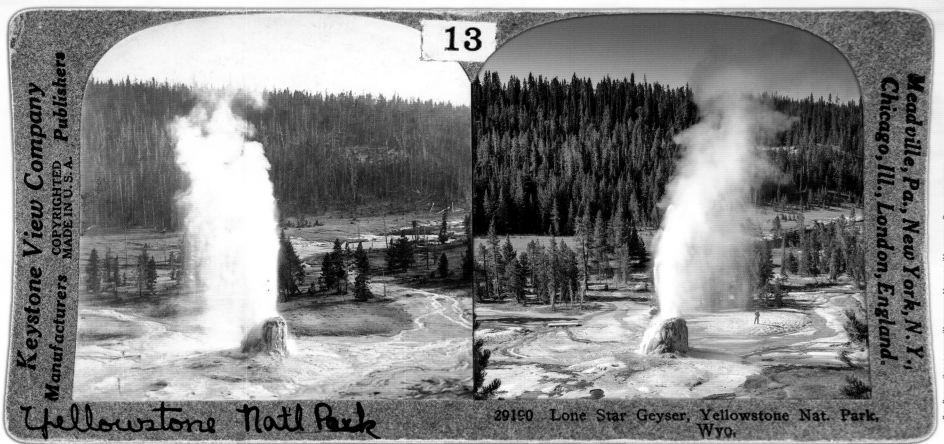

Keystone View Company
Manufacturers Copyrighted Publishers MADE IN U.S.A.

13

Yellowstone Nat'l Park

29190 Lone Star Geyser, Yellowstone Nat. Park, Wyo.

Meadville, Pa., New York, N.Y., Chicago, Ill., London, England.

Bob Berry Collection/Keystone View co./Unknown Photographer

8/8/13 • 44°25'8" N 110°48'24" W • Caution: Thermal Basin, Walk Around, Not Through.

Circa 1926 ~ Lone Star Geyser

Lone Star is about 2.5 miles from the nearest road, so there are usually few people—or none at all—and no boardwalk or fences. Arriving before dawn on this August morning, I was alone with the geyser.

The photo site is on a hill across from the log benches where people usually sit to observe. I was just getting my bearings when Lone Star began its eruption, and I couldn't prepare in time. Knowing that the next erup-tion would be in about three hours, I finished verify-ing the location and waited. Lone Star is very active between eruptions, producing a lot of steam vapor that you can enjoy for a while if you go here. I had time to set up a remote control and go down to stand next to the geyser for the photo above.

The historic image has been hand-tinted with oils to add color.

Author Collection/Union Pacific Railroad/Unknown Photographer

1928 ~ Old Faithful Geyser in Eruption & Old Faithful Inn

Publicity photos such as this one by the Union Pacific Railroad can give a clearer view of early tourism activity in national parks than provided by smaller postcards. This image reveals how close cars once parked near Old Faithful, at about the same location as the boardwalks used by people today. Note the density of the forest at this time, 60 years before the infamous Yellowstone fires in 1988. There are few images in this book that show a greater number of trees in the past than there are today; usually it's the opposite.

184

7/9/15 • 44°27′53″ N 110°49′28″ W

I recommend hiking to this point if your Yellowstone visit allows the time. The overlook is reached by a good trail from the geyser basin below, and offers an interesting panoramic view of the area. Changes include, from left, construction of the Snow Lodge; a recently-constructed Visitor Education Center (behind Old Faithful's plume); the addition of large parking lots (now well away from Old Faithful); a post office; the Ranger Station and Backcountry Office; maintenance areas; and staff housing and dormitories. Old Faithful Inn remains in place at right.

Note the larger crowds along the boardwalks around Old Faithful, an indicator of the visitation at Yellowstone and other major national parks on a typical summer day.

185

7/12/15 • 44°27′33″ N 110°49′43″ W

Bob Berry Collection/Henry Peabody

1926 ~ Old Faithful Geyser

The photos on the two previous pages were taken from the cliffs along the ridge at right in these images. I had a little trouble identifying a specific location for this historic view, as the base of Old Faithful is obscured by the eruption, but this is close.

Today's boardwalk around Old Faithful was con-structed about where cars used to park. One driver didn't even get out of his vehicle. Signs on the two cars at left indicate they had traveled from Velva, North Dakota, a journey of 700 miles at a time when roads were far less developed.

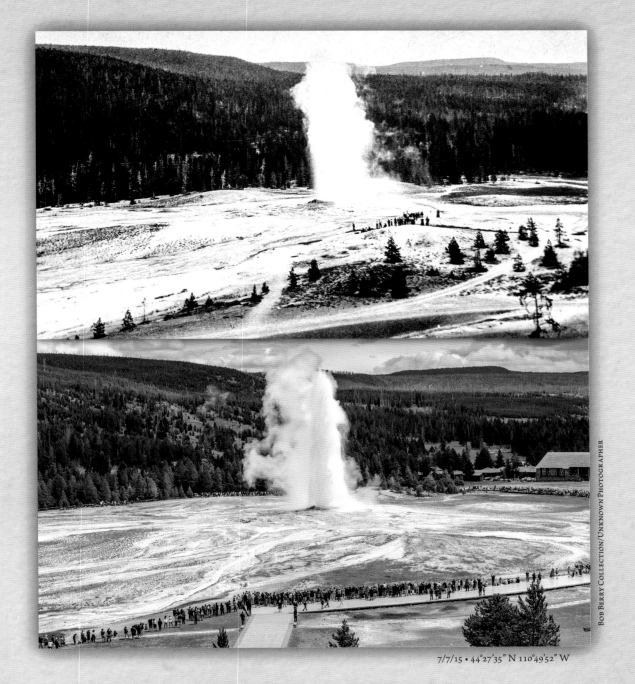

7/7/15 • 44°27'35" N 110°49'52" W

BOB BERRY COLLECTION/UNKNOWN PHOTOGRAPHER

Circa 1900 ~ Old Faithful FROM Roof of the Inn

An even earlier Old Faithful eruption was recorded (as I found out) from the roof of the nearby Old Faithful Inn, the grand old lodge not to be missed if you come to the park.

I made arrangements with a very helpful bellhop to gain access to the roof, where visitors are not normally allowed due to safety concerns.

Although these plumes look similar in height and volume from one century to the next, each of Old Faithful's eruptions is different. And the interval between eruptions is gradually getting longer.[35]

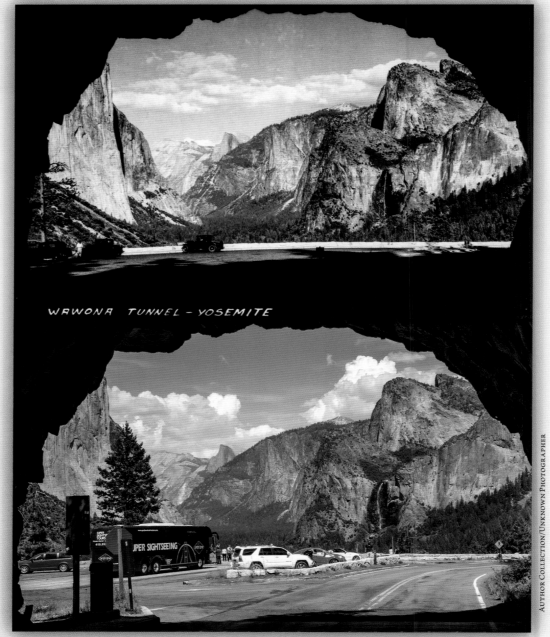

WAWONA TUNNEL - YOSEMITE

AUTHOR COLLECTION/UNKNOWN PHOTOGRAPHER

6/5/14 • 37°42'56" N 119°40'40" W • CAUTION: HIGH-SPEED TRAFFIC.

Circa 1935 ~ Wawona Tunnel into Yosemite Valley

Back when cars weren't so fast, and there weren't so many of them, it must have been easy for the photographer to frame Yosemite National Park from inside the new Wawona Tunnel, completed in 1933. I wasn't sure today's traffic would let me do the same.

After watching lines of cars, buses and RVs passing by, I realized that there would be gaps of a minute or so where I might step out from the narrow sidewalk along one side of the tunnel and rephotograph the view from the center of the road. The unchanged contour of the ceiling helped me find the correct alignment—after several attempts—without a tripod.

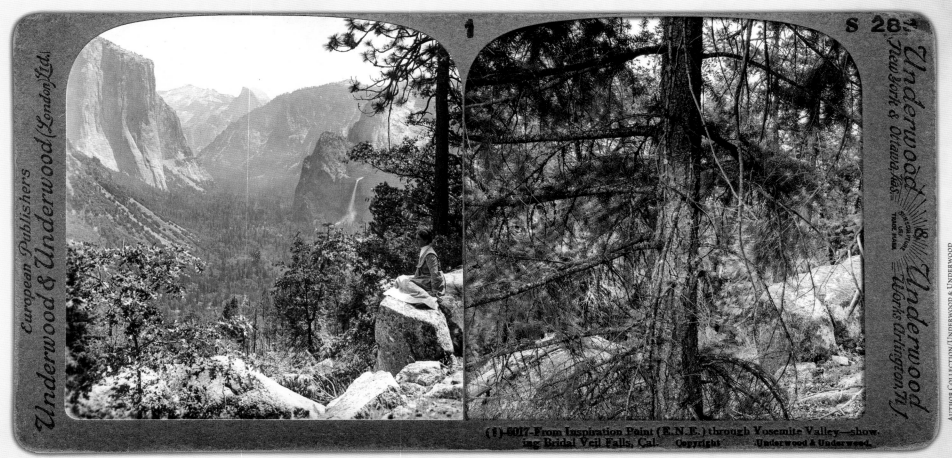

European Publishers
Underwood & Underwood (London, Ltd.)

1 S 28

Underwood
New York & Ottawa, Kas.

Underwood
Works Arlington, N.J.

AUTHOR COLLECTION/UNDERWOOD & UNDERWOOD

(1)-6017-From Inspiration Point (E.N.E.) through Yosemite Valley—showing Bridal Veil Falls, Cal. Copyright Underwood & Underwood.

6/4/14 • 37°42'49" N 119°41'15" W

1902 ~ From Inspiration Point Through Yosemite Valley

Inspiration Point was along the old Wawona Road, used first by wagons and later by automobiles, until today's Wawona Tunnel was completed in 1933. By hiking 1.3 miles up the Pohono Trail from the tunnel I reached this old visitor area. Just above the photo site I found remnants of the old road, parts of it still paved, disappearing a few hundred yards into the forest.

The near-absence of natural fires in Yosemite Valley has resulted in forest growth that has changed the environment over 110 years. Formerly open views of the valley are now closed by ever-encroaching trees, a mass of fuel that will continue to grow until the day when fire may return to the valley whether it is wanted or not.

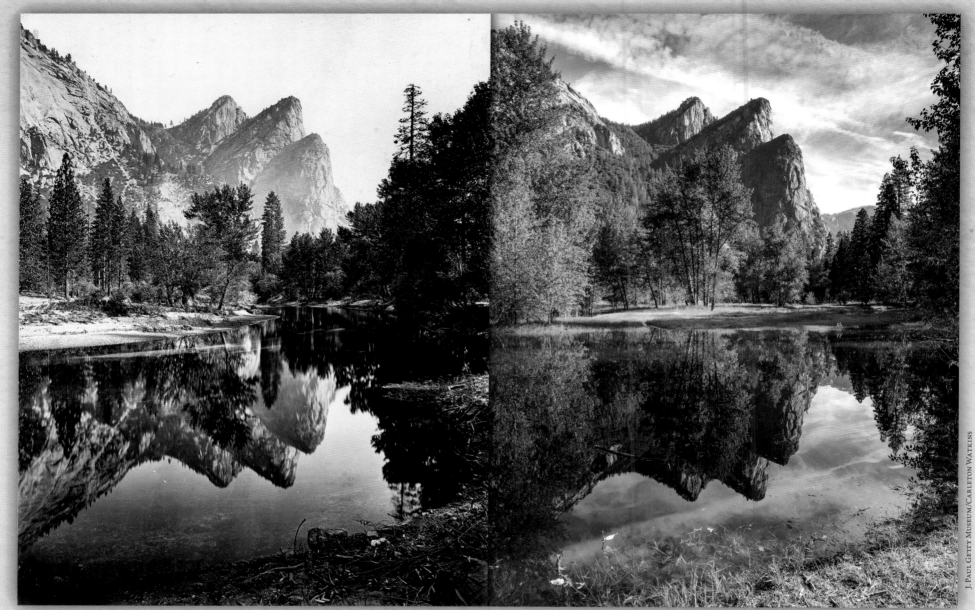

6/4/16 • 37°43'23" N 119°37'17" W

J. Paul Getty Museum/Carleton Watkins

1880 ~ Mirror – The Three Brothers

Preeminent Yosemite photographer Carleton Watkins recorded numerous images at this location over his years in the park. I too returned several times during the four-year period of working on this book. The reflecting pool is an oxbow of the Merced River, and normally dry (in my limited experience). In June 2016, during a period of warm weather, I noticed that the river was rising as snowmelt ran off from the mountains. I returned to this site to find the oxbow gently filling with water from the nearby Merced. In my work of rephotography, I usually don't worry about replicating transitory phenomena such as clouds, snow cover or water features. But at this unusual site I was delighted to experience what Watkins had found 136 years earlier. I wondered if perhaps he too had waited patiently for the river to rise.

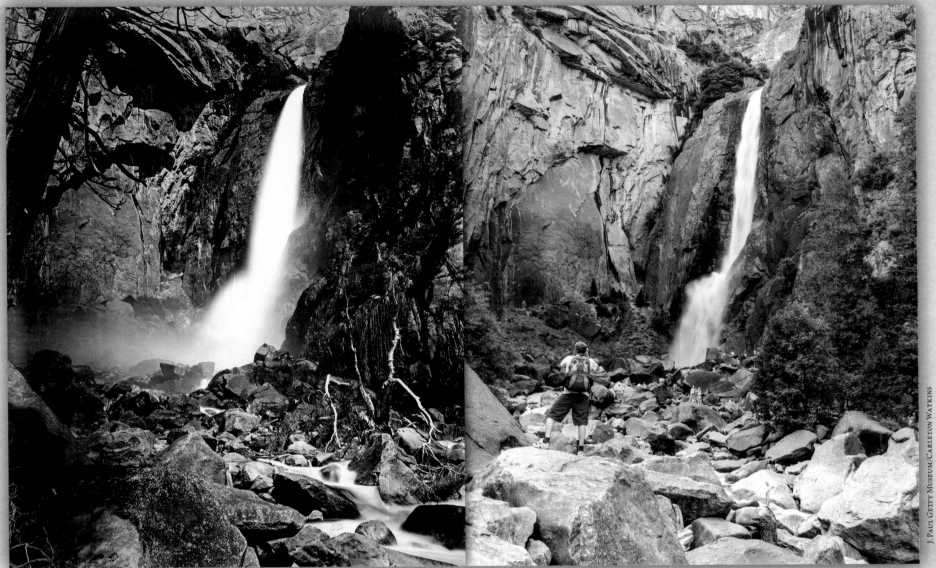

J. Paul Getty Museum/Carleton Watkins

6/8/14 • 37°44′60″ N 119°35′46″ W

1865 ~ Lower Yosemite Falls

Boulders around the base of Yosemite Falls are affected by natural forces of water and ice, and probably by the millions of visitors who have walked around this location. Remarkably, some of the boulders remain virtually unchanged in shape or position since Carleton Watkins set up his camera at this site in 1865.

I was just in front of today's Yosemite Falls footbridge to obtain the angle used by Watkins. The slope at far left in the foreground is a small portion of a huge triangular boulder that I recognized from other historic images taken around the Lower Falls. This helped me discern that another boulder (where another photographer stands in my photo) was the same one nearer to the camera, though its position seems to have shifted. It takes some careful study to pick out these details in a jumble like this, as I gradually tune out the noise of the water and of the dozens of visitors around me. Sometimes, deep in concentration, I get confused about which view is real, the one in my hand or the one in the viewfinder.

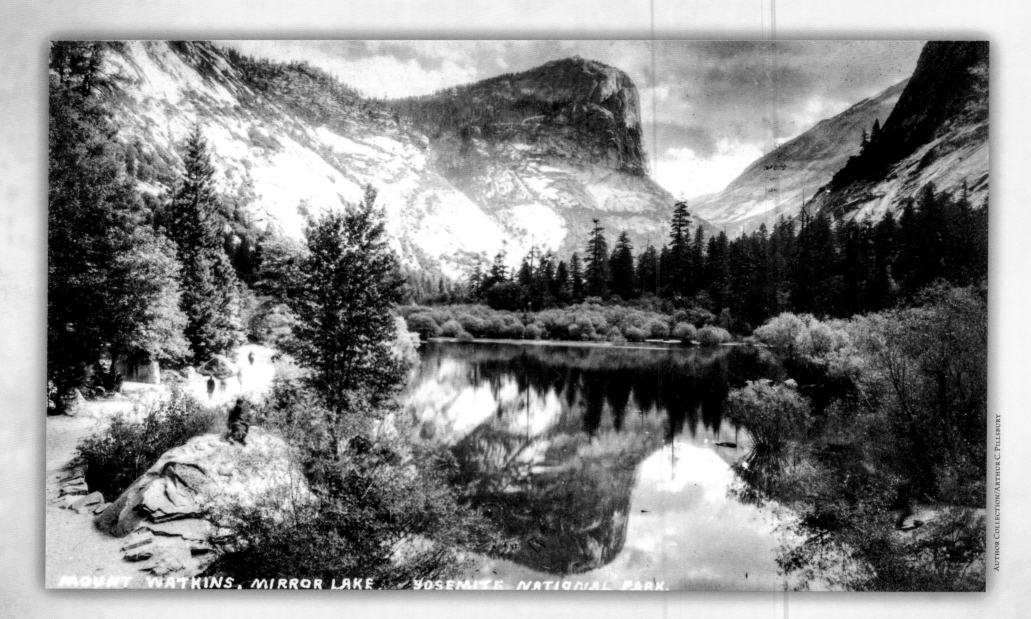

MOUNT WATKINS, MIRROR LAKE — YOSEMITE NATIONAL PARK.

Author Collection/Arthur C. Pillsbury

Circa 1905 ~ Mount Watkins, Mirror Lake

Mirror Lake is a remnant of a large glacial lake that likely filled the Yosemite valley in the centuries following the last ice age. The road around it was used by pedestrians (left) as well as wagons at the time of the historic photo. The reflective lake appears in dozens of historic photos I saw while working on this project. I selected this one because of its composition and because the current view wasn't completely blocked by trees, as it was from other sites.

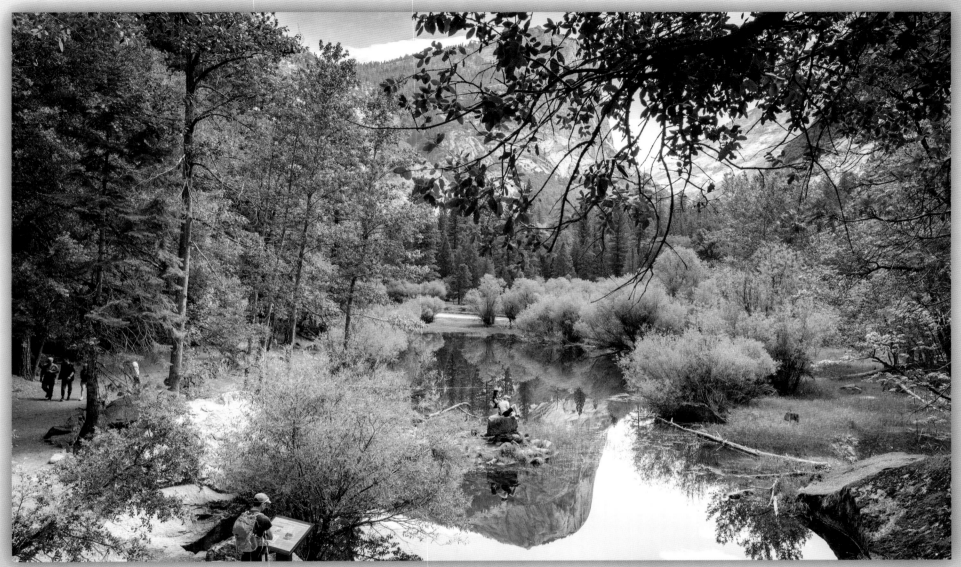

6/4/15 • 37°44'54" N 119°33'2" W

I found photographer Pillsbury's position by perching on a large boulder across the walking path from the lake. I was glad I could still see a reflection, but it looks as if the lake will fill in with sediment in a few decades, barring some other event or action. I could not find documentation about the little peninsula at center, but it appears to have been artificially constructed—perhaps as a photogenic focal point.

Trees and willows obviously do well in this environment and now partially block views of the lake, not just here but from many formerly open locations I examined around the shoreline. The oak growing in from overhead may eventually do the same here.

I'm planning a separate book that would focus exclusively on Yosemite National Park with perhaps another 100 photo pairs from across the park. Please visit www.paulhorsted.com for information.

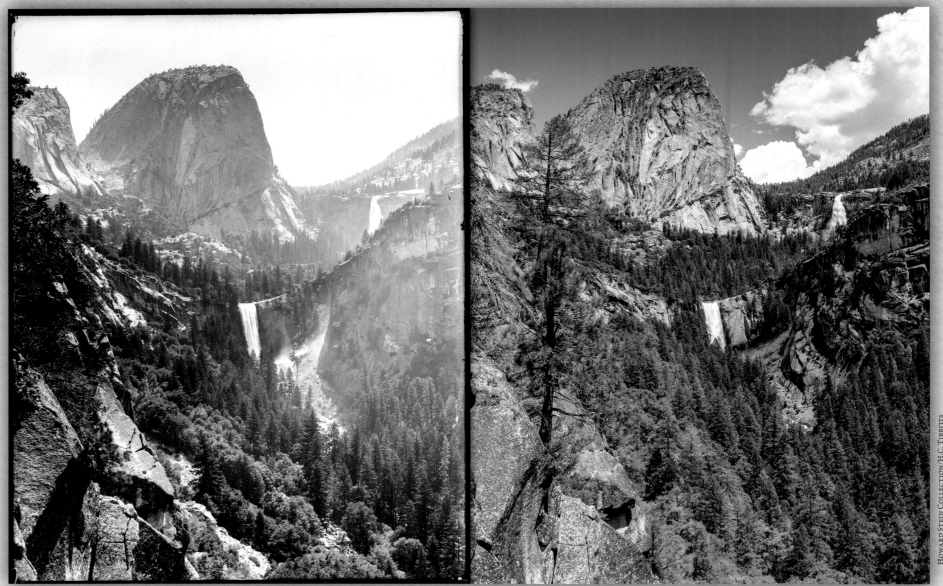

Howard Stein Collection/H.C. Tibbitts

5/27/16 • 37°43'39" N 119°33'19" W • Caution: At Cliff Edge.

1915 ~ View from Sierra Point

I was intrigued by historic photos taken from Sierra Point because it has been abandoned. A large rock slide in the 1970s at its junction with the Mist Trail below meant I had to scramble over large boulders the first 200 yards or so, before I glimpsed an old trail leading up the steep hill ahead. Here I found sections of carefully laid stone steps, so well-crafted that it was sad to see them not being put to greater use.

The little shrub at lower left in 1915 had in 101 years grown to about 10 feet. Bark beetles were starting to infest trees (red = dead) in the valley below.

From this location I could see four waterfalls: Vernal (center) and Nevada (top) as well as Illilouette and Yosemite (both visible in other directions). But on the way here I passed a couple of hair-raising drop-offs, and there is a distinct possibility of missing the trail and becoming lost up here. Do not attempt this as a casual hike.

California.--Yo-Semite Valley

John P. Soule, 199 Washington Street, Boston. Entered, according to Act of Congress, in the year 1870, by John P. Soule, in the Office of the Librarian of Congress, at Washington, D. C.

Author Collection/Publisher John P. Soule/Martin M. Hazeltine

1212. Vernal Fall, (350 feet high) and Cap of Liberty. 4600 feet above Valley.

6/6/14 • 37°43'35" N 119°32'49" W • Caution: Fast-moving Water.

Circa 1870 - Vernal Fall & Cap of Liberty

I worked my way very, very carefully over river-side boulders to reach this site, perhaps a hundred yards off the Mist Trail. (Note hikers up on the trail at right in the modern view.) To precisely match the historic photo (with the pointed foreground boulder and other landmarks correctly aligned), my tripod had to be positioned quite low, just behind a nearby boulder. It is likely that the much larger historic glass-plate camera was placed directly on the boulder, a technique I've deduced at other photo sites. Here at the edge of the roaring Merced River, it took about 90 minutes of test shots to work this out. I rephotographed this view during my first visit to Yosemite and it remains one of my favorites.

Although John P. Soule is credited on the mount as the stereoview photographer, he apparently purchased and published negatives originally made by Martin M. Hazeltine, a common practice among early photographers.[36]

The large tree to the right of the falls broke off in stages over time. It's partly intact in photos taken around 1920, but only a tall stump remains today. Despite that loss, tree cover is generally increasing in this scene, as it is in other areas of Yosemite.

2655 Yosemite, Cal.—the big tree room in Barnard's Hotel. Taber Photo, San Francisco.

Henry Art Gallery, U. of Washington/I.W. Taber after Carleton Watkins

Circa 1875 ~ The Big Tree Room in Barnard's Hotel.

This image bears the mark of Isaiah Taber, but was likely created by Carleton Watkins. Taber published many of Watkins' Yosemite negatives, acquiring them after Watkins went bankrupt around 1873.

I found references to the existence of this tree (now a tall stump) online, and located the site of the room built around it south of the Sentinel Bridge, just visible in the background of the modern photo.[37]

5/22/15 • 37°44'34" N 119°35'24" W

Looking around the base of the tall stump, I was very surprised to find a flat rock in the foreground that I realized had been the hearthstone of the fireplace in the original photo. This landmark helped me understand which side of the tree faced the room, and to accurately align the modern photo.

Later I discovered discreet brass markers on boulders around the stump, documenting corners of the room, which was attached to Barnard's Hotel (also known as Hutchings House at other times).

Author Collection/Keystone View Co./Unknown Photographer

Keystone View Company
Copyrighted, Underwood & Underwood
Manufacturers MADE IN U.S.A. Publishers

Meadville, Pa., New York, N. Y.,
Chicago, Ill., London, England.

V26060 T The Glorious Yosemite Valley, from Glacier
Point, Calif.

5/29/16 • Approx. 37°43′51″ N 119°34′28″ W • Caution: At Cliff Edge.

Circa 1925 ~ Glacier Point, Overhanging Rock, Half Dome

I found this site, away from the bustling overlook used by most visitors at Glacier Point, by starting down the Four Mile Trail and entering the woods. The area may be closed at times by the National Park Service, which has communication equipment in the area, but there were no "closed" signs when I visited. In fact, an obvious social trail carved out by numerous visitors led me to the cliff edge where the historic image was taken. Old-style fencing, perhaps from the 1950s, was still in place just off-camera. Judging from the number of historic photos I've seen that were taken here (with and without crazy tourists posing on the overhanging rock), this site has been visited by countless early photographers and visitors.

Note that this is *not* the same overhanging rock seen from the Glacier Point overlook about 100 yards above (opposite page). More than one of these overhanging rocks reach out from this mind-boggling cliff.

AUTHOR COLLECTION/H.C. WHITE

663 From Glacier Point across the valley to the Yosemite Falls, Yosemite Valley, Cal., U.S.A. Copyright 1904 by H. C. White Co.

5/31/15 • APPROX. 37°43'50" N 119°34'25" W • STAY BEHIND RAILING.

1904 ~ From Glacier Point Across the Valley to Yosemite Falls

This historic image was taken at the very edge of the cliff at Glacier Point, at the far left corner of what today is a fenced-in overlook. To create the matching image, I swung my tripod over the railing and balanced it on a small ledge on the other side, tying the tripod to the railing with a strap to avoid any chance of it getting loose. Then I only needed to make small adjustments up and down to get the exact angle of this other overhanging rock.

Where those early fearless (foolish?) visitors stood is within a closed area today for obvious safety reasons. If anyone wants to stand on a cliff edge where death is inches away, there are plenty of other places in Yosemite to do so without ruining the view for 200 people at an overlook.

BEINECKE RARE BOOK AND MANUSCRIPT LIBRARY, YALE UNIVERSITY/DETROIT PHOTOGRAPHIC CO./WILLIAM HENRY JACKSON

1898 – Half Dome & Glacier Point

This is another color-tinted "Photochrom" print (see page 176) typical of the later work of famed western photographer William Henry Jackson, who at this time in his career was a partner in the Detroit Photographic Company. An exclusive Swiss color-printing process allowed the company to represent black-and-white views in realistic color for prints and postcards. Jackson set up his camera on the edge of the Four Mile Trail, which runs from Glacier Point (upper right) down to the valley floor.

5/24/14 • 37°43'51" N 119°34'43" W

I shot this image at the end of a long day, after a hike to Union Point and back. I had scouted the location on my way down, but the light at that time was flat and uninteresting. After working most of the day at other photo sites along the Four Mile Trail, I passed here again near sunset and saw that the clouds had lifted until they covered only the highest points of Half Dome. I photographed here for over an hour as the sun beamed through cloud openings.

Note that both of Glacier Point's overhanging rocks (shown on the previous spread) are in view from this vantage point. Many of the same trees still stood here after 116 years.

U.S. GEOLOGICAL SURVEY/F.C. CALKINS

OPPOSITE: 6/7/14 • 37°44'48" N 119°31'48" W

1915 ~ Northeast Side of Half Dome, Exfoliation

The historic photo was published in a 1930 report by the U.S. Geological Survey to illustrate the onion-like shedding of layers of rock, known as exfoliation, seen clearly at Half Dome. I added an arrow pointing to two climbers, whose rope is faintly visible along the route established by George Thompson in 1875.

Today the Half Dome cables guide thousands of people who follow that route each year. Aggressive squirrels (like the one at left in the new photo) have learned to dig into backpacks left by climbers wanting to reduce their load for the final ascent.

My guide on my own first Half Dome ascent was Braden, the young man in the foreground of the modern photo. He honored his 53-year-old client by declaring "you're gnarly!" at the end of our 14-mile Half Dome hike. It's a compliment I will always treasure.

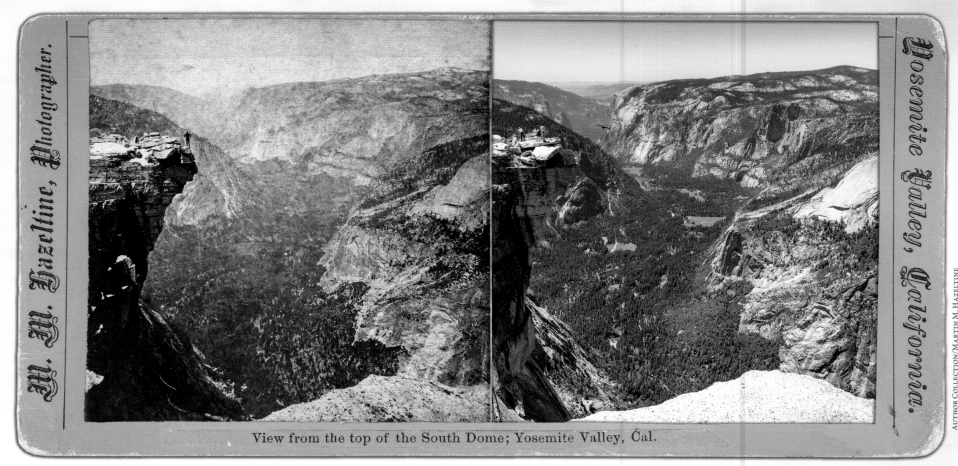

View from the top of the South Dome; Yosemite Valley, Cal.

5/27/15 • 37°44'46" N 119°31'59" W • Caution: At Cliff Edge.

1877 ~ View From the Top of the South Dome

After seeing low-quality reproductions of this ste-reoview on the Internet, I was excited to find an original offered at an online auction site, and even more delighted to reach the location myself a few months later. I paid a pretty penny for the historic image, but recognized that it likely shows pioneering climber George C. Thompson standing on a formation called the Visor at Half Dome, overlooking Yosemite Valley.

"South Dome" is an historic name for Half Dome, and Thompson was the first person to reach the summit, in October of 1875. One source says that Martin M. Hazeltine took photos of Thompson "on his third ascent" in 1877.[38] Obviously Thompson was a man with no fear of heights.

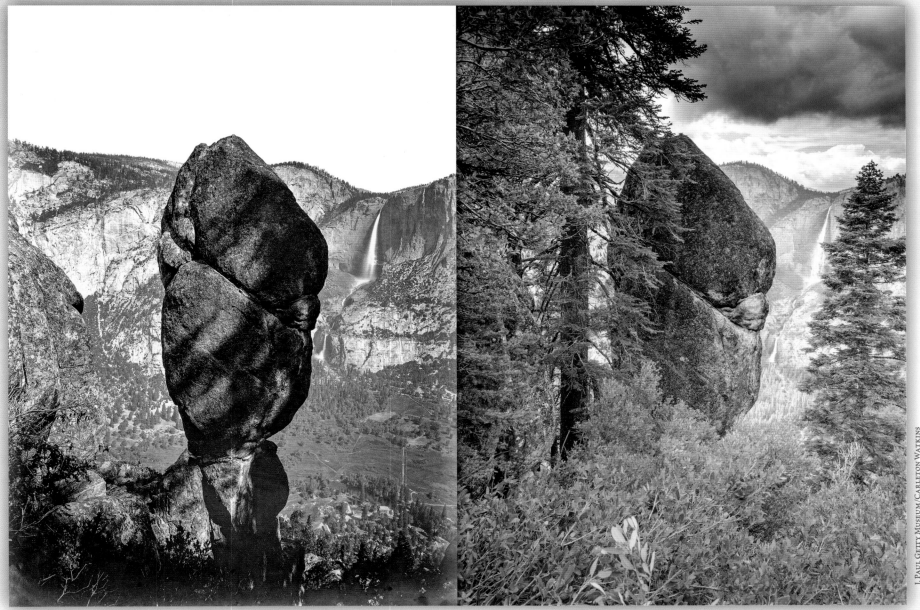

J. Paul Getty Museum/Carleton Watkins

5/24/15 • 37°44'6" N 119°35'15" W • Caution: No Trail, Steep Slope, Dense Vegetation.

Circa 1878 ~ Agassiz Rock and the Yosemite Falls FROM Union Point

Union Point is close to midway on the Four Mile Trail. A short spur (marked by a sign) leads from the main trail out to the point.

Getting to Agassiz Rock is another matter entirely. This unique formation is quite *near* Union Point, but today is surrounded by trees and manzanita bushes. To acquire the view I found myself bushwhacking off the spur trail. I literally got down on my hands and

knees and crawled through the undergrowth, then got up and climbed over more of it while searching for this site on a steep hillside below Union Point. Crouching down again to peer under bushes, I could see very old man-made rock walls and an abandoned, overgrown section of an earlier Four Mile trail, now bypassed. This is not a casual hike, and there are cliffs below, so use caution if you are determined to go take a look.

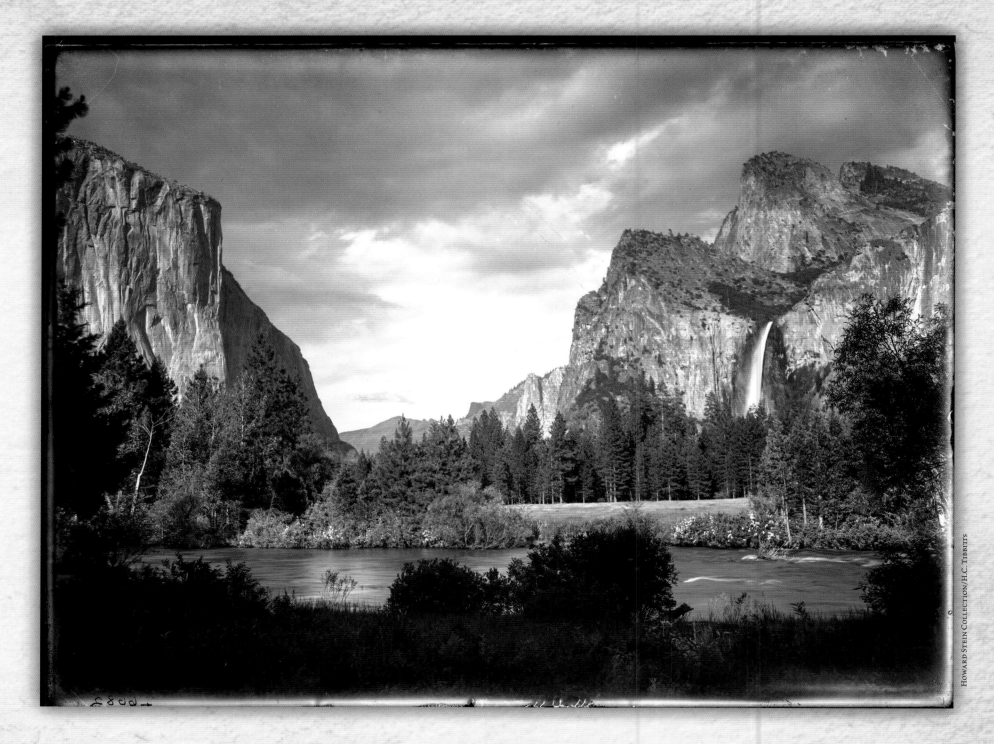

Howard Stein Collection/H.C. Tibbitts

1915 ~ Valley View

A classic view of Yosemite Valley, framed by El Capitan at left and Bridalveil Fall, was recorded by Howard Clinton Tibbitts on an 8x10 glass-plate negative. Several of Tibbitts' Yosemite and Grand Canyon images appear in this book. Early images of this area are sometimes titled "Rocky Ford" rather than "Valley View."

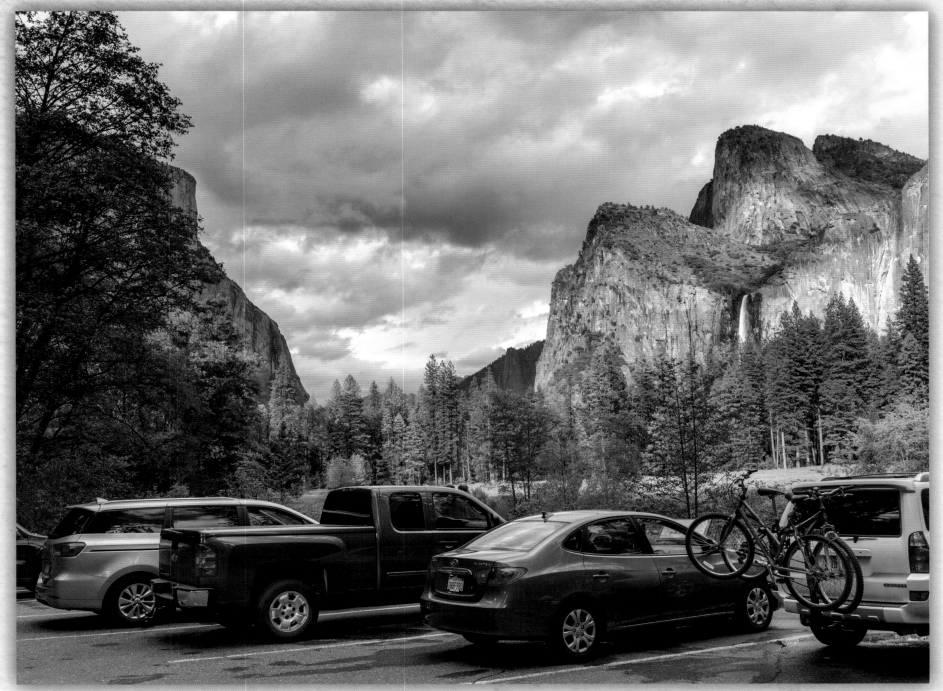

5/25/16 • 37°43′2″ N 119°39′43″ W

I was tempted to shoot the background as clouds began to break and beautiful light poured over the valley. But the Tibbitts image pointed me to the rear of today's parking area, so I backed up until the landmarks matched more precisely. The shrubs and natural surface of the former meadow have been "hardened" with pavement, and cars now block the view of the Merced River. Trees are more numerous and taller today, but some are dying from a pine bark beetle infestation.[39] The red, dying trees seen here were still green when I visited this location less than a year earlier.

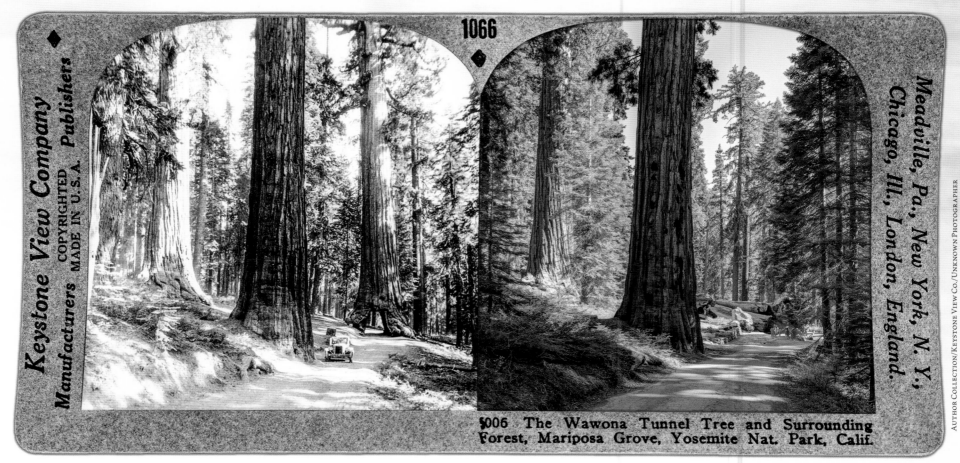

Keystone View Company
COPYRIGHTED Publishers
MADE IN U.S.A.
Manufacturers

Meadville, Pa., New York, N. Y.,
Chicago, Ill., London, England.

AUTHOR COLLECTION/KEYSTONE VIEW CO./UNKNOWN PHOTOGRAPHER

1066

5006 The Wawona Tunnel Tree and Surrounding Forest, Mariposa Grove, Yosemite Nat. Park, Calif.

5/26/14 • 37°30′55″ N 119°35′42″ W

Circa 1935 ~ The Wawona Tunnel Tree ᴀɴᴅ Surrounding Forest

My family and I hiked up to this site from the parking area at Mariposa Grove. Back in the day, a system of roads allowed wagons (and later cars) easy access to the Sequoias of Yosemite here. Today these old roads are used only for hiking; even the noisy motorized trams that once carried visitors to certain parts of this area were recently discontinued as part of a restoration project in the Grove.

An obvious change from the past is that the road—now a trail—is paved. Oh, yes, and that the 2,100-year-old (NPS estimate) Sequoia fell over during the severe winter of 1968-69. I was surprised it had lasted so long after being tunneled through in 1881. We are fortunate that the old practices of tunneling trees, feeding bears, pushing "fire falls" over cliffs, and routing cars and noisy shuttles through peaceful forests have gradually given way to the priorities of preservation and leaving nature, well, more natural.

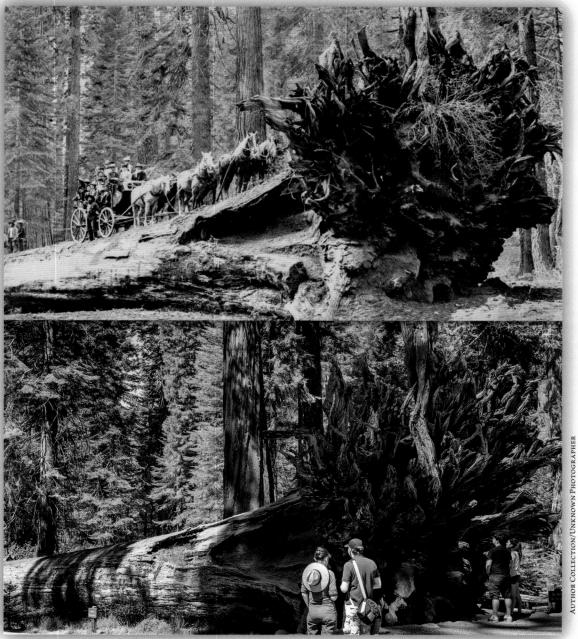

AUTHOR COLLECTION/UNKNOWN PHOTOGRAPHER

6/4/14 • 37°30'9" N 119°36'32" W

Circa 1900 ~ The Fallen Giant

The National Park Service says that this Sequoia tree fell several hundred years ago, but that it remains well-preserved due to tannin in the wood. It's located 100 yards from the parking area at Mariposa Grove.

Numerous historic photos show tourist-loaded wagons and carriages parked on the trunk; today, climbing on the trunk is discouraged to aid in its preservation. As this book was going to press, the Mariposa Grove was undergoing a major restoration, including the conversion of old roads into hiking trails as well as other improvements. I look forward to a nice, quiet hike around the Grove in the future.

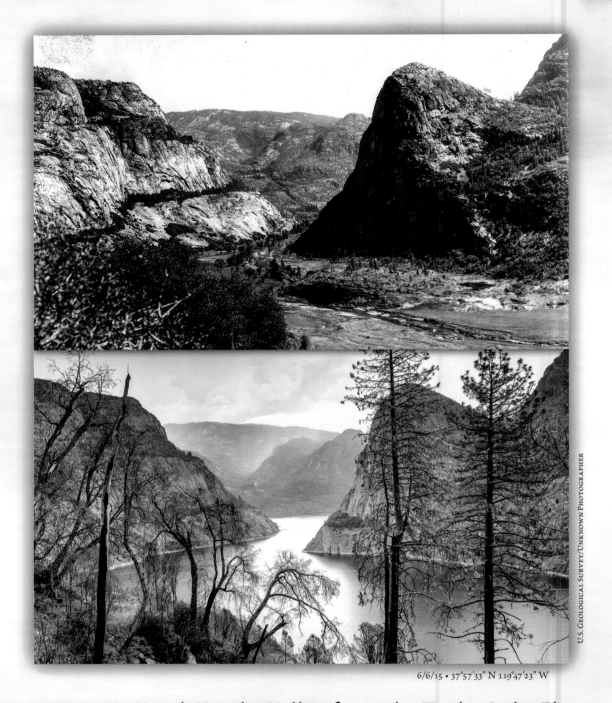

U.S. Geological Survey/Unknown Photographer

6/6/15 • 37°57′33″ N 119°47′23″ W

Circa 1914 ~ Up Hetch Hetchy Valley from the Trail to Lake Eleanor

What started on a beautiful day as a leisurely hike across the dam and up a trail on the northwest side of Hetch Hetchy Reservoir turned into a race against an incoming thunderstorm. I found this site just below the fourth switchback from the lakeshore. I took my photo, checked it on my laptop computer, and quickly retreated down the trail as the storm hit the other end of the reservoir.

The area is more open following the 2013 Rim Fire, which left dead or dying trees that might have previously blocked this view of the lake.

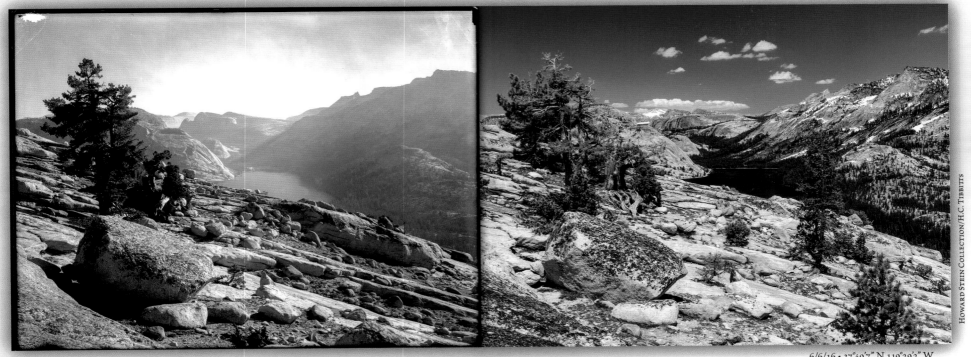

6/6/16 • 37°49'7" N 119°29'2" W

HOWARD STEIN COLLECTION/H.C. TIBBITTS

1915 ~ Tenaya Lake — Tioga Road

It was obvious that Tibbitts had climbed to some high vantage point for this view, and I was able to identify an initial search area by looking at maps and Google Earth before I traveled to Yosemite. On a June day in 2016 (my last in Yosemite while working on this book, on my way out of the park), I parked at Olmsted Point and started hiking up a granite dome high above the Tioga Road. After a couple of false starts, then backtracking, and after climbing for about a mile, I reached a summit where Tenaya Lake came into view, in nearly the same perspective that I could see in the Tibbitts view. Searching around the top, I recognized the foreground boulder as well as the large tree at left, in decline but hanging onto life after perhaps centuries on this rocky summit. Even more interesting to me was the small tree immediately to the right of the boulder; it has only grown a few inches in 101 years, yet it too clings to life on the granite. There are other trees like it here as well.

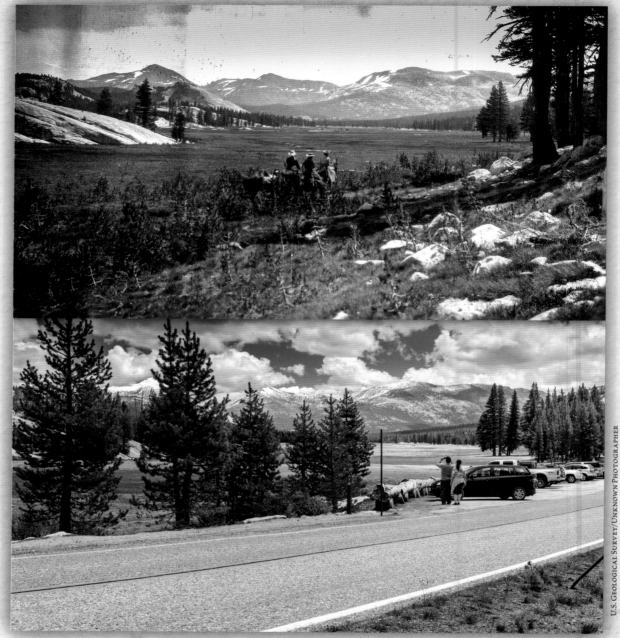

U.S. Geological Survey/Unknown Photographer

6/7/15 • 37°52'37" N 119°23'41" W

1903 ~ Tuolumne Meadows of the Upper Tuolumne Basin

Unidentified riders pause for an unknown photographer at the west end of Tuolumne Meadows in the historic image. They seem to be riding along an established trail, roughly where Tioga Road is today. As I waited near the site in a ditch along the highway, I realized that some of the trees now blocking the view of Pothole Dome at left are probably among the seedlings in the historic photo. A group of mature trees at center right are obviously still present today as well, but the rocky foreground hillside seems to have been obliterated during some stage of highway construction.

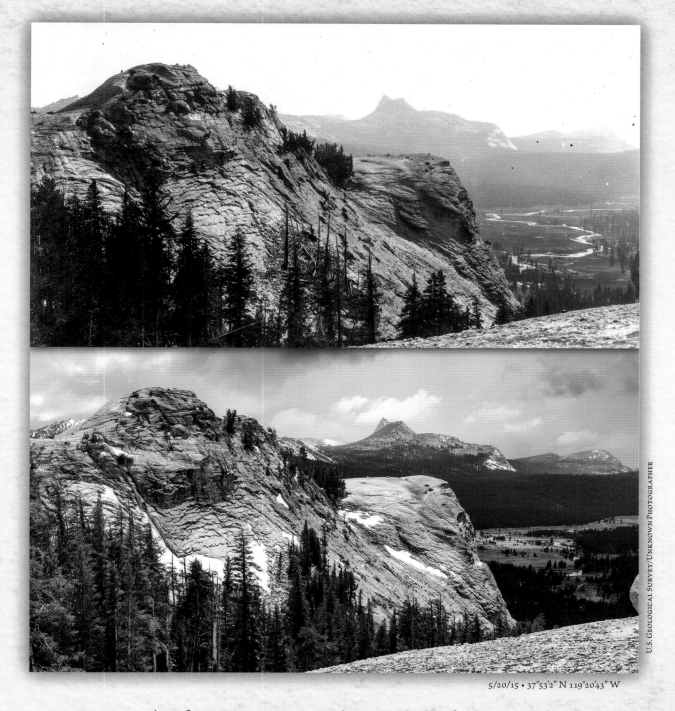

U.S. Geological Survey/Unknown Photographer

5/20/15 • 37°53'2" N 119°20'43" W

1903 ~ Chief Summit of Lembert Dome from Northeast

After I climbed Lembert Dome at left (I recall thinking I'd save Cathedral Peak in the distance for another day) I hiked over to find this photo site on a shoulder or sub-dome of Lembert. The view reveals an increase in tree density in the foreground as well as across Tuolumne Meadows below. Hiking up and across these domes is pleasant and recommended if you visit this part of Yosemite.

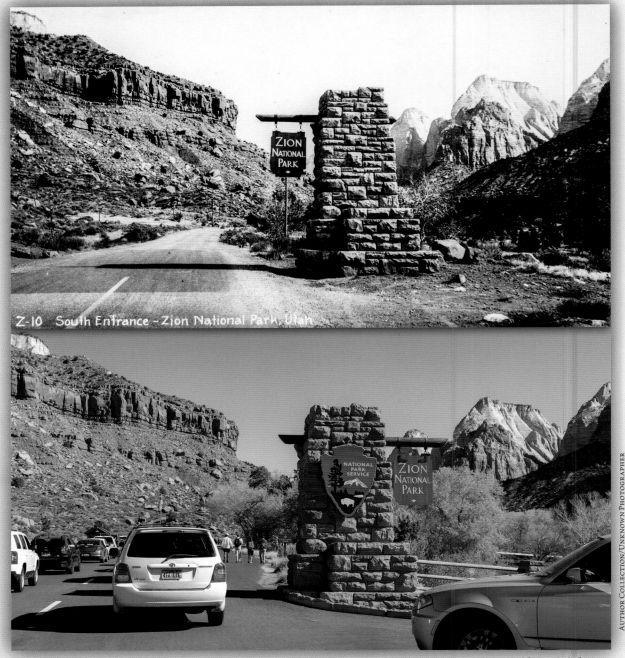

Z-10 South Entrance ~ Zion National Park, Utah

3/19/16 • 37°12'4" N 112°59'19" W

Author Collection/Unknown Photographer

Circa 1936 ~ South Entrance — Zion National Park

I stood in the roadway to accurately rephotograph this scene, originally taken from the edge of the historic road just outside Zion National Park. This wasn't too difficult on a day when the traffic behind me was backed up almost into the town of Springdale and moving very slowly. The entrance pillar appears to be original, although moving the sign to the right side was probably a good idea once RVs and other vehicles got large enough to come into contact with a hanging obstacle.

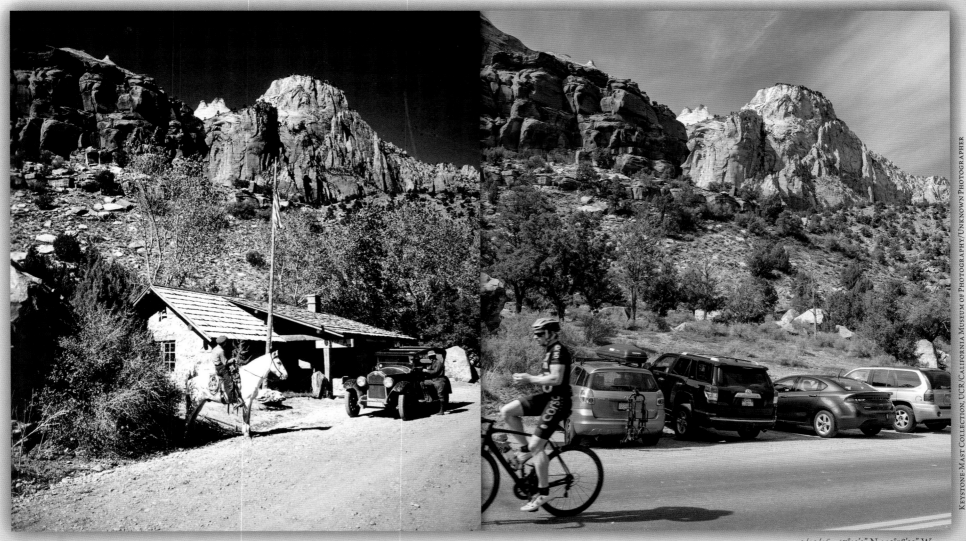

Keystone-Mast Collection, UCR/California Museum of Photography/Unknown Photographer

3/19/16 • 37°13′2″ N 112°58′33″ W

1925 ~ From Highway looking to Ranger Station and Sentinel Peak

After I found the background of this image and began working my way closer, I was pleased to see a distinctive boulder still in position at right. It helped me align my camera precisely.

The sign on the front post of the historic building reads "STOP Drivers Must Register Here." This seems to have been a check-in station, about 1.5 miles up the canyon from today's entrance. This wide spot in the road now has parking for a few cars, and there is no sign of the historic structure.

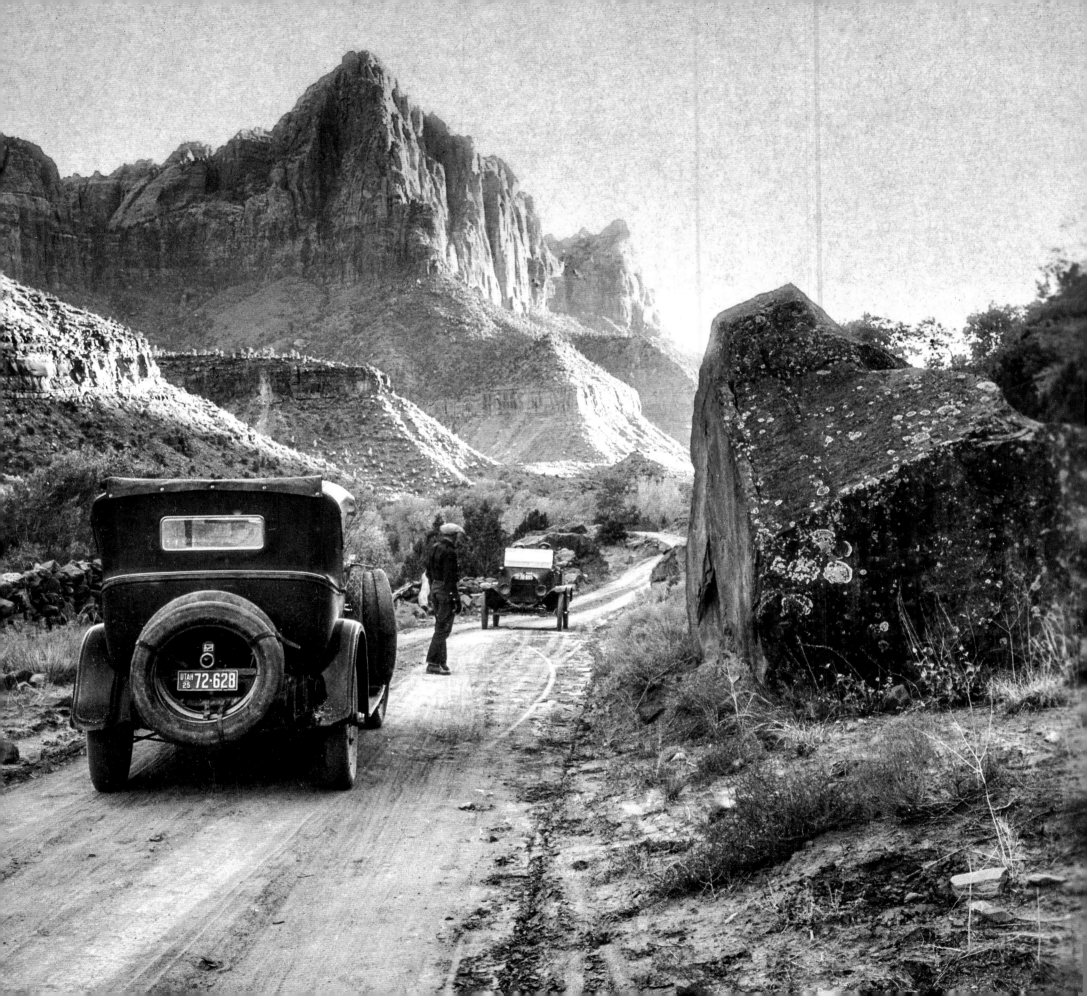

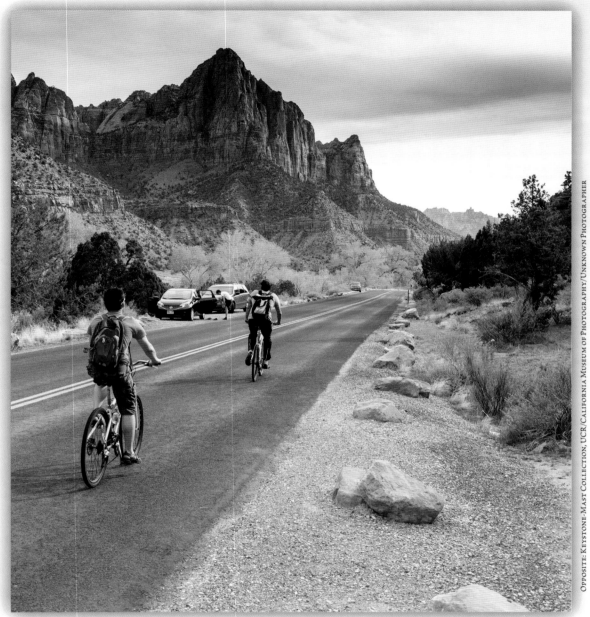

Opposite: Keystone-Mast Collection, UCR/California Museum of Photography/Unknown Photographer

3/19/16 • 37°12′51″ N 112°58′39″ W

1925 ~ The Watchman at Sunset

I searched up and down today's Zion Canyon Scenic Byway. I also looked in the woods nearby. But I could not find the large boulder seen in the historic photo, which I had assumed would still be in place. Careful study and the alignment of background landmarks point to this location, and it's logical that the road would not have been moved far from its original route.

I finally had to conclude that the boulder is gone, apparently removed when the highway was upgraded at some point in the past.

The year "1925" on the back of the historic photo is confirmed by the license plate on the old car, which has no fewer than five spare tires on board. Perhaps the highway upgrade was a good idea after all.

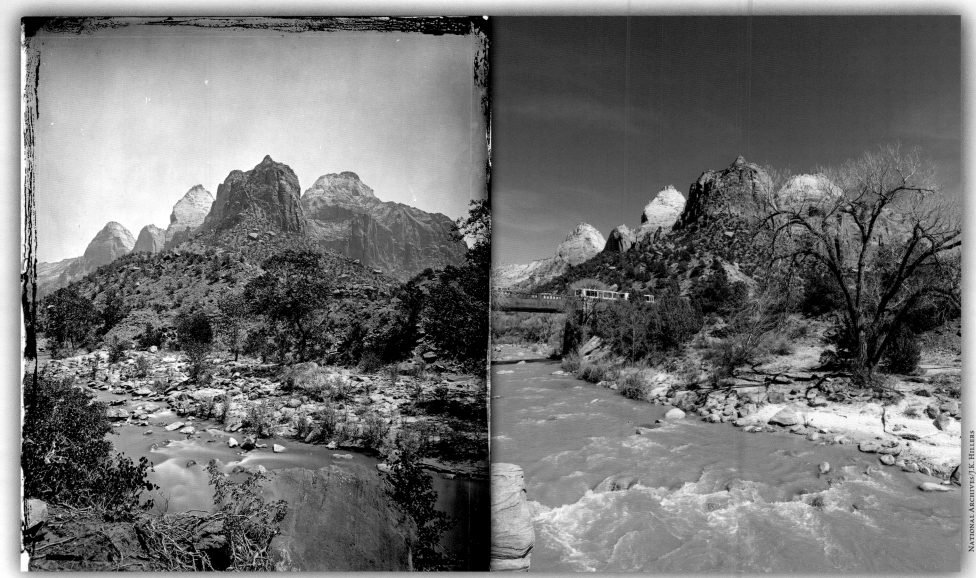

National Archives/J.K. Hillers

3/19/16 • 37°13′1″ N 112°58′32″ W

Circa 1872 ~ Castle Domes, Peaks from Sun Mountain to East Temple

I had visited the sites of photos taken by J.K. Hillers in the Grand Canyon (pages 93 and 96). Now I followed him around Zion. The location of his camera in this vicinity seems to have been washed out by flooding. I couldn't find the exact vantage point, but selected a large boulder near the Virgin River, very close to the historic site. (It may even have been the same boulder, moved a few feet by rushing water; if that seems hard to believe, see page 222.) In view here are several prominent Zion features, including Mountain of the Sun on the left, East Temple on the right, and the Twin Brothers as well as Mt. Spry between them. A bridge now carries traffic across the river, where visitors can continue up the canyon to the left or turn right to leave the park on the Zion-Mt. Carmel Highway.

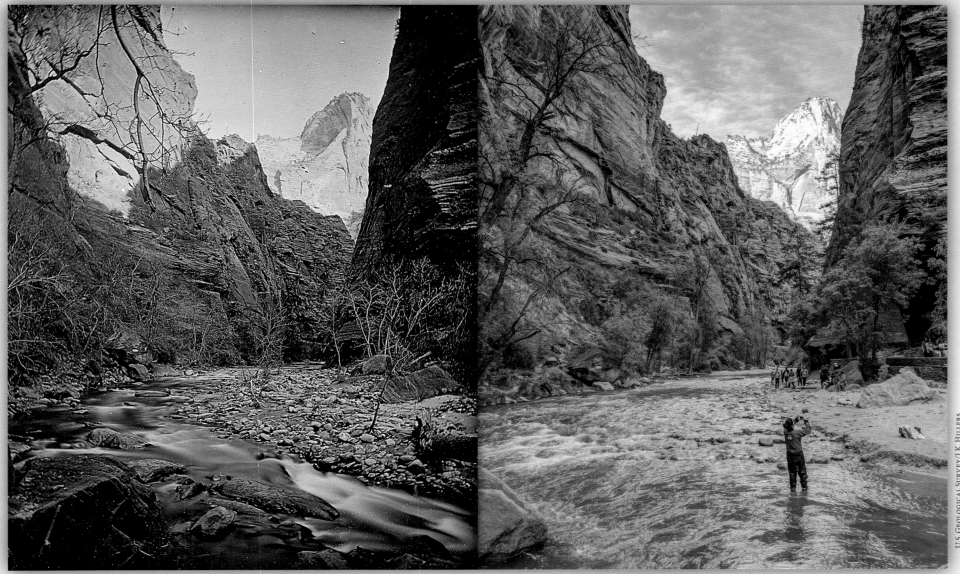

5/14/13 • 37°17'48.40" N 112°56'53.98" W

U.S. Geological Survey/J.K. Hillers

Circa 1872 ~ Head of the Narrows, North Fork Virgin River

The title of this photo led me to an area of Zion called the Narrows—the narrowest portion of Zion Canyon—and a trail that eventually requires wading in the Virgin River. Exiting a shuttle bus about a mile downstream, I followed a line of my fellow hikers along Riverside Walk to the point where the trail enters the water. A few people were wearing wet suits or other gear for protection from the chilly river. Looking around the beach at right, I realized I was standing in front of a triangular boulder visible in the historic photo. Here was one case where I found the foreground landmark before seeing the background of an historic image. I waded across the river "off trail" (as the others headed up the canyon, in the river but "on trail") and climbed a pile of boulders to achieve a view similar to that of the original image. The distant peak is enticingly named: Mountain of Mystery.

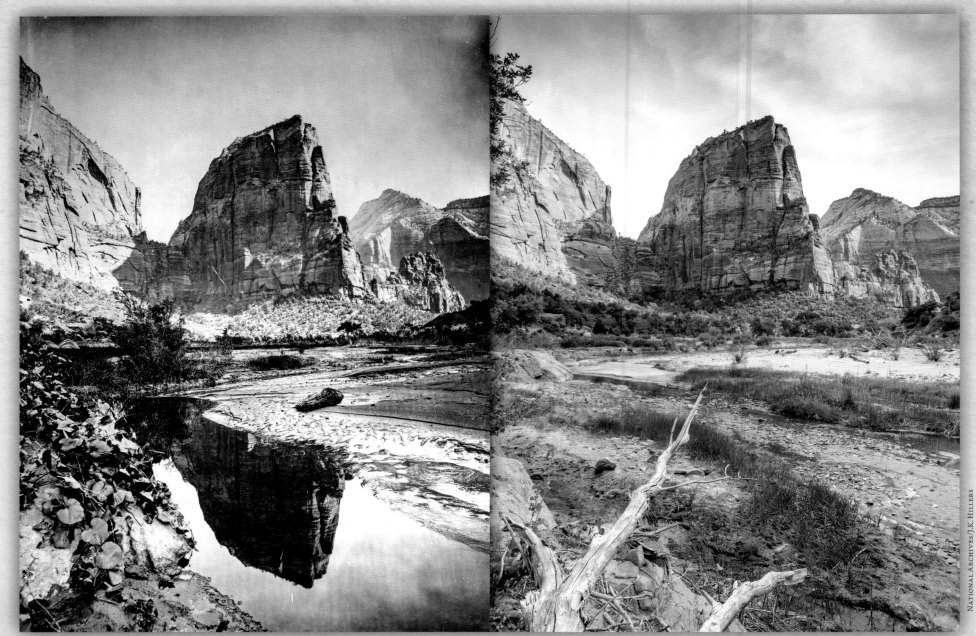

National Archives/J.K. Hillers

5/5/13 37°15'40" N 112°57'2" W

Circa 1872 ~ Reflected Tower, Virgin River

There was a little water flowing in the foreground when I located this site but, today at least, this is only a side branch of the Virgin River. So I didn't find the reflection I'd hoped for on my visit in May.

The "tower" of the photo's title is known today as Angels Landing. The West Rim Trail now runs behind the camera point and up through the gap at left, eventually reaching the summit of this impressive formation.

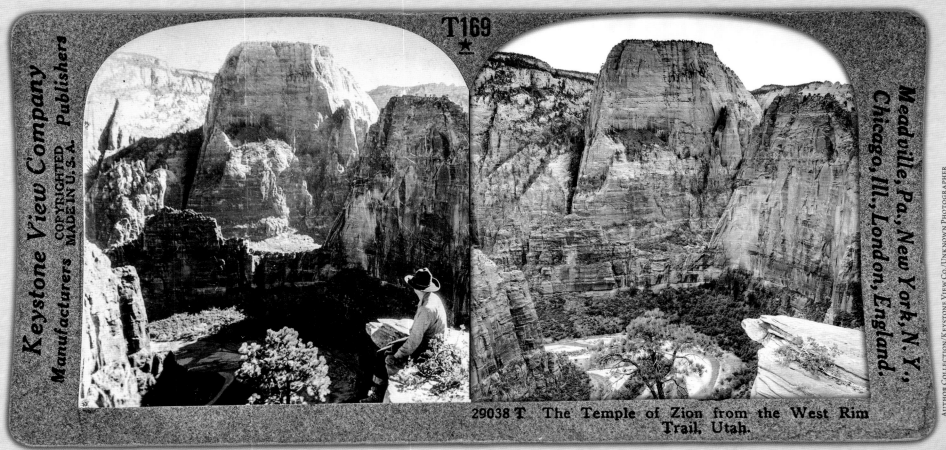

Keystone View Company
Manufacturers MADE IN U.S.A. COPYRIGHTED Publishers

T169

29038 T The Temple of Zion from the West Rim Trail, Utah.

Meadville, Pa., New York, N.Y., Chicago, Ill., London, England.

AUTHOR COLLECTION/KEYSTONE VIEW CO./UNKNOWN PHOTOGRAPHER

5/5/13 • 37°16'39" N 112°57'0" W • Caution: Cliff Edge Nearby.

1925 ~ The Temple of Zion from the West Rim Trail

I was able to project the approximate location of this site along the West Rim Trail by using Google Earth. About two miles up the steep trail from the parking lot (passing the spur trail to Angels Landing on the way), I found this cliffside point where the cowboy sat with his legs dangling over the edge about 1,200 feet above the canyon floor. I noted the tree still growing at center, having sprouted from the cliff face a few yards below the rim. As the stereoview caption indicates, the Temple of Zion is at center, while Angels Landing is at right.

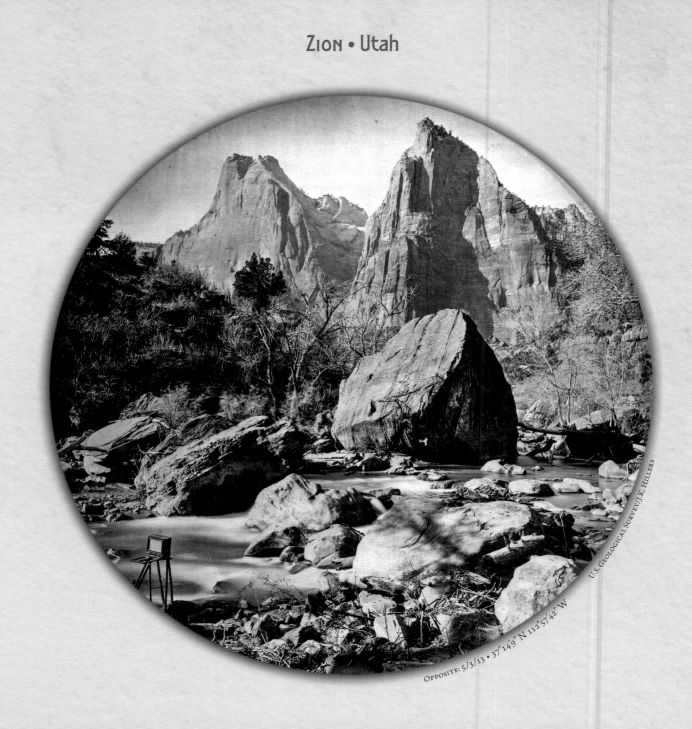

Opposite: 5/3/13 • 37°14'9" N 112°57'42" W

U.S. Geological Survey/J.K. Hillers

Circa 1872 ~ South Face of the East Peak of the Three Patriarchs

I located the correct viewing angle for these two of the Three Patriarchs peaks, and expected to find the large boulder in the middle foreground as well. However, a park ranger told me that over the years he had seen the Virgin River—at its highest flood levels—crest well above the boulder's height, and that he "could hear rocks tumbling in the current" during those floods. Given that sandstone is the dominant rock type here,

perhaps it's not surprising that this truck-size boulder is missing, likely broken into smaller pieces that are now somewhere downstream.

This image is dated 1872 by the U.S. Geological Survey. The round-format print is unusual. Kodak invented a round-format amateur-level camera in 1888, but some earlier method seems to have been used here.

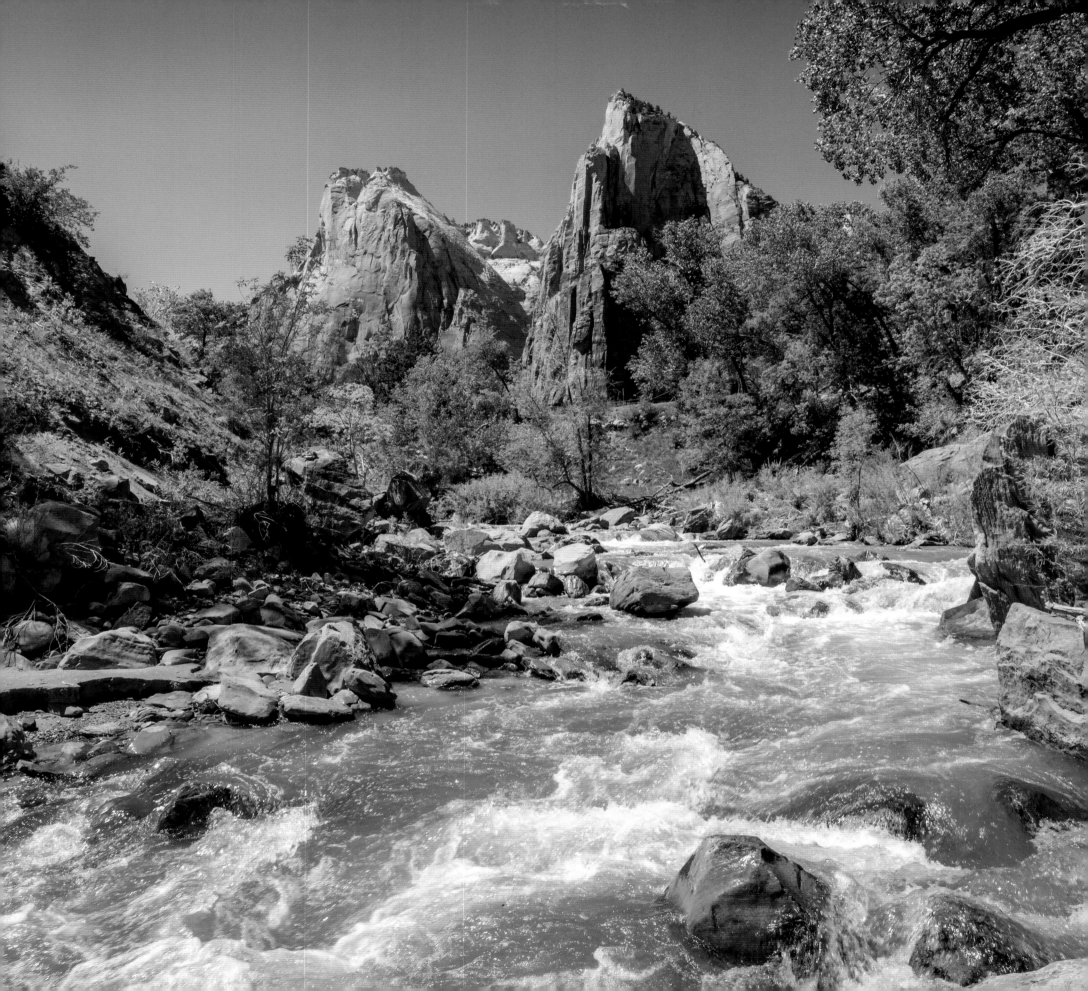

When I started thinking about a book featuring two dozen national parks across the country, the idea was exciting but also intimidating. It's a challenge to merely visit that many parks, let alone spend substantial time in each one searching vast areas for historic photo sites and creating matching images. I wasn't sure I could do it in any reasonable timeframe, but my experience in producing other books of this type (see Introduction, page 6) had taught me that almost anything was possible if taken one step at a time. So I began by looking at a map of the National Park System, hoping to create a list of priorities and determine what I might be able to accomplish in a book like this.

I decided early on to limit my initial list to the 59 "national parks," setting aside monuments, memorials, historic sites and other categories within

Tracking down an 1872 photo site in Zion.

the National Park System, which currently has 417 units of various designations. From that 59, I winnowed the roster to parks that were among the earliest admitted to the system. Finally, as an artistic decision, I considered which parks were the most appealing—to me, at least—in terms of the variety in their landscapes. At last I had a list of the 24 parks found in the table of contents. It's not that the other 35 don't deserve to be included in a book like this; it was simply a limit on my resources and time that caused me to draw the line. I also knew a book with 24 parks would still be sizable and able to stand on its own.

It took me four years to visit and rephotograph the 170 sites in this book, plus another 250 or so views that didn't make it into these pages. Many of those views can be found on my website, paul-horsted.com, but I would certainly consider adding a second volume if this book proves popular enough. It has truly been the project of a lifetime, and I'm thrilled to see it nearing completion as I write this. Sales of our other books continue to help underwrite projects like this one, and I am grateful to you, the reader, for your interest. I self-publish the books with my wife and book designer, Camille Riner, assisted by our daughter Anna Marie. Please visit my website or my social media pages, or look me up on Amazon.com if you'd like to support our work with the purchase of other titles. If you like this book, I think you'll find those volumes interesting as well.

Developing the project

I was 51 years of age when I started this project and 56 by the time it went into print. Before starting, I had visited only five of the parks on my final list, mostly as a casual tourist. So I began my research by acquiring guidebooks and reading online information about each park I intended to visit. I made lists of prominent feature names, tried to get

Cold and windy but sunny above the clouds at Haleakalá.

a sense of each park's history, and studied maps of major roadways and trail systems.

I have been a member of Search and Rescue in the Black Hills of South Dakota for nearly 20 years, so I know my way around the woods. But while I had done some hiking, I had never done a lot of backpacking and backcountry camping, which would be required if I didn't want this to be a "drive-by" project. Looking at historic photos, I came to understand that there were many remote locations—from the bottom of the Grand Canyon to the top of Yosemite's Half Dome—where some pioneering photographer had once placed a camera, and where I hoped to do the same. My predecessors may have reached these places in a wagon, on horseback or by mule, but I would have to hike, and in several cases stay overnight in the backcountry for two nights or longer.

So I began planning my kit—the camera, lenses, laptop and batteries that were lightest in weight but sufficient for good-quality photography. I found the lightest carbon-fiber tripod that would reach normal height. I searched out and tested the lightest possible camping gear, counting almost every ounce of my backpack, cookware, tent, sleeping bag and all the other accessories needed for relative comfort and safety in remote parts of our largest parks. In the end I had a pack which, when fully

loaded, including the camera equipment, weighed around 35 pounds, depending on how much water I would have to carry.

My gear ready, I could start the process that led to the final photo pairs in this book.

Selecting the historic photos

The raw materials of rephotography are interesting historic photos that depict the landscape. Subjects such as park buildings, vehicles and tourist groups are less useful for the type of work I do. Furthermore, high-resolution digital scans are a necessity to ensure that small details may be carefully examined and that the images are sufficient for quality publication. Relatively few online archives provide these types of scans, even for a fee. The National Park Service and its various parks, for example, share images online that, while interesting, are usually provided at low resolution or are not available for download. (Grand Canyon's archive is an exception.) Fortunately there are several other good sources, including a few that are free. The U.S. Geological Survey and the Library of Congress have placed thousands of easily searchable, high-resolution images online, including views of national park areas, all of them available to the public at no charge. Other archives, museums and libraries have also posted digital collections in recent years, with varying degrees of quality and resolution. The archives I accessed are listed on page 236, and in the collection credit that appears next to each historic photo.

While online archives were an important resource, there were times when the easiest way to acquire key images I really wanted to use was to purchase them from online dealers and auction sites. This part of the research and acquisition was enjoyable, something I could work on in the off-season when many parks were buried in snow. I could dream of my visits the following summer and lay plans to reach the location of photos I was viewing. In fact, as I became more familiar with each park, I often recognized specific locations in historic photos for sale that I already knew

Photographing Halema'uma'u before sunrise, Hawai'i Volcanoes National Park.

The cameras and other gear I carried for this project

The equipment I used while working on this book was selected for its light weight whenever possible. This list contains the majority of the items I carried, not including necessary accessories—such as a first-aid kit, water filter, spare batteries, headlamps and clothing—that aren't specifically described below.

Nikon D610 cameras with 18-35mm and 24-85mm lenses, plus 40mm and 50mm prime lenses.

Sony RX100 M3 camera for snapshots (some appearing in this book), video and record-keeping.

Eye-Fi WiFi SD card, plus regular SD cards.

MacBook Air, 11-inch

MeFoto RoadTrip Carbon Fiber tripod

Go-Lite backpack (now made by MyTrail)

Android-based phone with OruxMaps GPS app

Delorme InReach satellite texting device

Vasque Sundowner GTX backpacking boots

Sunday Afternoons sun hat

Columbia sun shirts

Black Diamond Carbon Cork trekking poles

LightHeart Solo tent

Kelty Cosmic Down 0 sleeping bag

Therm-a-Rest NeoAir XLite air mattress

Platypus water bottles

"Beer can" style cookstove, HEET fuel

Mountain House freeze-dried food

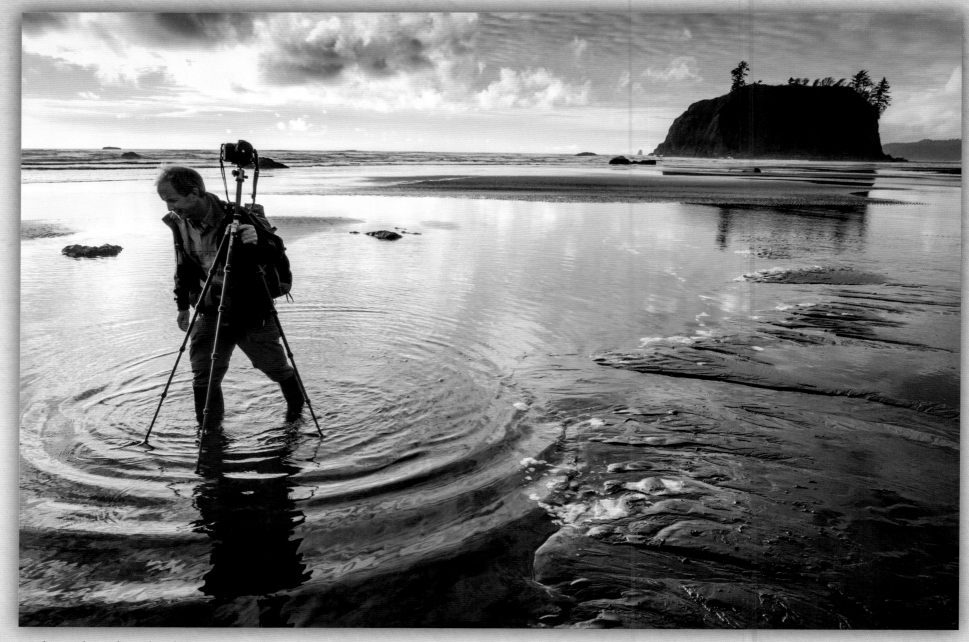

Working at low tide on the Olympic coast.

from my research would work well. The sites were accessible, for example, and located at key viewpoints that were not blocked by trees. All of the historic images marked "author collection" were obtained by purchasing them, the cost ranging from a few dollars to $200 or more. I now have a collection of hundreds of historic national park images, and eventually I will connect with some-one at the National Park Service or a private archive who will make them readily available online for free public use.

Since I have been asked about Ansel Adams during my live presentations, I'll mention that images by that preeminent photographer were not considered for this project. As much as I admire his work, I wanted to use the earliest views of places like Yo-semite, Yellowstone and the Grand Canyon, some of which predate Adams's work by 50 to 100 years.

Organizing the historic photos

This was an ongoing process as I learned more about each park using books, Google Earth and online field guides. In time I came to recognize many of the major landforms or viewpoints in each park, so almost any historic photo I encountered could

be linked to a particular geographic area. By using keywords in my photo software I could locate the digital scan of a particular image in seconds while in the field. I also placed 8x10-inch prints into binders, sorted by regions within each park for quickest possible access.

Pre-trip efforts to locate historic photo sites

I spent many hours using Google Earth to follow trails, study aerial views and review photographs posted by modern visitors. Those many hours of preparation saved a great deal of time in finding my way to photo sites once I reached the park. I might,

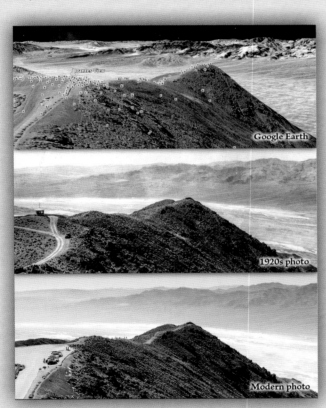

Above: Google Earth was useful in identifying some sites such as Dante's View in Death Valley.

for example, see the background of an historic image I was researching in an oblique view provided by Google Earth's satellite imagery. Or I might find it within a photo posted there by another visitor. In either case I could transfer the coordinates for that location to a hand-held GPS (an app on my phone),

which I could later use to find my way. Once I reached the general vicinity, I would have a much better chance of finding the historic photo site.

Sometimes this method placed me within yards of a photo site. Other times the site would still be a mile or more away, but I could eventually work my way there. What I might not know until reaching it, however, was whether it was now overgrown with trees, still buried under last winter's snow or closed to public access. These things are not always revealed in Google Earth, but that was part of the larger mystery I (usually) enjoyed solving.

Extensive use of Google Earth for virtual visits and following trails made the parks familiar to me in a way that would not have been possible had I just driven through the front gate with a map in my hand. The whole project would have taken months or perhaps years longer without this invaluable aid.

Planning my travels

The logistics for this project were somewhat complicated. I made my own travel arrangements, including hotels or camping on the way as well as flights and car rentals when needed. I preferred to drive if possible (from my home in the Black Hills of South Dakota) as that allowed me to bring all the gear I wanted and to possibly visit other parks along my route. I've also always loved driving across this country. But sometimes I flew to airports within driving range of a park rather than spend several days driving there, which gave me more time to explore and work.

One part of planning that was generally taken care of well in advance was obtaining permits for backcountry camping. Due to the distances involved for photo sites that were deep within a park (in the Grand Canyon and at Yosemite in particular), I needed to camp along the route once I had parked my car. And most backcountry permits are issued months ahead of time, due to public demand. Whenever the situation required me

Above: Closed areas at Bryce, Haleakalá and Glacier. Below: Camp at Horseshoe Mesa, Grand Canyon.

to ask for one upon arrival, I had to wait in line at a backcountry office and hope for one of the few last-minute permits typically held for this purpose. Fortunately I was able to plan ahead most of the time and receive a permit as soon as they became available. The National Park Service has a good and fair system for backcountry permits, but it was complicated at times to get where I wanted to go.

Another potentially complicated permit issue had to do with commercial photography. I have been asked, even by park staff, whether I needed permission to do my work. National Park Service guidelines, published at NPS.gov, state: "A permit is not required for a commercial photographer not using a prop, model or set, and staying within normal visitation areas and hours of operation."[40]

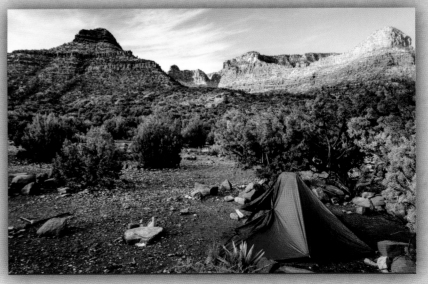

Browsing grizzly bear, Glacier.

Even so, my experience suggests that working photographers should be prepared to quote this passage. One Yosemite ranger who saw me working "professionally" with my camera on a tripod insisted "this park has different rules," and I was forced to call the film permit office there to confirm I was correct about not needing a permit for the work I was doing.

Tracking down the historic photo sites

So I've gathered the historic photos, mapped their possible locations on my GPS, found a hotel or campsite, and arrived at the park with a prioritized list of photographic locations to find.

Timing my arrival was a key part of the process, especially during the tourist season. Parking areas at Arches have sometimes filled up with cars, causing traffic to back up onto the highway. Zion has had similar issues—there has been talk of requiring reservations there—and the lines of slow-moving or stopped cars at Yellowstone can stretch for miles, especially if wildlife is near the road. By rising before dawn (and what photographer minds that) I found it was fairly easy to beat the crowds,

at least to begin with. In places like Yellowstone and Yosemite I would park at a central location and ride a bike to the day's destinations. Visiting in the off-season was another option for avoiding crowds at some parks, if weather permitted.

When I was ready to search for a specific photo site on my list, my GPS would suggest the best way to reach the general location I had projected weeks or months earlier while researching it in Google Earth. Some historic photo sites are along main roads or at obvious overlooks, and were relatively easy to find. The main difficulty I might encounter in those instances was the presence of too many people by the time I arrived, and I would have to decide whether to return at a better time or move on to a more promising site. But other locations were far more remote, and could pose problems that I would learn about only after a long hike.

One obstacle I encountered at almost every park was an area that had been closed to visitor access, either seasonally or permanently. The reasons listed on signs might include "habitat preservation," "vegetative restoration," "emergency closure" or wildlife breeding or feeding areas. Some areas are deemed too dangerous, like the thermal areas in Yellowstone, the caldera access at Hawai'i Volcanoes, or radioactive tailings in the Grand Canyon. The National Park Service labels other places "administrative," where they simply don't want the general public to wander, including employee residence areas (some of which were visitor areas at the time of the historic photos), antenna or communication sites, maintenance yards, gravel pits and construction sites. I encountered all of these examples while on my way to sites where earlier photographers had worked. Sometimes I was able to detour on a longer route to reach an open photo site, but not always. I could have applied for a per-

mit to enter closed areas—a costly, time-consuming and uncertain process—but I decided in all cases to move on to other photo sites that were not in closed areas, where readers of this book could also go. Still, there were times when I could see the site I was looking for just a few yards beyond a "closed area" sign, which could be frustrating.

A second potential obstacle was vegetation—new or growing trees and bushes partially or completely obscuring a view that had been open in the past. I encountered this at a good number of photo sites in nearly all parks I visited, generally due to the policy, beginning in the late 1800s, of suppressing natural, lightning-caused fires. The point is illustrated by several sites included in this book, but there were many other tree-blocked sites I chose not to include here.

Checking the shot at Glacier Point, Yosemite.

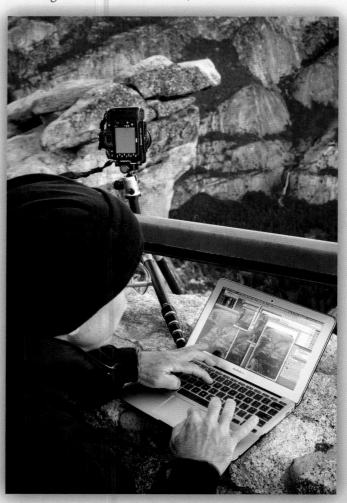

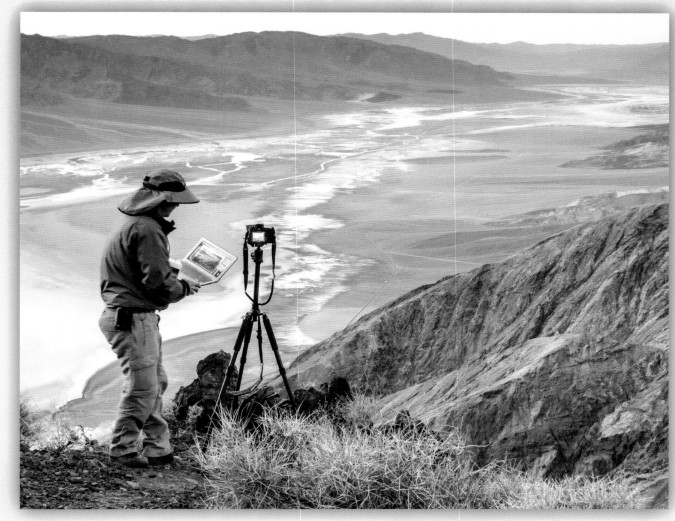

Above: Reviewing test shots above Death Valley.
Right: Filtering water at Hermit Creek, Grand Canyon.

The previous winter's snow could also be an issue, even in June or July. Large drifts on Mt. Rainier and on Yosemite's Clouds Rest forced me to compromise camera placement at photo sites. A large section of Crater Lake's road system was still closed in July due to lingering snow. The roads there were closed at another time due to a major wildfire, so I was delayed by both fire and ice in getting the shots I wanted around Crater Lake.

The weather itself—be it rain, fog or falling snow—held up my work at Mt. Rainier (twice), Yosemite, Grand Teton and Yellowstone among other locations. But while it slowed my progress, I never complain about bad weather. A photographer shoots through it when possible, and is often rewarded with some of the best photos as it starts to clear out.

Yet another obstacle I found was sites that had eroded, either partially or to the point that they were missing altogether. The areas most affected were in the Badlands, on the rim and along trails of the Grand Canyon, and along the Pacific shoreline in Olympic National Park. Sometimes I could still achieve an approximate view (as noted in captions where appropriate), but in other locations I was forced to give up.

Duplicating the historic image

In most areas, however, I arrived to find that the photo site still existed, access was unrestricted, the view was open and the weather was good. I had used my GPS to reach the approximate location as efficiently as possible without getting lost, and with the ability to see how far I had come. (I also carried paper maps as a backup.) But even with the GPS, I continued to use a technique I learned 20 years ago for finding a specific photo site, often with an accuracy of a foot or less. Once I have located the background in an historic photo (mountain, waterfall or canyon, for example), I search for a foreground object (like a boulder, cliff edge or tree stump) that should be somewhere in the scene in front of me. As I work closer to the true photo point, the background I'm seeking might now be a rock or other feature only a few feet away, which I compare to its alignment with a new foreground feature that might be just inches from the camera. When those landscape features are available for careful study, this process can get me extremely close to the location of the historic camera.

Ideally I would rephotograph sites at the time I found them, marking only the best sites for a second visit if the light or other conditions weren't right. Sometimes I could return to such a site during the same week; otherwise it might be a year or more before I could get back to it, during a return visit to that park. But I always tried to make a photo on my first visit, regardless of conditions, because I could never assume I'd be able to return. Some parks were too far from home (Acadia or

Great Smoky Mountains), and in other parks I might have no desire to revisit certain areas. Some were hard to reach due to dense thickets or cactus (at Mt. Rainier, Glacier, Olympic and Big Bend), while other sites were downright scary (in certain areas of Grand Canyon).

Once I found a site, I set up my camera approximately where I thought it needed to be and lined up the scene in my viewfinder with what I saw in the historic photo. I then took the first test shot, which my camera transmitted wirelessly to the laptop, where the historic image was already displayed. By overlaying the two images onscreen (looking through the past into the present, you might say), I could see whether I needed to change the focal length of my lens or adjust the camera position. A shift of only inches (side to side, forward and backward, up or down, or all three) could have a significant effect on the results, especially when foreground elements such as boulders or trees were close to the camera point. And when there were objects in the immediate foreground,

Stone tool along the Grand View Trail, Grand Canyon.

perhaps a foot from the lens or just below the camera, it was even more difficult to match the image. So being able to make direct comparisons on my laptop—repeating test shots as needed with each

movement of the camera—was the key to good results. Through this method I was usually able to create what I strive for, a precisely matched modern version of the historic image.

This is the part of the process that brought the most anticipation and excitement, when I came within the final few feet or inches of where the photographer set his tripod perhaps a century ago. I wrote about this feeling in the Introduction (page 6), but it was a magical time for me. Looking at the historic image laid over my own on the laptop screen, I could flip from past to present. When my work was done well, I could see through the new photo to the old, and compare every aspect of both images. Sometimes I even recognized features in front of me that I had overlooked in a dim or fuzzy corner of the historic photo.

Occasionally I obtained a matching photo on the first attempt, but it usually took four or five tries, with adjustments in between. There were also times when vegetation or other obstacles obscured the view and required perhaps 15 or 20 test shots before I was satisfied with the result. My ultimate, ideal goal was to place my camera within an inch or two of where the earlier photographer's camera had been. Then I would watch the light and continue shooting, waiting for people, traffic, clouds or sunlight to come and go across the scene until I had a good or—when everything came together—even a great shot.

The challenge of historic cameras and lenses

Given the thousands of models available over the years, few if any of the historic photographers represented in this book used the same cameras or lenses. As a result, an important part of rephotography is identifying the focal length of the original lens by comparing the placement of elements within an image to that produced by the lenses now available. For example, I've found that most stereo photographs (the historic photos in this book with a printed "frame," intended for insertion in stereo viewers of the 1800s and early 1900s) were taken with wide-angle lenses, approximating focal

Above: Corvette tire in ditch along Route 66, Petrified Forest. Below: Old coffeepot and mining debris, Horseshoe Mesa in the Grand Canyon.

lengths of 24mm to 35mm in relation to the 35mm digital or film cameras commonly used today. For postcard images, I've noted focal lengths of about 33mm to 50mm, with two examples from the 1940s (when lenses were becoming more sophisticated) reaching 80 or 105mm. To match these various historic lenses, I generally used Nikon zoom lenses of 18-35mm and 24-85mm, which accommodated most of the views in this book. Occasionally I switched to 40mm or 50mm "prime" lenses

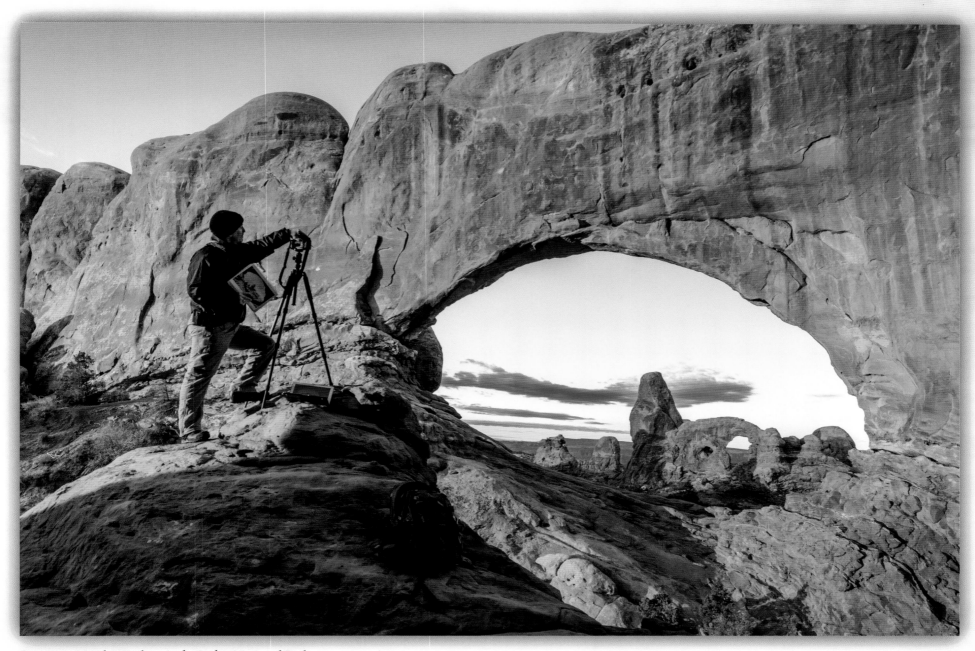

Sunrise at North Window Arch, Arches National Park.

to gain a little sharpness or to work in lower light. But the primes are heavier, so they often remained in the car or camp when I was on a long hike.

I also discovered that many historic photos were not taken with the camera perfectly level. Considering that early glass-plate cameras required photographers to compose the image while viewing it upside-down from the rear, probably with their head under a black cloth, this is not surprising. I always composed my own photos a little wider than the original, providing an extra margin at the edges to allow for possible error on my part. Of course I had the option of cropping the image later to match the original scene.

Readers can find their way to the scenes in this book with the help of latitude and longitude coordinates found next to or near each modern photo. Programmed into a GPS, they will normally lead to a point within 100 feet of where I stood, and often much closer. Please use extreme caution near cliffs, fast-moving water, geysers or other hazardous areas. Keep in mind that the most direct route the GPS points to may not be the easiest or the safest. It may even point you to places you should not

231

Backcountry toilet with a view at Grand Canyon.

go, due to variations in the accuracy of GPS systems, rounding errors on your particular device, or errors in entering the numbers. Look up often from your screen as you navigate.

Dating historic photos

I worked hard to ensure that the dates under each historic photo in this book are as accurate as possible, but it's helpful to remember that the process is more complicated than it might appear. Dates are seldom included on historic images, and

Above: Along the Iceberg Lake Trail, Glacier.
Opposite: Yosemite's Half Dome from near Clouds Rest.

even when there is a date or written information, no matter how authoritative or original it might seem, I've learned that it can sometimes be in error. The date could have been based on a postmark or when a tourist purchased the photo, years after it was taken. Even photographers and publishers made mistakes. I've seen multiple cases of "Yellowstone" being confused with "Yosemite" on historic photos, as one simple but surprising example. Copyright dates are also suspect. They might have been recorded a year or two after an image was actually made, or sometimes years later, when it was republished in another form.

If I could be certain the date and year on an image were correct (at least within a year or two), it is listed with the photo title. But if "circa" appears before the year, it means I had to make an educated guess about the photo's date of origin. I dated these "circa" photos in several ways: checking online archives that have access to the original photographer's information; looking for information on when a particular photographer was known to have worked in a given park; trying to determine when events in the photos took place or when certain buildings, roads or landmarks existed; and studying any automobiles or clothing styles visible in some photos. Less-certain clues to estimating a photograph's date include the style of the image, how it was published (as a stereoview or postcard) and looking at the stamp box on the reverse of photo postcards. Manufacturers used different designs on their postcard photographic paper, allowing for rough date estimates based on formats as they changed over time. It's not a perfect process, but I used every resource I could find in the quest for accurate dates. I welcome corrections or any information that might help further refine the dates of these images.

Today and tomorrow in the national parks

The one thing that all the historic images have in common is providing a frame of reference against which we can measure the progress of our nation's stewardship in caring for and protecting these invaluable places. Many of the photo pairs in this

book show areas of our national parks that look virtually unchanged, suggesting that preservation and protection are working quite well. Looking back to the time of other historic photos—when it was OK to bore tunnels through Sequoia trees as a novelty, when visitors were encouraged to feed garbage to bears, when we still thought of nature as something people should control—we can see in hindsight that these practices were unwise. The challenge for today is having the foresight to see where we may be going wrong now. Although its full impact isn't often visible in the photos selected for this book, based on my own experiences I would suggest that overcrowding is the biggest single issue facing managers at many of the parks featured here.

Perhaps in another 100 years someone will come along to revisit these photo sites and point out what we could have done better in our own era. (I would

Summertime on Mt. Rainier: the Skyline Trail on July 3.

be honored if my photos are useful to that future visitor.) Let's hope that we will not be found too wanting, and that our unique and treasured national parks will continue to endure and enchant for many generations to come.

Paul Horsted • Custer, SD

Endnotes

1. "Cruise Ship Forum Set." *Mount Desert Islander,* Bar Harbor, ME. 5/17/17. Web. Accessed 8/2/17. http://www.mdislander.com/maine-news/cruise-ship-forum-set

2. "River Otters On The Shore Of Schoodic Point In Acadia National Park, Maine." Schoodic Institute, Winter Harbor, ME. YouTube video. Web. Accessed 5/16/17. https://www.youtube.com/watch?v=pEn75dqoVC8

3. I found another print of this image, with the information about T.A. McIntire attached, in the digital collection of the Southwest Harbor Public Library, Southwest Harbor, ME. Personal visit on 9/17/14.

4. Lohman, Stanley William, and John R. Stacy. *The Geologic Story Of Arches National Park.* 1st ed. Washington: Superintendent of Documents, U.S. Government Printing Office, 1975, page 2. Print.

5. A U.S. Department of Energy interpretive sign near the tailings clean-up site explains the history of this project. Additional documents about the project are at the Grand County Library in Moab, Utah.

6. "Heavy traffic forces shutdown at entrance to Arches N.P." Moabtimes.com, Moab, UT. 5/28/15. Web. Accessed 5/17/17. http://www.moabtimes.com/view/full_story/26659449/article-Heavy-traffic-forces-shutdown-at-entrance-to-Arches-N-P-?instance=home_news_right

7. Shuler, Jay. *A Revelation Called the Badlands: Building a National Park, 1909-1939.* 1st ed. Interior, SD: Badlands Natural History Association, 1989, page 36. Print.

8. "Nonnative Species in Big Bend National Park." NPS.gov. Web. Accessed 7/30/17. www.nps.gov/bibe/learn/nature/nonnativespecies.htm

9. "Badwater Basin." Wikipedia.org. Web. Accessed 7/30/17. https://en.wikipedia.org/wiki/Badwater_Basin

10. A Park Service interpretive sign at the site refers to the Badwater Snail and trampling of the landscape around the pool by visitors to this area.

11. "Zabriskie Point." Wikipedia.org. Web. Accessed 7/30/17. https://en.wikipedia.org/wiki/Zabriskie_Point

12. "Frequently Asked Questions: Death Valley National Park." NPS.gov. Web. Accessed 7/30/17. https://www.nps.gov/deva/faqs.htm

13. "George M. Wheeler." West Point, NY: West Point Association of Graduates. Web. Accessed 7/30/17. http://apps.westpointaog.org/Memorials/Article/2120/

14. Hagen, John. "A History Of Many Glacier Hotel." Minneapolis: Glacier Park Foundation. Web. Accessed 6/2/17. http://www.glacierparkfoundation.org/History/mgh.html

15. Vaughan, Richard. "To the Ice: George Bird Grinnell's 1887 Ascent of Grinnell Glacier." Bloomington, IN: Indiana University Law Library, Maurer School of Law, 2010. Web. Accessed 7/26/17. http://www.repository.law.indiana.edu/facpub/747

16. Weeks after my visit to this photo site, I learned it had already been rephotographed in 1968, nearly 50 years before I got there, with the results published in an out-of-print 1987 book entitled *In the Footsteps of John Wesley Powell,* by Hal G. Stephens and Eugene M. Shoemaker. Learning I hadn't been "the first" here has not diminished the excitement of finding the site on my own.

17. Senf, Rebecca and Stephen J. Pyne. *Reconstructing the View: the Grand Canyon Photographs of Mark Klett and Byron Wolfe.* Berkeley: University of California Press, 2012, plate 19. Print.

18. "Jackson Hole & The President Arthur Yellowstone Expedition Of 1883." Jackson, WY: Jackson Hole Historical Society & Museum. Web. Accessed 4/6/17. http://jacksonholehistory.org/jackson-hole-the-president-arthur-yellowstone-expedition-of-1883/

19. "Menors Ferry Historic District: Grand Teton National Park." NPS.gov. Web. Accessed 6/4/17. https://www.nps.gov/grte/learn/historyculture/menors.htm

20. "Charges Dropped Against 2 Teens Initially Thought To Have Started Wildfire That Burned Into Gatlinburg." Wildfire Today. 6/30/17. Web. Accessed 7/29/17. http://wildfiretoday.com/tag/chimney-2-fire/

21. "Step On Charlie's Bunion." NPS.gov. Web. Accessed 6/5/17. https://www.nps.gov/experiences/charlies-bunion.htm

22. "The May 1924 Explosive Eruption of Kilauea." USGS.gov. Web. Accessed 7/25/17. https://volcanoes.usgs.gov/volcanoes/kilauea/geo_hist_1924_halemaumau.html

23. "Volcano Hazards Of The Lassen Volcanic National Park Area, California." USGS.gov. Web. Accessed 6/17/17. https://pubs.usgs.gov/fs/2000/fs022-00/

24. "The Eruption Of Lassen Peak: Lassen Volcanic National Park." 2017. NPS.gov. 2/28/15. Web. Accessed 6/29/17. https://www.nps.gov/lavo/learn/nature/eruption_lassen_peak.htm

25. "The History of Sunrise Lodge." Ashford, WA: Rainier Guest Services. Web. Accessed 6/7/17. http://mtrainierguestservices.com/about-us/history/history-sunrise-lodge/

26. Burtchard, Greg, Benjamin Diaz and Kendra Carlisle. "Paradise Camp: Archaeology in the Paradise Developed Area, Mt. Rainier National Park." National Park Service, 2008. Web. Accessed 6/7/17. https://www.nps.gov/mora/learn/historyculture/upload/Paradise%20Camp%20Report%20for%20Adobe%20Reader.pdf

27. Repanshek, Kurt. "Petrified Forest National Park." Park City, UT: National Park Advocates, LLC. 6/23/13. Web. Accessed 6/7/17. https://www.nationalparktraveler.org/2013/06/trails-ive-hiked-giant-logs-trail-petrified-forest-national-park23480

28. Davis, Ren, and Helen Davis. *Landscapes for the people: George Alexander Grant, First Chief Photographer of the National Park Service.* Athens: University of Georgia Press, 2015, pages 21 and 59. Print.

29. "History of Giant Forest Development." NPS.gov. Web. Accessed 8/3/17. https://www.nps.gov/seki/learn/historyculture/gfhistory.htm

30. "Giant Forest." Wikipedia.org. Web. Accessed 8/3/17. https://en.wikipedia.org/wiki/Giant_Forest

31. "The Myth Of The Tree You Can Drive Through: Sequoia & Kings Canyon National Parks." NPS.gov. Web. Accessed 6/8/17. https://www.nps.gov/seki/faqtunnel.htm

32. "Historic District: Wind Cave National Park." NPS.gov. Web. Accessed 6/9/17. https://www.nps.gov/wica/learn/historyculture/national-historic-district.htm

33. Ibid.

Ancient tree, large pine cone, Yosemite.

34. Whittlesey, Lee H. *Yellowstone Place Names*. Gardiner, MT: Wonderland Publishing Company, 2006, pages 202 and 203. Print.

35. "Old Faithful." Los Alamos: The Geyser Observation and Study Organization. Web. Accessed 5/10/17. http://www.geyserstudy.org

36. Palmquist, Peter E., and Thomas R. Kailbourn. *Pioneer Photographers Of The Far West: A Biographical Dictionary 1840-1865*. Stanford: Stanford University Press, 2000, page 284. Print.

37. "Hunting For The Hutchings House: Yosemite National Park." NPS.gov. 3/19/13. Web. Accessed 5/3/17. https://www.nps.gov/yose/blogs/hunting-for-the-hutchings-house.htm

38. Palmquist, Peter E., and Thomas R. Kailbourn, *op. cit.*, page 284.

39. "Yosemite National Park Reminds Visitors: Tree Mortality Can Cause Hazardous Conditions." Sierra Sun Times. 7/28/17. Web. Accessed 7/30/17. http://goldrushcam.com/sierrasuntimes/index.php/news/local-news/10601-yosemite-national-park-reminds-visitors-tree-mortality-can-cause-hazardous-conditions

40. See https://www.nps.gov/policy/DOrders/RM53.pdf, page 13. Accessed 7/28/17.

Car camping at Tuweep, north rim of Grand Canyon.

Bear Grass along Highline Trail, Glacier.

Bibliography

Davis, Ren and Davis, Helen. *Landscapes for the People: George Alexander Grant, First Chief Photographer of the National Park Service*. Athens, GA: University of Georgia Press, 2015.

Department of Interior (Pub.) *National Parks Portfolio*. Washington, 1915.

Diettert, Gerald. *Grinnell's Glacier*. Missoula, MT: Mountain Press Pub. Co., 1992.

Duncan, Dayton and Burns, Ken. *The National Parks: America's Best Idea*. New York: Alfred A. Knopf, 2009.

Fowler, Don (Ed.) *Photographed All the Best Scenery: Jack Hillers's Diary of the Powell Expeditions, 1871-1875*. Salt Lake City: University of Utah Press, 1972.

Ghiglieri, Michael. *First Through Grand Canyon*. Flagstaff, AZ: Puma Press, 2010.

Ghiglieri, Michael and Farabee, Charles Jr. *Off the Wall: Death in Yosemite*. Flagstaff: Puma Press, 2007.

Ghiglieri, Michael and Myers, Thomas. *Over the Edge: Death in Grand Canyon*. Flagstaff: Puma Press, 2001.

Jackson, William Henry and Fielder, John. *Colorado, 1870-2000*. Englewood, CO: Westcliffe Publishers, 2001.

Klett, Mark, Solnit, Rebecca and Wolfe, Byron. *Yosemite in Time*. San Antonio: Trinity University Press, 2005.

Klett, Mark and Wolfe, Byron. *Reconstructing the View*. Berkeley: University of California Press, 2012.

Oswald, Michael Joseph. *Your Guide to the National Parks*. Whitelaw, WI: Stone Road Press, 2012.

Shuler, Jay. *A Revelation Called the Badlands: Building a National Park, 1939-1989*. Interior, SD: Badlands Natural History Association, 1989.

Skurka, Andrew. *The Ultimate Hiker's Gear Guide*. Washington: National Geographic, 2012.

Stephens, Hal and Shoemaker, Eugene. *In the footsteps of John Wesley Powell*. Boulder: Johnson Books, 1987.

Whittlesey, Lee. *Death in Yellowstone*. Lanham, MD: Roberts Rinehart, 2014.

Historical photographers whose work appears in this book (alphabetical by last name):

A number of historic images in this book are credited "Unknown Photographer." For reasons that are unknown, these individuals (or their publishers) did not include their names on finished prints. Researching the known historic photographers (listed below) could be a book project in itself. Searches in the U.S. Copyright Office were not productive. Copyrights are now expired for many historic images, but I welcome information about surviving rights holders for any of these photographers. I felt a kinship with them as I stood where they had placed their cameras, and as I contemplated the vision they had in composing their images.

The names below are listed as generally published on the photographer's work or in sources that identify the photographer.

W.H. Ballard
William Bell
B. Bradley
Philip Brigandi
F.C. Calkins
Louis Canedy
W.R. Cross
Asahel Curtis
J.M. Davis
Jervie H. Eastman
L. Eddy
J. Boyd Ellis
F.J. Francis
Burton Frasher Sr.
George Grant
F. Jay Haynes

Martin M. Hazeltine
Tomar J. Hileman
Robert T. Hill
John K. Hillers
T.W. Ingersoll
William Henry Jackson
W.M. Kline
Tai Sing Loo
B.F. Loomis
R.E. Marble
Lester Moe
Mullen (spelling uncertain)
Timothy O'Sullivan
Frank Patterson
Henry Peabody

Arthur C. Pillsbury
Harry Reed
Harold Sanborn
B.L. Singley
John P. Soule
R.E. Stinson
I.W. Taber
James E. Thompson
H.C. Tibbitts
Charles A. Townsend
Elmer & Bert Underwood
Carleton Watkins
H.C. White
R.Y. Young

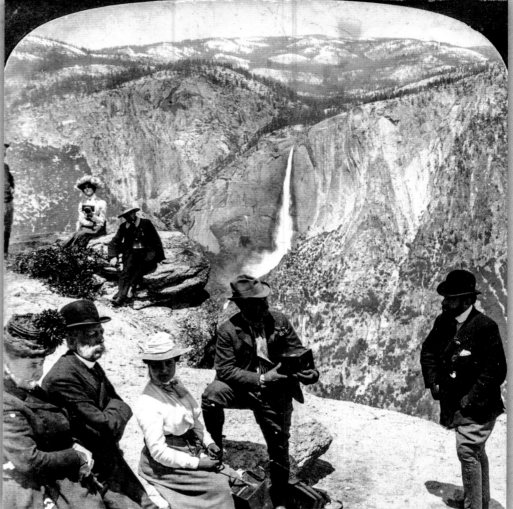

Circa 1900 shutterbugs at Glacier Point, Yosemite.

AUTHOR COLLECTION/AMERICAN STEREOSCOPIC CO./R.Y. YOUNG

Collections accessed for this book (alphabetical) * Denotes free online archive with scans available for download.

Beinecke Rare Book and Manuscript Library, Yale University
Bob Berry Collection, Cody, WY
Calvin M. McClung Historical Collection, Knox County, TN, Public Library System
Dan McPherson Collection, courtesy Ardelle McPherson
eBay.com
Henry Art Gallery, University of Washington (Seattle)
History Colorado, Denver
Howard Stein Collection
J. Paul Getty Museum*

Keystone-Mast Collection, University of California, Riverside/California Museum of Photography
Library of Congress*
Marfa, TX, Public Library
New York Public Library*
National Archives*
National Park Service, Grand Canyon National Park*
National Park Service, Harpers Ferry, WV
National Park Service, Wind Cave National Park*
Southwest Harbor (ME) Public Library Collection

Stephen Vandiver Jones Collection, courtesy Jacquelyn Jones Gunnarson, Jeanne Jones Manzer and other relatives and descendants of S.V. Jones
Thompson Photo Co., courtesy Anne Thompson, Knoxville, TN
U.S. Geological Survey*
Utah State Historical Society
Wikipedia.com* (links to historic photos at the National Archives and elsewhere)

Acknowledgements

This book would have never moved from dream to reality without the help of many people, to whom I am indebted.

My wife, Camille Riner, and our daughter Anna traveled with me to some of the parks in this book, but often I worked alone and was away from home for weeks at a time. They kept the rest of our business and household in good order during my absences. Once my field work and writing were done, Camille put in long hours designing the beautiful artisanal book you are now holding. She put up with my last-minute additions and changes of direction with good humor and an abundance of patience.

My parents, Burt and Gladys Horsted, continue to give us their love and support as we follow our artistic path. Camille's parents, Al and Linda Riner, do likewise, and assisted with proofreading. My brother Dan is always just a phone call away and also a supportive influence in my life.

Ernie Grafe served as my editor, as he has done since the 2002 publication of our first book (for which he was also my co-author; see page 2). My writing is massively improved by his efforts, and more than once he has caught potentially embarrassing errors with facts and figures.

National Park Service interpretive and archives staff at several parks gave me some of their valuable time. I'd especially like to thank Tom Farrell, Chief of Interpretation at Wind Cave National Park; Doug Crispin, interpretive ranger at Grand Teton; Doug Cox, Museum Curator at Death Valley; Colleen Hyde, Museum Specialist at Grand Canyon; and Bill Parker, Chief of Science and Resource Management at Petrified Forest. At other parks, my family and I were aided by excellent front-line NPS staff who answered our basic questions, as they do for all visitors.

Extra help obtaining scans of historic photos came from several individuals and institutions. Howard Stein archived the stellar H.C. Tibbitts collection, some of which appears in this book. Ren and Helen Davis shared scans they made from historic prints unearthed at National Park Service archives for their own book (see bibliography). Anne Thompson of Thompson Photo Products in Nashville loaned outstanding images of the Great Smoky Mountains taken by her grandfather, James E. Thompson. Leigh Gleason, Curator of Collections at the University of California, Riverside/California Museum of Photography, helped me navigate the invaluable Keystone-Mast Collection. Lisa McKeon and Suzanna Soileau, of the U.S. Geological Survey, replied within minutes to my queries. I appreciate their efforts.

I have lived long enough to know I can't make up stranger things than may actually happen. An alert friend, Sarah Kopp, was aware of my historical work in the Grand Canyon. She told me that her neighbor, Jacquelyn Gunnarson, was a descendant of Stephen Vandiver Jones, one of the men who accompanied the second Powell-Grand Canyon Expedition in 1871-72. It turned out that Jacquelyn and her sister, Jeanne Manzer, who both live just a few hours from my home, were caretakers of a col-

The S.V. Jones collection, a trove of historic photos.

lection of some 300 historic images once owned by their ancestor. They graciously gave me permission to make copies; one of the images appears on page 93 and is among my favorites from this project.

Braden Beane guided my first Half Dome climb; he works for LastingAdventures.com. Thanks, dude. A number of my other fellow travelers—usually people I met on backcountry trails—agreed to appear in photographs that are now part of this book. I am grateful for their assistance, all will receive a free book, and I hope to meet them on the trail again one day.

Bob and Robin Berry of Cody, Wyoming, have been my dear friends ever since Bob and I co-authored our earlier book, *Yellowstone Yesterday & Today.* Bob once again loaned me images from his museum-grade historical photo collection for this book. Bob and Robin also have a beautiful bed and breakfast in Cody. See www.robinsnestcody.com.

Bill Goehring, Steve Baldwin, Jon Nelson and Bob Kolbe have been my great friends for years, all of them acting as my sounding board as I work through artistic decisions on projects such as this one. Tom Sutter, a dedicated rephotographer in his own right, also encouraged my efforts. Thanks for being there, gentlemen.

As a small, independent publisher I'm grateful to my book distributors who place our books in front of potential readers. These distributors include DakotaWest Books, Rapid City, SD; Black Hills Parks & Forests Association, headquartered at Wind Cave National Park; Yellowstone Forever in Yellowstone; and Treasure Chest Books, Tucson, AZ.

We employed a small army of volunteer proofreaders as this book was about to go to press. This group included past and present National Park Service employees as well as friends and family. Any errors that may have slipped through remain entirely my own. Feedback, corrections or comments about this project are always welcome. Contact me via email at paul@paulhorsted.com or find me on social media.

 P.H.

Index

Index

Index

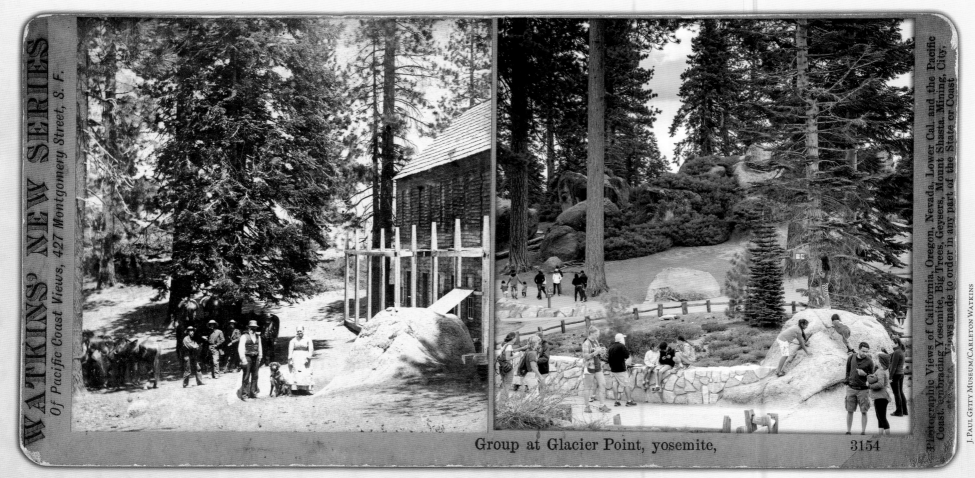

Group at Glacier Point, Yosemite, 3154

5/29/16 • 37°43'41" N 119°34'24" W

J. Paul Getty Museum/Carleton Watkins

Enjoy your National Park Treasures! Look for more at paulhorsted.com.